Photography in Africa

Photography in Africa

Ethnographic Perspectives

Edited by
Richard Vokes

JC JAMES CURREY

James Currey
is an imprint of Boydell & Brewer Ltd
PO Box 9, Woodbridge,
Suffolk IP12 3DF (GB)
www.jamescurrey.com

and of

Boydell & Brewer Inc.
668 Mt Hope Avenue
Rochester, NY 14620-2731 (US)
www.boydellandbrewer.com

British Library Cataloguing in Publication Data
A catalogue record for this book is available
on request from the British Library

ISBN 978-1-84701-053-7 James Currey (Paperback)
ISBN 978-1-84701-045-2 James Currey (Cloth)

The publisher has no responsibility for the continued existence or accuracy of URLs for external
or third-party internet websites referred to in this book, and does not guarantee that any
content on such websites is, or will remain, accurate or appropriate.

Papers used by Boydell & Brewer are natural, recycled products
made from wood grown in sustainable forests.

Designed and typeset in 10/12 pt Monotype Photina with Compacta Display
by Kate Kirkwood, Long House Publishing Services
Printed and bound in the United States of America

To the memory of the 185 people who died
in the Christchurch Earthquake
of 22 February 2011

Contents

List of Figures

Notes on Contributors

Judith Aston is a Senior Lecturer in Creative Media Practice at the University of the West of England. She holds a PhD in computer-related design from the Royal College of Art and a Master's degree in Social Science from the University of Cambridge. Her teaching and research interests are in digital archives, interactive documentary and digitally expanded film-making, with a particular focus on historical anthropology and sensory ethnography. She has presented her work at numerous conferences across the visual arts and social sciences, and has published several papers on her ongoing collaboration with Wendy James.

Jennifer Bajorek is finishing a book on photography and political imagination in Senegal and Benin, *The Atlantides of Memory: Photography and Decolonial Imagination in Africa*. She was recently co-editor (with Vikki Bell) of a special section of *Theory, Culture and Society* on photography and the state, and lead curator of *Contemporary Africa on Screen* at the South London Gallery. She is currently a fellow in the Center for Cultural Analysis at Rutgers University and a research associate of the Institute of Social and Cultural Anthropology at Oxford University.

Heike Behrend is now retired and living in Berlin; she was formerly Professor of Anthropology at the Institute of African Studies at the University of Cologne, Germany. She conducted intensive research in Kenya, Uganda, Ghana and Nigeria and she taught as a Visiting Professor at the École des hautes études in Paris, in the African Studies program of Northwestern University, Evanston Illinois, and at the University of Florida, Gainesville. In 2007 she was Senior Research Fellow at the IFK in Vienna and in 2010 a Visiting Professor at the Tokyo University of Foreign Studies, Japan. She has published extensively on photographic practices in Eastern Africa.

Neil Carrier is based at the African Studies Centre, Oxford. While his earlier research and publications looked at the stimulant *khat* and its 'social life' in Kenya and amongst the Somali diaspora, more recently he has been involved in a number of projects examining film and photography in East Africa, including his collaboration with Kimo Quaintance on the Paul Baxter collection. Currently he is immersed in an anthropological project examining the impact of diaspora in a Somali-dominated Nairobi suburb, and he hopes to make good use of photography in this work.

Erin Haney teaches in the Department of Fine Arts and Art History, George Washington University, in the District of Columbia. She is the author of *Photography and Africa* (2010, Reaktion), as well as articles on the intersection of photography, oral history, the nature and scope of family, private and civic photography collections in West Africa and in colonial collections in the US and Europe. Current curatorial projects attend to the creative photographic modernisms of nineteenth and early twentieth century urban West Africa, the

thread of social criticism in the work of contemporary photographers, and the subjectivities of African diaspora in the Middle East.

Wendy James is Emeritus Professor of Social Anthropology at Oxford, and Fellow of St. Cross College, having previously taught in the Universities of Khartoum, Aarhus, and Bergen. She is a Fellow of the British Academy, and in 2011 was appointed CBE. Her interests include the history of anthropological practice, and her main research has been carried out in the Sudan and Ethiopia. Her most recent books include *The Ceremonial Animal: A New Portrait of Anthropology* (OUP 2003) and *War and Survival in Sudan's Frontierlands: Voices from the Blue Nile* (OUP 2007; paperback with new preface, 2009). The latter was accompanied by a website produced in collaboration with Judith Aston: *www.voicesfromthebluenile.org.*

Corinne A. Kratz is Professor of Anthropology and African Studies at Emory University and Research Associate at the Museum of International Folk Art, Santa Fé. Her writing focuses on culture and communication; performance and ritual; museums, exhibitions, photography and representation. She began doing research in Kenya in 1974. Kratz is the author of *Affecting Performance: Meaning, Movement and Experience in Okiek Women's Initiation*, and *The Ones That Are Wanted: Communication and the Politics of Communication in a Photographic Exhibition*, which won both the Collier Prize and honorable mention for the Rubin Outstanding Publication Award. She has also curated museum exhibitions and co-edited *Museum Frictions: Public Cultures/Global Transformations* and a special issue of *Visual Anthropology*.

Katie McKeown is a PhD candidate in the University of Minnesota's History Department and is writing her dissertation on the history of conservation in southern Africa. Her research interests include visual, environmental, cultural, and animal history. Her work has been published in *Environmental History* and *History of Photography*. She holds an MSc in African Studies from the University of Oxford.

Christopher Morton is Curator of Photograph and Manuscript Collections at the Pitt Rivers Museum, and Departmental Lecturer in Visual and Material Anthropology at the Institute of Social and Cultural Anthropology, University of Oxford. He has worked extensively on anthropological photograph collections since 2002, especially relating to south Sudan. He is the co-editor (with Elizabeth Edwards) of *Photography, Anthropology, and History: Expanding the Frame* (Ashgate, 2009), and produced the exhibition and book *Wilfred Thesiger in Africa* at the Pitt Rivers Museum in 2010.

Katrien Pype is a postdoctoral reseacher (Marie Curie IOF, European Commission) at MIT (US) and K.U. Leuven (Belgium). She is a social and cultural anthropologist who has studied various aspects of Kinshasa's media world and the city's popular culture. Her main interests include social dynamics, aesthetics and communication strategies. Katrien has published on dance, sports, TV news, and media aesthetics in journals such as *Africa, Journal of Modern African Studies* and *Journal of Southern African Studies*. A book on the production of evangelizing television serials in Kinshasa is forthcoming with Berghahn Books. Katrien is currently studying the social and religious implications of ICT in the lifeworlds of Kinshasa's old aged.

Kimo Quaintance is a lecturer in International Relations at the University of the German Federal Armed Forces in Munich. After doctoral research on the culture of US national security strategy, he shifted focus to examining the impact of online social networks on communication and culture. He has collaborated with Neil Carrier in several cross-disciplinary efforts to apply photography and data visualization as research methods and tools for conveying research findings.

Richard Vokes is Senior Lecturer in Anthropology and Development Studies at the University of Adelaide, Australia. He holds a D.Phil. in Social Anthropology from the University of Oxford. He has been conducting fieldwork in South-western Uganda since 1999, and has long-standing research interests in this region, especially in the areas of visual and media anthropology. He is author of *Ghosts of Kanungu: Fertility, Secrecy and Exchange in the Great Lakes of East Africa*, which was a finalist for the Herskovits Prize in 2010.

Chris Wingfield is an associate lecturer at the Open University in the West Midlands and an honorary research associate at the Pitt Rivers Museum, University of Oxford and the University College London Centre for Museums, Heritage, and Material Culture Studies. He has most recently been researching the museum, exhibitions and collection of the London Missionary Society.

Acknowledgements

This publication began life at a workshop entitled 'The Image Relation' that was held in Wolfson College, Oxford, on 11 November 2009. Five of the chapters included here were first presented in that workshop (the chapters by James and Aston, Bajorek, Morton, Vokes and Wingfield). I would like to thank my co-convenors of the workshop, Marcus Banks and Benjamin Smith, for having helped to make the day such a great success, and for their ongoing support for this work. I would also like to thank Elizabeth Edwards for all of her input.

The costs of publication of this book were assisted by a grant from the College of Arts, the University of Canterbury, New Zealand. I would like to thank the College's Research Committee for this generous support.

As ever, I reserve my deepest gratitude for my lovely wife Zheela.

Introduction

Richard Vokes

<div style="text-align:right">**1**</div>

The past twenty years have witnessed a huge burgeoning of scholarly interest in all aspects of photography in Africa.[1] The origins of this growing field may be traced to a series of parallel developments in history, art theory, and anthropology, which began to converge from roughly the early 1990s onwards. In history, an emerging interest may be traced to a symposium on *Photographs as Sources for African History* that was organized by David Killingray and Andrew Roberts at the London School of Oriental and African Studies (SOAS) in 1988 (the collected papers of which were published by Roberts later that same year).[2] Although there were other significant books and articles on photography in Africa published at around the same time,[3] the collected papers of the SOAS meeting made a key contribution in defining a new programme for historical research, by providing one of the first comprehensive overviews of the history of photography on the continent, by offering important evaluations of surviving colonial, missionary, and museum/university archives,[4] and by introducing a series of debates about the value of photographs as a source for African history.[5] Moreover, the concerns of the conference have continued to occupy Africanist historians – and others – ever since. In the years following Killingray and Roberts' symposium, a growing body of research has provided ever more detail on the spread of photography across the continent,[6] has offered further descriptions of relevant archives,[7] and has continued to engage in debate as to what sort of truth values might usefully be derived from these visual sources.[8]

Yet over the last two decades, it is not only historians who have developed a new concern with photography in Africa. In addition, the period has also

[1] The majority of this introduction was written while I was resident as a visiting fellow at All Souls College, Oxford, in Hilary 2011. I would like to thank the Warden of All Souls, Sir John Vickers, and all of the fellows and staff of the college, for having made my stay in Oxford such a pleasant and stimulating one. In addition, I would like to thank Erin Haney, Corinne Kratz, Christopher Morton, and one anonymous reviewer for James Currey, for their extremely helpful comments and suggestions on an earlier draft. Of course, any mistakes or omissions remain mine alone.

[2] Killingray and Roberts' own introduction to these collected papers was then republished, in a slightly ammended form, in *History in Africa* (1989).

[3] Following the important early contributions of Bensusan (1966) Bull & Denfield (1970) and Sprague (1978), the second-half of the 1980s saw a growing interest in the history of photography in Africa. For example, see Alloula (1986), Fabb (1987), Monti (1987), and Geary (1988). Roberts' bibliography to the collected papers provides an extended list (1988: 159-168), although this was later superceded by Zaccaria's (then) comprehensive *Photography and African Studies: A Bibliography* (2001).

[4] See also Robert's earlier work in this area (for example, Roberts 1986), and Paul Jenkins' previous publications on the Basel Mission Archive (for example, Jenkins & Geary 1985). (Jenkins was another of the participants in the SOAS workshop.)

[5] See also Geary (1986).

[6] Key contributions include Prochaska (1991), Geary (2003), Schneider (2010), Peffer (2009: 241-280), and especially Haney (2010*b*: 13-55).

[7] For example, *The Standing Conference on Library Materials on Africa* (1995), see also Zaccaria (2001) and Stuehrenberg (2006).

[8] See especially Mack (1991), Enwezor & Zaya (1996: 17-44), Hartmann, Silvester & Hayes (1998), Ranger (2001), Jenkins (2002), Peffer (2008) and Maxwell (2011).

seen a growing engagement with the subject in art exhibitions, and amongst art theorists, art critics and indeed, art dealers. This interest began in the early 1990s when, as part of a broader re-engagement with 'contemporary' African art, a growing number of museums and galleries began to exhibit photographs taken by 'photographers born and/or still resident' in Africa (Haney 2010b: 8), alongside other African visual forms. The aim was to locate these photographers' works within broader stylistic and aesthetic trends, and in so doing, to perhaps trace the contours of a distinctively 'African photography' (i.e. one that differed from other regional traditions). One of the first institutions to incorporate photographs in this way was New York's Museum for African Art,[9] which as part of its seminal exhibition *Africa Explores: 20th Century African Art* (1991), included a number of images taken by a then unknown Malian photographer called Seydou Keïta.[10] However, within just a few years, African photography had also become the subject of exhibitions in its own right, as in the New York Guggenheim Museum's major exhibition, *In/sight: African Photographers, 1940 to the Present* (1996).[11] Equally importantly, though, during this same period the idea of a distinctively 'African photography' also began to be taken up within art theory. This began with the work of writers at *Revue Noire*, a journal on African art that was published in Paris between 1991 and 2001,[12] although the concept later became particularly associated with the journal *African Arts* (which from the late 80s onwards, published an increasing number of articles on photography).

One outcome of these various trends was a rise to prominence of certain African photographers, studios, and photographic milieux. The profiles of some of these were simultaneously also boosted by the operation of international art markets. For example, the growing renown of a photographer such as Seydou Keïta – who by the time of his death in 2001 had already become one of the most famous names in African photography – can be seen as a combined outcome of increased exposure, of deepening scholarly interest, *and* of a growing commercial engagement with his work. Thus, following the inclusion of his photographs in the 'Africa Explores' exhibition, Keïta was 'discovered' by a curator called André Magnin, who later travelled to Mali – in his capacity as an agent for the French-Italian collector Jean Pigozzi – and there purchased several hundred more of the photographer's negatives.[13]

[9] At that time, the museum was called the Center for African Art.

[10] Born in Bamako *c.*1921, Keïta had learned photography from his 'mentor' Mountaga Kouyata, before going on to produce over 10,000 images (most of them taken between 1948 and 1962), from his studio base in the Malian capital (Jedlowski 2008: 35).
The importance of the *Africa Explores* exhibition relates to the contribution it made, at this time, to a growing acceptance amongst art theorists, critics and dealers – and indeed, amongst the general public – that contemporary African art was indeed 'art'. It was therefore as part of this broader trend that the engagement with African photographers such as Keïta first began.

[11] An important early solo exhibition was South African photographer Santu Mofokeng's *Black Photo Album/Look at Me (Slides and Text Slides)*, at the Nederland Foto Insituut in Rotterdam, Holland (1998). See Mofokeng's personal website: http://www.santumofokeng.com.

[12] An anthology of *Revue Noire* articles was published first in French and Portugese editions (1998), and later in an English edition (1999).

[13] As described by Birgham (1999: 62), the curator of the *Africa Explores* exhibition, Susan Vogel, included 30 of Keïta's images in the show, which were enlargements of a series of negatives she had acquired from Keïta's family during an earlier visit to Bamako. However, in the period between her visit to West Africa and the exhibition in New York, Vogel had lost her travel notes, in which the photographer's name was recorded. As a result, she was forced to caption the images, in the exhibition, as photographer 'unknown'. According to Birgham, Magnin then saw

These negatives later formed the basis of a solo exhibition of Keïta's work at the Fondation Cartier in Paris (in 1994), which in turn resulted in an increasing number of academic publications being dedicated to his work.[14] Equally importantly, the Fondation Cartier show – and others that were to follow it – also created a growing international market for Keïta's work (one that was to eventually see a single Keïta image being sold by a New York gallery, in 2006, for US $16,000).[15] Moreover, Keïta's is far from being an isolated case here. As McKeown observes, over the past twenty years, museum curators and art theorists have become increasingly concerned with tracing the biographies of numerous African photographers (2010), whilst Peffer sardonically notes that many of these individuals have similarly gone on to become 'highly collectible, in part because of the curiosity factor, and in part because what can be bought for a song and sold for a mint has always aroused interest among dealers in African art' (2009: 279). Still, the field remains a compelling area for research. Thus, although few curators, or theorists, would today defend the notion of a single, monolithic 'African photography' – not least because the sheer diversity of photographic practices that have been identified across the continent (and in the Diaspora) compels us to instead think in terms of multiple, overlapping 'photograph*ies*'[16] – the general concern for exploring the subjects, stylistic and aesthetic considerations, and political implications, of photographs produced by those who identify themselves as African photographers remains current.[17]

The past twenty years has also witnessed a growing engagement with photography in Africa within anthropology.[18] Following the advent of visual anthropology as a distinctive sub-discipline from roughly the early 1970s onwards, an increasing number of scholars began to examine photography as an important subject of ethnographic enquiry.[19] However, a burgeoning interest in, specifically, photography in *Africa* traces to the later publication of Elizabeth Edwards' edited collection *Anthropology and Photography, 1860-1920* (1992). The central concern of Edwards' collection was a reconsideration of the photographic archives of the UK's Royal Anthropological Institute, and in pursuit of this, it developed a series of case studies about historical ethnographic photography, including a number that looked at various

[13 cont.] the photographs in the exhibition, and later decided to travel to Bamako himself, to identify who the photographer was, and to purchase more of his/her images. During his first vist to Mali, he was able to quickly achieve both of these goals (see also Jedlowski 2008: 36).

[14] A comprehensive bibliography is provided on Keïta's official website: http://www.seydouKeïtaphotographer.com/en/books/ See also Bigham (1999).

[15] See, 'Who Owns Seydou Keïta?', by Michael Rips, in the *New York Times* (22nd January 2006).

[16] See Behrend & Werner (2001: 241). The importance of thinking about all photographic histories and traditions in the plural was most strongly emphasized by Pinney & Peterson's later collection *Photography's Other Histories* (2003, to which Behrend also contributed a chapter, 2003a, see below). The collection includes ethnographic case studies from all over the world.

[17] Amongst the best introductions to contemporary African photographies are Matt, Miessgang & Wien (2002), Enwezor (2006), Grantham (2009) and Simon & Vanhaecke (2010).

[18] Although it should be pointed out that there is often substantial overlap between the fields of historical research, museum ethnography, and socio-cultural anthropology. For example, scholars such as Christraud Geary and Elizabeth Edwards, amongst others, have made substantial contributions to all of these areas of research.

[19] Significant early contributions include Scherer (1975), Edwards & Williamson (1981) and Banta & Hinsley, with O'Donnell (1986). See also Scherer (1990) for a comprehensive overview. In addition, the two main journals, *Visual Anthropology Review*, and *Visual Anthropology* (which were established in 1970 and 1987, respectively), have both carried numerous articles on photography from the time of their creation.

African examples.[20] Taken together, these case studies generated new ways of thinking about nineteenth-century ethnographic photography, and especially that which had been produced as part of a Victorian 'scientific' anthropology. In the period since its production, much of this imagery had come to be seen as deeply flawed, not least because of its overtones of scientific racism (see Maxwell 2008), but also because of its staged and artificial nature (for example, the posed portrait shots of J. W. Lindt, described by Poignant 1992: 54), and latterly, simply by its lack of relevance to the 'modern' anthropological project. However, by developing a series of 'counter-readings' of these photographs, the contributors to Edwards' collection attempted to go beyond or behind their producers' (presumed) intentions, and to recover the historical traces of the people depicted. In this way, one of the key contributions of the book was to show how this imagery, no matter how seemingly artificial, nevertheless recorded points in individual and collective lives in which subjects had been sutured into the anthropological project (see also Banks & Vokes 2010). This interest in the way in which anthropological imagery might be used as a source for investigating subjects' lives has since been extended to the study of later ethnographic archives as well (i.e. to the study of fieldwork photographs which were produced in the period *after* the discipline's faith in 'scientific photography' had waned).[21] In addition, though, in recent years a growing number of anthropologists have also begun to conduct ethnographic studies of contemporary 'African photographies'. On the one hand, these works have attempted to locate African modes of photographic production and representation within their wider social contexts.[22] On the other, they have also examined the products of African photography – i.e. the photographs themselves – as culturally-meaningful artefacts, or in other words as objects which may themselves develop a 'social life' of their own, as they become embedded within domestic activity, ritual practice, exchange networks, and so on.[23]

An interest in photography in Africa therefore began in history with a study of colonial and missionary archives, in art theory with the identification of African photographers and studios, and in anthropology with a re-examination of the discipline's own archive (and later also included a study of the social practices of contemporary African photographies). However, in more recent years, the boundaries between these various areas of interest have become increasingly blurred, as scholars across all these disciplines (and others besides) have written ever more expansively. The result has been the emergence of a sizeable new literature that addresses many areas of common concern relating to the history, practice and sociology of photography in Africa. Indeed, so extensive has this new literature become, that it today engenders a quite vast range of issues and debates, some of which are common to all scholarship in the field, some of which are only relevant for those working on photographs from a particular period, or from a specific geographical or

[20] See especially the chapters by Faris, Pankhurst, Prins and Vansina.
[21] Important studies of later ethnographic archives include Geary (2000), Comaroff & Comaroff (2007) and Morton (2009). See also various contributions in Morton & Edwards (2009). For an important contribution from outside Africa, see Young's study of Bronislaw Malinowski's fieldwork photography from the Trobriand Islands (1998).
[22] See especially Viditz-Ward (1987), Behrend & Wendl (1998), Behrend (2001), Behrend & Werner (2001).
[23] See Rowlands (1996), Wendl & du Plessis (1998), Kratz (2002), Behrend (2003*b*), Mustafa (2002), Vokes (2008) and Meyer (2010).

political region, or from a given photographic milieu, or which belong to a particular genre. Nevertheless, in seeking to engage the overall field, I find it useful to identify three alternative, yet overlapping, discursive contexts that have become the major frames for organizing much of the scholarship on this subject – and within which all of the chapters in this book can also be in some way located. These are: 1) a concern with photographic technologies, practices and images in movement; 2) a concern with the nexus between photography and political power and authority; and 3) a concern with the relationship between photography and the histories and processes of social change.

Photographies in movement

A concern with movement stems from the earliest attempts to document the history of photography in Africa, and from the image this produced of technologies and practices being rapidly spread across the continent by all manner of roving itinerant photographers, and by European 'explorers', missionaries, and colonial administrators. Photographic technologies arrived in Africa shortly after the invention of the daguerreotype in 1839, when the Ottoman Viceroy of Egypt, Pasha Mehmet Ali, was taught how to produce them by French painter Horace Vernet, who was resident in Cairo at that time (Haney 2010b: 13). In the decades following, commercial daguerrotypists (both African and European) became established in urban settlements all around the African coast, and although much of their production centred on studios, most appear to have also made extensive commercial forays into their urban hinterlands. Later, and especially following the invention of the 'dry-plate' method in 1871, a growing number of explorers, military officers, and government surveyors began to convey the technologies even further inland (Killingray & Roberts 1989: 198-200). Finally, following the introduction of portable Kodak cameras from the late 1880s onwards, photography was quickly carried into all remaining parts of the continent, as it became a (more or less) routine part of missionary work, official activity, and colonial settler life. In these ways, then, all of the earliest photographers in Africa appear 'to have made an art of crossing borders in an era of unprecedented momentum' (Haney 2010b: 13). Later, into the twentieth century, as cheap handheld cameras made photography ever more accessible to more and more people in Africa, as new types of professional photographer sought to picture an ever-widening range of African subjects (including wildlife photographers, photojournalists, photographic artists, and others), and as new forms of migration resulted in the elements of African photographies also being conveyed to the Diaspora, the technologies, practices and objects of photography were transmitted into even wider social and geographical domains.

However, the focus on movement relates not only to the spread of photographic technologies and practices across the continent, but also to the movement of the images themselves (i.e. those of African subjects) which from the very beginning were widely disseminated across the continent, and to all corners of the globe. As Haney again puts it, if early experiments in photography in Africa involved a 'burden of heavy cameras and equipment, the resulting images were relatively featherweight, easily borne on steamship routes, and so exchanged and proliferated across continents and oceans' (ibid.: 13). Recent work has highlighted that these circulations were frequently

shaped by pre-existing 'visual economies' (to use Deborah Poole's entitling phrase, 1997), some of which were local, or regional in scope, others of which covered the entire continent, and/or extended way beyond it. Indeed, from the beginning, photographs were embedded within multiple circuits (of different historical 'depth', and geographical 'scale') at the same time. For example, it is now clear that in addition to being shaped by local and regional networks of exchange, early circulations of photographs throughout West Africa and beyond cannot be understood independently of a wider 'Atlantic visualscape'. As described by Schneider (2010), the circuits of this visualscape were already well established by the sixteenth century, and had long shaped the circulations of multiple visual forms – including drawings, oil paintings, lithographs, and so on – as these passed between Europe, West Africa and the Americas. Not only did this visualscape determine a kind of 'infrastructure' of individuals and institutions through which early photographs were exchanged, but it also forged a relationship between other visual traditions and photography, one that resulted in certain tropes and even entire images being copied from one to the other. For example, in her study of the port cities of nineteenth century West Africa, including those of Cape Coast and Accra, Haney found that as a result of elite practice, emergent traditions of painted portraiture and photographic representation became mutually reinforcing (Haney, *n.d.* and 2010*a*).[24]

Yet so too recent work has also highlighted how the increasing flow of photographs out of the continent during the second half of the nineteenth century, and into the twentieth, was also driven by an ever greater demand for images of Africa amongst European and American viewing publics. A growing number of scholars have examined how during this period, images of the continent became incorporated into an ever widening range of popular visual formats, reflecting a fascination with Africa that was fuelled by an expanding tourist industry, by a growing interest in the exploits of explorers, and by the educational (and propaganda) efforts of European governments and missionary societies.[25] By the early 1900s, images from central Africa were being regularly incorporated into an ever greater range of news and satirical journals, advertising imagery, packaging materials, cigarette cards, and (especially) picture postcards. Moreover, as with research on the Atlantic visualscape, much of this work on popular forms has again highlighted the importance of maintaining a conceptual distinction between the photographic *image* and the *material* elements of its production and reproduction, i.e. such factors as 'its chemistry, the paper it is printed on, the toning', and so on. (This distinction is today emphasized in much theoretical writing on photographic 'materialities'; see especially Edwards & Hart 2004.) In other words, a large part of this research has also focused on those images which moved between material domains, as was then common, for example, in the practice of personal or official images being copied onto/into adverts, cigarette cards, postcards, and so forth. Indeed, in some cases, individual

[24] The development of the Atlantic visualscape during the late-nineteenth and early-twentieth centuries is explored from the other side of the ocean in Thompson's case study of photography and art in Jamaica and the Bahamas, *An Eye for the Tropics* (2006).
[25] See especially Coombes (1994), Ryan (1997), Geary (1998), Kratz & Gordon (2002), Landau (2002) and Sobania (2002 & 2007). A particularly interesting case study on early twentieth-centry images of Namibian bushmen is provided by Gordon (1997).

images appeared in a variety of popular formats.[26] Yet by being transferred in this way, the semiotics of the images were frequently altered, in some cases radically so. For example, I have elsewhere explored one set of examples from early twentieth-century Uganda in which photographs taken from an official album were later reprinted as picture postcards, in a manner that significantly altered the way in which a viewer would likely make sense of them (2010).[27] More recently, and as alluded to above, anthropologists have also begun to conduct ethnographic studies of the myriad of photographic exchanges which take place within African societies themselves, or between Africa and the Diaspora. Although a nascent field of study, this work has already begun to document the importance of those photographic exchanges which now so commonly take place as part of formal visiting, wedding rites, burial practices, and so on, in social milieux across the continent, and beyond (see above references).

However, the interest in movement has also been driven, at least in part, by a general rethinking of the very idea of 'the archive', and by a recognition of its own shifting nature. Following the work of theorists such as Allan Sekula and John Tagg in the 1980s,[28] and reflecting a wider trend within the history of photography in general (see Hamilton *et. al.,* 2002), publications such as Edwards' *Anthropology and Photography* (1992) drew attention to the fact that anthropological archives are not 'historically neutral resting-places for individually interesting images' (to borrow Morton and Edwards' phrase, 2009: 8), so much as 'living collections' that have been 'shaped [both] by the processes and procedures of the institutions that curate them, and [by] the researchers who use them' (ibid.). In other words, there has been a growing recognition that as with all photographic archives, anthropological repositories are shaped by myriad flows of images, and are embedded within wider visual economies (albeit in ones of varying scale; Poole 2005: 162). As Elizabeth Edwards elsewhere puts it, this detailed 'exploration of the structuring forms of accession, the processes of collecting and description, contexts of collecting and use, and the range of social practices associated with [archives] at an historically specific level' reveals archives to be less an outcome of some sort of 'universalizing desire' so much as an 'accumulation of micro-relationships in which objects are involved' (2001: 7, 28-29). For example, the approach has revealed how one of the 'great' anthropological archives of the nineteenth century, the Royal Anthropological Institute (RAI) photo library, was itself embedded in a wider visual economy of photographic 'collecting clubs' – which had become increasingly popular in Britain, at least, from the 1860s onwards (ibid.: 29-33). Subsequent work has revealed additional examples of archives which have been shaped by other kinds of circulations besides – including, in some cases, circulations which have seen images also moving *out* of given archival collections.[29]

[26] Geary (1998 & 2002). See also David (1986).
[27] In a more recent example, Kratz (2011) explores the effects of the way in which images of one particular African ethnic group, the Wodaabe of Niger, have proliferated across a vast array of visual media, in the period since the 1950s.
[28] See especially Sekula (1986) and Tagg (1988). See also Derrida (1996).
[29] Vokes & Banks (2010). See also Morton & Edwards (2009), and Peffer (2010).

Photography and power

A concern with the nexus between photography and power again stems from the earliest attempts to document the history of photographic technologies and practices in Africa. Specifically, the very fact that these elements had been spread by (amongst others) explorers, missionaries and colonial administrators, drew immediate attention to the fact that photography had also been an integral element of 'the European exploration, conquest, and colonization of Africa' (Sharkey 2001: 180). In this way, as Edwards describes, it was a 'part of Europe's new arsenal of technological advancements during the age of empire. As such, it served both to symbolise the power differential in the colonies, and to bring it into visible order'.[30] In fact, and as a great deal of research has subsequently explored, photography produced these effects in a number of different ways.[31] Firstly, in colonies and protectorates throughout Africa, photography quickly became a primary means for visualizing the state itself, and for picturing its key offices, rituals, and sites. As Liam Buckley identifies, such 'administrative photography' – i.e. that which was 'commissioned by the colonial governments, and consist[ed] of official state events, civic life, examples of "progress"', and so on – has been interpreted by some scholars as constituting a distinct genre in its own right, one which was 'firmly allied with imperial governance, serving as a "truthful witness" to the missionary work, surveillance and policing of western-style "progress"' (2010: 147).

To take my own research site of Uganda, during the early years of colonial rule in the country, a great deal of photographic practice revolved around the picturing of senior state officials (for example, the image of one particular commissioner, Sir James Hayes Sadler, became quite iconic in the early years of the twentieth century). So too, it frequently focused upon official state events (I have elsewhere documented how photographs taken at one particular event, the Kampala Agricultural and Industrial Exhibition of November 1908 played a key role in shaping visual imaginaries of the Ugandan state at that time). And it also involved the repeated picturing of certain iconic buildings (such as the succession of Anglican churches, and a cathedral, that were built on Namirembe Hill, in Kampala, between 1890 and 1919, images of which appear frequently in all remaining archives from Uganda). Later, several attempts were made to picture the new nation in a more systematic way, such as when the British Directorate of Overseas Surveys (DOS) undertook an aerial photographic survey of the country between 1954 and 1956, and when the Ugandan Land and Surveys Department undertook an extensive photo-mapping exercise of all of its 'modern' buildings and key infrastructure in the period after independence.

Yet it was not only official uses of photography that engendered a power dynamic in this way. So too more 'everyday' forms of photography – as were produced by urban studios, and latterly by the owners of personal cameras as well – were also marked by political imbalances. On the one hand, the fact that in certain colonial contexts expatriates – be they administrators, missionaries, or settlers – had easier access to photography (given the urban

[30] Edwards, cited in Peffer (2009: 242). For a broader introduction to the relationship between photography and colonialism, beyond only African contexts, see also Hight & Sampson (2004).
[31] Perhaps the most wide-ranging examination of the relationship between photography and colonial power is provided by Hartmann, Silvester & Hayes' *The Colonizing Camera* (1998). This collection develops an extended case study of South West Africa/Namibia. See also Hayes (1996).

location of the studios, and the general cost both of studio and of personal photography) resulted in Europeans being sometimes overrepresented in the resulting imagery. Certainly, this was the case across large parts of colonial East Africa.[32] On the other hand, the fact that many colonialists also used photography as a means for exploring imaginaries of class mobility, served to further emphasise the social distance between them and indigenous African populations. This was especially true of photographic portraiture produced in urban studios in South Africa, which was often marked by a certain theatricality (whereby 'members of the middle class could have themselves depicted in ways previously reserved for the aristocracy', Peffer 2009: 242). The fact that many of these South African studios, like their European equivalents, were located near to theatres, added further impetus to this performative dimension (ibid.: with reference to Sange's work on contemporaneous European studios).

However, the most marked political effects of colonial photography related to the ways in which it pictured African populations. Certainly, African subjects did exert some degree of agency over the photographic process. For example, in her work on Central Africa, Christraud Geary finds that from the time of the first photographic tour in the region – as was undertaken by the German doctor and zoologist Julius Falkenstein to the Kingdom of Loango (in present-day Congo-Brazzaville) between 1873 and 1876 – Africans did sometimes actively shape the encounter. Indeed, the key narrative of Falkenstein's tour was that 'requests for portraits by Africans were so great that towards the end of his stay he was unable to handle the demand' (2002: 81). Later, as photography spread more widely throughout the interior of the region, African kings and chiefs (and other authority figures), in particular, began to engage with photography, often entering into the same sort of theatricality that defined the urban studio experience (ibid.: 81-102; see also Geary 1988). And Haney's work on West African portraiture has shown that an ability to shape the photographic encounter was not always restricted to only African elites (see especially 2010b: 57-89). As a result, then, it is likely that all forms of photography in Africa were always, in some sense, influenced by local understandings of exhibition, comportment and display.[33]

Yet as Geary's work further highlights, even where African subjects *did* exert a degree of agency over the photographic encounter itself, this did not preclude the resulting images from being used in ways which still effected to classify African populations as socially inferior to European colonial society, and/or as internally differentiated amongst themselves. Thus, in the Central African context, at least, the fact that so much early photography did focus upon kings and chiefs and so on, meant that it could often be easily incorporated into wider fields of administrative photography, especially in contexts defined by indirect rule. In Rwanda, photographs (and other imagery) of King Musinga – who came to the throne in 1897, with the help of the German colonial authorities – and of the king's royal bodyguard, the *Ntore*, played a central role in establishing the so-called 'Hamitic hypothesis'. This was the idea that the king's ethnic group, the Tutsi, formed a 'natural' ruling class 'below' the Europeans (as it were), given that they were descended from a 'superior' race

[32] Although recent historical research has also emphasized just how variable the situation was – in terms of relative access to urban studios, and personal cameras – across the continent. For example, Haney and others have shown that in many West African urban centres, African-owned cameras outnumbered European-owned during the nineteenth century (see Haney n.d. & 2010b).
[33] See Sprague (1978) and Haney (2010a & 2010b).

of Caucasian stock, called the Hamites (Geary 2002: 90-7). As Geary describes, images of the *Ntore's* dances and high-jump competitions became particularly iconic, as a means for establishing the physical – and by implication, the intellectual – superiority of the Tutsi over Rwanda's other 'ethnic' groups (the Hutu and the Twa, ibid., 92-3). Later, this classificatory urge was extended to individual subjects as well, through the mass production of personal ID or 'passport' photographs. As Jean-François Werner has described of colonial Côte d'Ivoire, these images, when incorporated into various forms of official documentation, soon became both a necessary prerequisite for, and therefore a key marker of, full participation in certain colonial institutions (and therefore, ultimately, in the colonial state itself, 2001:252; see also Vokes 2008).

Photography as a means for visual classification was even more coercive in nature. Amongst the most troubling uses of the camera in Africa were certain sorts of anthropological photography which, influenced by Johann Kaspar Lavater's 'science' of physiognomy, attempted to establish an objective visual record of the 'average' physical characteristics of non-western races (as a means for inferring cultural – i.e. behavioural – traits, cf. Shortland, cited in Pinney 1992: 76). The endeavour required subjects to be photographed in some state of undress, and within a formalised system of display (such as against the background of a 'Lamprey grid' which was made up of a frame to which threads were tied so as to form two-inch squares).[34] In so doing, this type of photography invariably served both to depersonalize and to objectify its subjects, often in the crudest of terms.[35] Thus, writing about one such image taken in this 'scientific mode' – in this case a studio portrait of a half-naked South African boy called Tuma, who is pictured against a plain background with a ruler on it – Peffer notes that:

> the ruler on the wall in this photograph takes the place of the kinds of idyllic or classically composed scenes that more often made up the backdrop to commercial photographers' images. Here the subject is not part of the creative act of depiction, but is instead merely an object for scientific rationalization, of categorization according to racial type within a colonial hierarchy of the 'races'. (2009: 246)[36]

Located within regimes of 'authoritative knowledge' in this way, additional photographic registers frequently also cast members of certain of these African 'races' in infantile, exotic and even sexualized terms.[37] Moreover, the reversioning of such anthropometric imagery into popular formats often served to amplify these effects.[38] Thus, Peffer's reading of Tuma's photograph reminds us that 'while white subjects would have been able to negotiate the terms and settings of their pictures as well as control the distribution of their images, black subjects [often] had little or no control over the process or use of their depiction' (ibid.). And it was largely because of this history that following the emergence of 'modern anthropology', and the 'fieldwork revolution' in the period after WWI, most anthropologists chose to eschew the use of the camera

[34] The grid was named after J. H. Lamprey, who first defined the method in an article in the *Journal of the Ethnological Society of London* (1869).
[35] For a wider discussion of the role of the background, or 'backdrop', in colonial photography, see Appadurai (1997).
[36] One of the best known examples of an attempt to use visual data as a means for establishing racial classifications in this way is Seligman & Seligman's *Pagan Tribes of the Nilotic Sudan* (1932).
[37] See especially Azoulay (1980), Alloula (1986) and Prochaska (1991).
[38] Geary (2002: 23-57). See also Landau & Kaspin (2002) and Vokes (2010).

as a means for data collection (Grimshaw 2001: 3-5).[39]

In these ways, then, photography was used both to define, and to place in order, the life of the colony, and to visually classify its subject populations (see also Landau 2002). Yet if some forms of colonial photography *did* produce political effects of this sort, then so too other photographic modes engendered a degree of resistance to these. As Liam Buckley further observes, those scholars who argue that administrative photography *was* a distinctive genre throughout the colonial period typically also distinguish this from a second mode of 'vernacular photography'. This second mode 'includes images captured by photographers who specialized in studio and street portraiture. These photographs are understood to exist outside colonial governance, subverting its power in self-representation and aesthetic acts of resistance.' In his view, 'administrative photography serves and reinforces colonial power, following strict rules of protocol. Vernacular photography is simultaneously recognized as potentially subversive, resistant, independent and elusive to administrative strictures' (2010: 147; cf. Ranger 2001). Haney similarly finds that there is a 'strong undercurrent' in much of the early writing towards a distinctively 'African photography' which seeks to establish that 'most photographers "from Africa" were in some way contesting ... colonial visual tropes' (2010b: 9; see also Enwezor & Zaya 1996). In one such example, Geary compared picture postcards produced by European and African studio photographers in the period between 1895 and 1920, and found that certain racist stereotypes of the European producers' cards appear to have been reworked into images of cultural heritage and cultural pride in the African studios' work (1998: 163-76).[40] However, Geary also notes that a paucity of surviving material from the African studios with which she is concerned makes it difficult for her to draw stronger conclusions, and this is a general problem for the field as a whole.[41]

However, irrespective of whether African studio photography did engender a mode of subversion in this way, it is clear that other modes of photography on the continent certainly had this effect. For example, it is well documented that throughout the 1890s and early 1900s (in particular), photographs produced by missionaries and others in the Congo Free State played a key role in documenting the atrocities that were then being carried out by various state-sponsored entities. These photographs later occupied a central position in the visual propaganda efforts of reform groups such as Edmund Morel's

[39] Many non-anthropologists did, however, continue to produce photographic portraits of 'ethnic types' after this time, of course. Although in these later examples the visual symbols of 'science' (grids, rulers, and the like) are no longer present, such images are arguably no less demeaning to their photographic subjects.

[40] Given how small her sample of African photographers is, Geary stresses that her tentative argument and would require further research for corroboration.

 Nevertheless, Geary's argument draws our attention to the fact that what does, and does not, constitute a 'stereotype' is often quite contextual, and may depend, in particular, upon the positioning of the viewer. The implication is that all stereotypes (be they racist or otherwise) are in some sense unstable over time. I would like to thank Erin Haney for her clarification on this point (pers. comm. 14th July 2011).

[41] The reasons why so little early photography by Africans remains are various, but include the fact that African climates are rarely conducive to the preservation of photographic objects (Geary, ibid.), and that in many African countries, colonial photographic archives have now fallen into disrepair (albeit for a variety of different reasons, Buckley 2005). Whilst a dearth of surviving early photography is an issue for all historians, it is especially problematic for those writing for African photography (or photographies) as a mode of 'resistance', given the obvious political imperatives of this work (cf. Haney 2010b: 9).

Congo Reform Association.[42] However, the connection between photography and resistance in Africa is today most closely associated with the various forms of 'struggle photography' that developed in South Africa during the apartheid years, from the 1950s onwards.[43] Although struggle photography encompassed a range of different approaches and projects – for example, the photojournalistic work of contributors to *Drum* magazine is clearly quite different from the aesthetically more complex photography of someone like David Goldblatt[44] – there is no doubt about the overall subversive intentions, and effects, of much South African photography during this time (i.e. during the period of the apartheid years). As Peffer puts it, 'in practice, there was a wide spectrum of formal approaches deemed "appropriate" by those who hoped to chronicle and aid the struggle. This can be illustrated through a comparison of two photographic anthologies that bracketed the 1980s: *South Africa: The Cordoned Heart* ([Badsha] 1986), and *Beyond the Barricades: Popular Resistance in South Africa* ([Hill & Harris] 1989)'. Thus, while the images in the former 'make use of oblique or wide angles of vision to give environmental context, and strategic use of shadow and tonal complexity to bring about the emotional depth of their subjects', the latter, by contrast, 'is less lyrical, more stridently realist, and more pointedly political' (2009: 255). Moreover, *Beyond the Barricades* may be further distinguished from a later type of struggle photography that developed during the period of political transition in South Africa in the early 1990s. Focused primarily upon the urban poor, much of this later imagery was more violent in nature, and especially emphasized representations of the brutalized black body (ibid.: 258 and cf. Hayes n.d.).[45] Although South African struggle photography remains the best known example of its type in Africa, one can also find other examples of photojournalism and documentary photography being used in support of social and nationalist causes elsewhere on the continent as well.[46]

[42] See Peffer (2008) and Haney (2010*b*: 91-103).

[43] The tradition of photography as a tool for political subversion in South Africa is sometimes traced back to the pre-apartheid days, and in particular to the work of Leon Levson (1883-1968), who was one of the first people to use photography to document the deprivations of urban life for black South Africans (see Minkley & Rassool 2005). However, it is also recognized that this tradition especially flourished during the country's apartheid years (1948-1994).
The best introduction to South African 'struggle photography' is Darren Newbury's *Defiant Images* (2010). See also Hayes (*n.d.* & 2007), Peffer (2009: 251-259), Knape & Robertson (2010) and Seippel (2010).

[44] For examples of Goldblatt's work, see Goldblatt & Gordimer (1973), Goldblatt (1975), and Goldblatt, Goldblatt & van Niekerk (1989).

[45] Hayes (*n.d.*) argues that this shift towards more violent imagery was primarily shaped by the circulations and marketing of images from South Africa at this time, and by the desires of international media outlets to provide greater coverage of the country's growing political tensions during this period.
 However, the central argument of Hayes' article is that much of the struggle photography produced between the mid-1980s and the year of the transition (1994) conformed to a style of radical social realism that is sometimes referred to as 'street photography'. Moreover, that precisely because of this, it was also highly gendered – in that it focused on a primarily male public space (i.e. 'the street'). As a result, almost all of the struggle photography of these years can be further contrasted with later modes of political photography in South Africa – i.e. ones that developed in the post-apartheid era – in which women are much better represented, both as photographers and as photographic subjects (n.d., 6 & passim).

[46] For example, in a particularly interesting series of studies, Bajorek has examined the complex relationship between photography and emergent forms of nationalism in colonial and post-colonial Senegal (see especially 2010*a* & 2010*b*, and also her chapter here).

A concern with photography and social change in a sense developed as an extension to these studies of movement and power. In other words, it followed that if photography *had been* an integral part of colonial expansion, and if it *had* played a key role in the processes of both colonial and post-colonial state formation (and in modes of resistance to these), then so too it must surely have had significant effects upon wider processes of social change as well – including such things as changing notions of personhood, the emergence of new social imaginaries, the reworking of collective memories, and so on. For example, Werner's work on photography in colonial Côte d'Ivoire has highlighted how ID photographs produced for primarily classificatory purposes also had a profound impact upon developing concepts of personhood in that country (see especially 2001: 262-3). Specifically, Werner shows how the key visual trope of the passport picture – i.e. its focus upon a single head or body, set against a white (or in another way plain) background – served to cast people outside of their webs of social relations, and without any reference to their lived contexts.[47] In this way, it played a key role in emphasising a type of personhood that at the beginning of the colonial period was still relatively novel in Côte d'Ivoire, namely one based on a 'modern' notion of *in*dividual personhood (ibid.).

Further research has also pointed to the ways in which family portraiture produced in some African studios has influenced changing notions of kinship. For example, it is noteworthy that when East African studios did take family portraits of African subjects, these tended to reproduce the key tropes of European family photographs in their entirety. Thus, their photographs tended to be saturated with the visual symbols of (upper-class) Victorian domesticity, with their subjects typically dressed in lounge suits and crinoline dresses, and pictured alongside vases of flowers, draped curtains, hat stands, and the like. In addition, and perhaps more importantly, the studio photographers who produced these images also conveyed an image of African familial relations in which an (imagined) nuclear family was central, and in which alternate generations were both distinct and hierarchically organized – thus reproducing the European colonial ideal (the former effect was achieved through the selection of people to be included in the portrait, the latter through the symmetrical placement of adjacent generations within it).[48] In Uganda, both of these factors – i.e. a reworking of personhood, and the development of new ideas about kinship – appear to have been at play. Thus, in this context, at least, if the ID picture was similarly instrumental in emphasising a notion of *in*dividual personhood, then so too family portraiture has also served to cast that individual in a particular way – as the outcome of a specified nuclear family, itself the product of a broader, and peculiarly linear, family history (Vokes 2008: 348-50).

Additional work has looked at other ways in which colonial-era photographs have continued to act as sites for the construction of personal, 'ethnic' and national identities, from the time of their production onwards. For example, Gore shows how photographs taken of the fallen *Oba* (King) Ovonramwen of

[47] Again, note the role of the background here, or the 'backdrop' as Appadurai refers to it (1997).
[48] For example, see Behrend's work on Kenyan studios (1998: 162) and cf. Bouquet's discussion of the symmetry of family photographs in contemporary Holland (2000).

Benin – as were produced by the British administration of Southern Nigeria following their punitive raid against Benin in 1897 (which resulted both in the *Oba*'s exile, and in his kingdom's incorporation into the colonial state) – have since been used to rework collective historical memories amongst Edo-speaking ethnic groups in post-colonial Nigeria (2001). Specifically, Gore traces how several images of Ovonramwen – including one which was taken on board ship while he was en route to exile in Calabar – have since become part of 'the ongoing processes of memory work' in this context (Werbner, cited in Gore 2001: 328), serving as a powerful reminder – both to Edo-speakers themselves, and to ethnic 'others' – that the (current) *Oba's* 'legitimacy is rooted in the precolonial traditions of the Edo kingdom' (ibid.: 321), and that he is also – partly as a result of this historical grievance – a valid traditional figure within the contemporary, post-colonial, Nigerian state. As Gore documents, this effect became particularly marked during the centenary commemorations in 1997 of the British punitive raid against Benin, in large part because of the ubiquity of these images at the time (reproduced as they were in a wide range of media – including on commemorative 'posters, calendars, almanacs, cups and plates, as well as commemorative cloths issued by the [current Edo] royal family', ibid.: 325).

Thus, a concern with photography and social change stemmed, to a significant degree, from the study of colonial photographies and their (ongoing) effects. However, in recent years the field has expanded much further still, to also include an examination of the role of photography within a broad range of contemporary processes of social change. To focus on just three strands within this burgeoning body of work, the past decade or so has seen a growing interest in the ways in which photographic technologies, practices and products both shape, and are shaped by: a) expanding tourist markets, b) increasing urbanization, and c) the deepening of the various processes that are often collectively referred to as 'globalization'. Certainly, connections between photography and tourism, photography and urbanization, and so on, are themselves not new. For example, it is well established that a desire to picture tourist sites was one of the key drivers for the initial growth of photography in places like Egypt.[49] Elsewhere, other scholars have long demonstrated connections between photographic and emergent urban imaginaries, in locations across Africa,[50] and additional examples could also be cited. Nevertheless, the period since 2000 has seen an expanding interest in the variety of ways in which African photographies (in particular) are implicated in each of these three trends (all of which have themselves accelerated in recent times, of course, as a result of a variety of factors, including the expansion of international air travel, and the advent of new media such as mobile phones and the internet).

To cite just a few examples of this new research, Bruner has looked at the intrinsic role played by photographic encounters in mediating the relationship between tourists and Maasai workers at a present-day 'tribal' safari lodge

[49] Although, as Haney cautions, this appears to have been particular to only a specific number of places. Thus, tourism may not have played as important a role in the general spread of photography across the continent as a whole as is sometimes supposed (2010*b*: 15-23).
[50] In addition to Peffer's work (above), see also Kallaway & Pearson's *Johannesburg: Images and Contunities* (1986), and Norwich's *A Johannesburg Album* (1986). See also Plissart & de Boeck (2005) which, amongst other things, examines the ways in which photography might be used to capture aspects of the urban experience in contemporary Kinshasa.

in Kenya (2004).[51] Hersant has explored the complex interactions between itinerant photographers and various categories of residents in Lome, Togo, showing how the former's practices differentially shape the latter's experience of their urban locales (2001). Meanwhile, in a series of seminal studies, Behrend (2000 and 2003a) has looked at the ways in which techniques of photo-collage enable Kenyan subjects to picture themselves undertaking imaginary 'world tours' which act out, photographically, movements which are not possible for them in reality (given their prevailing socio-economic circumstances). In this way, photography enables these people to creatively engage with the processes of globalization from which they are otherwise excluded.[53]

Finally, it is worth noting that a number of scholars looking at photography and broader histories and processes of social change have again found it useful to carefully consider the multiple relationships between the photographic *image* and the photographic *object*. In other words, some theorists have drawn attention to the fact that in attempting to understand the connections between photography and changing notions of personhood, developing ideas of kin relations, and so on, it is crucial to look not only at modes of 'photographic representation and self-fashioning' (i.e at the semiotics of the images), but also at the way in which the photographic image-*objects* themselves are circulated, reproduced and displayed (cf. Kratz chapter here). For example, several studies have shown how emergent notions of individualism are not only an outcome of photographic representation, but are equally shaped by the practices involved in creating personal photograph albums (which may also develop a narrative of the self).[54] Other works have looked at how changing notions of familial relations are an outcome both of image construction, *and* of practices of display – such as the way in which studio photographs are displayed within domestic spaces such as 'parlors' (see especially Rowlands 1996).[55] Meanwhile, work such as Gore's (above), highlights how photographs' effects upon historical consciousness, and their affective power as mnemonics, may have less to do with any qualities of the images themselves, so much as with the way in which they are subsequently reproduced and circulated.

[51] Bruner's work here expands upon some of his earlier studies with Kirshenblat-Gimblett (see for example Bruner and Kirshenblat-Gimblett 1994: 444 & passim). For a comparison with a South African example, see Finlay (2009).

[52] One of the most common ways in which the Likoni photographer construct these imaginary tours is by placing their subjects in front of backdrops depicting various symbols of international tourism: aeroplanes, global landmarks, and the like. Yet by using the backdrop in this way, they are also subverting the disciplinary function of the colonial-era backdrop (in addition to the discussion above, see especially Appadurai 1997). For another example of an African photographer using backdrops as a means for exploring the imaginary, see Zeitlyn (2010).

[53] See also Behrend's work on Ugandan studio photographers Ronnie Okocha Kauma and Afandaduula Sadala (2001).
 In addition, the work of South African-born photographer Pieter Hugo provides a particularly interesting visual study of the marginalization of Africa within certain contemporary processes of globalization. See especially his book *Permanent Error* (2011).

[54] See for example, Mustafa's work on Nigeria (2002), Buckley's work on the Gambia (2006), or my own work on Uganda (2008).

[55] Domestic interiors have also become a major concern within much contemporary African photography. For example, South African Zwelethu Mthethwa has become particularly well known for his images of domestic interiors in Cape Flats settlements (outside of Cape Town). As with the academic research to which I refer here, Mthethwa's pictures are particularly concerned with the relationship between personhood and display in these slum dwellings. (For introductions to Mthethwa's work, see Enwezor 2010 and Wu 2010.)

The volume

If these are the three discursive contexts that have become the major frames for organizing scholarship on photography in Africa, therefore, the contributions to the present volume – which are based on empirically rich historical and ethnographic cases studies, drawn from across the continent – attempt to extend each of these frames in a number of different ways. Thus, the first section of the book, *Photography and the Ethnographic Encounter*, makes a significant contribution to our understanding of the anthropological archive, by developing a chronological narrative of the way in which ethnographic fieldworkers in Africa have employed photography from the mid-1920s onwards – a subject that is approached through a detailed examination of the photographic engagements of four prominent Africanist anthropologists: Evans-Pritchard, Max Gluckman, Paul Baxter and Wendy James. All of the chapters in this section take seriously the notion that archives must be interrogated as 'accumulation[s] of micro-relationships' (above), as each attempts to reconstruct the 'biography' of one particular fieldwork archive, and to uncover the specific relationships through which this was brought into being. The endeavour reveals a number of insights, beginning with an emphasis upon the key fact that photography apparently *did* remain a central element in the ethnographic encounter, even in the period after most professional anthropologists had begun to eshew the use of photography as a means for data collection (in reaction to the racist overtones of the earlier 'scientific' anthropological photography, described above). In other words, all of the chapters in this section emphasize – as have other recent works on twentieth-century fieldwork photography[56] – that anthropologists did continue to take pictures, and the camera did continue to be a key mediator between the anthropologist and his/her respondents, even when relatively few of them regarded photographs as a form of scientific 'data'.[57]

The reasons *why* photography remained so central to the ethnographic encounter after this time are complex, but relate in particular to the utility of photographs as a means for engaging with certain sorts of fieldwork situations, and for recording certain kinds of research information. These points emerge most clearly in the chapters by Morton and Wingfield, both of which explore how, in the context of certain public rituals and events, for example a Zande initiation ritual, or an official ceremony to open a new bridge, both Evans-Pritchard and Gluckman (respectively) appear to have been confronted with moments of action in which it was simply more convenient to take a quick photograph of what was going on, than to attempt to record it in writing (although both ethnographers did also make written notes about the events after they had finished, of course). Moreover, in Gluckman's case, he appears to have later used some of these photos as an *aide memoire* when producing his later written account of the event (in what became his famous article on 'The Bridge'). Indeed, Wingfield's analysis even suggests that Gluckman may have found his photographs of the event *more* useful than his written fieldnotes, when

[56] See, for example, Geary (2000), Comaroff & Comaroff (2007), Morton (2009) and Morton & Edwards (2009).
[57] Although throughout the early twentieth century, at least, anthropologists did continue to include photographs in their publications as a form of *illustration*. This trend continued until around WWII, after which the costs of reproduction increased significantly. I would like to thank Christopher Morton for his clarification on this point (pers. comm. 15th June 2011).

preparing that article. However, perhaps this should not really surprise us. After all, much of the work on 'photo elicitation' has highlighted the ways in which photographs can act as powerful mnemonics for ethnographic respondents (see for example, Collier & Collier 1986), from which it follows that they may also do so for ethnographers as well. For example, it is apparently quite common that anthropologists will browse through their fieldwork photographs – in a general, non-specific way – in order to get themselves 'in the mood' when preparing to write. However, such is the emphasis that is now placed on fieldnotes within the discipline – indeed, to the point that written notes have become, in some contexts, almost fetishized as the *only* valid means for recording ethnographic information (see the discussions in Sanjek 1990) – that it *is* in fact a revelation for us to discover that Gluckman may have acted in this way.

Yet, the reasons why anthropologists continued to use photography in the field were not only instrumental in nature. In addition, ethnographers' use of photography appears to have also had a performative dimension, such that the very act of taking a photograph became itself a means for the researcher either to participate in the public ritual, or even just to engage in a dyadic relationship. Thus, just as a contemporary 'western' wedding guest's photographic practices may become a key means for him/her to join in the nuptial ceremony, so Evans-Pritchard's use of photography in the Zande initiation rites appears to have become a central means for 'bringing him into' those proceedings (in which he had a stake, in the form of his servant Kamanga, who was one of the initiands. See Morton's chapter.) Indeed, for this reason, Morton has elsewhere defined Evans-Pritchard's role – albeit in relation to his later engagement in another ritual, the Nuer rite of *gorot* – as that of a 'participant-photographer' (2009). Moreover, the chapters collected in this volume demonstrate the various ways in which that epithet may also be applied to other ethnographers as well. For example, Baxter also used photography in a performative way, in his case employing it as a means for generating new research engagements during otherwise 'quiet periods' in his fieldwork (Carrier & Quaintance). Meanwhile, in perhaps the most dramatic example, James' use of photography at one point made her a key mediator in an international network of communication between members of a displaced refugee community, giving her a vital role in allowing people to know which of their family members had even survived the flight from their homeland.

However, as Morton reminds us, in order to develop a truly 'relational' analysis of these fieldwork archives, it is necessary to move beyond just a focus on the ethnographers' intentions, to also look at the way in which respondents' agency may have further shaped the images as well. Certainly, the central argument of Morton's chapter here is that discernible changes of composition, form, etc. across Evans-Pritchard's entire oeuvre of research photos (from multiple periods of fieldwork he conducted among the Ingessena/ Gamk, Zande and Nuer between 1926 and 1936), are probably best explained with reference to the way in which his various respondents influenced his photographic practice. Yet the effect of indigenous agency is no less evident in the other chapters presented here as well. Thus, for example, Carrier and Quaintance's description of Baxter's photographic practice highlights the way in which his Borana respondents might sometimes refuse to have their pictures taken, whilst Wendy James' account reveals that her respondents exerted an influence over both who was to be photographed – and how they should

appear in those images (as exemplified by her anecdote of a refugee family living in a camp in Ethiopia who insisted on changing into their 'Sunday best' for a photograph to be sent to their relatives abroad) – *and* over how those photographs were to be subsequently used (i.e. to whom they should be sent in the US, or wherever). Indeed, so marked is the role of indigenous agency across all of these chapters, that its effects may even be understood as one of the key characteristics distinguishing the photography of these post-1920s anthropologists (all of whom were engaged in long-term fieldwork) from the – clearly more coercive practices – of those earlier anthropologists who worked in the 'scientific' mode.

In these ways, then, the chapters in Part I also begin to speak to a concern with photography and power. However, the second section of the book, *Picturing the Nation: Photography, Memory and Resistance,* engages debates in this field even more directly. Specifically, several of the chapters here develop upon Liam Buckley's claim that fine-grained historical and ethnographic analysis reveals how in certain colonial and post-colonial contexts, the distinction between 'administrative photography' and a second, vernacular mode which was/is subversive of this, may not, in fact, be as clear-cut as previously imagined. The central thrust of Buckley's argument is that 'the contexts of these two modes ... [were] often closer in practice than is usually supposed'. Thus, for example, his own work on the Gambia Colony shows how colonial administrators frequently hired local photographers to provide a 'vernacular window' on government policies, and how they questioned the relevance of colonial media produced in London for addressing everyday problems in the Gambia (they instead favoured visual media that were specifically tailored to local interests and needs). According to Buckley, these considerations resulted in a series of 'administrative experiments' based around the recruitment of local photographers. Moreover, these photographers' 'aesthetic practices inaugurated a political consciousness of colonial devolution within the administrative hierarchy' (2010: 147-148).

In a similar vein, Bajorek's chapter here is also concerned with tracing the overlapping contexts of state bureaucracy and 'popular' photography in late-colonial Senegal. In the first of her two examples, she explores how the illustrated magazine *Bingo* (which was published in Dakar from 1953 onwards) had significant links to officialdom – for example, it was founded by a politician, Ousmane Socé, it published the photographs of a range of senior government figures, and its readership was largely made up of educated civil servants – yet also became a key site for the dissemination of 'popular' photography across the Afrique Occidentale Française (AOF). Thus, although the journal did publish images produced by the colonial information service and various state-sponsored photographic studios (in its early days, at least), it became the norm for the magazine to publish its readers' own photographs (and their commentaries on these), usually presenting several of these images at once, in a 'collage' layout. Yet in these ways, the magazine also became a key medium for the dissemination of various new collective identities, some of which were ultimately subversive of state agendas, amongst them emergent imaginaries relating to pan-Africanism, feminism, and class consciousness.

Bajorek's second case study concerns the career of one independence-era photographer in Saint-Louis, Doudou Diop. This example again involves links to

the state, in that both Diop himself, and many of his clients, were government employees (Diop was an accountant in the French army), and that the 'rhythms' of his photographic practice were in large measure dictated by the demands of both his and his clients' professional (i.e. official) duties. As a result, it became typical for Diop's studio – which was located in his family home – to be opened only in the evening, at the end of the working day. Yet the fact that Diop's photography *was* disciplined by bureaucratic regimes in this way did not stop either him, or his clients, from using the medium as a means for experimenting with (then) emergent social imaginaries, including some that could be classified as 'political'. However, once again here, Bajorek does not reduce these effects to an aggregate of individual photographic intentions, or individual acts of resistance, but instead sees them – as with the *Bingo* example – as an outcome of the context in which these photographs were collectively exchanged and displayed. Thus, she argues that it was precisely because Diop's studio *was* only open after work that it generated a particularly intense form of sociality and camaraderie around photographic objects, one that was especially conducive to the use of the medium as a means for forging new, shared identities.

Haney's chapter is similarly concerned with complicating our understanding of the relationship between official and vernacular modes of photography. Her primary concern here is to try to recover a more extensive archive of early photography from (what became) Accra than that which is contained in only official institutional archives (such as the Ghanaian national archives, European museum collections, and so on). She attempts this through a detailed examination of the photographic practices of the Lutterodts, an elite family of West African merchants, who, from the 1870s onwards, patronized a network of studios and intinerant photographers that eventually stretched from Freetown (in present day Sierra Leone) to Luanda (Angola). Consideration of this network's photography reveals not only that the emergence of certain forms of African (i.e. vernacular) photography in fact *pre-dates* the establishment of colonial rule in some parts of coastal West Africa, but that throughout the colonial period, the output of these African-controlled studios was in some locations greater than that of state-sponsored operations.

In these ways, then, Haney's chapter challenges previously assumptions about the privileged status of official photography during the colonial period (above), by suggesting not only that colonial expansions were in fact *only one of* the sets of circuits through which photography was disseminated across this part of the continent (at least), but also that in some places administrative photography did not dominate the field in quite the way that is often imagined. In addition, given that the vernacular modes with which she is concerned here in some locations pre-dated colonialism, it becomes difficult to reduce these to simply a mode of resistance to the European presence. Moreover, Haney further suggests that surviving Lutterodt photographs may today continue to develop even more complex meanings still. This is because as (primarily) *family* holdings, surviving Lutterodt photographs can today continue to be copied, exchanged, and displayed in ways that historic photographs held in institutional archives cannot (and they can therefore be used to forge and sustain a much wider range of shared memories relating to different sorts of private and public memories and histories).

Yet if these family archives *do* make such an important contribution to our understanding of the West African photographic archive, then why have

they been for so long overlooked? A large part of the answer here lies in the simple fact that so few of their individual images *have* survived. This is partly an outcome of environment, but is also – in the Lutterodts' case, at least – a result of a majority of their images having been destroyed, or else lost, or exchanged. For example, it appears to have been quite common for Lutterodt photographers to scrub pictures, in order to reuse their glass plates, or to dump boxes of photographs in order to make room for further storage. In addition, much of what does remain is now widely dispersed. Nevertheless, for Haney, the fact that so many of these images have not survived, or are now dispersed, does not in itself preclude them from scholarly consideration. Instead, it simply requires different methods, whereby analysis of these photographs is approached through a reconstuction of their traces, rather than through a direct engagement with the physical image-objects themselves, and through fieldwork, rather than institutional research.

Amongst other things, Haney's argument also reminds us that it is not only forms of photographic production that produce political effects, but also acts and processes of photographic erasure (and in her most dramatic example, she records how, following its rise to power in a coup of 1966, the government of Kofi Busia conducted a great act of iconoclasm, whereby its officers attempted to burn all archive photographs – and all other archival materials – associated with the former presidency of Kwame Nkrumah). Moreover, McKeown's chapter is similarly concerned with the political effects of photographic erasures (albeit ones of a quite different order). Thus, in her case study from Mozambique, she argues that political motivations, and outcomes, may be evidenced not only by what is pictured in photographs but also, and sometimes more importantly, by what is intentionally *left out* of them. Specifically, she shows how images of the iconic Gorongosa National Park have been reworked through three distinct phases of Mozambique's history, often in ways which erase any visible symbols of the landscape's former uses. Thus, she traces how at first, the Portugese colonialists erased all signs of human presence (as a means for representing the park as a quintessential 'African Eden'). Later, during the country's post-independence civil war, the opposition guerrilla force, the Mozambican National Resistance (RENAMO), erased all evidence of the state's former presence in the park (as part of their own attempts to image Gorongosa as the 'Capital of Free Mozambique'). Finally, following the end of that civil war, in 1992, the new government of Mozambique once again tried to photograph a landscape free of human intervention (as a means for imaging a 'paradise regained'), in an attempt to rejuvenate the country's then flagging tourism industry.

The subject of photographic erasures emerges in other chapters presented here as well, including in Pype's work on Congolese President Joseph Kabila's political propaganda in present-day urban Kinshasa. Again drawing a distinction between the photographic image and object, Pype shows how the effectiveness of Kabila's propaganda is as much an outcome of the ways in which he displays his image – and, more importantly, of the ways in which he limits the ability of his rivals to display their portraits – as it is of any inherent quality of the image itself. Moreover, given this context, acts of iconoclasm targeting Kabila's image become marked here as especially potent acts of subversion. This is demonstrated most vividly in the anecdote relating to the parade of supporters of Kabila's (then) main political rival Jean-Pierre Bemba, who, out of sight of the television cameras, systematically

stamp upon and burn every picture of the president along one of Kinshasa's main thoroughfares, the Boulevard Lumumba. Yet Pype's chapter also extends our understanding of the relationship between photography and power in other ways besides. In particular, in her analysis of Kabila's *La Visibilité des 5 Chantiers* ('the visibility of the 5 construction sites') campaign, Pype shows how governments may employ photography not only as a means for 'placing in order' existing political domains, but also as a means for engendering and projecting their future political aspirations. Thus, in this example, although none of President Kabila's 5 projects are actually yet finished, by picturing himself at work on the projects, on billboards across Kinshasa, he is able to begin to take credit for the benefits that these projects are anticipated to generate.

Several of these themes and issues are further explored in Part III of this book, 'The Social Life of Photographs'. Thus, my own chapter – which traces the history and sociology of a vernacular mode that emerged in South-western Uganda from the late-1950s onwards – is also concerned with complicating our previous understandings of the relationship between 'official' and 'popular' forms of photography. However, I attempt to do so less by challenging the idea that administrative photography *was* a distinctive genre in this particular place and time, but by suggesting that what makes the vernacular mode different from this cannot be reduced to issues of 'self-representation and aesthetic acts of resistance' (see p. 11, above). Instead, by drawing upon recent work on photographic materialities, I argue that in South-western Uganda, the vernacular mode also became marked by an entirely different set of orientations toward the photograph, whereby the physical image-object itself came to be perceived as, quite literally, an extension of its subject's body. As a result, photographs produced in this mode were (and are) frequently circulated both as a means for maintaining fundamental social ties, and as a way to extend the most meaningful social networks. In this way, the profound impact that photography has had on shifting notions of personhood, kinship, and so on, in South-western Uganda may be seen as less an outcome of representation and self-fashioning (although these are not unimportant), so much as a reflection of the effects that photographic image-objects have had upon existing circuits of exchange, and the possibilities they have afforded for the creation of new types of networks.

Also informed by recent discussions of photographic materialities, the subject of photographic exchanges emerges in both of the other chapters of this section as well. In her examination of the place of photography within changes that have occurred in wedding ceremonies along the Kenyan coast, Behrend finds that from the 1950s onwards, it has become standard practice for hired photographers to picture all aspects of these ceremonies, but especially certain standard elements within them (including the point at which the bride is presented to the groom, and the point at which – towards the end of the festivities – she mingles on stage with her female kin, affines, and associates). However, even more important than these acts of photographic commission are the distributions of photographs that are now made throughout these events, both to relatives and to guests. In this way, it has become common practice for elite families, in particular, to not only hire photographers to cover their events, but to also pay these cameramen to develop the pictures 'on the go', in order that these can then be given out during the ceremony

itself. Their reasons for doing so reflect the wider context here, in which social rank and status have for long been associated with an ability to stage public events of conspicous consumption. In this setting, then, the scale of the photographic distributions that are made at a wedding has itself come to symbolize the social standing of the host family. In addition, though, the subsequent circulations and consumption of these same photographs – it being generally anticipated that they will be widely exchanged, both along the coast, and to the Diaspora – also now serves as an ongoing reminder of the same. Moreover, this subject of photographic exchanges also emerges in Kratz' chapter. In a quite different example – concerning a former predominantly hunter-gatherer people, the Okiek, who live on the other side of Kenya – she shows how in a context in which photography is not yet easily accessible or affordable, borrowing photographs from affinal kin constitutes one of the key means through which young people (in particular) may attempt to bolster their collections. In many instances, their reasons for doing so reflect attempts to gather enough photographs to mount meaningful displays in their new family sitting-rooms (an architectural feature that has become increasingly popular among Kipchornwonek and Kaplelach Okiek since the 1980s).

Yet if Behrend traces the way in which photographic exchanges *have* become part of typical wedding ceremonies on the Kenyan coast, then the main focus of her chapter are those Muslim women who, as acts of piety, have begun to eschew having their photographs taken, both as part of their own weddings, and when attending other people's functions (as either relatives or guests). Behrend argues that this refusal to be pictured is best understood as an attempt by these women to instantiate the Islamic interdiction of all forms of photography. In addition though, and of particular interest for my discussion here, it is also driven by a more specific fear that precisely because wedding pictures are circulated so widely (above), were one of these women to be photographed in this context, then this would almost certainly result in her image being later passed on to people outside of her own kinship group (thereby violating her personal sense of *purdah*). For both of these reasons, then, these women sometimes also engage in acts of inconoclasm (for example, when one of their pictures is taken accidentally, as part of a wedding crowd). Moreover, other types of photographic 'avoidance' are examined in both of the other chapters in this section as well. Thus, my own chapter explores the attempts by some Ugandan young people, in particular, to conceal certain sorts of photographic exchanges, whilst Kratz looks at which images Okiek chose *not* to display on their new sitting-room walls (such as pictures of certain categories of kin). Interestingly, in both cases, the logics informing these practices are explicable not only in terms of how people relate to the photographic image-objects, but also in terms of how the different photographs relate to others with which they are placed in sequence (either in albums, or in sitting-room displays. In this way, then, both of these chapters – as others in this volume as well – also begin to explore questions of photographic *relationality* (cf. Vokes 2008).

However, the main focus of Kratz' chapter is the practices of display themselves, and what these might also reveal about changing notions of personhood, social relations, identity and the life course. Thus, she argues that the very fact that sitting-room displays *did* emerge amongst the Okiek from the 1980s onwards is itself revealing of broader socio-economic transformations

that were impacting their lives during this period (as indeed are other, earlier, shifts in modes of photographic diplay in this setting). In addition, though, they also reflect the changing ways in which Okiek relate to their domestic spaces as 'affectively textured settings', or in other words, as spaces which may evoke various feelings of, for example, history, identity, and belonging. In other words, they also index shifting modes of *experience*. This is explored by Kratz in her discussion of how for some Okiek the new sitting-room displays have become a key site in which 'to see' (*-suee*) certain types of relationships. Significantly, though, the concept of 'seeing' here captures more than just a visual action, but also refers to a form of embodied experience. Moreover, in this way, Kratz' chapter also makes an important contribution to a recent turn in visual anthropology in general, which has seen increasing attention being paid to the 'affective' force, or power, of all visual forms, including photographs (see also Pype's discussion of 'haptic', or 'tactile visuality' in her chapter on Congolese political imagery).[58]

In summary, then, the contributions to the present volume not only contribute to each of the three discursive frames identified above, but they also extend these in a number of important ways. Firstly, by interrogating anthropology's own photographic archive from Africa as an 'accumulation of micro-relationships' (above), the volume raises new questions about the relationship between photographic representation and practice in the history of ethnographic research, about the relationship between private and public anthropological archives (and shifts that have occurred between the two), and about the role of indigenous agency in shaping ethnographic photography. Secondly, by developing detailed historical and ethnographic studies of the relationship between photography and statecraft, it also develops new problematics concerning the relationship between 'official' uses of photography and the emergence of 'popular' modes, concerning how various sorts of photographic 'erasures' also produce political effects, and about how photographs may also help to project political aspirations. Finally, by examining the various ways in which photography may be implicated in broader processes of social change, the volume also develops new ways of thinking about how engagements with the photographic image-*object* may also be implicated in changing notions of personhood, about how photographic exchanges may also shape emergent marriage practices, and about how modes of display might also affect shifting modes of memory and experience.

Yet in all of these ways, this book also develops a number of broader insights into how additional histories might be extracted from all photographic archives in and on Africa, into the possibilities and limits of photography as a tool in all forms of political action, and into the complex political and social contexts of all African photographies. In so doing, the volume also points to important future directions for research on photography in Africa. Thus, with so many new archival projects currently underway across the continent – including many that are explictly concerned with recovering and/or preserving various types of 'non-institutional' collections (see Haney's chapter), and many others that are engaged in various forms of photographic 'repatriation' (see Carrier & Quaintance) – it is certain that many more alternative, and complex, histories of photographic practice, representation, and circulation will emerge in the years ahead. As they do so, our current narratives about the emergence

[58] For more on photography and affect, see Smith & Vokes (2008).

and spread of photography in Africa – and about the ongoing place of historical photographies in various types of 'memory work' – will doubtless become significantly more refined. In addition, further ethnographic studies will probably continue to complicate our understanding of the relationship between photography and political agency. Some of this future work may well continue to explore questions of photography and statecraft, for example by looking at recent attempts to use photography in processes of voter registration,[59] at additional examples of state-sponsored iconoclasm, or at the place of photography in political advertizing more generally. However, it is also likely that in coming years, new research will increasingly also focus upon uses of photography by various non-state political actors. Thus, although some work has already begun to look at the photographic practices of armed insurgent groups,[60] of domestic opposition parties (see Pype's chapter), and of civil society organizations,[61] much more remains to be done in each of these areas.

Finally, additional ethnographic studies – employing an ever-widening range of visual research methodologies[62] – will doubtless also continue to extend our understanding of the ways in which African photographies are embedded within wider social processes, whilst providing an ever-growing range of comparative examples concerning the place of photography within different sorts of: ancestor rituals, diasporic communications (see Aston & James), divination practices, exchange relations, funerary rites, homemaking projects (see Kratz's chapter), new religious movements (Vokes 2009, Meyer 2010), urban cultures and wedding ceremonies (to name just a few). Moreover, given the particular interest of this field upon the photographic *object*, it will be intriguing to see how all of these aspects are further effected by the growing availability of *digital* photographic technologies. For instance, it is interesting to note that in relation to my own field site of South-western Uganda, although digital technologies have only become available in significant numbers since 2009, they have already begun to generate keen discussion, across a wide variety of social contexts. Thus, even before any particularly marked social effects have been generated by these new technologies, people are already beginning to debate such questions as what impact pre-natal scan images will have upon concepts of personhood (in a context in which practically *any* reference to an unborn child is generally regarded as strictly taboo), what effect digitial portraits will have upon exchange relations (in a context in which photographic image-*objects* play a significant part in many types of exchange relationship, see my chapter below), and what impact the advent of Facebook and other social networking sites will have upon relations between people 'back home' and those now living in the Diaspora.

[59] For example, this was tried in Uganda in the run-up to the 2001 general elections. Although technological difficulties resulted in that experiment being abandoned, the country's Electoral Commission has subsequently restated its desire to one day develop a photographic database of all of the country's registered voters.
[60] For example Finnstrom's *Living With Bad Surroundings* (2008) points to some interesting examples of the ways in which photography has been used by Uganda's Lord's Resistance Army (LRA).
[61] See for example Bleiker and Kay's work on photography and empowerment in the context of HIV/AIDS prevention and activism (2007).
[62] Including, no doubt, an ever-widening range of 'participatory' visual methods. The best known of these remains Wang and Burris' 'photonovella' method – now commonly known as 'photovoice' – but there are also other examples of recent innovation. See Wang and Burris' original discussion of photonovella (1994), and a more recent contribution by Young and Barrett (who worked with homeless 'street children' in Kampala, 2001).

Alloula, M. 1986. *The Colonial Harem*, Minneapolis: University of Minnesota Press.

Appadurai, A. 1997. The Colonial Backdrop. In *Afterimage* 24 (5): 4-7.

Azoulay, P. 1980. *La Nostalgèrie Française*, E. Baschet: Paris.

Badsha, O. (ed.). 1986. *South Africa: The Cordoned Heart*, Gallery Press: Cape Town.

Bajorek, J. 2010a. 'Photography and National Memory: Senegal about 1960'. In *History of Photography* 34 (2): 158-69.

—— 2010b. Of Jumbled Valises and Civil Society: Photography and Political Imagination in Senegal. In *History and Anthropology* 21 (4): 431-52.

Baloji, S. & B. Jewsiewicki. 2010. *The Beautiful Time: Photography by Sammy Baloji*, New York: Museum for African Art.

Banks, M. & R. Vokes. 2010. Introduction: Anthropology, Photography and the Archive. In *History and Anthropology* 21 (4): 337-49.

Banta, M. & C. M. Hinsley, with J. K. O'Donnell. 1986. *From Site to Sight: Anthropology, Photography and the Power of Imagery*, Cambridge MA: Peabody Museum.

Bell, C., O. Enwezor, O. Oguibe & O. Zay (eds). 1996. *In/Sight: African Photographers, 1940 to the Present*, New York NY: Guggenheim Museum Publications.

Behrend, H. 1998. A Short History of Photography in Kenya. In *Anthology of African and Indian Ocean Photography* (eds) Revue Noire. Paris: Revue Noire,.

Behrend, H. 2000. 'Feeling Global': The Likoni Ferry Photographers of Mombasa, Kenya. In *African Arts* 33 (3) 70-76+96.

—— 2001. Fragmented Visions: Photo Collages by Two Ugandan Photographers. In *Visual Anthropology* 14 (3) 301-320.

—— 2003a. Imagined Journeys: The Likoni Ferry Photographers of Mombasa, Kenya. In *Photography's Other Histories* (eds) C. Pinney & N. Peterson. Durham NC: Duke University Press.

—— 2003b. Photo Magic: Photographs in Practices of Healing and Harming in East Africa. In *Journal of Religon in Africa* 33 (2) 129-145.

Behrend, H. & J-F. Werner. 2001. Photographies and Modernities in Africa. In *Visual Anthropology* 14 (3) 241.

Behrend, H. & T. Wendl (eds). 1998. *Snap Me One! Studiofotografen in Afrika*. Munich: Prestel.

Bensusan, A. D. 1966. *Silver Images: The History of Photography in Africa*. Cape Town: H. Timmins.

Bigham, E. 1999. Issues of Authorship in the Portrait Photography of Seydou Keïta. In *African Arts* 32 (1) 56-67+94-96.

Birgham, E. 1999. Issues of Authorship in the Portrait Photographs of Seydou Keïta. In *African Arts* 32 (1) 56-67.

Bleiker, R. & A. Kay. 2007. Representing HIV/AIDS in Africa: Pluralist Photography and Local Empowerment. In *International Studies Quarterly* 51 (1) 139-163.

Bouquet, M. 2000. The Family Photographic Tradition. In *Visual Anthropology Review* 16 (1) 2-19.

Bruner, E. M. 2004. *Culture on Tour: Ethnographies of Travel*. Chicago: University of Chicago Press.

Bruner, E. M. & B. Kirshenblatt-Gimblet. 1994. Maasai on the Lawn: Tourist Realism in East Africa. In *Cultural Anthropology* 9 (2) 435-470.

Buckley, L. M. 2005. Objects of Love and Decay: Colonial Photographs in a Postcolonial Archive. In *Cultural Anthropology*. 20 (2) 249-270.

—— 2006. Studio Photography and the Aesthetics of Citizenship in the Gambia. In *Sensible Objects: Colonialism, Museums and Material Culture* (eds) E. Edwards, C. Gosden & R. B. Phillips. New York: Berg.

—— 2010. Cine-film, Film-strips and the Devolution of Colonial Photography in The Gambia. In *History of Photography* 34 (2) 147-157.

Bull, M. & J. Denfield. 1970. *Secure the Shadow: The Story of Cape Photography from its Beginnings to the End of 1870*. Cape Town: T. McNally.

Collier, J. & M. Collier. 1986. *Visual Anthropology: Photography as a Research Method*. Albuquerque: University of New Mexico Press.

Comaroff, J. & Comaroff, J. 2007. *Picturing a Colonial Past: the African Photographs of Isaac Schapera*. Chicago & London: University of Chicago Press.

Coombes, A. 1994. *Reinventing Africa: Museums, Material Culture and Popular Imagination*. New Haven: Yale University Press.

David, P. 1986. La Carte Postale Africaine (1900-1960). In *Revue Juridique et Politique Independance et Cooperation* 40 166-177.

Derrida, J. 1996. *Archive Fever: A Freudian Impression*. Chicago: Chicago University Press.

Edwards, E. 2001. *Raw Histories: Photographs, Anthropology, and Museums*. Oxford: Berg.

Edwards, E. (ed.). 1992. *Anthropology and Photography, 1860-1920*. New Haven & London: Yale University Press in association with the Royal Anthropological Institute.

Edwards, E. & J. Hart (eds). 2004. *Photographs, Objects, Histories: On the Materiality of Images*. New York: Routledge.

Edwards, E. & C. Morton. 2009. Introduction. In *Photography, Anthropology, and History: Expanding the Frame* (eds) C. Morton & E. Edwards. Farnham: Ashgate.

Edwards, E. & L. Williamson. 1981. *World on a Glass Plate: Early Anthropological Photographs from the Pitt Rivers Museum*. Oxford: Pitt Rivers Museum.

Enwezor, O. 2006. *Snap Judgements: New Positions in Contemporary African Photography*. London: Steidl.

Enwezor, O. 2010. *Zwelethu Mthethwa*. New York: Aperture.

Enwezor, O. & O. Zaya. 1996. Colonial Imaginary, Tropes of Disruption: History, Culture, and Representation in the Works of African Photographers. In *In/Sight: African Photographers, 1940 to the Present* (eds) C. Bell, O. Enwezor, O. Oguibe & O. Zaya, New York: Guggenheim Museum Publications.

Fabb, J. 1987. *Africa: The British Empire from Photographs*. London: Batsford.

Faris, J. C. 1992. Photography, Power and the Southern Nuba. In *Anthropology and Photography, 1869-1920* (ed.) E. Edwards. New Haven & London: Yale University Press in association with The Royal Anthropological Institute.

Finlay, K. 2009. The Un/changing Face of the Khomani: Representation through Promotional Media. In *Visual Anthropology* 22 (4) 344-361.

Finnstrom, S. 2008. *Living with Bad Surroundings: War, History and Everyday Moments in Northern Uganda*. Durham NC: Duke University Press.

Geary, C. 1986. Photographs as Materials for African History, Some Methodological Considerations. In *History in Africa* 13 89-116.

—— 1988. *Images from Bamum*. Washington DC: Smithsonian Institution Press.

—— 1998. Different Visions? Postcards from Africa by European and African Photographers and Sponsors. In *Delivering Views: Distant Cultures in Early Postcards* (eds) C. Geary & V-L. Webb. Washington DC: Smithsonian Institution Press.

—— 2000. Photographing in the Cameroon Grassfields, 1970-1984. In *African Arts* 33 (4) 70-77+95-96.

—— 2003. *In and Out of Focus: Images from Central Africa, 1885-1960*. Washington DC: Smithsonian Museum of African Art.

Goldblatt, D. 1975. *Some Afrikaners Photographed*. Johannesburg: C. Struik.

Goldblatt, D. & N. Gordimer. 1973. *On the Mines*. Cape Town: C. Struik.

Goldblatt, D., B. Goldblatt & P. van Niekerk. 1989. *The Transported of KwaNdebele: A South African Odyssey*. New York: Aperture.

Gordon, R. J. 1997. *Picturing Bushmen: The Denver African Expedition of 1925*. Athens OH: Ohio University Press.

Gore, C. D. 2001. Commemoration, Memory and Ownership: Some Social Contexts of Contemporary Photography in Benin City, Nigeria. In *Visual Anthropology* 14 (3) 321-342.

Grantham, T. (ed.). 2009. *Darkroom: Photography and New Media in South Africa Since 1950*. Charlottesville VA: University of Virginia Press.

Grimshaw, A. 2001. *The Ethnographer's Eye: Ways of Seeing in Anthropology*. Cambridge: Cambridge University Press.

Hamilton, C., V. Harris, M. Pickover, G. Reid, R. Saleh & J. Taylor (eds). 2002. *Refiguring the Archive*. New York: Springer.

Haney, E. (n.d.). *If These Walls Could Talk! Photographs, Photographers and Their Patrons in Accra and Cape Coast, Ghana, 1840-1940*. PhD Thesis, University of London, 2004.

—— 2010a. Film, Charcoal, Time: Contemporaneities in Gold Coast Photographs. In *History of Photography* 34 (2) 119-133.

—— 2010b. *Photography and Africa*. London: Reaktion.

Hartmann, W., J. Silvester & P. Hayes. 1998. *The Colonizing Camera: Photographs in the Making of Namibian History*. Cape Town: University of Cape Town Press.

Hayes, P. (n.d.). The Form of the Norm: Spectres of Gender in South African Photography of the 1980s. Unpublished paper presented at the Love and Revolution Workshop, University of the Western Cape, Cape Town, October 2010.

—— 1996. 'Cocky' Hahn and the 'Black Venus': The Making of a Native Commissioner in South West Africa, 1915-46. In *Gender and History* 8 (3) 364-392.

—— 2007. Power, Secrecy, Proximity: A History of South African Photography. In *Kronos* 33 139-62.

Hersant, G. 2001. A Vignette from Lome: The Street Photographers' Blues. In *Visual Anthropology* 14 (3) 243-249.

Hight, E. M. & G. D. Sampson (eds). 2004. *Colonialist Photography: Imag(in)ing Race and Place*. New York: Routledge.

Hill, I. T. & A. Harris (eds). 1989. *Beyond the Barricades: Popular Resistance in South Africa*. New York: Aperture.

Hugo, P. 2011. *Permanent Error*. London: Prestel.

Jedlowski, A. 2008. Constructing Artworks. Issues of Authorship and Articulation around Seydou Keïta's Photographs. In *Nordic Journal of African Studies* 17 (1) 34-46.

Jenkins, P. & C. Geary. 1985. Photographs from Africa in the Basel Mission Archives. In *African Arts* 18 (4) 56-63+100.

Jenkins, P. 2002. Everyday Life Encapsulated? Two Photographs Concerning Women and the Basel Mission in West Africa, *c.* 1900. In *Journal of African Cultural Studies* 15 (1) 45-60.

Kallaway, P. & P. Pearson (eds). 1986. *Johannesburg: Images and Continuities. A History of Working Class Life Through Pictures, 1885-1935*. Braamfontein: Ravan Press.

Killingray, D. & A. Roberts. 1989. An Outline History of Photography in Africa to c. 1940. In *History in Africa* 16 197-208.

Knape, G. & S. Robertson. 2010. *Ernest Cole: Photographer*. London: Steidl.

Kratz, C. 2002. *The Ones That Are Wanted: Communication and the Politics of Representation in a Photographic Exhibition*. Berkeley: University of California Press.

—— 2011. *Recurring Wodaabe: Proliferating Images of Nomads, Gender and Performance*. Keynote Address, 15th Triennial Symposium on African Art, Los Angeles, 24th March 2011.

Kratz, C. & R. J. Gordon. 2002. Persistent Popular Images of Pastoralists. In *Visual Anthropology* 15 (3-4) 247-265.

Lamprey, J. H. 1869. On a Method of Measuring the Human Form for the Use of Students of Ethnology. In *Journal of the Ethnological Society of London* 1 85-85.

Landau, P. S. 2002. Empires of the Visual: Photography and Colonial Administration in Africa. In *Images and Empires: Visuality in Colonial and Postcolonial Africa* (eds) P. S. Landau & D. D. Kaspin Berkeley: University of California Press.

Landau, P. S. & D. D. Kaspin (eds). 2002. *Images and Empires: Visuality in Colonial and Postcolonial Africa*. Berkeley: University of California Press.

Mack, J. 1991. Documenting the Cultures of Southern Zaire: The Photographs of the Torday Expeditions, 1900-1909. In *African Arts* 24 (4) 6-69+100.

Matt, G., T. Miessgang & K. Wien (eds). 2002. *Flash Afrique!: Photography from West Africa*. London: Steidl.

Maxwell, A. 2008. *Picture Imperfect: Photography and Eugenics, 1870-1940*. Brighton: Sussex Academic Press.

Maxwell, D. 2011. Photography and the Religious Encounter: Ambiguity and Aesthetics in Missionary Representations of the Luba of South East Belgian Congo. In *Comparative Studies in Society and History* 53 (1) 38-74.

McKeown, K. 2010. Studio Photo Jacques: A Professional Legacy in Western Cameroon. In *History of Photography* 34 (2) 181-192.

Meyer, B. 2010. 'There is a Spirit in that Image': Mass-produced Jesus Pictures and Protestant-Pentecostal Animation in Ghana. In *Comparative Studies in Society and History* 52 (1) 100-130.

Minkley, G. & C. Rassool. 2005. Photography with a Difference: Leon Levson's Camera Studies and Photographic Exhibitions of Native Life in South Africa, 1947-1950. In *Kronos* 31 184-213.

Morton, C. 2009. Fieldwork and the Participant-Photographer: E. E. Evans-Pritchard and the Nuer Rite of *Gorot*. In *Visual Anthropology* 22 (4) 252-274.

Morton, C. & E. Edwards (eds). 2009. *Photography, Anthropology, and History: Expanding the Frame*. Farnham: Ashgate.

Mustafa, H. N. 2002. Portraits of Modernity: Fashioning Selves in Dakarois Popular Photography. In *Images and Empires: Visuality in Colonial and Postcolonial Africa* (eds) P. S. Landau & D. D. Kaspin. Berkeley: University of California Press.

Newbury, D. 2010. *Defiant Images: Photography and Apartheid South Africa*. Pretoria: Unisa Press.

Njami, S. & F. Vanhaecke (eds). 2010. *A Useful Dream: African Photography 1960-2010*. Milan: Silvana.

Norwich, O. 1986. *A Johannesburg Album: Historical Postcards*. Craighall: A. D. Donker.

Pankhurst, R. 1992. The Political Image: The Impact of the Camera in an Ancient Independent African State. In *Anthropology and Photography, 1869-1920* (ed.) E. Edwards. New Haven & London: Yale University Press in association with The Royal Anthropological Institute.

Peffer, J. 2008. Snap of the Whip/Crossroads of Shame: Flogging, Photography, and the Representation of Atrocity in the Congo Reform Campaign. In *Visual Anthropology Review* 24 (1) 55-77.

—— 2009. *Art and the End of Apartheid*. Minneapolis: University of Minnesota Press.

—— 2010. Editorial. In *History of Photography* 34 (2) 115-118.

Pinney, C. 1992. The Parallel Histories of Anthropology and Photography. In *Anthropology and photography, 1869-1920* (ed.) E. Edwards. New Haven & London: Yale University Press in association with The Royal Anthropological Institute.

Pinney, C. & N. Peterson (eds). 2003. *Photography's Other Histories*. Durham NC: Duke University Press.

Plissart, M-F. & F. de Boeck. 2005. *Kinshasa: Tales of the Invisible City*. Ghent: Ludion.

Poignant, R. 1992. Surveying the Field of View: The Making of the RAI Photographic Collection. In *Anthropology and Photography, 1869-1920* (ed.) E. Edwards. New Haven & London: Yale University Press in association with The Royal Anthropological Institute.

Poole, D. 1997. *Vision, Race and Modernity: A Visual Economy of the Andean Image World*. Princeton: Princeton University Press.

—— 2005. An excess of description: ethnography, race, and visual technologies. In *Annual Review of Anthropology* 34 159-179.

Prins, G. 1992. The Battle for Contol of the Camera in Late Nineteenth Century Zambia. In *Anthropology and Photography, 1869-1920* (ed.) E. Edwards. New Haven & London: Yale University Press in association with The Royal Anthropological Institute.

Prochaska, D. 1991. Fantasia of the *Photothèque*: French Postcards Views of Colonial Senegal. In *African Arts* 24 (4) 40-47.

Ranger, T. 2001. Colonialism, Consciousness and the Camera. In *Past and Present* 171 203-215.

Revue Noire (eds). 1999. *Anthology of African and Indian Ocean Photography* (English Edition). Paris: Revue Noire.

Roberts, A. (ed.). 1986. Bibliographical Essays. In *The Cambridge History of Africa Vol. 7: From 1905-1940* (ed.) A. Roberts. Cambridge: Cambridge University Press.

—— (ed.). 1988. *Photographs as Sources for African History*. Papers presented at a workshop held at the School of Oriental and African Studies, London, May 12-13th, 1988. London: S.O.A.S.

Rowlands, M. 1996. The Consumption of an African Modernity. In *African Material Culture* (eds) M. J. Arnoldi, C. Geary & K. Hardin. Bloomington: Indiana University Press.

Ryan, J. 1997. *Picturing Empire: Photography and the Visualization of the British Empire*. London: Reaktion.

Sanjek, R. (ed.). 1990. *Fieldnotes: The Making of Anthropology*. Ithaca: Cornell University Press.

Scherer, J. C. 1975. Pictures as Documents: Resources for the Study of North American Ethnohistory. In *Studies in the Anthropology of Visual Communication* 2 (2) 65-66.

—— 1990. Historical Photographs as Anthropological Documents: A Retrospect. In *Visual Anthropology* 3 (2-3) 131-155.

Schneider, J. 2010. The Topography of the Early History of African Photography. In *History of Photography* 34 (2) 134-146.

Seippel, R-P. (ed.). 2010. *South African Photography: 1950-2010*. Berlin: Hatje Cantz.

Sekula, A. 1986. The Body and the Archive. In *October* 39 3-64.

Seligman, C. G. & B. Z. Seligman. 1932. *Pagan Tribes of the Nilotic Sudan*. London: G. Routledge and Sons.

Sharkey, H. J. 2001. Photography and African Studies. In *Sudanic Africa* 12 179-181.

Smith, B. & R. Vokes (eds). 2008. Haunting Images: The Affective Power of Photography. In *A Special Issue of Visual Anthropology* 21 (4) 240.

Sobania, N. W. 2002. But Where are the Cattle? Popular Images of the Maasai and Zulu Across the Twentieth Century. In *Visual Anthropology* 15 (3-4) 313-346.

—— 2007. The Truth Be Told: Stereoscopic Photographs, Interviews and Oral Tradition from Mt. Kenya. In *Journal of Eastern African Studies* 1 (1) 1-15.

Sprague, S. F. 1978. Yoruba Photography: How the Yoruba See Themselves. In *African Arts* 12 (1) 52-59+107.

Stuehrenberg, P. F. 2006. The Internet Mission Photography Archive. In *Journal of Pacific History* 41 (2) 237-238.

Tagg, J. 1988. *The Burden of Representation: Essays on Photographies and Histories*. Minneapolis: University of Minnesota Press.

The Standing Conference on Library Materials on Africa (eds). 1995. *Images of Africa: The Pictoral Record*. African Research and Documentation, no. 68.

Thompson, K. A. 2006. *An Eye for the Tropics: Tourism, Photography, and Framing the Caribbean Picturesque*. Durham NC: Duke University Press.

Vansina, J. 1992. Photographs of the Sankuru and Kasai River Basin Expedition Undertaken by Emil Torday (1876-1931) and M. W. Hilton Simpson (1881-1936). In *Anthropology and Photography, 1869-1920* (ed.) E. Edwards. New Haven & London: Yale University Press in association with The Royal Anthropological Institute.

Viditz-Ward, V. 1987. Photography in Sierra Leone, 1850-1918. In *Africa* 57 (4) 510-518.

Vokes, R. 2008. On Ancestral Self-fashioning: Photography in the Time of AIDS. In *Haunting Images: The Affective Power of Photography* (eds) B. Smith & R. Vokes. In *A Special Issue of Visual Anthropology* 21 (4) 345-363.

—— 2010. Reflections on a Complex (and Cosmopolitan) Archive: Postcards and Photography in Early Colonial Uganda, *c.* 1904-1928. In *History and Anthropology* 21 (4) 375-409.

Vokes, R. & M. Banks (eds). 2010. *Routes and Traces: Anthropology, Photography and the Archive*. In *A Special Issue of History and Anthropology* 21 (4).

Wang, C. C. & M. A. Burris. 1994. Empowerment Through Photo Novella: Portraits of Participation. In *Health Education and Behaviour* 21 (2) 171-186.

Wendl, T. & N. du Plessis. 1998. *Future Remembrance: Photography and Image Arts in Chana*, Germany, 54 mins.

Werner. J-F. 2001. Photography and Individualization in Contemporary Africa: An Ivoirian Case-Study. In *Visual Anthropology* 14 (3) 251-268.

Wu, C. 2010. What is This Place? Transformations of Home in Zwelethu Mthethwa's Portrait Photographs. In *African Arts* 43 (2) 68-77.

Young, L. & H. Barrett. 2001. Adapting Visual Methods: Action Research with Kampala Street Children. In *Area* 33 (2) 141-152.

Young, M. 1998. *Malinowski's Kiriwina: Fieldwork Photography, 1915-1918*. Chicago & London: University of Chicago Press.

Zaccaria, M. 2001. *Photography and African Studies: A Bibliography*. Pavia: University of Pavia.

Zeitlyn, D. 2010. Photographic Props/The Photographer as Prop: The Many Faces of Jacques Touselle. In *History and Anthropology* 21 (4) 453-477.

PART I

Photography & the Ethnographic Encounter

Double alienation
Evans-Pritchard's Zande & Nuer photographs in comparative perspective
Christopher Morton

2

I had no interest in witchcraft when I went to Zandeland, but the Azande had; so I had to let myself be guided by them. I had no particular interest in cows when I went to Nuerland, but the Nuer had, so willy-nilly I had to become cattle-minded too...

E. E. Evans-Pritchard (1973a: 2)

Introduction

My starting point in this chapter is a museum curator's general observation: the photographs that Evans-Pritchard took of the Azande are quite different in nature from those he took of the Nuer.[1] This might seem like a straightforward sort of statement, but actually opens up a very complex area of photographic investigation. Why should they be so different, given that they were taken by the same fieldworker, and at a similar time? Much writing on the history of photography and anthropology has given prominence to shifting academic disciplinary frameworks in the shaping of modes of visual representation (e.g. Edwards 2001; Pinney 1992, 1997), but relatively little attention has been paid to how the archival record has been shaped by differently patterned indigenous responses to the camera. Herle, for instance, discusses how John Layard's photographs from Malakula taken in 1914–15 are suggestive of a more participatory form of fieldwork, but also describes 'the complex intersubjective relations involved in their production' (2009: 261). In the case of Evans-Pritchard's archive, I want to argue that such differences as exist boil down to very different historical and cultural relations to exogenous influences within Zande and Nuer society in the early 1930s, and that this is inscribed within the archival record, played out in modes of self-presentation to Evans-Pritchard's camera. Questions of self-presentation inevitably also open up questions about pose. How do we read pose, in the intercultural context of an archive held in a European museum? What sort of history is a photograph anyway? If it is inevitably an ambivalent document, is there an inherent productivity to such ambivalence? One concept that I will explore is the notion of visual distance as an index of social distance when comparing these two sets of photographs. As a colonial technology, photography resonated very differently with Zande and Nuer communities in the 1920s and 30s. Arguably, these differing relationships to both the anthropologist and his camera do pattern the archive, and suggest analytical routes beyond those reductive discussions of asymmetrical power relations so redolent of Foucaultian-derived approaches to anthropological photography and the 'colonial archive'. As Elizabeth Edwards and I have argued (Edwards & Morton 2009: 3), such analyses have always tended to suppress precisely those voices and histories

[1] All of Evans-Pritchard's photographs from southern Sudan are available online, for this assertion to be tested, at http://southernsudan.prm.ox.ac.uk.

that they were intended to valorize, and a greater analytical awareness of the role of indigenous agency in the shaping of anthropology and its visual deposits is needed if new forms of indigenous history are to emerge.

Historians of southern Sudan might argue that it isn't that surprising that Evans-Pritchard's Zande and Nuer photographs are so different, when one considers the marked difference between the two societies on a whole range of social, cultural and historical levels. Whilst this question seems straightforward, it actually opens up a complex area of investigation into the social and cultural processes involved in the production of field photography, as well as the role of photographic intentionality in the shaping of the visual record. Why are there no group portraits of Nuer families? Or age mates? Why are there relatively few informal images of Azande involved in everyday tasks and activities? Such questions open up interesting areas of investigation into the under-analyzed role of indigenous agency in the shaping of the ethnographic archive. In order to fully accommodate such a role for indigenous agency, I will argue, we must critique the primacy of photographic intentionality as the supreme arbiter of what is visually recorded – of what is seen and what is left unseen – and the resulting texture of the archive. Whilst Evans-Pritchard's attitude to his field photography, as I have discussed elsewhere (Morton 2005; 2009a; 2009b), certainly fits the pattern suggested by Edwards and Hart of 'a visual notebook, the reactive product of fieldwork rather than a central process of interrogation' (2004: 57), my argument in this chapter will be that, just as with a textual field notebook, the visual one is patterned according to a whole range of historical and socio-cultural factors affecting the situational nature of the ethnographic encounter, and indigenous attitudes towards both the fieldworker and the camera (see also Carrier & Quaintance, this volume).

Fieldwork contexts

In early November 1926 Evans-Pritchard arrived in what is now Blue Nile Province of Sudan, to carry out research among the Ingessana (Gamk) people of the Tabi Hills (Evans-Pritchard 1927; 1932a). This short period of initial fieldwork, consisting of two months spent in the vicinity of Soda, the site of an old Sudan government station, was carried out to help provide information for his supervisor Charles Seligman's ethnographic survey of the country, published some years later (Seligman & Seligman 1932: 429-37). During the process of cataloguing Evans-Pritchard's photographs it became clear that his photographic work in this first period of fieldwork among the Ingessana was markedly different from that of his subsequent Zande fieldwork. Among the Ingessana, Evans-Pritchard undertook a limited photographic sequence of physical type photographs, usually both profile and full-face, with his coat for a backdrop.[2] Such overtly scientific-reference imagery is entirely absent from his Zande photographs, although many of them were presumably taken on the same first expedition to the Sudan. Although Evans-Pritchard took a large number of Zande portraits, they are characterized by a much less shallow or scrutinizing focal plane, and although sometimes repetitive (such as the series of portraits of the sons of Prince Rikita) each image is inflected by the personality of the individual, with no attempt made by Evans-Pritchard

[2] See for instance http://southernsudan.prm.ox.ac.uk/details/1998.344.7.2/

to strip the subject of 'modern' or incongruous possessions or clothing.[3]

On the surface, then, a cross-section through Evans-Pritchard's field archive could superficially suggest a shift in fieldwork methodology – a development represented by a retreating focal depth of the images – from scientific scrutiny to relaxed portraiture; from an approach where context is intentionally excluded to one where context crowds in. Another interpretation would be that the Ingessana photographs demonstrate the particular concerns of more limited 'survey' ethnography, whereas the Zande portraits emerge from deeper social relationships established over time; the product of a more immersive fieldwork methodology (Morton 2009a: 255-77). Working from the surface of the image, it could be argued that Evans-Pritchard's archive visually demonstrates the disciplinary shift within British anthropology in the 1920s, with radically different notions of what constituted a 'scientific' approach laid bare in the photographic record. The evidence for this line of interpretation, however, is undermined by the written record, which in fact indicates not a linear progression in Evans-Pritchard's methodology but the coexistence of parallel ethnographic investigations with differing methodological concerns, one of which was being undertaken on behalf of his supervisor C. G. Seligman. The written record shows that Evans-Pritchard did in fact carry out physical measurements during his Zande fieldwork (Seligman & Seligman 1932: 496), and that although not taken according to accepted methods, six of his Zande portraits were cropped and enlarged to provide a comparison of 'Zande types' in Seligman's survey of the Sudan.[4] Evans-Pritchard later wrote that on his first expeditions to the Sudan he had 'taken around ... callipers and a height-measuring rod ... to please my teacher Professor Seligman. I have always regarded, and still regard, such measurements as lacking scientific value, even being almost meaningless; but so it was at that time' (1973b: 242). Evans-Pritchard's Ingessana photographs can in one sense be understood as those of a research assistant, operating according to the needs of his supervisor's project.

The reading of focal depth as social depth in Evans-Pritchard's Ingessana and Zande portraits shows how a preconceived analytical structure can heavily influence our reading of intention, evidence and meaning in historical photography. Probably the most obvious example of this sort of interpretive reading is Wolbert's analysis of the photographs reproduced in *The Nuer*. Noting that Evans-Pritchard had used a Rolleiflex camera during his fieldwork, Wolbert argues that,

> By using this camera, Evans-Pritchard probably prevented the not very co-operative Nuer from noticing when he photographed them. They perhaps did not even realize that a technical device was targeted at them. 'The "Nuer gaze" and the power of the picture sequence turn out to be nothing more than an editorial trick to transform the field researcher's lack of proximity into ethnographic authority'. (Wolbert 2000: 334, 337)

From both an archival and historical perspective, however, this line of interpretation does not match the evidence, since Evans-Pritchard's Rolleiflex photography took place during his last two brief visits to Nuerland in 1935

[3] See for instance http://southernsudan.prm.ox.ac.uk/details/1998.341.529.2/
[4] See Seligman and Seligman 1932: Plate LVI (opposite page 496). Evans-Pritchard made all of his Zande photographs available to the Seligmans, who cropped around the faces of Zande portraits to present them in a more uniform manner as comparative data on types. In only one or two instances did Evans-Pritchard ever photograph a Zande subject in profile.

and 1936, where he was much more socially accepted, and when his social relationships were much more intimate. Evans-Pritchard's two distinct phases of Nuer fieldwork (1930–1 and 1935–6) were carried out in extremely different political and social contexts in the region; contexts that, I argue, are inscribed within the archive. Whereas the political situation in 1930 meant that his photography was highly restricted, his return to eastern Nuerland in 1935 was photographically prolific. This photographic practice was brought about by a transformed set of relations to the Nuer in his later fieldwork. In 1935 he spent a month at the home of his cook, Tiop-Lier, who had worked for him in 1931, and whose relatives at Mancom made him 'welcome on his account' (Evans-Pritchard 1951: 106). In 1936 he spent five out of seven weeks in the home village of Nhial, a youth who had worked for him in both 1930 and 1931, and whose community considered him a 'friend of the family' (Evans-Pritchard 1974: 35). Far from demonstrating ethnographic distance, these later Rolleiflex photographs frequently demonstrate close social relationships and social acceptance of his activities, as I have discussed in detail in relation to his record of the Nuer rite of *gorot* in 1936 (Morton 2009a).

Zande self-presentation

Evans-Pritchard's Zande photographs are of course quite diverse in subject matter, including individual and group portraits, activities, techniques, material culture (such as spirit shrines), and ritual (such as oracle consultation). Most of his Zande negatives are quarter-plate size film negatives, possibly taken with a camera adapted for film packs. In fact this is the main format for his photography between 1926 and 1930, and is therefore present throughout much of the Azande, Moro, Ingessana and Bongo material. It is also a significant format in the first Nuer series between 1930 and 1931.[5] The technology here is significant, since his lack of confidence with early cameras meant that he 'tried to take two or three photos of whatever it was I was taking a picture of, varying the time exposure or stop, so one of them was certain to be reproducible' (1973b: 241). This comment also suggests the extent to which Evans-Pritchard understood the illustrative and corroborative importance of his field photographs for subsequence publications.

The Zande photographs are also characterized by a strong sense of self-presentation to Evans-Pritchard's camera which, arguably, suggests a general awareness of photography among many Azande, even though very few would have owned photographs themselves. In a series of some twenty portraits of the sons of Prince Rikita, for instance, each sitter poses in the same camp chair with a grass fence behind. Despite the uniformity and repetitive nature of the series, Evans-Pritchard's framing lacks any sense of scientific scrutiny, and instead is suggestive of having been commissioned by Rikita to make portraits of his sons. Most of the prints from this series in Evans-Pritchard's archive contain traces of having once been placed in an album, possibly used

[5] This size film (designated 118 size) was used by a number of cameras. Kodak, for example, introduced the No.3 Autograph camera from 1914-1926. This produced 3¼- by 4¼-inch negatives, usually six exposures to a spool, yet the 1928 Kodak dealer catalogue noted that 118 film would also 'be supplied in 12 exposure spools, on request, for the use of Travelers, Explorers etc'. The mechanically printed numbers on the bottom of many of the negatives is evidence that they actually come from a film pack. These were packs of sheet film that could be used with an adaptor in place of dark slides holding glass plates.

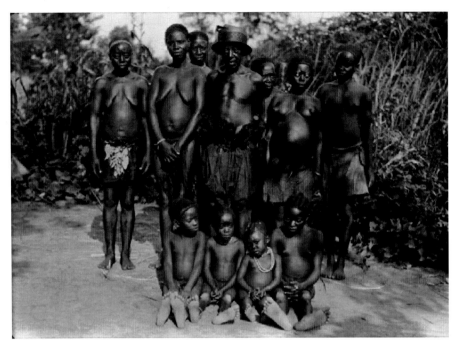

Figure 2.1 Group portrait of Ongosi, a courtier of Prince Basongoda's court, with some of his wives and children. Yambio, Western Equatoria, southern Sudan.

Photograph by E. E. Evans-Pritchard, 1927-30. Reproduced by kind permission of the Pitt Rivers Museum, University of Oxford. Classmark: 1998.341.270.1.

by him during fieldwork. Carrier and Quaintance (this volume) make the interesting observation that archival photographs have a significant 'social currency' in fieldwork contexts, eliciting memories and stories that would be difficult otherwise. We know that Evans-Pritchard returned with prints on his second Zande expedition, and can only surmise that he also showed them and discussed them with Zande informants.

Many of the Zande portraits are characterized by a style of pose that has the subject looking straight at the camera, feet together and arms straight to the side of the body. The rigidity of this pose is also submissive; the subject has been asked to pose for the camera, and the response is formal and acquiescent. There are also some formal Zande group portraits, such as one of Chief Ongosi with his wives and children (Figure 2.1). This particular portrait is one of those that prompted my attempt to compare Evans-Pritchard's Zande and Nuer images. Why is this sort of group portrait not only absent from Evans-Pritchard's Nuer photographs, but also inconceivable? The answer cannot reasonably lie in any shift in his photographic style or interest, or shift in ethnographic focus, but in differing attitudes to photography by Azande and Nuer during his fieldwork. He also photographed Prince Gangura, seated, with wives and daughters standing behind him and sons on the ground in front (Figure 2.2), as well as Gami, a commoner provincial governor, with a line of sons to his left, daughters to his right, and wives and younger children seated on the ground (Figure 2.3). These portraits are strongly suggestive of the important role photography played in the social and political network that Evans-Pritchard relied upon during his fieldwork, and that there was a strong local demand for portraiture, to affirm kin ties and political prestige.

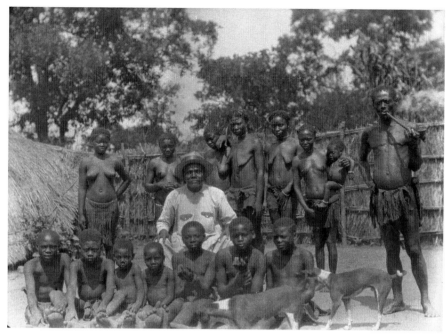

Figure 2.2 *A family portrait of Prince Gangura with children at his feet and wives, daughters and man smoking a pipe standing behind him. Yambio, Western Equatoria, southern Sudan.*

Photograph by E. E. Evans-Pritchard, 1927-30.
Reproduced by kind permission of the Pitt Rivers Museum, University of Oxford. Classmark: 1998.341.410.1.

Figure 2.3 *Group portrait of Gami, a commoner governor, surrounded by his family, with a line of sons to the right, daughters to the right, and wives and younger children seated. Yambio, Western Equatoria, southern Sudan.*

Photograph by E. E. Evans-Pritchard, 1927-30. Reproduced by kind permission of the Pitt Rivers Museum, University of Oxford. Classmark: 1998.341.725.1.

Figure 2.4 *Group portrait with Evans-Pritchard seated in a chair and a group of Zande boys saluting in a line behind him, with sticks as imitation rifles slung over their shoulders. Yambio, Western Equatoria, southern Sudan.*

Photographer unknown (but seemingly taken with E-P's camera), 1927-30. Reproduced by kind permission of the Pitt Rivers Museum, University of Oxford. Classmark: 1998.341.576.

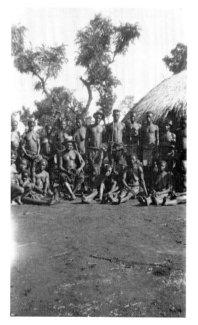

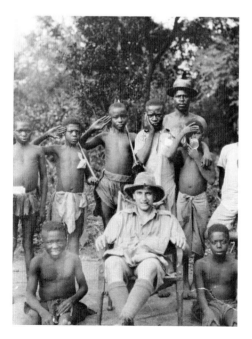

With King Gbudwe having been overthrown in 1905, Azande had been under colonial control for a number of years before Evans-Pritchard arrived in 1926. The opinion of early colonial observers among the Azande, such as P. M. Larken, was that the Zande cultural area had grown significantly in the nineteenth century as a result of warfare, and particularly through the assimilation of neighbouring (often acephalous) groups (Larken 1926: 21). Cultural assimilation was therefore a long-established part of what political assimilation into the greater Zande system meant for most people. In Evans-Pritchard's opening account of Zande culture in *Witchcraft, Oracles and Magic among the Azande* (1937), he psychologizes this historical process, stating that:

> ... in the experience of the author ... the Azande are so used to authority that they are docile; that it is unusually easy for Europeans to establish contact with them ... that they adapt themselves without undue difficulty to new conditions of life and are always ready to copy the behaviour of those they regard as their superiors in culture (Evans-Pritchard 1937: 13)

In one of the best-known, and most enigmatic, photographs of Evans-Pritchard in the field, he is pictured seated on a chair surrounded by Zande boys, some of whom hold sticks as imitation rifles, and salute in military manner (Figure 2.4). Has the photographer (Larken?) suggested a pose to these boys, who dutifully copy him? The boy in the shirt holds his hand against his face. Does he just fail to imitate the saluting pose? Or is he merely weary with instruction and colonial coercion? His left arm, leaning tenderly over the younger boy to his left, adds an affectionate and relaxed tone – one of many tensions that make this image so fascinating. On the surface such an image places the anthropologist uncomfortably at the heart of the Zande experience of colonialism. But couldn't it just as easily also be a tongue-in-cheek play on colonial imagery and power relations on the part of Evans-Pritchard and the photographer? This is certainly my reading.

Relationships between closely associated photographs from Evans-Pritchard's Zande fieldwork are often suggestive of the social interplay surrounding his photography there. Let us examine for instance two photographs of one of Evans-Pritchard's closest informants, Ngbitimo (also known as Zambaliru).[6] The first image is a portrait of Ngbitimo standing next to medicines growing in the centre of his homestead, two of his wives sitting on a termite mound in the distance, with a tuka (spirit-shrine) lying on the ground in front of them. In the second portrait, Evans-Pritchard has shifted his position to the left in order to include offerings placed on a tuka to the right of frame. This time two of Ngbitimo's wives stand either side of him, one of whom is gesturing towards her husband. I think it is unlikely that Evans-Pritchard has prompted this gesture, which seems to be a spontaneous act. But what is this gesture? Is it a Zande gesture of a wife presenting her husband to the camera, a way of visually indicating status to the viewer? If so, what sort of local understandings about photographic representation does it presuppose? Or is it just a gesture that has nothing to do with the act of photography, and was just caught accidentally? Either way, the presence of this gesture transforms the image into something more than Evans-Pritchard's intention, and appropriates it.

[6] Available online via http://southernsudan.prm.ox.ac.uk/details/1998.341.556.2/ and http://southernsudan.prm.ox.ac.uk/details/1998.341.301/

There are two important strands to this idea, the first being that such acts of self-representation are suggestive of a cultural awareness of photography, and the second that cultural responses to the act of photography such as the gesture, may often be articulated through already existing modes of public comportment, such as in formalized greetings and spatial arrangements at social gatherings. Elizabeth Edwards has discussed the way in which these sorts of indigenous presentations may emerge through the apparently dominant or overt discourse in which photographs are embedded, in her example of two photographs of rival Samoan claimants and their supporters seated on the deck of HMS Miranda. Such photographs, Bronwen Douglas has argued, 'inadvertently register shadowy traces of local agency, relationships and settings' (1998: 70). If we take another look at the group portrait of Prince Gangura and some of his family (Figure 2.2), it is clear that notions of local agency, relationships and settings are not inadvertent, but subtly undermine the notion of the 'colonial gaze'. In other words, this doesn't feel like a photograph 'about' or 'of' a Zande prince and his family, but 'for' a Zande prince and his family. Again, it is the presence of gesture within the pose, this time by two boys sitting at the front, that arrests our attention as some sort of communication directed towards us.

In the group portrait of the governor Gami and his family (Figure 2.3), within whose homestead Evans-Pritchard stayed, the use of a chair by the head of the family is also used to indicate status, with older males again standing to the left side. What seems apparent in both group portraits is a process whereby local expectations of photographic representation, possibly derived partly from a limited local circulation of photographs or print media, are mediated by pre-existing cultural practices, especially those derived from the spatial organization at Zande group meetings. Since we are told by Evans-Pritchard that Zande men and women never sit together in public, these group portraits, with boys sitting with women and men standing behind, take on additional local inflections and relationships beyond the camera. In one sense, the very existence of such formal photographic situations (absent in his Nuer photographs) obviously indicates some sort of local understanding of photography, its technologies, intentions, uses, and manners of representation. But we have as yet little knowledge of what such local understandings were among the Azande in this period.

We might compare such group portraits with others taken just across the border in the Belgian Congo by Herbert Lang in 1913 of the Zande chief Akenge with a number of his wives.[7] Again, there is a temptation to try and understand such photographs in terms of what sort of relationship there is between the photographic pose and pre-existing spatial dynamics at Zande social gatherings. But it is also tempting to try and understand what sort of indigenous self-representation they may represent, rather than focusing on whether Lang is working with representational norms. More research may reveal the extent to which such portraits actually reveal complex understandings and manipulations of photographic representation on the part

[7] Herbert Lang's photographs from the 1909–1915 Congo expedition of the American Museum of Natural History are available online via http://diglib1.amnh.org. The photograph has the reference number 111631, and was taken by Lang in Akenge in September 1913. The description runs: 'The biggest hut in Azande style in his village. In front, the chief is surrounded by some of his most favored women.'

of chiefs in particular. We might then compare, for instance, Schweinfurth's portrait of the Mangbetu King Munza of 1874,[8] with both Lang's portrait of the Akenge chief in 1913, and Evans-Pritchard's frontispiece of a Zande deputy in 1937. Rather than seeing such similarities as the consolidation of western norms in the depiction of central African chieftaincy, further research may suggest instances in which local chiefs also played a role in the development of such norms. The symbolism of the pose of authority is also used in a more subtle way by Evans-Pritchard as a frontispiece in particular. Why for instance is this photograph used, when it is made clear throughout the book that witchcraft is neither practised, nor believed in, by the ruling class in Zandeland? The metonymic burden of the frontispiece image in this instance is perhaps related to the language of its caption. Here we have a society, the caption tells us, with a prince, a prince's court, a deputy, and a knife of office. In other words, the values of aristocracy, order, hierarchy and stability. Given Evans-Pritchard's attempt in the following analysis to demonstrate the validity of the Zande *logos* as expressed through witchcraft and oracular practices, the frontispiece image resonates with the wider conclusions of his thesis concerning the workings of the social system, in which he explicitly acknowledges the influence of Radcliffe-Brown. Whilst it is possible that Evans-Pritchard's choice of frontispiece intentionally echoes that of Schweinfurth's frontispiece image of King Munza, thereby consolidating a long-established representational trope of Zande political authority, we should not discount the possibility, given that a number of similar images were taken by Evans-Pritchard of other deputies in such a pose, that Zande courtiers themselves were complicit in the composition of images that enhanced and demonstrated their political status.

Nuer transformations

When Evans-Pritchard first arrived in Nuerland, in January 1930, the society that he encountered was markedly different from that of the Azande; not politically centralized, without elaborate social and political hierarchy, either no deference to European authority or openly hostile towards it, and little enthusiasm for exogenous ideas and material culture. As Johnson has discussed (1982; 1993), the 1920s was a tumultuous period in Nuer history, during which time the Sudan Government was embroiled in various attempts to control and administer the cattle-keeping Nuer groups of Upper Nile Province. These actions had come to a critical phase by the end of 1927, when government attempts to intimidate the Nuer prophet Guek Ngundeng using airplanes failed. Government actions the following year brought another Nuer prophet Dual Diu into open rebellion, and troops were sent throughout Nuer country east of the Nile in an attempt to capture the leaders of these uprisings (Johnson 1982: 231). Desperate for more information about Nuer society and political organization in order to exercise control, the Sudan Government informed Evans-Pritchard that the Nuer would now be an urgent priority for any subsidy for research (Johnson, 1982: 232). Reluctant to abandon his Zande studies at a critical stage, Evans-Pritchard nonetheless agreed to begin work among the Nuer, and even expressed enthusiasm in doing so, 'partly

[8] Published as the Frontispiece to Georg Schweinfurth's *The Heart of Africa*, Vol. 2, 1874, with the caption 'King Munza in full dress'.

because I feel sorry for the Nuer and would be glad to help them settle down peacefully by making myself intimate with their life'.[9]

After a troubled beginning to his arrival in Nuerland, Evans-Pritchard eventually met up with his Zande companions Mekana and Kamanga, and drove to Muot Dit in Lou Nuer country with a Nuer youth named Nhial (Evans-Pritchard 1940: 10).[10] In a letter to the Civil Secretary Harold MacMichael in March 1930 however, Evans-Pritchard described the problems of conducting research amongst the traumatized and suspicious Nuer: 'From our point of view the natives of this area are too unsettled & too resentful and frightened to make good informants & the breakdown of their customs & traditions too sudden & severe to enable an anthropologist to obtain quick results.'[11]

The picture of obstinacy and evasiveness towards the anthropologist painted by Evans-Pritchard in his Introduction to *The Nuer* (1940: 11-14), needs to be understood in the context of Nuer attitudes towards someone who they rightly saw as an agent of an alien government, and who, as Johnson points out, 'had bombed them, burned their villages, seized their cattle, took prisoners, herded them into dry "concentration areas", killed their prophet Guek and had blown up and desecrated the Mound of his father Ngung-deng, their greatest prophet' (Johnson 1982: 236). Evans-Pritchard wrote, for instance, that 'When I entered a cattle camp it was not only as a stranger but as an enemy, and they seldom tried to conceal their disgust at my presence, refusing to answer my greetings and even turning away when I addressed them' (1940: 11).

Evans-Pritchard's second period of fieldwork amongst the Nuer (this time in eastern Nuerland) the following year, from February to June, began to yield some results. In a letter to Malinowski in May 1931, however, he expressed continued frustration:

> I am still sweating away at the Nuer. They are really quite impossible – possibly like Bateson's 'Bainings'.[12] I have spent weeks learning the language and it is only now when I am preparing to leave more or less that info comes in – not pours in but trickles ... it is a most depressing piece of work altogether. Still on the other hand it is rather fun after the easy Zande work tackling a really difficult culture.[13]

For Evans-Pritchard, it was clear that the Nuer frequently considered photography in general as a tool of a hostile and alien government. In western Nuerland in 1930 his attempts to photograph cattle led to an undescribed, yet serious incident, and 'for the remainder of that expedition I abstained from photographing a single cow' (1937b: 242). For the Nuer, government interest in their cattle had hitherto taken the form of fines, confiscation or bombing. 'On no account', advised Evans-Pritchard in the government journal *Sudan*

[9] Typewritten report from E. E. Evans-Pritchard to Harold MacMichael, 8 February 1929, quoted in Johnson 1982: 232.
[10] Johnson quotes a letter from Evans-Pritchard to Matthew, 4.12.30, in which he states that the 'only informant whom I managed to procure on my last trip was a half-witted youth from Yoinyang' (1982: 237). Nhial also assisted Evans-Pritchard during his fieldwork in 1931 and in 1936 Evans-Pritchard stayed with Nhial at Nyueny as 'a friend of the family' (Evans-Pritchard, 1956: 35), proving that Nhial was a central figure in facilitating Evans-Pritchard's Nuer fieldwork.
[11] Letter from E. E. Evans-Pritchard to Harold MacMichael, 27 March 1930, quoted in Johnson 1982: 236.
[12] A reference to Gregory Bateson's fieldwork among the Baining people of New Britain (Papua New Guinea) in 1927-8, which was notoriously difficult.
[13] London School of Economics archive, Malinowski Papers, Mal 7/11, letter from Evans-Pritchard to Malinowski, 20 May 1931.

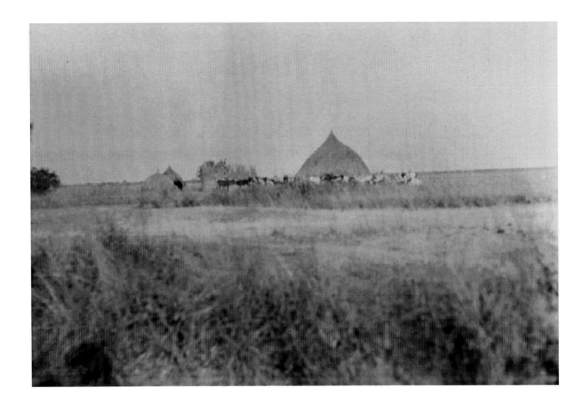

Figure 2.5 The huts, large windbreak and cattle byre (luak) of a Nuer homestead set on a sandy ridge. Jonglei, southern Sudan.

Photograph by E. E. Evans-Pritchard, 1930. Reproduced by kind permission of the Pitt Rivers Museum, University of Oxford. Classmark: 1998.346.57.1.

Figure 2.6 Wia, a son of Cam of Yakwach village on the Sobat River. Evans-Pritchard employed Wia in 1931 during his fieldwork amongst the Lou Nuer.

Photograph by E. E. Evans-Pritchard, 1931. Yakwach village, Upper Nile, southern Sudan. Reproduced by kind permission of the Pitt Rivers Museum, University of Oxford. Classmark: 1998.346.62.1.

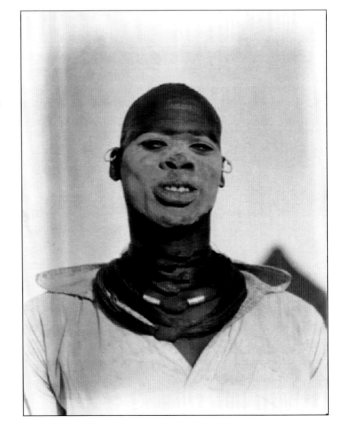

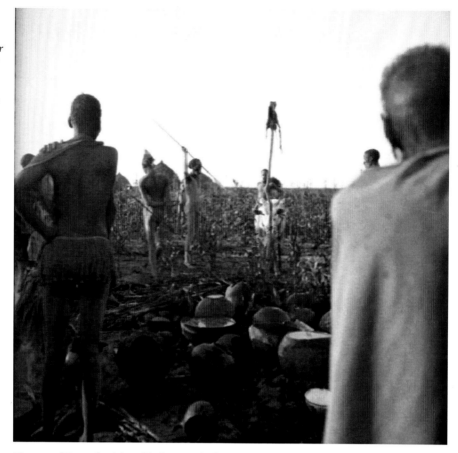

Figure 2.7 A man makes an invocation before sacrificing an ox for the spirit (colwic) of a girl killed by lightning, next to her shrine. Wahda, Nyueny village, southern Sudan.

Photograph by E. E. Evans-Pritchard, 1936. Reproduced by kind permission of the Pitt Rivers Museum, University of Oxford. Classmark: 1998.355.537.1.

Notes and Records, 'should the cattle be photographed till friendly relations are established ... It was only when I acquired a few cattle of my own [in 1931] and had a stake in the kraal that I was able to establish real contact with the people' (ibid.: 242-3).

From a total of over one thousand photographs taken by Evans-Pritchard during his Nuer fieldwork, only about a quarter relate to his much longer eight and a half months of fieldwork during 1930-1, with three-quarters having been taken during the shorter three months of fieldwork in 1935-6. Many of the photographs taken in 1930-1 are inflected by the sort of social distance experienced by Evans-Pritchard described above, with images of homesteads and cattle-camps taken from afar (Figure 2.5),[14] or when deserted. When people are included, it is almost always the youths and young children that he spent most time with, and with whom he was on friendly terms (1940: 11). Occasionally striking portraits of these youths appear, especially from Yakwach cattle camp on the Sobat River in 1931 (Figure 2.6),[15] but there are no portraits of adult men or women, possibly since few were at the dry-season camps.[16] Although a feature of the photography of his second period of fieldwork, there are also very few images of Nuer dance events. As has been mentioned, the nature of the images shifts considerably in 1935-6, with numerous photographs

[14] Available online at http://southernsudan.prm.ox.ac.uk/details/1998.346.57.2/
[15] Available online at http://southernsudan.prm.ox.ac.uk/details/1998.346.62.2/
[16] Where images of adult Nuer do appear, they are usually photographed seemingly without their knowledge (see for instance http://southernsudan.prm.ox.ac.uk/details/1998.204.5.36.2/).

of differently marked cattle, milking activity (unthinkable in 1930), domestic activities and dances.

Photography became a much more central tool of fieldwork for Evans-Pritchard during 1935-6, no doubt because he was highly aware of the limited time available to record details for subsequent analysis, as well as of the need for decent illustration in any publication (almost all images published in *The Nuer* were taken in 1935-6).[17] In 1936, for example, Evans-Pritchard was able, with the Rolleiflex he mostly used, to record photographically Nuer ritual activity for the first time. I have discussed at length elsewhere (Morton 2009a) his photographic record of the rite of *gorot*, a fertility rite involving the sacrifice of an ox by suffocation, which took place in 1936, probably at Nyueny village. Another ritual event that Evans-Pritchard witnessed in 1936, a *colwic* ceremony, proved much more difficult to photograph successfully, since most of it took place at dusk, although one taken on the following morning proved successful enough to be used in his later publication *Nuer Religion* as Plate IX, captioned 'Invocation'.[18] Another photograph from the sequence (Figure 2.7)[19] situates Evans-Pritchard at the periphery of the ritual events, witnessing the sacrifice along with women and youths from some distance.

This is in distinction to his movement through the ritual space during the *gorot* rite, where he takes photographs from very close to the sacrifice itself. In the *colwic* photograph, a senior maternal uncle with raised spear invokes *kwoth* (God) as he sacrifices an ox for the spirit of a girl (called Nyakewa) killed by lightning, next to a shrine made for her. The shrine is visible in the foreground just beyond the beer vessels, consisting of a low earthen mound with a shrine-stake (*riek*) at the centre and part of another sacrifice placed on top. Nyakewa was considered to have become a *colwic*, a spirit taken directly by God. The specific intervention by the divine via lightning was considered so dangerous to all associated with the deceased that sacrifice was made by all relatives (in all more than twenty animals were sacrificed over several days).

Beyond intentionality

Although Evans-Pritchard's anthropological investigations were framed some-what differently between the two groups, with enquiries among the Azande focused on witchcraft and magic, and among the Nuer more generally relating to social and political structure, such differences in ethnographic focus influence the photographic record only to a certain extent. So, for instance, there are examples of oracle consultations, *tuka* (spirit shrines), and magic-related material culture in his Zande photography, but they do not dominate; other long sequences, such as beer brewing, food preparation, and house construction, feature only in passing in his written ethnography.

In the introduction to this chapter I argued that the role I was proposing for indigenous agency in the shaping of the field archive would involve rethinking the primacy given to photographic intentionality. The notion that

[17] He had returned to the Nuer in 1935 only by chance since his Leverhulme Research Fellowship to study the Galla (Oromo) in Ethiopia was curtailed by the Italian invasion. The Leverhulme Trust also supported his fieldwork in Kenya in 1936, after which he paid a final visit to the Nuer in October–November.

[18] The *colwic* images can be viewed online via http://southernsudan.prm.ox.ac.uk with the search term 'colwic'.

[19] Available online at http://southernsudan.prm.ox.ac.uk/details/1998.355.537.2/

photography is a way of seeing the world mediated by a photographer, and that photographs are the result of repeated choices made between possible images by that photographer, underlies much critical writing on the medium. John Berger writes for instance that 'Every image embodies a way of seeing ... Every time we look at a photograph, we are aware, however slightly, of the photographer selecting that sight from an infinity of other possible sights... The photographer's way of seeing is reflected in his choice of subject' (1972: 10).

The authorial voice of the photographer is something that underlies, for instance, much modernist thinking on photography as both art and reportage. Vilém Flusser, for instance, defined a photographer as 'a person who attempts to place, within the image, information that is not predicted within the program of the camera' (2000: 84). And for Sontag 'photographs really are experience captured, and the camera is the ideal arm of consciousness in its acquisitive mood. To photograph is to appropriate the thing being photographed.' (1979: 3-4) For other writers, such as Tagg, photographic intentionality is subordinate to those institutional and social practices and power structures which give photography its meaning (Tagg, 1988). This approach is also found in the work of Sekula, who has examined how photographs function in systems of commodity exchange within capitalism, and in particular its dual historical role in the creation of likenesses, both of the bourgeois self, and of the criminal (Sekula, 1986). For both Tagg and Sekula, the photographer is secondary to the institutional processes in which photographs are generated and consumed.

Although Evans-Pritchard's sponsorship by the colonial Sudan Government during his fieldwork would seem to provide a rich context in which to examine his photographs from this perspective, there is little evidence that his fieldwork was directly influenced by colonial power structures, and was frequently antagonistic towards them. Only weakly can Evans-Pritchard's Zande or Nuer photography be considered as 'instrumental' photography, in which 'colonised peoples ... were constituted as the passive ... objects of knowledge' (Tagg, 1988: 11) within social science discourse. Such an analysis would certainly apply more to his Ingessana photographs under the auspices of Seligman's survey. But, as argued above, although Evans-Pritchard's Zande and Nuer photographs were taken within a colonial context, Tagg's notion of instrumental photography is much more relevant to nineteenth-century forms of disciplinary image production and consumption, and much less relevant to images that emerged from the intensive, individual fieldwork of the twentieth century. Indigenous agency is apparent, for instance, throughout Malinowski's photography in the Trobriand Islands from 1915 to 1918, despite its apparently aestheticized and static character. Towards the end of his stay on Mailu Island, for instance, he recorded in his diary:

> Went to the village hoping to photograph a few stages of the bara [dance]. I handed out half-sticks of tobacco, then watched a few dances; then took pictures – but results very poor. Not enough light for snapshots; and they would not pose long enough for time exposures. At moments I was furious with them, particularly because after I gave them their portions of tobacco they all went away. (Quoted in Young 1998: 6)

Young's conclusion about Malinowski's preference for framing people and objects in their social context in the middle distance, rather than up close as portraits, is that his style was 'methodologically driven' (1998: 18) by an incipient 'functionalist' approach. However, it is less clear whether Trobriand attitudes towards close portraiture were of relevance to their absence from his archive.

In one sense the problem here is that photography is only a weak carrier of intentionality. Partly this is due to its inherent analogical nature, 'a message without a code' as Barthes memorably described it (Barthes 1985: 5), which means that photographic intentionality is only one factor in the process of inscription. This leaves the question of photography's communication of meaning far from resolved. 'Insofar as photography is (or should be) about the world', wrote Sontag, 'the photographer counts for little, but insofar as it is the instrument of intrepid, questing subjectivity, the photographer is all' (1977: 122). As Elizabeth Edwards and I have argued (Edwards & Morton 2009: 4), the inherent instability of photographic meaning undermines photographic intentionality as a dominant analytical position. The random inclusiveness (and hence visual excess) of photographic inscription, its fixity of appearance and yet potentially infinite recodability, as well as its temporal and spatial slippages across both literal and metaphorical border zones, means that interpretations that privilege the subjective vision of the photographer tend to dissolve when scrutinized from a historical perspective, or mirror the analyst's own critical position. And yet, as Edwards elsewhere points out, 'photographic inscription is not unmediated; the photograph is culturally circumscribed by ideas of what is significant or relevant at any given time, in any given context ... the inscription itself becomes the first act of interpretation' (2001: 9). Another layer of intentionality, of course, is found in Evans-Pritchard's subsequent treatment of his photographs in various publications, what Barthes termed the image's connoted message (1985: 6), something that I have explored in detail elsewhere (Morton 2005).

This more situational understanding of the nature of photographic inscription in the field enables us to reinsert indigenous agency in the creation of field imagery in a much more analytical way. If field photographs are culturally circumscribed by context-driven ideas of significance or relevance, then this is never wholly determined by the field photographer, but is arguably often partly (even sometimes wholly) determined by indigenous attitudes towards the camera. If inscription is the first act of interpretation, then the visual interpretation of both Zande and Nuer culture, already discussed, needs to be understood in the context of cultural co-production – situationally determined, and historically circumscribed. Just as our expectations of photography as a medium are grounded in its ability to perform a version of reality – photography's indexical relationship to the world – so must any argument about the role of indigenous agency be grounded in the materiality of photography; it has to be demonstrated. In order to do this I will turn back to Evans-Pritchard's photographs, and explore the way in which its relational nature is revealing of aspects of indigenous agency. As Edwards rightly points out, 'Meanings are made through dynamic relations between photographs and culture that do not stop at the door of the archive' (2001: 12).

The relational image: seriality and embodiment

All of my published research on Evans-Pritchard's field photography thus far (2005; 2009a; 2009b) has been characterized by a methodological focus on the archival photograph as a relational and biographical object, and has been concerned with tracing the complex archival relations between some of Evans-Pritchard's well-known published photographs. My use of the term 'relational'

here refers to the way in which photographic meaning emerges from an individual image's relationship to others in a series. Fieldwork photographs are relational in a number of different ways and on a number of different levels, both spatially and temporally. For instance, they may form part of a sequence of images relating to an event or ritual, or a technological theme such as weaving, which is more fragmented over the course of fieldwork. Images also usually contain relations to other images in time and space through the process of inscription. The relational dimension of a photograph is here a recognition of the way in which any photograph is suggestive of relationships beyond itself to other photographs, rather than merely within its own frame. Materially, photographs are related as numbered frames on a film, or dated slides, or as digital images with embedded metadata about their production, and hence relationships to other images. It is only by examining the archival image in this relational context that we can investigate the question of indigenous agency on a sound methodological footing, because the relationships between moments of inscription are particularly revealing about the social and cultural contexts that surround particular photographs. The relational understanding of the photograph is also connected to ongoing debates about the 'agency' of the image within social relations (Gell 1998; Edwards 2001: 17–21), or their role as 'social objects' (Edwards 2005: 27) that are entangled with material and sensory processes in the communication of meaning. Ethnographic studies have shown for instance how photographs sometimes 'stand for' deceased kin within existing social networks (Smith & Vokes 2008), as well as the social incorporation of archival photographs of deceased relatives by families as part of processes of so-called 'visual repatriation' (Morton & Oteyo 2009; Bell 2003). Other studies have focused on the use of photographs of deceased family members and elites as part of processes of commemoration, in which the mobilization of the photograph effectively extends the social agency of the deceased person beyond death (e.g. Gore 2010). Outlining the relevance of Gell's concept of agency to visual anthropology, Vokes (2010) argues that agency in the form of 'abduction' is also emergent from the process of photographic inscription: 'practically all photographic theory begins from a reading of the photographer's intentions, and all photographs may also be interrogated in terms of their subjects' intentionality' (2010: 377).

In the case of Evans-Pritchard's Zande and Nuer photographs the tracing of such questions of photographer/subject intentionality and image relationality is best illustrated by two groups of images relating to ritual activity. The first example is a series of photographs of the initiation of Evans-Pritchard's servant Kamanga into the Zande corporation of witchdoctors (see Morton 2009b). These twelve photographs form one pack of mechanically-numbered film negatives. In only a few cases however is that original frame number still visible, and in a few other cases the numbers have been clipped. This leaves five frames without numbers, but which can be convincingly put into sequence based on what we know about the event from Evans-Pritchard's published account (1937a: 239-42). Evans-Pritchard's own diagrammatic representation of the spatial organization of a Zande witchdoctor dance area shows that the position from where most of the photographs were taken, outside the open-sided shelter, is not with the other male spectators, but on the opposite side, so that the drummers appear in the background, as the *abinza* (witchdoctors) address their audience. It seems likely that he moved

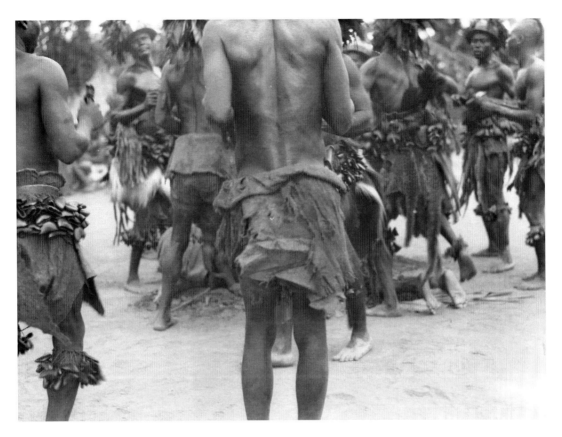

Figure 2.8 A group of abinza *(witchdoctors) dancing around an initiate who has been lowered into a ritual grave. Western Equatoria, Yambio, southern Sudan.*

Photograph by E.E. Evans-Pritchard, 1928-9. Reproduced by kind permission of the Pitt Rivers Museum, University of Oxford. Classmark: 1998.341.163.1.

from the area where the spectators were gathered to his shelter behind to take the photographs, and then remained there during the ritual burial part of the event. As the ritual hole is dug towards the right side of the dance-ground and the dancers dance around it, Evans-Pritchard appears to move towards Kamanga in the hole, and then to the right side to get a better view (Figure 2.8). He is here standing at the very edge of the area demarcated by horns as the area in which uninitiated *abinza* may not enter, and the sense of embodiment is at is most insistent. At this point Evans-Pritchard becomes a social actor within the ritual event:

> While Kamanga was in the hole, his wives, one of his brothers, his brother-in-law, two of his cousins, one or two friends, and I advanced to the edge of the hole and there threw down spears, knives, rings, bracelets, leglets, old tins, Belgian Congo coins, and Egyptian piastre and half-piastre pieces. (1937a: 241)

The shift in photographic proximity, from periphery to centre, thereby mirrors what we know from Evans-Pritchard's text about his movement as a social actor in the ritual space. Although his photographic engagement is mostly concerned with the ritual burial, the significant phase of the offering of gifts is not photographed, presumably since Evans-Pritchard is here actively involved as a social actor in the proceedings.

That he makes this movement within the dance-ground is not without indigenous meaning. To cross over into the dance area demarcated by horns thrust into the earth was forbidden for an uninitiated person, 'and were he to do so he would risk having a black beetle or piece of bone shot into his body

by an outraged magician' (1932b: 301). As sponsor of the initiate, Evans-Pritchard's proximity to the *abinza* towards the end of the ritual was a result of his fulfilling the important role of sponsor of the initiate, a role that placed him at the ritual centre of proceedings. However, the sponsor of an initiate was normally a senior local witchdoctor (1937a: 204), and so Evans-Pritchard's indigenous categorization is somewhat ambiguous, somewhere between local patron of *abinza* and the initiate's sponsor.

The detailed comparison made in this example between the archival relations between twelve photographs, and the textual account of events they relate to, enables us to gain a widened understanding of how photographic intentionality interweaves with indigenous agency in such situations. These images cannot simply be read in terms of Evans-Pritchard's intention to visually represent stages of a Zande ritual, but within the social and cultural dynamic of his social involvement in Kamanga's initiation, as a social actor in the event itself, and the actions of the Zande participants. Why was the important stage of the offering of gifts into the ritual hole not photographed? Or the dropping of a liquid into the initiate's eyes and nose? The relations between the images from this sequence suggests that events such as these generate their own opportunities that shape the visual record in situational ways, and that indigenous agency plays an influential role.

Collective witness

The question of intentionality and indigenous agency also hangs over a series of photographs that Evans-Pritchard took in 1936 of the Nuer rite of *gorot* (see Morton 2009a) described and illustrated in his volume *Nuer Religion* (1956: 217-18). I have re-associated three film-rolls relating to this event – identified by Evans-Pritchard on the reverse of his working prints – but which were subsequently dispersed throughout his collection. In two of the films what seems to emerge is a strong sense of the collective nature of the *gorot* ceremony, with family members gathered closely around, some assisting at points, other watching. The importance of collective witness and group involvement is a common feature of Nuer religious practice, and especially sacrifice, which involves numerous relatives who travel considerable distances to attend, and which ends with the distribution of meat among relatives. The group witnesses that a sacrifice has been carried out as part of the family's obligation to spirits, they witness which direction the beast falls after sacrifice, and they gather to hear the lengthy invocations that precede it.

Evans-Pritchard as participant-photographer is also part of this dynamic collective witness, moving with onlookers as they witness different aspects of the ceremony (see also Wingfield, this volume). In these two films the nature of his photographic engagement seems to sway with the collective witness of the group, shown by the presence of other onlookers on either side of the frame. The images of the circling of the hut by the youth with the boiled ox hump in particular demonstrate that the socio-spatial dynamic of the earlier suffocation element of the rite, where onlookers sat patiently nearby to watch, had transformed into a more participatory and informal rite, in which Evans-Pritchard had to jostle for position to gain a view of the scene (Figure 2.9). Yet again, the question of why certain elements were not photographed emerges, if part of Evans-Pritchard's intention was to create a visual record of stages

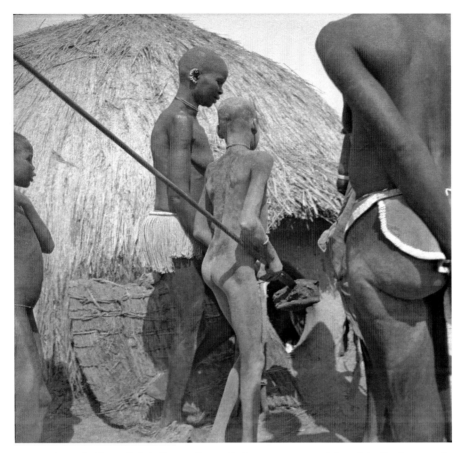

Figure 2.9 Youth offering the boiled hump of a sacrificed ox to a young married couple inside a hut, part of the gorot *rite. Wahda, possibly Nyueny village, southern Sudan.*

Photograph by E. E. Evans-Pritchard, 1936. Reproduced by kind permission of the Pitt Rivers Museum, University of Oxford. Classmark:1998.355.77.1.

of the rite. It may be, for instance, that there are no images of the part of the rite that took place in the hut interior because Evans-Pritchard's entry into the young couple's hut would not have been considered appropriate, or that photographing the couple eating meat together would have been to record something considered humiliating, since married couples did not eat in each other's presence.[20]

The importance of the active witness of kin is often considered an intrinsic part of the efficaciousness of ritual, and it is during these periods of concentrated and focused, almost structured, participation and witness by the wider group that Evans-Pritchard seems to become most photographically engaged, rather than a detached observer. The idea of the photographer as a social actor in events, forming part of the collective witness of the group, is also evident in other published ethnographic series of ritual. In Turner's photographs of the Ndembu ritual of *isoma* for instance, the couple being treated stand in a ritual hole whilst the ethnographer takes his place alongside the officiants and other

[20] In the published account the indigenous voice comes through only fleetingly, although in the case of eating in front of his wife we are informed that 'the husband told me afterwards that this was the most humiliating part of the rite' (Evans-Pritchard, 1956: 218).

kin members gathered to witness and sing the *kupunjila* or 'swaying' song (Turner 1969: Figures 1-7). From this perspective, the agency of the collective group in shaping the activity of the participant-photographer and the resulting archival record is crucial. The ethnographer's engagement with events can thus be seen as being guided by the engagement of the witnessing group, and his photographic engagement forms part of the way in which the collective witness of the group is dynamically involved with events as they unfold.

Conclusion: double alienation

Recent anthropological writing on the history of photography has sought to stress the multiple surfaces and histories of the technology, and its inherent uncontainability as a medium (e.g. Pinney & Peterson 2003; Lidchi & Tsinhnahjinnie 2009). Rather than seeing photography as a fundamentally Western technology appropriated by others, both anthropologists and indigenous artists and critics have sought to highlight the way in which photography has been remade and rethought in contemporary culture; how archival images and their troubling colonial contexts are engaged with (the desire to 'look past' in Aird's words) in order to reappropriate the likenesses of ancestors (Pinney 2003: 4–8; Aird 2003; Brown & Peers 2006; Smith & Vokes 2008) and achieve 'visual sovereignty' (Tsinhnahjinnie 2003: 41; 2009: 10-13). In Australia, indigenous people are increasingly demonstrating the potential for the likenesses of ancestors to be alienated or reclaimed from colonial-era photographs and their often stereotypical interpretations, by mobilizing the indexical nature of the image and thereby its emotive potential as a direct connection to deceased individuals. For Donna Oxenham, a Yamajti woman from Western Australia, even images as troubling as those depicting 'neck-chaining, slavery and murder' are nonetheless 'an avenue for Aboriginal people today to find images of their loved ones and ancestors and to be able to place them into physical contexts' (Oxenham, quoted in Lydon, 2010: 247). Nothing could illustrate more forcibly the inherent mutability of photographic meaning within any given historical moment.

My intention in this chapter has been to extend the anthropological recognition of multiple and overlapping histories, and argue for a greater acknowledgment of the field photograph as a cultural co-production, doubly alienated from the cultural contexts of both fieldworker and indigenous community. If 'photographs are necessarily contrived and reflect the culture that produces them' (Pinney 2003: 7), the field photograph is a particularly odd cultural hybrid in this regard. Arguably, the inherent cultural ambiguity of the field photograph, being a product of the cultures of both the fieldworker and the culture being studied, lies at the heart of anthropological fieldwork. As Evans-Pritchard noted, 'one enters into another culture and withdraws from it at the same time ... one becomes, at least temporarily, a sort of double marginal man, alienated from both worlds' (1973a: 4). Those working in the areas of museology and intellectual property rights, for instance, increasingly recognize the cultural ambiguity of the field photograph. Collaboration and consultation with indigenous communities regarding the right to use and exploit historic photographs is a process that implicitly acknowledges the co-productive nature of the archive: photographs are both 'made' by a photographer, and 'taken' from their subject. This dynamic has historically opened up performative spaces

where ideas of culture and identity have been enacted. As Lydon has argued in relation to nineteenth-century photographs taken at Coranderrk Aboriginal Station in Victoria, Australia, although 'some historians have seen Aboriginal people as passive, subjects easily changed within these "didactic landscapes" … the photographic archive reveals substantial evidence for a more contested, complex interaction' (2005: 10).

I have argued in this chapter that the double alienation that lies at the heart of field photography is not a static process, but one that is dynamically formed in the fieldwork situation, and influenced by political and cultural factors. I have argued that the historical, political and cultural factors affecting Zande and Nuer attitudes towards Evans-Pritchard and his camera could not have been more contrasting (1973a: 2-3). This, I have argued, is inscribed within the archive on a number of different levels, such as forms of self-presentation, distance and proximity, and across periods of fieldwork, as with the increasing diversity and familiarity evident within Evans-Pritchard's second phase of Nuer photography. Further, I have argued that the examination of indigenous agency in the shaping of the field archive should also be methodologically grounded in the archive itself, rather than at the level of analysis. Building upon an approach recently elaborated elsewhere (Morton 2009a; 2009b), I have argued that archival images need to be understood as relational objects in terms of their spatial and temporal connections to other images, and discussed how this approach allows a greater understanding of the shaping of the visual record in the field, and the influence of indigenous agency in its creation, extent, and character. Beyond this, I have also argued that Evans-Pritchard's photographic engagement with certain events needs to be reconnected to processes of collective witness in which the fieldworker is included, rather than as a 'participant-observer' which situates the photograph outside of indigenous contexts of production. As Evans-Pritchard notes, his own fieldwork, and hence his photographic record, was to a great extent guided and mediated by certain key indigenous informants, 'through whose eyes I saw the social world around us' (1951: 106).

Acknowledgements

I would like to thank Marcus Banks, Jeremy Coote, Elizabeth Edwards, Wendy James, Douglas Johnson and Richard Vokes for their helpful comments. The research on which this chapter is based was carried out as part of an AHRC-funded project 'Recovering the Material and Visual Cultures of the Southern Sudan: A Museological Resource' (led by Jeremy Coote and Elizabeth Edwards) 2003-2005, and as part of a subsequent HEFCE-funded Career Development Fellowship at the Pitt Rivers Museum, University of Oxford, 2005-2010.

Bibliography

Aird, M. 2003. Growing up with Aborigines, in *Photography's Other* Histories (eds) C. Pinney & N. Peterson, Durham, NC & London: Duke University Press.

Barthes, R. 1985. *The Responsibility of Forms*, New York: Hill and Wang.

Bell, J. 2003. Looking to see: reflections on visual repatriation in the Purari Delta, Gulf Province, Papua New Guinea, in *Museums and Source Communities: A Routledge Reader*, (eds) L. Peers & A. K. Brown, London: Routledge.

Berger, J. 1972. *Ways of Seeing*, London: BBC/Penguin Books.

Brown, A. K. & L. Peers with members of the Kainai Nation. 2006. *'Pictures Bring Us Messages'/ Sinaakssiiksi Aohtsimaahpihkookiyaawa: photographs and histories from the Kainai Nation*, Toronto: University of Toronto Press.

Douglas, B. 1998. Inventing natives/negotiating local identities: postcolonial readings of colonial

texts on island Melanesia, in *Pacific Answers to Western Hegemony: Cultural Practices of Identity Construction*, (ed.) J. Wassmann, Oxford: Berg.

Edwards, E. 2001. *Raw Histories: Photographs, Anthropology and Museums*, Oxford: Berg.

—— 2005. 'Photographs and the sound of history', Visual Anthropology Review 21 (1-2): 27-46.

Edwards, E. & J. Hart (eds) 2004. *Photographs Objects Histories: On the Materiality of Images*, London & New York: Routledge.

Edwards, E. & J. Hart 2004. Mixed box: the cultural biography of a box of 'ethnographic' photographs, in *Photographs Objects Histories: On the Materiality of Images*, (eds) E. Edwards & J. Hart, London & New York: Routledge.

Edwards, E. & C. Morton 2009. Introduction, in *Photography, Anthropology and History: Expanding the Frame*, (eds) C. Morton & E. Edwards, Farnham: Ashgate Publishing.

Evans-Pritchard, E. 1927. 'A preliminary account of the Ingassana tribe in Fung Province'. *Sudan Notes and Records* 10.

—— 1932a. 'Ethnological observations in Dar Fung', *Sudan Notes and Records* 15 (1): 1-61.

—— 1932b. 'The Zande corporation of witchdoctors (part one)', *Journal of the Royal Anthropological Institute* 62 (2): 291-336.

—— 1937a. *Witchcraft, Oracles and Magic Among the Azande*, Oxford: Clarendon Press.

—— 1937b. 'The economic life of the Nuer: cattle (part 1)', *Sudan Notes and Records* 20 (3): 210-45.

—— 1940. *The Nuer: A Description of the Modes of Livelihood and Political Institutions of a Nilotic People*, Oxford: Clarendon Press.

—— 1951. *Kinship and Marriage Among the Nuer*, Oxford: Clarendon Press.

—— 1956. *Nuer Religion*, Oxford: Oxford University Press.

—— 1973a. 'Some reminiscences and reflections on fieldwork', *Journal of the Anthropological Society of Oxford* 4 (1): 1-12.

—— 1973b. 'Some recollections on fieldwork in the twenties', *Anthropological Quarterly* 46 235-42.

Flusser, V. 2000 [1983]. *Towards a Philosophy of Photography*, London: Reaktion.

Gell, A. 1998. *Art and Agency: an Anthropological Theory*, Oxford: Oxford University Press.

Gore, C. D. 2010. 'Commemoration, memory and ownership: Some social contexts of contemporary photography in Benin City, Nigeria', *Visual Anthropology* 14 (3): 321-42.

Herle, A. 2009. John Layard Long Malakula 1914–1915: the potency of field photography, in *Photography, Anthropology and History: Expanding the Frame* (eds) C. Morton & E. Edwards, Farnham: Ashgate Publishing.

Johnson, D. H. 1982. 'Evans-Pritchard, the Nuer, and the Sudan Political Service', *African Affairs* 81 (323): 231–46.

—— 1993. *Governing the Nuer: Documents by Percy Coriat on Nuer History and Ethnography 1922–1931*, Oxford: JASO.

Larken, P. M. 1926. 'An account of the Zande', *Sudan Notes and Records* 9 (1): 1-55.

Lidchi, H. & H. J. Tsinhnahjinnie (eds) 2009. *Visual Currencies: Reflections on Native Photography*, Edinburgh: National Museums of Scotland.

Lydon, J. 2005. *Eye Contact. Photographing Indigenous Australians*, Durham, NC & London: Duke University Press.

—— 2010. ' "Behold the tears": photography as colonial witness', *History of Photography* 34 (3): 234–50.

Morton, C. 2005. 'The anthropologist as photographer: reading the monograph and reading the archive', *Visual Anthropology* 18 (4): 389-405.

—— 2009a. 'Fieldwork and the participant-photographer: E. E. Evans-Pritchard and the Nuer rite of *gorot*', *Visual Anthropology* 22 (4): 252-74.

—— 2009b. The initiation of Kamanga: visuality and textuality in Evans-Pritchard's Zande ethnography, in *Photography, Anthropology and History: Expanding the Frame*, (eds) C. Morton & E. Edwards, Farnham: Ashgate Publishing.

Morton, C. & G. Oteyo. 2009. 'Paro manene: exhibiting photographic histories in western Kenya', *Journal of Museum Ethnography* 21 (Dec): 155-64.

Pinney, C. 1992. The parallel histories of anthropology and photography, in *Anthropology and Photography 1860–1920*, (ed.), E. Edwards, Newhaven & London: Yale University Press.

—— 1997. *Camera Indica: the social life of Indian photographs*, London: Reaktion.

—— 2003. Introduction: 'how the other half...', in *Photography's Other Histories* (eds) C. Pinney & N. Peterson, Durham, NC & London: Duke University Press.

Pinney, C. & N. Peterson (eds) 2003. *Photography's Other Histories*, Durham, NC & London: Duke University Press.

Schweinfurth, G. 1874. *The Heart of Africa: Three Years' Travels and Adventures in the Unexplored Regions of Central Africa from 1868 to 1871 (Vol. II)*, London: Sampson Low, Marston, Searle & Rivington.

Sekula, A. 1986. 'The body and the archive', *October*, 39 (Winter): 3-64.

Seligman, C. & B. Z. Seligman. 1932. *Pagan Tribes of the Nilotic Sudan*, London: Routledge.

Smith, B. & R. Vokes (eds) 2008. Haunting Images: The Affective Power of Photography, in A Special Edition of *Visual Anthropology* 21 (4).

Sontag, S. 1979 [1977]. *On Photography*, London: Penguin Books.

Tagg, J. 1988. *The Burden of Representation: Essays on Photographies and Histories*, Basingstoke, UK: Palgrave Macmillan.

Tsinhnahjinnie, H. 2003. When is a photograph worth a thousand words? in *Photography's Other Histories*, (eds) C. Pinney & N. Peterson, Durham NC & London: Duke University Press.

—— 2009. Dragonfly's home, in *Visual Currencies: Reflections on Native Photography*, (eds) H. Lidchi & H. J. Tsinhnahjinnie, Edinburgh: National Museums of Scotland.

Turner, V. 1969. *The Ritual Process: Structure and Anti-Structure*, London: Routledge & Kegan Paul.

Vokes, R. 2010. 'Reflections on a Complex (and Cosmopolitan) Archive: Postcards and Photography in Early Colonial Uganda, c.1904-1928', *History and Anthropology* 21 (4): 375–409.

Wolbert, B. 2000. 'The anthropologist as photographer: the visual construction of ethnographic authority', *Visual Anthropology* 13 (4): 321-43.

Young, M. 1998. *Malinowski's Kiriwina: Fieldwork Photography 1915–18*, Chicago: Chicago University Press.

3

Photographing 'the Bridge'
Product & process in the analysis of a social situation in non-modern Zululand
Chris Wingfield

Max Gluckman's 'Analysis of a Social Situation in Modern Zululand' is well known as one of the classic papers of mid-twentieth century African anthropology. 'The Bridge' must be one of the few articles in the history of anthropology to become widely known by a nickname, which derives from its first section describing in detail the events surrounding the opening of a bridge at Malungwana drift on 7 January 1938. Originally published in two parts in the journal *Bantu Studies* in 1940, it was republished by the Rhodes-Livingstone Institute in 1958 alongside a related article from 1942 'Some Processes of Social Change Illustrated with Zululand Data'. 'The Bridge' has been described as 'the foundation text of what became known as the Manchester School of Social Anthropology' (Macmillan 1995: 39) and the first fully developed example of 'the extended case method' (Frankenberg 1982: 4). It has also been referred to as 'one of the most significant anthropological critiques of segregationist policy in South Africa in the first half of the twentieth century' (Cocks 2001: 739).

A shortened version of the article, under the title 'The Bridge: Analysis of a Social Situation in Modern Zululand' has more recently been published in Joan Vincent's (2002) reader, *The Anthropology of Politics*. Although this reproduces Gluckman's sketch map of the event, it does not include the four black and white photographs that were reproduced as plates alongside the article in both previous versions. It is the absence of these photographs in 2002, rather than their presence in 1940 and 1958, which has prompted this paper. What difference do the photographs make to 'the Bridge'? One way of addressing this question is to deal with each of the published versions of the paper as finished products, and consider the degree to which the images either reinforce, or undermine Gluckman's construction of 'ethnographic authority' (*cf.* Wolbert 2000). Another way of approaching the question is to consider the involvement of photographs in the processes that led to the construction of 'the Bridge' as a publication (cf. Morton 2005). This tension between analyzing the products of human action and the processes involved in their creation is a significant one for the anthropology of photography, but also for anthropology as a whole. While the history of the discipline includes other discussions of the dynamic relationship between product and process (Blacking 1969), it is in relation to recent work in Science and Technology Studies, and particularly that associated with Bruno Latour and actor-network theory that I propose to consider the photographs Gluckman took at 'the Bridge'.

In contending that photographs, as products, make a significant difference to Gluckman's published article, I also intend to suggest that photography, as a process, was important to his fieldwork practice. While participant observation, as the key technique of mid-twentieth century Social Anthropology, has been characterized in opposition to the collecting activities associated with Victorian anthropologists of an earlier generation (Stocking 1983), I hope to suggest that the collecting of photographs, as a form or auto-archiving, was a significant

part of Gluckman's fieldwork practice. While Gluckman may have been participating in, as well as observing the opening of the bridge, he was also recording it with his camera. Morton (2009a) has coined the term 'participant-photographer' to describe Evans-Pritchard's photographic fieldwork practice, and it is an equally apt description of Gluckman's engagements at the bridge. However, unlike the ceremonial events in relation to which Morton (2009a; 2009b) has explored Evans-Pritchard's photographic practice, Gluckman was participating at 'the Bridge' alongside a number of other photographers. Like them he was self-consciously creating a visual record of particular moments in the event that could, as photographs, be transported to other times and places and re-viewed. While Gluckman's textual description of the event begins to explore the role that photography as a process played in the ceremony at 'the Bridge', he is not explicit about the degree to which when he came to analyze events at 'the Bridge' and write about them as a 'social situation', he turned to his photographic record as one of the products of his engagements in the field.

Histories of anthropology and photography in Africa

One version of the history of anthropology and photography has suggested that while photographs functioned as important sources of evidence for nineteenth century armchair anthropologists, they were subsequently displaced through an emphasis on the production of ethnographic texts by anthropologists who themselves engaged in overseas fieldwork. Grimshaw (2001: 54) noted that 'it has always seemed puzzling to contemporary anthropologists why the active use of visual media disappeared so quickly from the twentieth-century project' and suggested that 'the particular way of seeing animating the Malinowskian project ... renders the camera, and other scientific instrumentation obsolete.' Pinney (1992: 81) has suggested that 'in the postwar period ... anthropology has so profoundly and subliminally absorbed the idiom of photography within the production of its texts that it has become invisible, like a drop of oil expanding over the surface of clear water.' Given that Grimshaw (2001:54) herself recognized that Malinowski took many photographs in the field (cf. Young, 1998), this apparent invisibility of photography for more recent commentators may indicate something about the ways in which later anthropologists were taught to appreciate the discipline's classic texts, rather than anything about the degree to which photography was actively used during the processes involved in their construction.

Barbara Wolbert (2000) in her discussion of the photographs published by Evans-Pritchard in *The Nuer* (1940), has noted the ways in which discussions of 'The Anthropologist as Author' during the 1980s failed to give due consideration to the 'Anthropologist as Photographer'. This suggests that the seeming invisibility of photographs to late-twentieth century anthropological commentators may have resulted from a disciplinary blind-spot. It is arguably this same blind-spot which allowed 'the Bridge' to be re-printed in 2002 without its accompanying photographs, which I suggest originally formed a core part of the evidence presented by Gluckman, as well as suggestive evidence of his 'active use' of visual media during analysis. Morton (2005: 394) has suggested that the frequent cross-references by Evans-Pritchard to plates in the text of *The Nuer* suggest 'that the photographs he had selected were laid out for reference during the writing process'. Although less explicit attention is drawn to the

photographs in the text of 'the Bridge', evidence nevertheless suggests that Gluckman also referred to his photographs during the writing process. A close reading of the captions printed alongside each of the published photographs reveals him guiding the reader through an analysis of the significant details recorded by each photograph. Indeed, these captions appear to replicate the interrogative process Gluckman subjected these photographs to himself as part of his own analysis of the event. This technique of analysing photographs for their significant details appears to have allowed Gluckman to use what Edwards and Morton (2009: 4) have called the 'random inclusiveness' of photographs to see things that may not have been apparent to him during his original participation in the event.

While Gluckman's use of photographs can be fruitfully compared to that of Evans-Pritchard, as two anthropologists working at approximately the same time in different parts of Africa, the connections between the two are suggestive of a wider network of those working in African anthropology at the time. In a footnote to the 1940 version of 'the Bridge', Gluckman (1940a: 2, note 1) acknowledges a considerable debt to Evans-Prichard, as well as to Meyer Fortes. He approvingly cites Evans-Pritchard's (1937) *Witchcraft, Oracles and Magic*, as well as Fortes (1937) 'Communal Fishing and Fishing Magic in the Northern Territories of the Gold Coast'. He also cites their as yet unpublished *African Political Systems* (Fortes and Evans-Pritchard, 1940) in which he had a paper, as well as Evans-Pritchard's *The Nuer* (1940), which he seems to have read in manuscript. Mentioned in the same footnote was another of Gluckman's mentors, Isaac Schapera, who had taught him as an undergraduate at the University of Witwatersrand (Kuper 2007: 25). According to the visual evidence of Schapera's recently published photographs, he had also visited Gluckman in Zululand in 1937 (Comaroff *et al.* 2007: Plate 9.10). Jean and John Comaroff (2007) have suggested that Schapera understood fieldwork photography to have an important empirical function. However, in contrast to Grimshaw's (2001) stark characterization of Structural Functionalism in terms of 'The Light of Reason', they have termed Schapera's approach to photography 'The Modest Art of Showing it like it is' (Comaroff & Comaroff 2007: 6). It is perhaps significant that 'the Bridge' sees Gluckman mobilizing photographs, as 'objects of evidence' (Engelke 2008) in explicit defence of Schapera and Fortes from an attack by Malinowski (Gluckman 1940a: 10). Whatever might have become the case in relation to the anthropological use of photographs later in the twentieth century, it seems that on the eve of the Second World War, the 'Malinowskian project', with its implications for anthropological 'ways of seeing' and the active use of visual media, was far from being universally accepted by anthropologists working in Africa.

'The Bridge' has largely been remembered in anthropology for its demonstration that Zululand society involved the local whites as much as it did the Zulu. This position was taken by Gluckman largely in response to a volume on *Methods of Study of Culture Contact in Africa*, published by the International Institute of African Languages and Cultures in 1938 (Gluckman 1971: 377). While he acknowledged (Gluckman 1940b: 173, note 2) that this volume had provided a stimulus to his work in the field, he was not explicit about whether he had received it before or after his day at 'the Bridge' on 7 January 1938. In his introduction to the volume, Malinowski (1938: xiii) had disapprovingly quoted Schapera's argument that 'the missionary, administrator, trader and

labour recruiter must be regarded as factors in the tribal life in the same way as are the chief and the magician' as well as Fortes' suggestion that they 'can be treated as integrally part of the community'. In his concern to emphasize the disruptive effects of change and 'maladjustment', Malinowski (1938: xv) asserted that 'The concept of Africans and Europeans, missionaries and witchdoctors, recruiters and indented labourers, leading a contented tribal existence suffers from a taint of smugness and sense of unreality.' Gluckman (1940b: 174) seems to have been keen to use 'the Bridge' to demonstrate that treating Africans and 'Europeans' as a single community in equilibrium did not necessarily imply 'a contented tribal existence'.

Interestingly, Malinowski (1938: i) began his essay by adopting 'a bird's-eye view of Africa to-day', seemingly describing what he had seen as a 'passenger flying over the inland route of the Imperial Airways' as far as Nairobi. By contrast, Gluckman, Schapera and Fortes all had extensive experience of fieldwork in Africa, as well as having grown up in South Africa themselves. While the integration of whites and blacks into a single society may have been more apparent to them than to those visiting from Europe, they were certainly more aware of the political implications of arguing otherwise (Gluckman 1975). That Gluckman was himself South African and writing for a journal published in South Africa are important factors in understanding the position he takes in 'the Bridge' (Macmillan 1995: 51). In addition, he could hardly understand himself as remote from the event as it unfolded since he had been at school with L. W. Rossiter, the Government Veterinary Officer (GVO), but also with J. Lentzner, the engineer in the Native Affairs Department who had directed the building of the bridge, the first in Zululand built under new schemes of 'Native Development' (Gluckman 1940a: 4). For Gluckman, Zululand formed an extension of the world he had grown up in, and as a result it would have been almost impossible for his fieldwork photographs to achieve 'the effacement of any marks of the presence of the photographer's culture' (Pinney 1992: 76).

Photographs: 'the Bridge' and symmetrical anthropology

According to Gluckman (1940a: 10), 'That Zulu and Europeans could co-operate in the celebration at the bridge shows that they form together a community with specific modes of behaviour to one another.' While this impression is certainly reinforced by the photographs published alongside the article (Figures 3.1-3.4), a consideration of these in relation to others in Gluckman's archive suggests that they were probably not originally taken with the intention of supporting this argument. While they provide evidential support for Gluckman's account by visually demonstrating aspects of his description, such as the adoption of European forms of dress and the involvement of motor-vehicles in the ceremony, 'Europeans' themselves are not prominently represented in the photographic record. The most prominent is the Chief Native Commissioner (CNC) who appears in Figure 3.2. This photograph shows a number of men listening to the CNC speaking. Gluckman suggests in his text that the CNC made speeches in English and Zulu to each of the two groups, and the direction of his gaze in the photograph suggests that he may be speaking to the Zulu. Although the main caption for this image is 'The CNC speaking', he only appears, partially

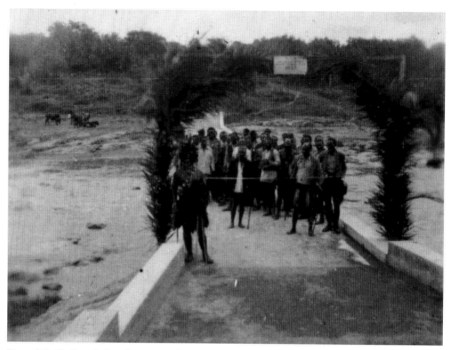

Figure 3.1 Gluckman's first plate. Original caption: 'Zulu cross the bridge to welcome the C.N.C. and Regent. Note man in war-dress on guard; men's clothes; notice in English.'

Reproduced by kind permission of the RAI Photo Library - Gluckman Collection. Classmark: RAI 32705.

Figure 3.2 Gluckman's second plate. Original caption: 'The C.N.C. speaking.
(From left to right) Mahlabatini magistrate, C.N.C., Matolana, interpreter Mkize, Mshiyeni, Government Zulu policeman. This photograph was taken from the European group. Note man in war-dress between Mshiyeni and policeman. Behind him, in white coat, is Mshiyeni's chauffeur.'

Reproduced by kind permission of the RAI Photo Library - Gluckman Collection. Classmark: RAI 32701.

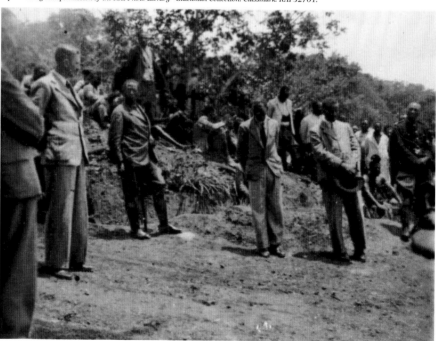

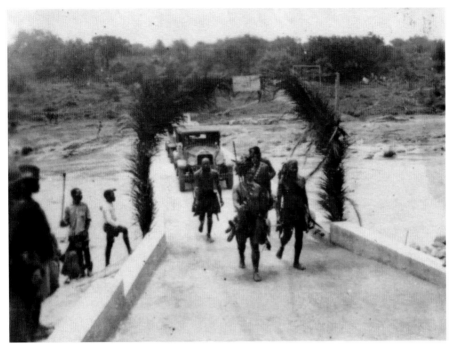

Figure 3.3 Gluckman's third plate. Original caption: 'Warriors, singing the ihubo, *lead the cars back over the bridge. Note man chanting with his stick lifted; in left foreground, next to policeman, is an* induna *in the military garb much favoured by Zulu.'*

Reproduced by kind permission of the RAI Photo Library - Gluckman Collection. Classmark: RAI 32706.

Figure 3.4 Gluckman's fourth plate. Original caption: 'On the northern bank, after the opening of the bridge looking east from the road. On left, round goalposts, the missionary (in front of nearer post) leads the hymns singing. At nearer end of this group are a number of pagans. On right, cattle are being cut up. Behind the Zulu in the white jacket is the G.V.O. who is talking to him and the Zulu in war-dress. In middle distance, behind the two cattle, is the clump of trees where the Regent's party is.'

Reproduced by kind permission of the RAI Photo Library - Gluckman Collection. Classmark: RAI 32707.

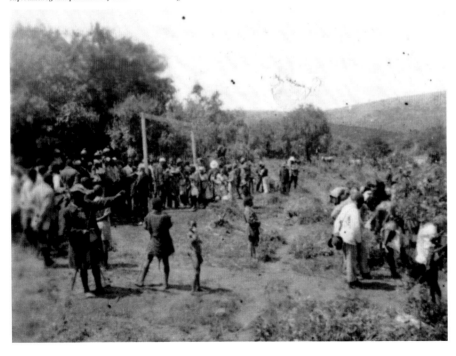

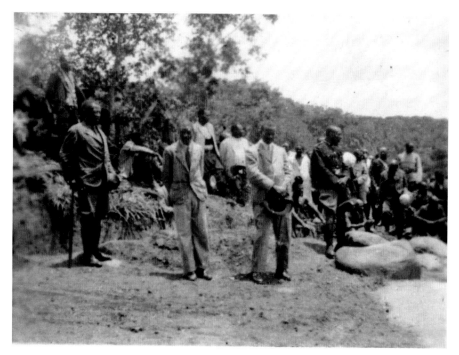

Figure 3.5 Gluckman's archival photograph no. 515 which shows a number of Zulu also pictured in Figure 3.2, but does not show the presence of the CNC. However, if the number sequence of the photographs is correct, then this may be because the CNC was driving his car across the bridge at the time the photograph was taken. This may be what some of the Zulu, such as the Regent, are looking at, although the man Gluckman refers to as Mshiyeni's chauffeur does appear to be in this photograph.

Reproduced by kind permission of the RAI Photo Library - Gluckman Collection. Classmark: RAI 32702.

Figure 3.6 Gluckman's archival photograph no. 514 which shows a view from behind of a number of Zulu also pictured in Figure 3.2, and suggests their position was on the road at the south end of the bridge. If the numerical sequence of Gluckman's photograph numbers is correct, they may be watching the cars cross the bridge, although Mshiyeni's chauffeur also appears to be in this photograph. Reproduced by kind permission of the RAI Photo Library - Gluckman Collection. Classmark: RAI 32703.

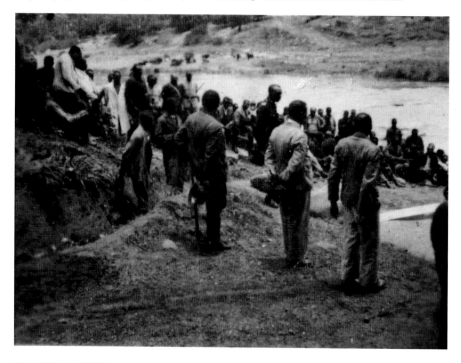

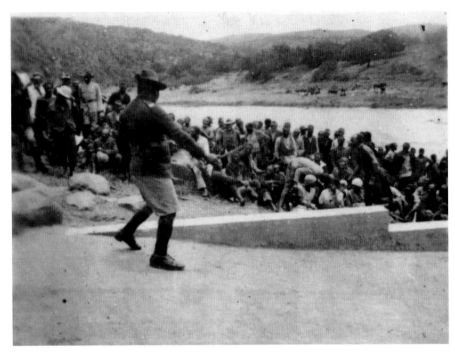

Figure 3.7 Gluckman's archival photograph no. 512 showing a Zulu in police dress walking onto the bridge. Like all the unpublished photographs, this was taken from the east side of the bridge, where Gluckman recorded that the 'Europeans' gathered during the ceremony.

Reproduced by kind permission of the RAI Photo Library - Gluckman Collection. Classmark: RAI 32704.

Figure 3.8 Gluckman's archival photograph no. 509 which appears to show a group of people, possibly including Swedish missionaries, gathered to the west of the road by the bridge before the ceremony.

Reproduced by kind permission of the RAI Photo Library - Gluckman Collection. Classmark: RAI 32700.

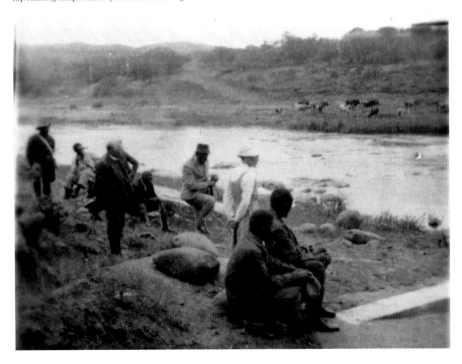

obstructed, near the left edge of the photograph. The rest of the photograph depicts prominent Zulu participants in the ceremony, who are referred to in the caption, as well as a number of other Zulu behind. Significantly, this image contrasts with Figures 3.5–3.7 that appear to have been taken from a similar position. Although taken from slightly different angles, these all only show Zulu participants in the event.

In his caption to Figure 3.2, Gluckman notes that 'This photograph was taken from the European group', and the visual evidence suggests that all four of these photographs (Figures 3.2 and 3.5-3.7) were taken from the east side of the road, looking west. Gluckman's sketch map suggests that this was the main location of the twenty-four 'Europeans' during the ceremony. In terms of what Morton (2009a: 261), following Hall (1968), has referred to as 'proxemics', Gluckman's photographs represent a 'European' view of the ceremony, which involves looking across to the west side of the road where most of the Zulu had gathered. These photographs show that the speakers stood on the road dividing the two groups at the approach to the bridge. Interestingly, another of Gluckman's unpublished images (Figure 3.8) appears to show a more mixed group of Zulu and 'Europeans' in the area to the west of the road, where the Zulu were located during the ceremony. The attitudes adopted by those present, some of whom may be missionaries, as well as the fact that this appears to be the first photograph in Gluckman's sequence from the event (in terms his ordering of the photographs in his album as well as the numbers applied to them, see Figure 3.10), suggests that this image shows people waiting for others to arrive and the ceremony to begin. While a mixed crowd may have waited together, Gluckman's photographs suggest that by the time the ceremony formally began, the road became the dividing point for Zulu and 'Europeans', including himself. Gluckman's photographic perspective on the event reinforces the sense of him as a 'participant-photographer' (Morton 2009a) whose own physical position was largely dictated by his own racial and social identity.

Taken together, Gluckman's published and unpublished photographs suggest that when they were taken, he may not have been expecting to present an overview of the ceremony that would demonstrate the involvement of 'Europeans' as well as Zulu. Had he done so, presumably he would have attempted to position himself somewhere he could photograph the spatial division of the two groups, something he ends up representing in 'the Bridge' though a sketch map. Had he been as much an observer and photographer of the 'European' parts of the ceremony, as a participant, Gluckman might have photographed the shelter on the East side of the road where the 'Europeans' initially gathered and later had tea and cake (Gluckman 1940a: 5,7). This shift in rhetorical intention on Gluckman's part, between the time the photographs were taken and their publication, suggests that the presence of the CNC on the edge of Figure 3.2 may be an example of the 'random inclusiveness' of photography (Edwards & Morton, 2009: 4), the significance of which was only later realized.

In his introduction to the paper, Gluckman (1940a: 2) states that he deliberately chose 'these particular events from my note-books because they illustrate admirably the points I am at present trying to make'. This reinforces the suggestion that the way in which Gluckman analysed the event may only have occurred to him subsequently. One field diary that survives at the Royal Anthropological Institute for the day in question states only 'Opening

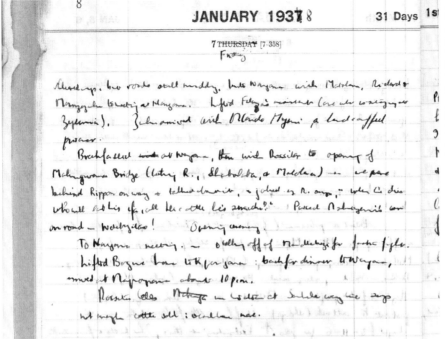

Figure 3.9
Gluckman's research
diary for the day at
the bridge. Although
written in 1938,
this is a 1937 diary
with 7 crossed out
and changed to 8.

Reproduced by kind
permission of the RAI
Archive - Gluckman
Collection. Classmark:
Brown Box - Zulu
Notebooks.

Figure 3.10 Page from Gluckman's album of contact prints including those from the opening of the bridge. Although numbered, the photographs have been placed in a different sequence, which appears to correspond with the order of the ceremony as Gluckman describes it. If, however, the number sequence is correct, then this suggests that Gluckman's Figure 3.4, photograph no. 510, was taken before rather than after the main ceremony, and does not actually show what he claims it does.

Reproduced by kind permission of the RAI Photo Library - Gluckman Collection. Classmark: RAI 32694 – RAI 32709.

Ceremony' for this part of the day (see Figure 3.9), although there is reported to be a slightly more detailed, but still brief, description surviving elsewhere (Macmillan, 1995: 40, note 2). Presumably other notes existed that have either not survived or been located in Gluckman's archive. Nevertheless, the photographic evidence suggests that Gluckman was probably not originally intending to document the European involvement in the ceremony on 7 January 1938, and had to analyse his records of the day retrospectively in order to write 'the Bridge'. Receiving a copy of *Methods of Study of Culture Contact in Africa* later in the year most likely prompted this.

If Gluckman's analysis in 'the Bridge' is largely the result of a subsequent analysis of his field materials, then presumably his photographic record was of particular importance. In contrast to more deliberately focused field notes, the 'visual excess' (Edwards & Morton, 2009: 4) of his photographs may have allowed Gluckman to interrogate them more easily in terms of new questions. As well as providing evidence of a number of significant details that Gluckman uses in his account, the photographs may also have functioned as visual *aides mémoires*, allowing him to remember more about the ceremony as it had unfolded. This would have been particularly the case once the photographs were placed in sequence, as they appear to have been in his album of contact prints (however, see Figure 3.10 for the suggestion that the numbers on the photographs suggest a different sequence). While only two of the four published photographs (Figures 3.2 and 3.4) demonstrate the presence of white participants at the opening of the bridge, Gluckman's subsequently written textual description was clear that the CNC, the GVO, the labour recruiter for Rand Gold Mines and the Swedish Missionaries all had significant parts to play in the ceremony. In addition, Gluckman's analysis of Zulu participation included accounts of the roles played by the Zulu Regent and local headmen, but also by independent church leaders and returned migrant workers. By exploring a ritual enacted at the opening of a new bridge, rather than a first-fruits or initiation ceremony, Gluckman was able to use the event and the photographs he had taken of it to make visible, in a Durkheimian manner, the structuring relationships that involved the full range of otherwise dispersed participants in society in 'modern Zululand'.

Gluckman's use of the adjective 'modern' in the title was presumably a deliberate rhetorical decision to emphasize the range of contemporary influences on the ceremony, rather than focusing on more 'traditional' forms of Zulu authority. In suggesting that *We Have Never Been Modern*, Bruno Latour (1993) has argued against any radical distinction between contemporary western society —— the 'moderns', and non-western peoples such as the Zulu. By suggesting that Zululand was itself modern, Gluckman performed a parallel, if reverse, rhetorical move. While Latour was concerned to justify the extension of anthropological methods of study to the contemporary west, and particularly to the study of science and technology, Gluckman was anxious to emphasize the integration of somewhere as seemingly marginal as Zululand into the operation of global capitalism. From the travels of labour migrants to the mines of southern Africa, to the responsibility of the GVO for local cattle, there are a range of ways in which he demonstrates that Zululand forms part of the international networks of science and technology that have been the focus for much of Latour's own work. While Latour has argued for a symmetrical anthropology that studies the centre as well as the margins,

Gluckman's paper on the 'the Bridge' illustrates another kind of symmetrical anthropology, even if he ultimately understood the equilibrium between whites and blacks in Zululand itself to be asymmetrical (Frankenberg, 1982: 5). It is possible to understand Gluckman in writing about 'Modern Zululand' to simply be claiming that Zululand in 1938 was at least as modern as anywhere else, and thereby anticipating Latour's 1991 argument that the West was at least as non-modern as anywhere else. In Latourian terms, by drawing attention to the nature of society in Zululand as a 'proliferating hybrid' necessarily involving whites and blacks, Gluckman was able to draw attention to South African policies of segregation as a vain project of 'purification'.

Nevertheless, Gluckman's photographic record of the ceremony at 'the Bridge' suggests that as a participant-photographer at the event, he may not have fully appreciated the degree to which the ceremony functioned as a hybrid ritual form, that nevertheless served to purify 'Europeans' and Zulu into spatially separated groups. Rather, it seems that he arrived at this perspective later, possibly as a result of analysing his field materials in the light of subsequent reading. In the absence of Gluckman's full range of field notes it is hard to be certain, but it may have been his photographs and their 'random inclusions', such as the presence of the CNC in Figure 3.2, that allowed him to re-analyse the event subsequently in symmetrical terms and appreciate the full extent of 'European' involvement.

The double symmetry of 'the bridge'

As well as advocating treating contemporary western society in the same manner as human life in other places and times, Latour (1993: 96-7) has suggested that in becoming symmetrical, anthropology should take seriously the active part played in human lives by non-humans. Gluckman's paper, which describes the involvement of a number of non-humans such as cars and items of clothing in the ceremony, also goes some way towards this form of Latourian symmetry. However, just as the presence of the CNC in Figure 3.2 may have been an unintended consequence of the 'random inclusiveness' of photography, the presence of non-humans at the opening of 'the Bridge' may have been something that became more apparent to Gluckman when interrogating his photographs subsequently. Each of the captions for Figures 3.1-3.3 ends with a series of details shown by the photograph, to which Gluckman draws the reader's attention. The caption to Figure 3.4 reads like an extended note and functions in the same way to explore the photograph for significant details, such as the spatial distribution of different groups of Zulu. By 'showing it like it is', Gluckman's photographs recorded seemingly incidental details, such as the clothing worn by a range of human participants, and provided a source that could be subsequently interrogated.

Some of the non-human participants in the event, however, do not require the same degree of exegesis by caption to become visible. Appearing at the centre of two of Gluckman's published photographs, Figures 3.1 and 3.3, is the most significant non-human actor of all —— the bridge. Despite the cross-cutting interests of a variety of Zulu and 'European' actors, according to Gluckman: 'one may say that the groups and individuals present behave as they do because the bridge, which is at the centre of their interests, associates them in a common celebration' (1940a: 28).

The bridge was:

> planned by European engineers and built by Zulu labourers... would be used by a European magistrate ruling over Zulu and by Zulu women going to a European hospital... was opened by European officials and the Zulu Regent in a ceremony which included not only Europeans and Zulu but also actions historically derived from European and Zulu cultures (ibid., 1940a: 11).

Significantly Gluckman also notes that the bridge was paid for with Zulu taxes. If Bruno Latour were looking for an apt example of the agency of a non-human actor, and in particular one with the capacity to assemble other human and non-human entities around it, it would be hard to better that of the bridge, provided by Gluckman in 1940. It would also be hard to find a better example than its opening ceremony of a hybrid form that emerged in spite of a range of official policies aimed at the purification of Africans and Europeans.

The first part of Gluckman's article effectively describes a rite of passage that broadly follows the phases of ritual outlined by Van Gennep (1909). However, instead of marking human life events such as birth, initiation, or death, the ritual marks the formal coming into being of the bridge. The bridge occupies a liminal position when the ceremony begins, having been planned and built over a number of months in an area that was presumably cordoned off. The opening ceremony marks the final stage of its formal incorporation into the life of Zululand society. Like a human prepared for initiation, the bridge is decorated for the occasion with 'arches of branches ... erected at each end' (Gluckman, 1940a: 5), a detail captured in Figures 3.1 and 3.3. To formally mark that the bridge was not yet open to traffic, a tape was stretched across the arch at the bridge's southern end, the breaking of which was a key moment in the ceremony. While Figure 3.1 features the arch with its branches and tape, the caption largely describes the actions of the human participants in the ceremony, even though it is clear from their stance in the photograph that they were not moving when it was taken:

> Zulu cross the bridge to welcome the C.N.C. and Regent.
> *Note* man in war-dress on guard; men's clothes; notice in English.

Gluckman's text makes it clear that the crowd in the photograph are the Zulu who built the bridge. Having gathered at the North end of the bridge, they 'marched across the bridge till they stood behind the tape at the southern arch: they saluted the Chief Native Commissioner with the Royal Zulu salute, *Bayete*, then they turned to the Regent and saluted him' (Gluckman, 1940a: 6). While these actions are not documented in the photograph, the details 'noted' in the caption, such as the notice on the arch in English as well as the dress of the various participants, may have been derived from the photograph. This 'Note' also draws attention to the 'man in war-dress on guard' who stands on the other side of the ribbon from the crowd as a way of pointing out the difference between his dress and the other 'men's clothes'. The text (Gluckman, 1958: 5) suggests he was a local *induna*, with a different status to the men who had built the bridge, who themselves although not 'in wardress ... carried sticks and shields'. Gluckman (1940a: 6) suggested that while important Zulu 'were nearly all dressed in European riding clothes ... the King wore a lounge suit.' He also noted that whereas Christians tended to wear full European dress, pagans generally wear shirts and coats over skin girdles. What Gluckman (1940a: 6) calls 'the motley combinations of European and Zulu dress' as well as the use

of a notice in English and the receipt by the Native Commissioner of a Zulu salute, all make clear the hybrid nature of ceremony and the complex ways in which both Zulu and White material and ceremonial forms were deployed. This is also captured by Gluckman's description of the announcement by the Zulu Regent, Mshiyeni, that the Government was slaughtering a beast as part of the ceremony, and that the CNC had stipulated that they pour the gall over the feet of the bridge according to Zulu custom. The irony of this, as pointed out by Gluckman, was that the Regent himself was a Christian.

While clothing and cattle, as non-humans, may have had a role in the ceremony, the most significant part was played by cars. Indeed it was the CNC's car which broke the tape stretched across the arch, at the head of a number of others that were driven across the bridge and back to mark its formal opening (Gluckman, 1940a: 7). While the text suggests that the CNC drove his own car, it seems as if the car of the Zulu Regent was probably driven by his white-coated chauffeur. The procession was led across the bridge and back by a body of warriors in Zulu war dress singing the Butelezi *ihubo* (clan song), a part of the ceremony documented in Figure 3.3. Cars emerge from Gluckman's analysis as important actors in Zululand society. As well as describing the role of the cars in the ceremony at the bridge, he describes their role in transporting himself and others such as the Regent and CNC to the ceremony, and even records that the Zulu sat in the back, while he and the GVO sat in the front. Cars also seem to be significant in enabling particular conversations, and Gluckman records what was said on the way to the ceremony, and that it was said in Zulu. It is of course significant that although Gluckman suggests that the bridge would be used by Zulu women to get to the Ceza Swedish missionary hospital, famed for its skill in midwifery, the bridge nevertheless appears to have been designed with cars primarily in mind, having no pedestrian walkway or railing. Since the bridge has been built for cars, it was perhaps obvious that it should be opened by cars, but this part of the ceremony, and the photograph that records it (Figure 3.3), focuses attention on the relationship between the bridge and the cars as different kinds of non-human agents, as well as the somewhat more incidental framing of this image by Zulu warriors in ceremonial dress.

Following the formal ceremony, Gluckman describes the consumption and exchange of food and drinks, with 'Europeans' having tea and cake in the specially erected shelter (some of which was sent out to the Zulu regent by a female missionary). However, much of Gluckman's textual description relates to what happened on the other side of the bridge where most of the Zulu gathered following the ceremony, and where he himself went. Gluckman makes it clear that while Europeans could cross the river into the Zulu space at will, Zulu presence in the European enclosure was limited to the servants responsible for serving refreshments. Gluckman's presence on the Zulu bank of the river allowed him to record the distribution of meat and beer among the Zulu, as well as noting that some beer was sent to the CNC by the Regent, according to Zulu custom. According to Gluckman, the scene on the north bank is captured in Figure 3.4, which was published with the following caption:

> On the northern bank, after the opening of the bridge looking east from the road. On left, round goalposts, the missionary (in front of nearer post) leads the hymns singing. At nearer end of this group are a number of pagans. On right cattle are being cut up. Behind the Zulu in the white jacket is the G.V.O. who is talking to him and the Zulu in war-dress. In middle distance, behind the two cattle, is the clump of trees where the Regent's party is.

Gluckman describes these three groups of Zulu in the text: those who gathered around the Regent (invisible in the photograph), those responsible for preparing the meat, and the group who gathered around the Swedish missionary singing hymns, a group Gluckman states he did not himself visit. Indeed, a note in 'the Bridge' (Gluckman, 1940a: 28, note 1) states that the missionary complained about 'the somewhat loud conversation of the G.V.O., Lentzner, the Agricultural Officer and myself'. This suggests that although Gluckman crossed the bridge to be among the Zulu, he nevertheless continued to be socially involved with his two old school friends. While Morton (2009a: 267) has suggested that the inability of lone fieldworkers to take notes and photographs at the same time has an impact on the relative partiality of the photographic record, in Gluckman's case the tension may have been stronger between his roles as an active participant and as an observer/photographer. The relatively small number of photographs that Gluckman took at 'the Bridge' may be as much a consequence of his active engagement with friends throughout the day, as the result of a concentration on note-taking.

While Gluckman's textual description of the location of the Zulu in space following the ceremony appears to relate to the details captured by Figure 3.4, it is very hard to make out very much from this image, apart from the missionary directing hymns in front of the goalposts. Given the sequence of the numbers applied to the photographs, which would have this image coming after Figure 3.8 (see Figure 3.10), it is tempting to suggest that the image printed as Figure 3.4 may not show the northern bank after the opening of the bridge, but rather beforehand. Gluckman's text (1940a: 5) confirms that there were Zulu on the other side of the river when he arrived with the GVO before the ceremony, and the missionary might have initiated a hymn practice in preparation for the hymn that would begin the formal ceremony (Gluckman 1940a: 6). The image includes the GVO but not Lentzner, who arrived late, and given that the text suggests that the three were having a loud conversation near the missionary, this might suggest that this photograph was wrongly attributed by Gluckman, whether deliberately or not. However, this speculation cannot be confirmed unless it can be demonstrated that the source of the handwritten photograph numbers, written on the prints in Gluckman's album, derives from a sequence of negatives on a roll of film. What this uncertainty demonstrates, however, is that while Gluckman's written account appears to draw on his photographs as a visual source for significant details, it also relies on his presence at the event in order to interpret the photographs, identify key participants, as well as to relate the photographs to a narrative of the day.

The text records the details of a number of intangible events that could not be captured by photography, such as the content of conversations, what songs were sung when, and who made which speeches. It seems very likely that Gluckman took notes in addition to his photographs even if, as Morton (2009a) has suggested, he would have been unable to take notes at the same time as he was taking photographs or actively participating in the event. Nevertheless, Gluckman's photographs appear to have been an extremely important visual prompt in writing his account, enabling him to re-view aspects of the events as they took place at the bridge, and possibly to make visible the degree to which 'Europeans' and their goods were significant actors in Zululand society. Publishing a selection of four photographs alongside his

account allowed him to provide evidential support for his position, and his captions involve readers by guiding their viewing through a process of interrogating the photographs, drawing attention to significant details that might not otherwise be apparent.

While much of the detail in Gluckman's account can be derived from, or at least partially confirmed by, the four photographs that he published alongside his text, his textual description of the roles played by non-humans at the opening of the bridge was not simply an incidental consequence of using photographs as a source. At a theoretical level, Gluckman seems to have understood that a range of things played an important role in allowing Zulu and Europeans to form associations. He argued that 'there is a material basis for the differentiation, and for the co-operation, between Zulu and European' (Gluckman 1940a: 20), suggesting that the inter-dependent interests between Zulu and Whites were established by 'The Zulu desire for the material goods of the Europeans, and the Europeans' need for Zulu labour and the wealth obtained by that labour' (Gluckman 1940a: 21). Nevertheless, by providing visual evidence, Gluckman's photographs supported his claim that rather than simply being theoretically motivated, this approach was 'forced on me by my material' (Gluckman 1940a: 10).

Photography as process

Gluckman's decision to publish photographs featuring Zulu alongside Europeans (Figures 3.2 and 3.4), and not to publish three photographs of the event that only showed Zulu participants (Figures 3.5-3.7), was certainly part of a deliberate strategy to highlight the hybrid nature of the opening of the bridge, and, by extension, Zululand society. This strategy can be fruitfully compared to that adopted by Donald Thomson, an Australian contemporary working in Arnhem Land. Despite having been involved in organizing an aboriginal Special Reconnaissance Unit during the Second World War, when Thomson came to publish his *Economic Structure and the Ceremonial Exchange Cycle in Arnhem Land* (1949), he excluded references to exchanges with 'European' Australians, creating an account set in a mythical ethnographic present prior to European influence. Thomson's photographic strategy is similarly exclusionary and reconstructive, and the first photographic plate in the book features a craftsman pictured with stone spear heads, even though iron-headed spears were by then in wide circulation. Thomson appears to have been anxious to exclude evidence of European influence from his photographs, which were carefully composed for his glass plate camera (Peterson 1983: viii). As a result, though static, they remain aesthetically appealing, particularly to the romantically inclined. However, by focusing on the visually exotic to the exclusion of the familiar, they became part of a rhetorical process of purification. This contrast makes it important to stress the significance of the photographs Gluckman chose to publish. Not only do they provide key evidence in support of his main argument, but they also make much of this argument for him in visual form. However, the difference between Gluckman and Thomson's photographs is at least partly a product of the technological processes of photography they were involved in. By using a handheld rather than a heavy glass plate tripod camera, Gluckman could

move more easily among participants at the event, capturing action as it unfolded before him. The process of photography as Gluckman engaged in it was a form of empirical documentation rather than ethnographic reconstruction, and to a certain extent enabled the analytical viewpoint that he was subsequently able to adopt. While Gluckman's photographs may not retain the visual appeal of those that were carefully composed by Donald Thomson, which have provided inspiration for contemporary filmmakers (Hamby 2007), they nevertheless do a significantly better job of capturing the complexity of the social processes witnessed by Gluckman in the field.

Nevertheless, it is not just anthropologists who take and use photographs, and Gluckman was not the only person taking photographs at the bridge on 7 January 1938. Indeed, he records something of the role that photography played in the ceremony as it unfolded, stating that when the cars drove back over the bridge, they were 'stopped by the European magisterial clerk who wanted to photograph them' (Gluckman 1940a: 7). It seems very likely that Figure 3.3 was taken at this point, perhaps at the same time as a number of other 'Europeans' photographed the cars, led by Zulu warriors. This is not the only point in Gluckman's account when he records the photographing of exotically dressed Zulu warriors by 'Europeans', noting that his friend, the engineer Lentzner, 'got two warriors to pose on either side of him for a photograph of his bridge' (Gluckman 1940a: 8). This choice of Zulu warriors as suitable subjects for photography, rather than the men who actually helped him build the bridge is significant, and was presumably motivated by the visually striking attire of the warriors, in contrast to the 'motley dress' of the others. Gluckman's ethnographic description of the deployment of photography by 'Europeans' in this setting is suggestive of the ways in which photography tends to emphasize the most visually spectacular and exotic features of particular events. Even Gluckman's own photographs include many more photographs of the 'Zulu' across the road, than they do of the 'Europeans' he was interacting most closely with. Gluckman's description of the social processes in which photography is embedded allows one to gain a sense of the ways in which these processes can leave their mark on the products they result in, in this case the photographs.

Photographs seem to have been deliberately taken by a number of participants during the day's events to record particular moments so that they could be re-viewed again in different places, at later times and by different people for a range of purposes. It is significant that those taking the photographs all seem to have been white, and Gluckman refers to this as part of his analysis of the asymmetries embedded in the event: 'Europeans could more or less freely move among the Zulu, watching them and taking photographs, though few chose to do so' (Gluckman 1940a: 14). While 'Europeans' may have been the main photographers, it seems that the Zulu were not unaware of the rhetorical possibilities of photographs. Gluckman has recorded elsewhere that while he was in Zululand, the Zulu regent asked him 'to photograph him ploughing, so that he could show his people that: "I am a chief of the plough, not of the spear"' (Gluckman 1971: 381). While Gluckman's access to the technology of photography may have made him unusual and attractive at certain times, it seems that during the opening of the bridge he was just one photographer among many. Indeed, it is hard to tell whether his photographs were originally

taken with any anthropological intention, or whether he originally took them primarily as a participant who was there to celebrate the achievement of an old friend. His comment on the loudness of his conversation with his friends suggests that these relationships played an important part in determining the nature of his engagement throughout the day, and may even have had an impact on the extent of his photographic record. The four published photographs form part of a series of only eight that survive from the ceremony, and one suspects that had Gluckman been intending to create a deliberate record for serious subsequent analysis he might have taken rather more. It may be that Gluckman's photographic record of events at 'the Bridge' was little different to that of his friend Lentzner, or the 'European magisterial clerk'. There may be nothing particularly anthropological about Gluckman's photographs from the day, apart from the way in which they were subsequently used. When taken, they may have simply been representative of the way in which Gluckman, alongside a number of other 'European' participants, was using the process of photography to mark and record a ceremonial event in which they were involved.

Photography, as a technology of inscription and imprinting, creates a more or less permanent mark out of a particular moment in the flow of time. As such, it has many similarities to other marking technologies such as incision and scarification, which elsewhere form important elements in rites of passage (Fontaine 1985). A photograph that records and fixes a moment of ritual transition can function in a similar way to a scar produced through a technique of bodily incision, and become a visual, as well as bodily, focus for memories of the event. It is perhaps significant that Barthes (2000 [1980]) chose to use the word *punctum* to consider the capacity of photographs to become a focus for emotional memories. Photography as a technique of inscription and incision, like scarification, circumcision or tattooing, lends itself to the recording of significant rites of passage and marking the transitions that they enact. Although ceremonies may be ephemeral, they nevertheless provide a means of visually marking an event performed to enact transition or transformation. This visual display, when captured through photography, can result in a photograph that becomes the focus for memories of the event in the same way that bodily forms of incision can function as visual reminders to others of the rite from which they result. The transition of the bridge, from being in construction to being open, is perhaps the single most significant event in its existence. As a fairly unremarkable construction in Zululand, the bridge at Malungwana drift is unlikely to have been photographed much at any other time in its existence. Nevertheless, on the day of its opening, it seems to have been a frequent subject for a range of photographers. This concentration of photographic activity around a significant rite of passage may not be unusual or specific to the bridge as a non-human actor. Humans also seem to be most frequently photographed when undergoing rites of passage. Personally, I don't think I have ever been photographed as many times as on my wedding day. I also know that in the course of everyday life, my camera frequently lies untouched, only to be taken out of the drawer for weddings, birthdays and other ceremonial events. When enacted at a particular moment during a rite of passage, photography can play an important role in marking, recording and constituting a shift in the social role of its subjects, whether these are humans or bridges.

Photographs as products

Gluckman, through his fieldwork photography, created photographs as products that would form part of a record that could be consulted at a later time in another place. In this, his use of photography is little different from other photographers at the ceremony. Nevertheless, the fact that this record of the event existed allowed him to return to his photographs and engage with them analytically and anthropologically to clarify details he might not otherwise have been able to remember. A close reading of his own photographs may have allowed Gluckman to make out features of the event that were not apparent to him at the time he participated in it. The claims to authority of much mid-twentieth century anthropology have been built around the ethnographer's physical presence in the field; however, there is a degree to which the practice of fieldwork might be better understood as an active exercise in archiving. By deploying a range of technologies such as photography and note-taking, and compiling maps and genealogies, an archive is created by fieldworkers from which analysis can proceed when they are situated back in their studies. In considering the implications of the work of Bruno Latour (and particularly Latour, 1999) for anthropology, Richard Vokes (2007: 402) has suggested that the particular form of this archive becomes crucial to the 'later construction and stabilization of ethnographic representations'. The depth of detail that Gluckman is able to include in 'the Bridge' appears to derive at least as much from what his archive, and particularly his photographs, allowed him to see later, as from his actual physical presence and participation in the event.

While field notes are of course an important part of the archive generated by fieldworkers, photographs have considerable advantages, not least of which is that they can record significant details that may not have been apparent to the photographer at the time they were taken. In short, the photographs that Gluckman took at the opening of the bridge may have allowed him to see things in his study that even his 'ethnographer's eye' did not see on the day in question. Gluckman's camera recorded things that he may not have known he was recording at the time, and so, like other scientific instruments such as a microscope or telescope, it allowed him to see more, and to see differently than he otherwise could. What is perhaps crucial about Gluckman's photographs is that they allowed him to analyse in detail and at length an event he had witnessed briefly as it had unfolded before him, when his role may have been more participant than observer. Although accounts of the rise of Social Anthropology have concentrated on the practices of fieldwork (Stocking 1983) and of ethnographic writing (Clifford & Marcus 1986), it is arguable whether the fieldwork revolution of the early twentieth century would have taken place without the possibilities offered by relatively cheap, light-weight and portable cameras. Freed from the need to collect artefacts as examples of local material culture, the anthropologist could instead collect images of human life as it unfolded before his eyes with his camera. Nevertheless, the analysis of photographs on return from the field unfolded in very similar ways to practices involved in analysing other items of material culture. Starting with a finished product, the analyst must attempt to recover the social processes involved in its production from the way in which its material form embodies particular relations. It is the way in which photographs, as products, materialize particular moments of relation in a relatively stable form that allows them to

be subsequently analysed for information about the social processes involved in the event at which they were taken, whether by historically minded scholars, or by participant-photographers themselves.

Conclusions: towards a symmetrical anthropology (of photography)

I have suggested that Max Gluckman's 'Analysis of a Social Situation in Modern Zululand' is an early landmark in symmetrical anthropology in several significant respects. Its treatment of 'Europeans and Zulu' as part of a single social system, but also its recognition of the important roles played by non-human actors, mark it out as an important antecedent of more recent anthropological concerns, particularly as expressed by Bruno Latour (1993). However, there is another degree in which it is possible to relate Gluckman's paper to Latour's arguments for a more symmetrical anthropology, and this relates to the question of Social Anthropology's own claims to modernity. One version of Social Anthropology's origin myth traces its inception to publications by Malinowski and Radcliffe-Brown in 1922, a year of other significant modernist publications including James Joyce's *Ulysses* and T. S. Eliot's *The Waste Land*. Edwin Ardener (1985) has identified Social Anthropology as a species of modernism, and the manifesto claims of Social Anthropology's founding fathers suggested that it was a deliberate attempt to escape from an established anthropological tradition they repeatedly characterized as 'conjectural history'. This 'non-modern', but holistic anthropology integrated a range of approaches, including archaeology, and had its main institutional and professional home in museums. As a means of avoiding the sorts of archaeological questions that had dominated the Victorian tradition from which it sought to break, Social Anthropologists adopted a determined 'presentism' (Fardon, 2005: 74). In attempting to purify the discipline of archaeological approaches more concerned with the past than the present, distinct university departments and institutional structures were created for Social Anthropology, while participant-observation was emphasized as a distinctive fieldwork practice alongside ethnography as a form of writing.

Elements of this ongoing exercise in self-definition are suggested in an excerpt from an article by Ronald Frankenberg (1982) that was printed after 'the Bridge' in Vincent's 2002 reader under the title '"The Bridge" Revisited'. The excerpt ends by suggesting that Gluckman 'taught us' that it was 'social relations in action, rather than artefactual *things*, that made up the culture of a community' (Vincent 2002: 64). While it is arguable whether Gluckman directly made such a claim, it is nevertheless useful to draw attention to the implied dichotomy, if only as part of an attempt to transcend it. For the purposes of argument, I suggest that 'social relations in action' can be glossed as the 'processes' involved in human life, and 'artefactual *things*' as their 'products'. While photography as a process undoubtedly has a role to play in influencing social relations in action, it would be absurd to suggest that photographs as products, or artefactual *things*, are not significant in times and places other than those in which they were taken. 'Social relations in action' inevitably have an enormous influence on the contents of particular photographs. However, once taken developed and printed, the photograph as a product can make a difference in places and times, and in ways that would have been completely unanticipated at the moment it was taken. Alfred

Gell has also emphasized the study of social relations in his suggestion that an anthropological theory of art should focus on the 'social context of art production, circulation and reception, rather than the evaluation of particular works of art' (Gell 1998: 3). His argument is built around an understanding of Social Anthropology as a discipline whose subject matter is 'social relationships', but in Gell's case this self-definition is largely drawn in contrast to American Cultural Anthropology, the subject matter of which he suggests is 'culture'. According to Gell (1998: 4), 'The problem with this formulation is that one only discovers what anybody's 'culture' consists of by observing and recording their cultural behaviour in some specific setting, that is, how they relate to specific "others" in social interactions.' While this may be true if the only available tool of the anthropologist is participant-observation, archaeological techniques and approaches have developed precisely as a means of discovering the 'culture' of people who are no longer around to observe and record.

By reversing Frankenberg's formulation, we might understand 'culture' to be the artefactual products of social processes. It might have been obvious for a field-working Social Anthropologist of the later twentieth century to think that his work began in the midst of social processes, but when working with archives, museum collections or archaeological sites it is more common to encounter 'culture' as product, removed from the social processes that created it. While it could be argued that any context is necessarily a social context, and that an archive or archaeological site is also a setting for social interactions, these are nevertheless not necessarily the most significant social relations that the material form of a particular cultural product bears witness to. When approaching a thousand-year-old Indian sculpture that lay buried in the ground for hundreds of years (cf. Wingfield 2010b), or seeking to understand an item of seeming ritual magic that has been encased at a museum for a hundred years (cf. Wingfield 2010a), limiting one's analysis to the context of social relations in which an object exists at the time of study would be an unnecessarily restrictive approach. It might be necessary, instead, to understand some contemporary contexts as the outcome of the processes of 'incapsulation' (Collingwood & Knox 1946: 114), by which the products of the past become embedded in the present.

The work of archaeology, as an attempt to reconstruct human life in the past, generally begins with a series of related material forms. It proceeds through the detailed interrogation of these, and their relations with one another, towards attempting to re-imagine the social processes that produced them and gave them their current form. This is precisely the way in which I have conducted the research for this paper, beginning with a comparison and analysis of the three published versions of Gluckman's article. However, it is also the way in which I have suggested Max Gluckman engaged with his own photographs when trying to analyse an event of which they were ultimately products. While archaeology seemingly begins its analysis with static material culture or 'artefactual things', ethnography appears to emerge through engagement in the midst of unfolding social processes. Nevertheless, archaeology, through practices such as excavation, enacts a series of social processes in order to begin making sense of the things it studies. Similarly, through engagement with social processes, participant-observation creates a series of products, such as photographs and field notes, in order to record and begin making sense of these processes. While an archaeologist has to work

hard to deduce process from product, the participant-observer set down in the midst of a series of complex events may, if anything, struggle to make out the 'culture' that is the product of the processes going on around them – aptly expressed by the proverbial difficulty of seeing 'the wood for the trees'. In either case, process and product are brought together by the researcher in order to develop understanding.

It might seem that the analyses of archaeologists, unlike ethnographers, do not begin with things that they have had a hand in making, but understanding an archaeological site involves analysing a series of textual and photographic records that have been self-consciously created as a fieldwork archive during the process of excavation. It is the preservation of such archives that allows one archaeologist to re-analyse the records of another, and to draw different conclusions, a not infrequent occurrence. By examining Gluckman's unpublished photographs alongside his published ones, I have attempted a similar process of re-analysis. While the archaeological process generally begins with an attempt to understand a material product, rather than an unfolding social process, the forms in which excavation is documented are not dissimilar to the archives of field notes and photographs created by participant-observers. The main difference between these different types of fieldwork archive is that archaeological records are necessarily more standardized since they generally involve a number of people cooperating in their creation in the first place. Nevertheless, whether adopting an archaeological or an ethnographic approach, it appears to be impossible to separate process and product in any satisfactory way, whether one understands 'culture' to be 'social relations in action' or 'artefactual *things*' as its products.

I have suggested that Gluckman's description of the social processes surrounding the opening of the bridge was itself a textual product that derived in large part from the process of analysing another series of cultural products, his photographs and fieldnotes of the event. If we extend the notion of 'culture as product' beyond material forms to more ephemeral intangible forms, then the ceremony enacted at the bridge can itself be understood as the product of a range of complex social processes. Gluckman's attempt to make sense of the ceremony can itself be understood as quasi-archaeological in its approach, unfolding and unpacking the event in order to set it in relation to a series of wider social processes that unfolded over long periods of time and on large geographical scales. While many twentieth-century Social Anthropologists may have proactively engaged in a process of purification in relation to archaeology, Gluckman (1965: 10) himself seems to have been more ambivalent. In expressing surprise that anthropologists such as Malinowski had failed to recognise Africans and Europeans as a single social group in 'the Bridge', Gluckman (1940a: 11, note 3) suggested that 'Possibly it is because anthropologists have not rid themselves as they claim of the archaeological bias'. Gluckman himself seems to have been something of a transitional figure with regards to the separation of archaeological and ethnographic approaches in twentieth century anthropology (see Gluckman 1965: 4). Having registered for a Diploma in Anthropology at Oxford in 1934, he attended lectures in Social Anthropology but also took classes on technology and archaeology. These were taught at the Pitt Rivers Museum by Henry Balfour, a living representative of the nineteenth-century holistic approach to anthropology. Gluckman went on to become the first person to submit a doctoral thesis in Anthropology

at Oxford, and this was largely based on historical and archival work on the Zulu. Indeed, while the first part of 'the Bridge' is concerned with the immediate events on a particular day in 1938, most of its second part attempts to understand these in terms of the longer-term development of Zululand society. A great deal of what I have described as the 'symmetry' of Gluckman's approach to 'the Bridge', his sensitivity to the role of material technology, as well as of long-term historical processes in shaping contemporary events, may have emerged during his training in an approach to Anthropology that pre-dated the 'Malinowskian project'. Indeed, Gluckman (1971: 377) himself has suggested that 'the Bridge' was written at the time of the 'breakup of general anthropology into several disciplines'.

Tim Ingold (2008) has recently argued that 'Anthropology is not Ethnography', and it seems clear that in approaching photographs as products, rather than photography as process, the best way of doing this may not be through participant-observation. In writing about photographic archives as the 'excavated material culture of the colonial and imperial heritage of anthropology', Pinney (1992: 90) referred to their 'forensic possibilities'. Rather than reach for what he refers to as 'medical metaphors', it would be equally possible to engage with approaches to 'excavated material culture' in archaeology, and thereby recognize the complementarity inherent in the asymmetry that has developed between the two disciplines over the last century. Indeed, while Social Anthropology's presentism may once have been accompanied by an archaeological concentration on the past, archaeologists have been increasingly using archaeological methods as a way of engaging with a wide range of material forms in the present, or, as they sometimes call it, 'the contemporary past' (Harrison & Schofield 2010). Despite the 'purification' that was attempted between the disciplines of Archaeology and Social Anthropology during the twentieth century, hybrid forms nevertheless proliferated, including perhaps the quasi-archaeological manner in which Gluckman appears to have used his own photographs. In developing a symmetrical anthropology of photography that considers photographs as cultural products alongside photography as a social process, archaeological as well as ethnographic perspectives will be needed.

Bibliography

Ardener, E. 1985. Social Anthropology and the Decline of Modernism, in *Reason and Morality*, (ed.) J. Overing, London: Tavistock.

Barthes, R. 2000 [1980]. *Camera Lucida*, London: Vintage.

Blacking, J. 1969. 'Process and Product in Human Society: Inaugural Lecture', Johannesburg: Witswatersrand University Press.

Clifford, J. & G. E. Marcus. 1986. *Writing Culture: The Poetics and Politics of Ethnography*, London: Berkeley.

Cocks, P. 2001. 'Max Gluckman and the Critique of Segregation in South African Anthropology, 1921-1940', *Journal of Southern African Studies* 27 (4): 739-56.

Collingwood, R. G. & T. M. Knox. 1946. *The Idea of History*, Oxford: Clarendon Press.

Comaroff, J. L. & J. Comaroff. 2007. Introduction: The Portraits of an Ethnographer as a Young Man, in *Picturing a Colonial Past: The African Photographs of Isaac Schapera*, (eds) J. L. Comaroff, J. Comaroff & D. James, Chicago & London: University of Chicago Press.

Comaroff, J. L., J. Comaroff & D. James (eds). 2007. *Picturing a Colonial Past: The African Photographs of Isaac Schapera*, Chicago & London: University of Chicago Press.

Edwards, E. & C. Morton. 2009. Introduction, in *Photography, Anthropology and History: Expanding the Frame*, (eds) C. A. Morton & E. Edwards, Farnham: Ashgate.

Engelke, M. 2008. 'The Objects of Evidence', *Journal of the Royal Anthropological Institute* (Special Issue) 14: S1-21.

Evans-Pritchard, E. E. 1937. *Witchcraft, Oracles and Magic among the Azande*, Oxford: Clarendon Press.

Evans-Pritchard, E. E. 1940. *The Nuer: A Description of the Modes of Livelihood and Political Institutions of a Nilotic People*, Oxford: Clarendon Press.

Fardon, R. 2005. Tiger in an Africa Palace, in *The Qualities of Time: Anthropological Approaches*, (eds) W. James & D. Mills, Oxford: Berg.

Fontaine, J. La. 1985. *Initiation*, Harmondsworth: Penguin.

Fortes, M. 1937. 'Communal Fishing and Fishing Magic in the Northern Territories of the Gold Coast', *Journal of the Royal Anthropological Institute* 67: 131-42.

Fortes, M. & E. E. Evans-Pritchard (eds). 1940. *African Political Systems*, Oxford: Oxford University Press.

Frankenberg, R. 1982. Introduction: A Social Anthropology for Britain? in *Custom and Conflict in British Society*, (ed.) R. Frankenberg, Manchester: Manchester University Press.

Gell, A. 1998. *Art and Agency: An Anthropological Theory*, Oxford: Clarendon Press.

Gennep, A. Van. 1909. *Les Rites De Passage*, Paris: Nourry.

Gluckman, M. 1940a. 'Analysis of a Social Situation in Modern Zululand —— A', *Bantu Studies* (14): 1-30.

—— 1940b. 'Analysis of a Social Situation in Modern Zululand —— B', *Bantu Studies* 14: 147-74.

—— 1942. 'Some processes of social change illustrated from Zululand', *African Studies* 1 (4): 243-60.

—— 1958. *Analysis of a Social Situation in Modern Zululand*, Manchester: Rhodes Livingstone Institute and Manchester University Press.

—— 1963. Introduction. in *Order and Rebellion in Tribal Africa*, (ed.) M. Gluckman, London: Cohen & West.

—— 1971. The Tribal Area in South and Central Africa, in *Pluralism in Africa*, (eds) L. Kuper & M. G. Smith, Berkeley CA: University of California Press.

—— 1975. Anthropology and Apartheid: The Work of South African Anthropologists, in *Studies in African Social Anthropology*, (eds) M. Fortes & S. Patterson, London: Academic Press.

Gluckman, M. & F. Eggan. 1965. Introduction, in *Poltical Systems and The Distribution of Power*, (ed.) M. Banton, London: Routledge.

Grimshaw, A. 2001. *The Ethnographer's Eye: Ways of Seeing in Anthropology*, Cambridge: Cambridge University Press.

Hall, E. T. 1968. 'Proxemics', *Current Anthropology* 9 (2-3): 83-108.

Hamby, L. 2007. 'Thomson Time and *Ten Canoes*', *Studies in Australasian Cinema* 1 (2): 127-46.

Harrison, R. & J. Schofield. 2010. *After Modernity: Archaeological Approaches to the Contemporary Past*, Oxford: Oxford University Press.

Ingold, T. 2008. 'Anthropology Is *Not* Ethnography', *British Academy Review* 11: 21-3.

Kuper, A. 2007. Isaac Schapera (1905-2003): His Life and Times, in *Picturing a Colonial Past: The African Photographs of Isaac Schapera*, (eds) J. L. Comaroff, J. Comaroff & D. James, Chicago & London: University of Chicago Press.

Latour, B. 1993. *We Have Never Been Modern*, New York & London: Harvester Wheatsheaf.

—— 1999. Circulating Reference: Sampling the Soil in the Amazon Forest, in *Pandora's Hope: Essays on the Reality of Science Studies*, (ed.) B. Latour, Cambridge & London: Harvard University Press.

Macmillan, H. 1995. 'Return to Malungwana Drift - Max Gluckman, the Zulu Nation and the Common Society', *African Affairs* 94: 39-65.

Malinowski, B. (ed.). 1938. *Methods of Study of Culture Contact in Africa*, London: Oxford University Press.

Morton, C. 2005. 'The Anthropologist as Photographer: Reading the Monograph and Reading the Archive', *Visual Anthropology* 18 (4): 389-405

—— 2009a. 'Fieldwork and the Participant-Photographer: E.E. Evans-Pritchard and the Nuer Rite of Gorot', *Visual Anthropology* 22 (4): 252-74.

—— 2009b. 'The Initiation of Kamanga: Visuality and Textuality in Evans-Pritchard's Zande Ethnography', in *Photography, Anthropology and History: Expanding the Frame*, (eds) C. A. Morton & E. Edwards, Farnham: Ashgate.

Peterson, N. 1983. Preface, in *Donald Thomson in Arnhem Land*, (eds) D. F. Thomson & N. Peterson, South Yarra, Vic: Currey O'Neil.

Pinney, C. 1992. The Parallel Histories of Anthropology and Photography, in *Anthropology and Photography, 1860-1920*, (ed.) E. Edwards, New Haven & London: Yale University Press.

Stocking, G. W. 1983. The Ethnographer's Magic: Fieldwork in British Anthropology from Tylor to Malinowski, in *Observers Observed: Essays on Ethnographic Fieldwork*, (ed.) G. W. Stocking Madison: University of Wisconsin Press.

Thomson, D. F. 1949. *Economic Structure and the Ceremonial Exchange Cycle in Arnhem Land*, Melbourne: Macmillan.

Vincent, J. 2002. *The Anthropology of Politics: A Reader in Ethnography, Theory, and Critique*, Malden, MA: Blackwell.

Vokes, R. 2007. (Re)Constructing the Field through Sound: Actor-Networks, Ethnographic Representation and 'Radio Elicitation' in South-Western Uganda, in *Creativity and Cultural Improvisation*, (eds) E. Hallam & T. Ingold, Oxford: Berg.

Wingfield, C. 2010a. 'A Case Re-Opened: The Science and Folklore of a "Witch's Ladder"', in *Journal of Material Culture* 15 (3): 302-22

—— 2010b. Touching the Buddha: Encounters with a Charismatic Object, in *Museum Materialities: Objects, Engagements, Interpretations*, (ed.) S. H. Dudley, London & New York: Routledge.

Wolbert, B. 2000. 'The Anthropologist as Photographer: The Visual Construction of Ethnographic Authority', *Visual Anthropology* 13 (4): 321-43

Young, M. W. 1998. *Malinowski's Kiriwina: Fieldwork Photography 1915-1918*, London: Routledge and Kegan Paul.

Frontier photographs
Northern Kenya
& the Paul Baxter collection
Neil Carrier & Kimo Quaintance

4

Introduction

Where did you find these ghosts?
(Borana man in Marsabit, April 2010)

Such is the affective force of photography in bringing people face to face with long dead kin or their own earlier selves that a link between photographs and 'ghosts' appears near-universal, as demonstrated by Smith and Vokes (2008). This link emerged in Marsabit, Kenya, during a photo-elicitation and repatriation project that took place in April and July 2010. In this project, images of people, places and objects photographed in the region sixty years earlier generated great excitement as word of mouth spread that friends and relatives from long ago might once more be seen. It was in the context of an expanding crowd of people intently examining the images that the above quotation about 'ghosts' was heard. To answer the question posed, the *ekera* ('ghosts' in the Borana language) were found in the photographic collection of Paul T.W. Baxter, who conducted anthropological fieldwork among the Borana of what was then known as Kenya's 'Northern Frontier District' almost sixty years earlier, between 1951 and 1953. Paul Baxter donated this collection of 650 images to the Pitt Rivers Museum in late 2007, and the 2010 project[1] explored the potential in repatriating these images to where they originated. It attempted to elicit memories of people of that earlier era, and the social changes wrought in the region in the intervening years. It also attempted to explore the history and power of photography in this marginalized part of Kenya.

This chapter is based on meetings with Paul and Pat Baxter as well as the fieldtrip, where an album of thirty or so enlarged images from the collection were taken to Marsabit and Moyale along with a laptop and hard drive containing the full collection. In what follows, we draw out the significance of the Baxter collection for the people of northern Kenya, and the practice and meaning of photography for fieldworkers and photographic subjects then and now. While photography for Paul was mainly an adjunct to written note-taking, the collection that resulted is invaluable. By living with a people for so long and building trust, anthropologists can capture scenes of life inaccessible to most outsiders, as published collections of Malinowski's and Schapera's images also reveal (respectively: Young 1998; Comaroff *et al.* 2007). For the current authors, Paul's hard work in building trust in the field sixty years ago was encapsulated in the collection, and helped generate a positive reception for them upon its return. For those in the pictures or their relatives – and for Kenya Borana in general – the collection offers links to an era suffused with nostalgia, and the images speak to both their past and their present. We conclude with the suggestion that photography remains an uncommon yet

[1] This project was funded by the British Institute in Eastern Africa, to whom many thanks are due. Thanks also to Chris Morton at the Pitt Rivers for permission to use the photographs, Dave Anderson, Halake Denge, Hassan Kochore, Emma Lochery, Badr Shariff Ali, Hannah Elliott, Joseph Mutua and, of course, to the people of Marsabit and Moyale, and Paul and Pat Baxter.

much appreciated pursuit around Marsabit, further intensifying the value of the Baxter collection and the worth in returning such images from whence they came.

Photo elicitation and repatriation

Since the early days of the technology, anthropology has made much use of photography as a visual record of people and places, and as illustrative adjuncts to text in published work. However, it was in the second half of the twentieth century that photography's methodological potential was more deeply explored. Articles and textbooks such as Collier's (1957; 1967) addressed a wide range of uses to which anthropologists can put photography: from making photographic surveys, photographing social interaction, to interviewing using photographs. The latter, more widely known as 'photo elicitation', has become perhaps the most widely-practised methodology to emerge from such work. Early articles stressed how much more engaged informants could be through the use of photography compared with word-only interviews (Collier 1957). More recent work attests to this: for example, Kratz found in her research that photographs were 'mnemonics that prompted people to talk about events, people, and social relations, going beyond what was shown' (2002: 148). Harper has also encouraged the use of photo elicitation, stating that it 'mines deeper shafts into a different part of human consciousness than do words-alone interviews', and this owes much to the nature of the photograph with its apparent ability to 'capture the impossible: a person gone; an event past' (2002: 22-23). Beyond photo-elicitation using pre-existing images, it is also claimed that the process of photography itself offers much research potential: '[u]sed with discretion and imagination, the camera can provide the fieldworker with rapid orientation to new circumstances and means of establishing a role and rapport' (Collier & Collier 1986: 28). As we shall argue, our experience of photography in Marsabit, and the reaction of people to both the Baxter collection and our own photographic exploits, supports these claims.

However, while researchers – including ourselves – have found photography an engaging way to connect with people in the field, its use in this respect is not unproblematic. Wright (2004) draws attention to how photo-elicitation often is so focused on images within photographs and identifying people and places that it ignores how photographs and photography are perceived by source communities. Like Edwards (2001), he demands that more attention be given to the materiality of photographs: how they are treated as objects, not just viewed as images. Furthermore, photo elicitation such as that promoted by the Colliers has been critiqued for being a one-way process, being more about what the ethnographer can learn for his or her purposes, rather than the different meanings and use the photographs might have for source communities (Edwards 2003: 87). Such a critique highlights key issues, in particular, those surrounding 'photo repatriation'. These emerge out of debates about the purpose of museums and their collections in the twenty-first century, and the importance of improving access of source communities to collections, and ensuring their involvement in guiding the future uses made of them.[2] While studying archived collections of photographs can be interesting from an

[2] For an examination of the repatriation potential of an archive of sound recordings based in South Africa, see Lobley 2010.

academic point of view, the photographs almost certainly will have a deeper significance for the people represented in the images. Important work in photo repatriation – such as that by Poignant (1996) – has shown this consistently.

By taking collections out of the archives and bringing them back to the people for whom they have the most meaning, very different perspectives emerge as people relate not to unknown representatives of an exotic culture, but to kin and representatives of a very personal history. While we may think we know what archived images 'mean', to quote Peers and Brown (2009: 265): '[w]e seldom know much about their other realities, about the quite different sets of meanings attached to them within their source communities, about who the people in such photographs are to their relatives, who often recognize them and reattach biography and history to their images.' Furthermore, photo collections can be put to use politically by source communities to make and contest claims about land and identity, as work by Binney and Chaplin (2003) and Bell (2003) demonstrates. Thus, their potential worth stretches far beyond the academic.

Museums and other archival institutions are far more sensitive today to this value that photographic collections hold for source communities, and repatriating images is now a key aim of museums such as the Pitt Rivers where the Baxter Collection is housed. Clearly accessioning, cataloguing, digitizing and protecting photographic collections must still absorb time and resources. However, as we shall show in our discussion of the Baxter Collection and its return to northern Kenya, if resources are found to repatriate such collections, then they can have a meaningful after-life beyond the archive.

Northern Kenya and the Baxter Collection

Kenya's Northern Frontier District and its people

What became known as the 'Northern Frontier District' (NFD) of Kenya was occupied by the British 'as a buffer against Italy and Ethiopia' to protect British interests to the south (Fratkin & Roth 2005: 40). It extends over a vast territory (equalling the size of the rest of the country), and was designated a 'closed district' early last century where official policy was to prevent migration from the south, and leave the mainly pastoralist people to their own ways while offering them the *Pax Britannica* (Hogg 1986: 319). Infrastructure was limited with only a few roads built, while there were no schools or hospitals, and administration principally consisted in 'preventing inter-pastoralist raiding' (Fratkin & Roth 2005: 40). A number of administration posts were established, including Marsabit in 1909, and other posts such as Loiyangalani and Archers Post. Despite the restriction of movement into the NFD, the livestock trade was developed and facilitated by the building of roads such as that from Moyale to Isiolo in the 1930s, and merchants settled in the administrative posts to sell imported goods (ibid.: 41).

At the turn of the last century, the NFD was populated by an array of pastoralist groups, including Samburu, Rendille, Gabbra, Borana, Somali and Turkana, whose shifting alliances and identities are well described by Schlee (1989). In the present chapter, the Borana (one group within the wider Oromo people) are the major focus, and they had 'grazed and watered their stock over extensive areas of what is now Kenya since, at the very least, the middle of the [19th] century' (Baxter 1978: 161). They settled into three groupings,

those moving back and forth across the border with Ethiopia and watering herds between Turbi and Moyale in the dry season, those on Mount Marsabit itself (which rises from the desert like an oasis of green), and those who moved south into what became Isiolo District (ibid.: 161). While many Isiolo Borana converted to Islam under the influence of Somalis, the Borana of Mount Marsabit and further north were to remain traditionalists, as they were at the time when Paul arrived there in 1951 (although Islam and Christianity have now spread among Borana in Marsabit and Moyale districts). Much of Borana life revolves around the intricate and ancient *gada* age-generation system (Baxter 1954; 1978), whose underlying concepts 'dominate Boran ritual thought and behaviour' (1978: 154). Ritual leaders and sacred sites of the *gada* are in Ethiopia, leading Kenyan Borana to feel separated: in the 1950s they 'denigrated themselves to [Baxter] as only being "part-Boran" because of their separation' (ibid.: 162).

Pastoralist sedentarization was discouraged by the British, and, as summarized by Fratkin and Roth (2005), '[t]he majority of the district's pastoralists were left relatively undisturbed, as long as they paid their taxes, stayed in their designated grazing areas, and their warriors did not raid each other's livestock'. Some British administrators posted to the north developed a real love for the district. There was a romance to the district evidenced by such books as that by Alys Reece, the wife of a famous administrator in the north, Gerald Reece (1966). Reece felt very protective towards pastoralists in the NFD, doing much to prevent what he saw as the corruption of their way of life by outside influences (Anderson & Carrier 2009). The years following Independence brought great changes, not least those wrought in the conflict known as the 'Shifta War', where Somalis in the north attempted to force through secession of the region to Somalia. This conflict was to leave a lasting mark on the Borana of Marsabit, as enforced sedentarization around the town led to the creation of permanent villages and the difficulties and opportunities that sedentarization can bring (Fratkin & Smith, 1995).

Independence brought little development to northern Kenya: in colonial times, the Baxters remember people saying 'we're heading to Kenya' when leaving Marsabit for Isiolo and central Kenya, alluding to the north's marginality in regard to the rest of the country. Such a sentiment survived post-Independence (Arero 2007), as Kenyatta did little to develop the north in comparison with the fertile central highlands and Nairobi, and the region became notoriously insecure on the periphery of the state. Symbolic of this mutually ambivalent relationship was the road between Isiolo and Moyale. This was a bone-crunching journey over corrugated *murram* in the 1950s, and remains so today – a startling contrast with the road north of the Ethiopian side of Moyale to Addis Ababa, which is paved all the way. The north's continued marginalization in the context of deflated post-independence expectations, combined with a recent series of severe droughts, have led many Borana to remember the 1950s – the era represented in the photographic collection – with some nostalgia as a time when milk was in plenty.

The anthropologist, his research, and photography

Paul Baxter came to the Institute of Social Anthropology at Oxford after studying English Part 1 (under F. R. Leavis) and Anthropology Part 2 for his first degree at Cambridge. Together with fellow Cambridge students David Brokensha and

David Pocock, Baxter then studied for a B. Litt. in Social Anthropology at Oxford, which he was awarded in 1951. This work formed the basis for a contribution on the Azande for Daryll Forde's Ethnographic Survey of Africa (Baxter & Butt 1953). For his D. Phil. under the supervision of Evans-Pritchard, Paul had hoped to conduct fieldwork among pastoralists in British Somaliland, only to be refused entry by the then governor, Gerald Reece, who did not want an anthropologist 'meddling' in the country.[3] Instead, still hoping to study a pastoralist people, he turned his attention to the Borana of northern Kenya. He remembers that the Colonial Social Science Research Council (CSSRC) had a list of peoples in British territory where an anthropological study would be welcome (drawn up by Isaac Schapera), and the Borana were amongst them. They had been written about before in southern Ethiopia (for example, Cerulli 1922), but not in Kenya. His decision to make them the focus of his study was supported by Evans-Pritchard, and a grant from the CSSRC provided funding for his fieldwork. Preparations included satisfying the administration that his research would not be of a 'meddling' nature, and Richard Turnbull (then Provincial Commissioner of the Northern Frontier District at the time) vetted Paul at Oxford prior to his departure for the field.[4]

Preparations complete, Paul, his wife Pat and young son Tim, set off from the London docks in February 1951 for their journey through the Mediterranean, the Suez Canal and on to Mombasa, arriving in early March. From there, they travelled by train to Nairobi, and after wading through colonial bureaucracy, the young family travelled up to Marsabit by truck to begin two years of fieldwork. From the hardships of an impecunious student life in post-war Britain, the Baxter family were perhaps well positioned to survive life in this remote outpost of the British Empire. They found themselves amongst only a handful of European residents with little in the way of modern conveniences or fresh agricultural produce. Nanyuki, the source of such supplies, was a gruelling day's journey away along a corrugated unpaved road. However, meat and milk were readily available to go along with supplies of tea, sugar and maize flour, while the beauty of Marsabit's location – a mountain oasis rising from the northern deserts – and the fascinating people living around it, provided a different sort of sustenance.

Marsabit was not the only locale for Paul's fieldwork – he made a trip up to Moyale, and also spent time with Borana near Garba Tulla on the Waso Nyiro and Orma on the Tana River – but it was where he spent most of his two years in Kenya. The family had the use of a grass-thatched mud home in the small administrative centre of Marsabit as a base; Paul estimated he spent a quarter of his time there, while Pat spent around half her time there. The rest of the time was spent staying in a tent at outlying stock villages (*ola* in the Borana language), and in particular, at the *ola* of Jilo Tukena, who later became chief of the Borana of Marsabit. Jilo Tukena was a man for whom Paul developed great respect, finding him possessed of an enquiring mind, being as curious about life in Europe as Paul was about life in Marsabit. When Paul arrived, the chief at the time was a man named Galgallo Duba. Duba Abaale –

[3] A later governor had a more positive view of anthropology, and thought how good it would be to bring in an anthropologist – paving the way for Ioan Lewis' fieldwork in 1955.

[4] While in Marsabit, Paul was unintentionally given access to a file about him and his research held at the DC's office: he was amused to see that Turnbull had written, after meeting him, words to the effect that, 'if we must have an anthropologist, we could do worse.'

an elderly man photographed by Paul whom we met (see below) – remembers Galgallo visiting the *ola* of Jilo Tukena to explain the reason for Paul's visit and to ask that he be allowed to go about his research. His activities struck some Borana as odd, though Paul remembered others seeing it as only natural that someone was interested in their intricate culture and social structure. Paul and his family soon became familiar figures in certain villages, including that of Jilo Tukena. Many Borana knew Paul, and many of those we encountered remember hearing of him as 'Aba Timmy': the 'father of Timmy' in Borana.

For Paul, research involved much sitting around observing everyday activities and ceremonies, while grasping for the meaning in what was going on. He had gained some knowledge of Oromo before reaching Marsabit, but still faced a challenge to become fluent; however, his growing ability to speak the language well marked him out from other Europeans, and Borana still remember him speaking the language fluently. Acculturating to life in the villages also had its challenges. Informants we met who remembered Paul fondly recounted a *faux pas* where he was offered a gourd of milk, and drank the entire gourd himself, rather than passing it around to share as custom dictated. According to Paul, it was only after meeting Eike Haberland – a German scholar who had been studying Borana in southern Ethiopia – that his material started to make sense. They met during a short visit to Moyale, and Haberland provided much important cultural context from Ethiopia (for his work, see Haberland, 1963). Things then became easier, and after his two years in the field, he returned to Oxford to complete his D. Phil. thesis: 'The Social Organisation of the Galla of Northern Kenya'.[5] This thesis remains unpublished, though it has proved influential and is widely cited amongst Oromo scholars and those interested in age-set systems. It also provided the foundation for many of Paul's later publications dealing with Oromo and the *gada* system.[6]

Paul's research was funded by the Colonial Social Science Research Council (Mills, 2002), and his grant covered the cost of a camera which had to be returned to the council after his fieldwork. He bought a medium format camera with two Zeiss lenses (one of which he scarcely used). This was the first sophisticated photographic equipment Paul had owned, having previously only used a Box Brownie. He was not given any advice from Evans-Pritchard or others on the use of photography in fieldwork, and was given little advice on fieldwork in general: on the latter, he was told by Evans-Pritchard more or less to 'follow his nose', and listen to the people he met to learn from them what they valued.

Paul took photographs whenever he had film. The difficulty in obtaining this commodity was a real constraint on his photography, as he was reliant on people coming up from Nairobi to bring him new film, and, more to the point, film was expensive, especially on Paul's meagre allowance. He was able to take more photographs after realizing that his camera could halve medium format negatives and so double the number of pictures taken from one roll of film, but even so, photography could not become an everyday practice in the field. When he did have film, much of his photography served as an extension of

[5] At the time, 'Galla' was the standard term for Oromo-speaking people like the Borana, though it is now avoided as it has pejorative associations.
[6] For a selection of Paul's publications, see Baxter and Almagor 1978; Baxter 1965, 1970, 1972, 1978; Baxter, Hultin and Triulzi 1996.

note taking, being able to capture in an instant details that would have taken too long to write out. However, he found photography could get in the way of written note taking, especially as focusing the camera took time and effort, and he would mostly leave the camera in its case to concentrate on writing.

In the field, Paul found more limitations to photography. Crucially, the light sensitivity of his camera and film was not sufficient to take pictures in low light. This meant that any activities taking place indoors – including important sequences in ceremonies such as the *gubbisa* naming ceremony (see below) – could not be photographed. Also, many ceremonies took place at night, and again his camera was useless in this regard. Thus, many ceremonies and activities could not be photographed in their totality. The ebb and flow of his photography resembles that recounted by Morton in regard to Evans-Pritchard's photography (Morton 2009), as certain moments would find him taking far more photographs than at others. In his many photographs of a *gubbisa* (see below), one does get the impression of the ebb and flow in intensity of this multi-day ceremony: many images are focused squarely on crucial aspects in the ceremony, and are usually taken at close range. During lulls, Paul could wander further from the event and take more panoramic shots.

Of course, Paul's ability to photograph was dependent upon the reaction of his photographic subjects. He emphasizes how he had to have a relationship of trust with people before he could photograph them. The photographs he took certainly suggest that his informants were tolerant of his photography. In particular, his portrait photographs of the *ola* of Jilo Tukena show faces of people clearly comfortable in Paul's presence, having lived with him in their midst for some time. The trust he gained was highlighted by Bokayo Jilo Tukena and Duba Abaale (see below) in their memories of Paul's fieldwork, stating to us in 2010 that Paul became like a member of the family; Paul himself spoke of a transition from being a *kesuma* ('guest') to being a *nam wora* ('person of the home') in a video message we brought from him for Bokayo, referring to his acceptance in *ola* Jilo Tukena. This trust also derived from the interest Paul showed in Borana culture. Bokayo remembers other Europeans in the area, but none showed the level of interest in, and respect for their culture that he did, and none could speak the language. Borana were aware that his photography was part of his wider effort to understand their society.

As for the reactions of Borana to being photographed, Paul remembers some being unreceptive, while one of his pictures shows an elder covering his head so as to avoid the camera. The explanation was offered to him at the time that Borana were afraid of having their spirit 'captured' by the camera, but only ever by people who didn't mind being photographed speaking on behalf of those who did. In April 2010, the notion that Borana of that earlier generation were afraid of being photographed was put to us by an ex-MP of Marsabit (Jarso Jilo Falana), with a similar explanation offered. However, Paul found that, in the main, people were comfortable to be photographed once at ease with him, although most were not especially interested in seeing the results of the process. He would show some Borana – including Jilo Tukena, who was curious about everything – pictures once developed and sent back from Nairobi, although the delay in getting the pictures from Nairobi meant that by the time the pictures had arrived, the urge to see the images had often gone. Paul and Pat did have non-Borana men working for them – including a Mnyamwezi driver – who were keen on seeing their photographs, and they

gave away some to them. Also, one of the photographs in the collection features a Somali man in a suit next to his Borana wife: this photograph was instigated by the couple themselves who wanted a portrait shot. Most Borana, however, were indifferent, just seeing Paul's use of his camera as an esoteric practice of a *ferenji* (the term used there for Europeans). They certainly never asked Paul to use his camera or demonstrated a deeper interest in the photographic process.

After approximately two years of fieldwork, Paul, Pat and Tim Baxter returned home to the UK in 1953. They then moved back to Oxford where Paul set to work writing his thesis. For him, his photographs were useful in remembering details needed for his writing, and in giving his supervisor and others in the department a visual taste of life in northern Kenya. However, more than this, they could be used by Paul and his family to transport themselves back to Marsabit from their often cold student accommodation in Oxford. After completing his thesis, Paul was not able to use these photographs in his work. This was partly because in his post-DPhil career, he never had the opportunity to teach about Borana. He first returned to East Africa to conduct 18 months of fieldwork in Kabale, Uganda, then secured a teaching post in the Gold Coast in the exciting times of its transition to the independent state of Ghana, after which he moved for a spell of teaching in Swansea, and finally to Manchester, where he joined the department built by Max Gluckman. In his publications on the Borana and on the Oromo more widely, he also did not use these photographs (though his 1978 chapter contains a picture he took on a later research trip among Borana in Ethiopia). They were much used personally, however, placed in a photograph album that goes alongside others containing family pictures taken on the same trip. The negatives remained in a biscuit tin until 2007, when Paul donated them to the Pitt Rivers Museum through Chris Morton, the curator of photographs at the museum.

The collection

The Paul Baxter Collection, now housed at the Pitt Rivers Museum, contains 648 negatives and a photo album. The negatives and album almost match in terms of the images contained, and in their numbering, though at some points there are discrepancies. As part of his donation, Paul also prepared an index, naming many of the people, places and event or objects photographed. In many cases, the index refers to relevant sections in Ton Leus' dictionary of Borana culture (Leus 2006).

The collection covers a large geographic range, being mainly focused on the Borana of Marsabit, although also encompassing Gabra living to the north, Borana near Moyale, the 'Waso Borana' living near Garba Tulla, and Laisamis (where Paul photographed wells and rocks with holes scooped out for playing a board game), Wajir (including images of a military garrison), and Garissa. The range of activities pictured is also large. These include ceremonies such as a long sequence taken at a naming ceremony for a first-born son (*gubbisa*) at *ola* Jilo Tukena on Mount Marsabit. Paul's long sequence of *gubbisa* photographs (around eighty photographs) include images of most sections of the event, although his camera was unable to take pictures inside the *galma* (a purpose-built ceremonial house) and at night (attendees sing and chant throughout the night before the ox is slaughtered). In 2010, we were also able to attend, film

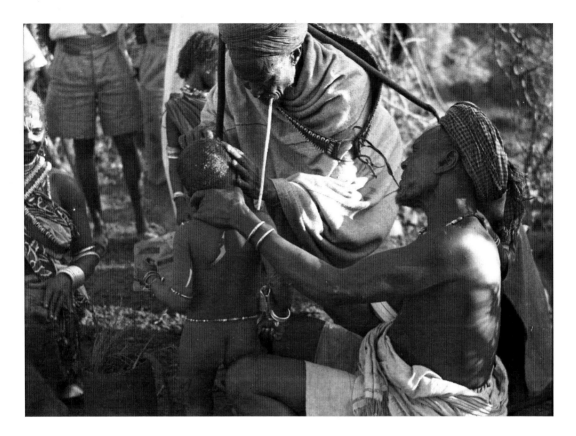

Figure 4.1 Young boy having his head shaved as part of the gubbisa *naming ceremony, c. 1952.*
Reproduced by kind permission of the Pitt Rivers Museum. Classmark: 2008.2.2.398.

Figure 4.2 Mother of a child being named in a gubbisa *ceremony. Note ceremonial dress.*
Reproduced by kind permission of the Pitt Rivers Museum. Classmark: 2008.2.2.339.

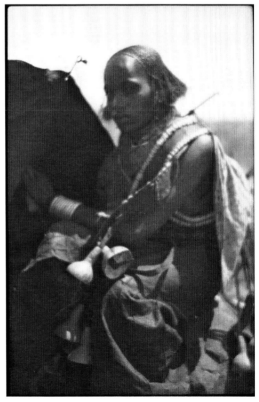

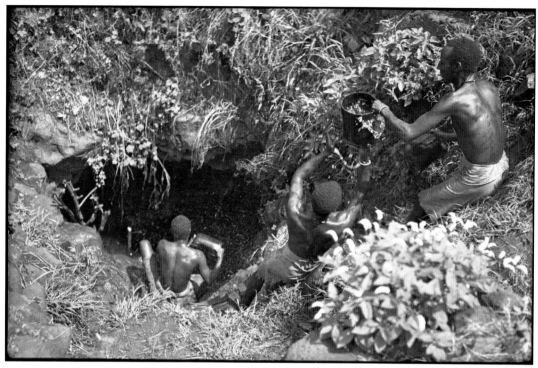

Figure 4.3 Borana drawing water for their cattle, Sagunte Wells, Marsabit.
Reproduced by kind permission of the Pitt Rivers Museum. Classmark: 2008.2.2.169.

Figure 4.4 Bokayo Jilo Tukena and child, c.1953.
Reproduced by kind permission of the Pitt Rivers Museum. Classmark: 2008.2.2.74.

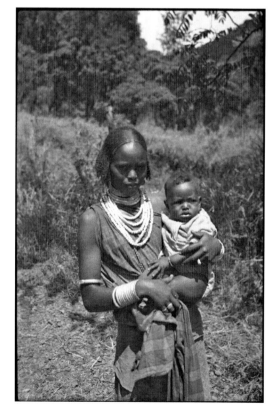

and photograph a *gubbisa* (see Figures 4.1 and 4.2), an event that has changed little in the intervening years.

Paul also photographed burials, veterinary procedures (including camel castration, goat castration, and treatment of cattle by a *ciireesa*, a Borana traditional doctor), and more everyday activities such as herding, watering cattle at wells, milking, weaving and those of a blacksmith at his forge. His shots of the Sagunte wells on Mount Marsabit are some of the most compelling.

Paul photographed his subjects from a range of distances, with some pictures showing him right in the midst of the action, others further away to capture a more encompassing shot, and yet others at a far distance to capture panoramas. As well as capturing people in mid-activity, Paul also took a number of portrait shots. Several of these are of children, and show well the different hair-styles worn by Borana children (Baxter 1978: 170ff), all symbolic of their stage in life. (Such hairstyles are much less common nowadays in Marsabit.) His photographs of children resemble those taken by Schapera, in whose pictures '[t]he angle of his shots, not to mention the inquisitive, direct eye contact made by his young subjects, suggest that he never condescended to them, that he was at ease in their company, that they were at ease with him' (Comaroff *et al.* 2007: 7).

One of Paul's most frequent subjects was Bokayo Jilo Tukena, whom we met in 2010. Her expression in the image reproduced opposite (Figure 4.4) was used by former MP Jarso Jilo Falana in 2010 as evidence that Borana were unhappy to be photographed. However, after tracking down Bokayo later that same visit, she explained how she remembered Paul taking a picture of her with her child, and that she had been sad as the photo was taken when Paul and Pat were leaving: thus, the personal story behind the image undermines attempts to generalize about how Borana of that generation felt about photography. A number of the photographs are of extremely important figures in the region including Jilo Tukena, Gufu Sora (chief of the Borana of Moyale), and Haji Galma Diida (chief of the Waso Borana, later killed in an ambush by pro-secessionist fighters in June 1963 [Aguilar 1996]).

A collection dealing with northern Kenya in that era is a rarity. There had been important photographic work done in the region before, but mainly of animals, notably by Martin and Osa Johnson who lived by the shores of Gof Sokorte, a crater on Mount Marsabit they named 'Lake Paradise', in the 1920s (Johnson 1997 [1940]). Also, Joy Adamson took photographs of Borana and others in northern Kenya for her 'Tribal Heads' work around the same time as Paul and family were living in Marsabit (in fact, Paul has a number of animal photographs taken by Joy, having met her and George Adamson and visited them at their home in Isiolo). There are also a number of photographs available online from the NFD in colonial times.[7] Clearly, other amateur photographers visited the region too, as well as professional film-makers who made use of northern Kenya's people and places in films like *Mogambo*. However, the Baxter Collection is the result of two years' living and working with people whom Paul got to know well, just as they became accustomed to him. As such, Paul had unprecedented access to activities and ceremonies not previously photographed in the region, and given the marginality of the area, little photographed since. They offer snapshots of people and their activities

[7] For example, see http://www.gordonmumford.com/eastafrica/n-frontier.htm (accessed 18/10/10).

and material culture at a time when few people had cameras, and so provide a benchmark from which social changes (and changes in landscape usage) can be observed. The photographs also provide a resource with which Borana in Marsabit are eager to engage, as their return to Marsabit in 2010 was to reveal.

Return to Marsabit

A two-day trip to Marsabit in April 2010 provided the first opportunity to see the potential in 'repatriating' the Baxter collection. This exploratory trip involved Carrier and students from the British Institute in Eastern Africa taking a selection of thirty of Paul's photographs (reproduced A4 size on a photocopier) and a computer with the whole collection stored on a hard drive.[8] The hasty nature of this trip meant that the team did not have Paul's index to the photographs with them, and identifying people and locations thus required some detective work and much luck. The latter was in great supply in the choice of lodging, as the staff at the Jey Jey Centre (owned by Jarso Jilo Falana) proved a mine of information and community contacts. Most importantly, the staff there recognized Bokayo Jilo Tukena from the image of her with the child (Figure 4.4), and after a few false leads, we were taken to meet her. Meeting Bokayo was a moving experience. She and her husband Jilo had seen Paul a couple of times in the intervening decades since his fieldwork, but not for thirty or so years, and she was delighted to hear that Paul and Pat were alive and well in the UK.

Her memories of Paul, Pat and Timmy were vivid, and she looked back on the era when the pictures were taken with nostalgia – at that time, she said wistfully, 'I was a person' (a phrase translated from the Borana – *gaffas aknama jira*), an idiomatic way of saying 'when I was young and strong'. She remembered Paul's interest in the *aadaa* ('customs') of the Borana, and also that Paul was always taking photographs – she playfully recalled asking, 'will you ever be satisfied?' Indeed, she does feature in a number of Paul's photographs, a testament to the amount of time he spent in her village. She recalled individual photographs, including the one of her and her child (Figure 4.4). Hearing that Carrier would be meeting Paul and Pat before returning to Marsabit in July, she readily agreed to record a message for them (in Borana), asking whether they and their family 'had peace' (*nageni badada?*) and reassuring them that she and her family also had peace. This greeting prompted a response from Paul in the form of the video addressed to Bokayo that the team returned with in July.

While collections of ethnographic photographs can provide source communities with links to their own ancestors, an aspect that should not be ignored is their power to renew links between these communities and the ethnographers who studied them. Such ethnographers are often well remembered amongst such communities, which is certainly the case with Paul. They become part of the history of a people, and the memories they leave behind endure.

[8] These students were Badr Shariff Ali, Hassan Kochore (himself a Borana from Marsabit), and Emma Lochery. Thanks to all of them.

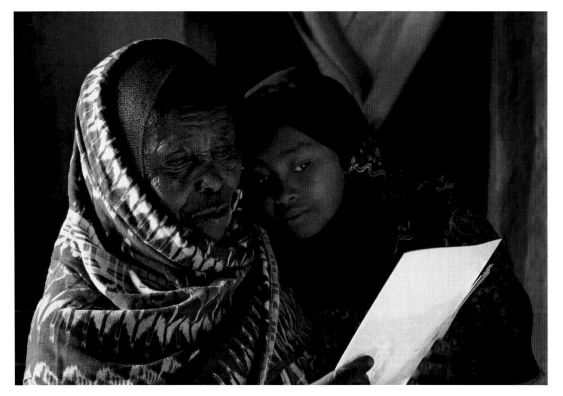

Figure 4.5 Bokayo and young relative looking at a photograph of Paul Baxter taken in the 1950s, Marsabit, July 2010.
Photo by: Kimo Quaintance.

The Baxter Collection as 'social passport'

The April trip suggested the potential of a photo-repatriation and elicitation research project using the Baxter Collection, and laid the foundations for the return trip in July. This was a longer research trip, involving two and half weeks fieldwork in Marsabit (and a brief trip to Moyale) and a team now also comprising Quaintance, who was charged with recreating photographs from the collection, as well as exploring reactions to photography in contemporary Marsabit. We intended to find more of the locations in the photographs, and identify more people within the images, hoping to build as large a network of knowledgeable informants as possible to reduce the risk of misidentifications by cross-checking information. At first, it was all too easy to make mistakes, and we have a number of photographs of people holding pictures of their 'ancestors' who turned out not be their ancestors. Some were too keen to see their kin or themselves in the images, with one informant even misidentifying herself as one of the subjects of Paul's pictures. As we became aware of such dangers and wary of accepting identifications without triangulation against other sources, the data we collected became more accurate and useful for the cataloguing of the collection.

Following the logical sequence of photographic documentation identified by Collier and Collier (1967, 1986) – from outside to inside, from most public to most private – our photographic research in July can be seen to have evolved in three distinct phases:

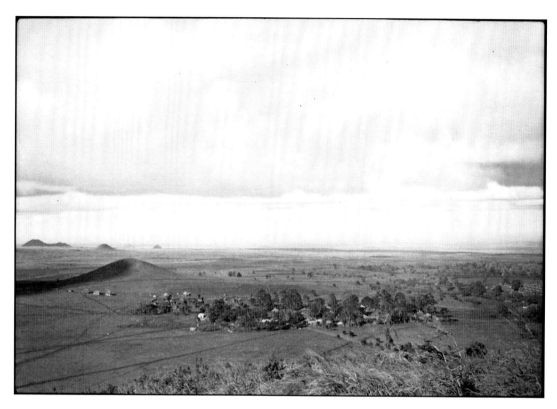

Figure 4.6 Marsabit from above, c.1952.
Reproduced by kind permission of the Pitt Rivers Museum. Classmark: 2008.2.2.640.

Phase one – capturing a changed landscape. First were journeys outward to make contact with local sources and match landscape photographs from Paul's collection to collect more contextual details for the future cataloguing of the collection, and to provide comparative visual data on changing patterns of landscape usage. This phase of research involved talking with many Marsabit inhabitants, some of whom had no links to the town in the 1950s. While few knew the individuals photographed in the album, all were fascinated by the physical changes to Marsabit town, and proved invaluable in identifying the terrain depicted in his photos.

Our first photographic foray was to find the exact location of Paul's view of Marsabit from above (Figure 4.6) to document the physical changes to the town since his time. In terms of human changes to the Marsabit landscape, population growth has been dramatic since the early 1950s, jumping from fewer than 5,000 residents in 1951, to nearly 40,000 in 2010, while the Marsabit district population has jumped from approximately 20,000 in 1951, to nearly 200,000 in 2010 (Witsenburg & Roba 2007). The strain of population growth and attendant deforestation on Marsabit Mountain, combined with recent droughts, have led to an acute shortage of water in the area, with several Marsabit informants commenting that these factors have had a significant impact on local cattle wealth and life in general. A comparison between Paul's photograph and our recent one provide a vivid contrast between 'then' and 'now', illustrating the vast growth of the town and the changes in vegetation.

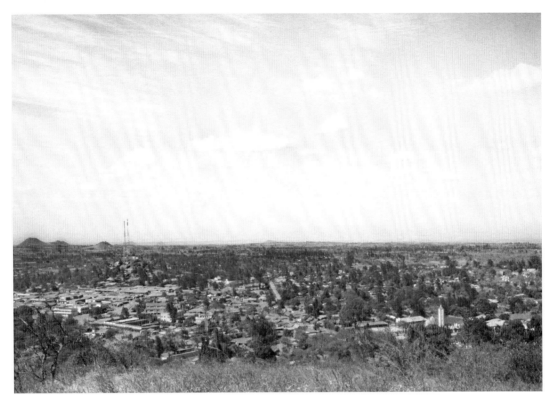

Figure 4.7 Marsabit from the same location, 2010.
Photo by Kimo Quaintance.

Another example of this research phase involved the search for a hill pictured in Paul's photographs where the village of Paul's informant Warrio Elema had been located. Having recognized the hill to the south of Marsabit town when driving through the area, we photographed it (now devoid of settlement), and spoke to nearby Rendille men and women who had moved into the area many decades ago. Whereas in Paul's day, the area was occupied by Borana, now Rendille dominated. In examining the photographs of old Borana settlements, Rendille emphasized that Marsabit as a whole should be thought of as a Rendille area, implying that they had precedence over the Borana. This reflected a tension between the two groups that has simmered over the years, occasionally spilling over into violence over land and water resources, and mutual livestock raiding (Fratkin & Roth 2005). The mutual suspicion of Borana and Rendille was summarized self-reflexively by a Rendille we met that day: 'The trouble is that the Borana are bad people ... [reflective pause] And Rendille are too!' Rendille were intrigued by the collection, especially by the length of years since the photographs were taken, although they were disappointed upon flicking through the pictures and finding no Rendille.

Phase two – the fame of the photographs spreads. From these initial forays and with the help of staff at the Jey Jey Centre, word circulated through Borana networks about the photographic collection, drawing to us a stream of visitors – mainly older men – keen to see if their own relatives were pictured. One such man was Boru Galgallo, whose young days had involved herding cattle

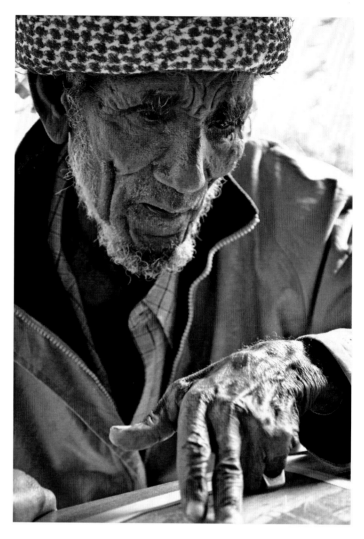

Figure 4.8 Photo-elicitation in Marsabit with informant Boru Galgallo, Jey Jey Centre, July 2010.
Photo by Kimo Quaintance.

around Marsabit; as a consequence, he had met many of the people in the photographs. He provided information on the life trajectories of some of the photographic subjects, studying the images intently while transported back to his youth. His memory was astounding, and he corrected a number of false leads we had been given. One of these we had discovered ourselves to be a misidentification, but still mentioned to him as a way of gauging his memory – he soon corrected us and gave the right identity.

Another man who tracked us and the collection down at the Jey Jey Centre was Guyo Bonaiya Dido, the son of Bonaiya Dido, a *ciiressa* ('traditional doctor') who is still well remembered in Manyatta Jilo where he lived. He was happy to be photographed with a picture of his father (Figure 4.9) proudly rearranging his headdress to mirror the style worn by his father in the photograph.

We were keen to meet anyone from the images still alive, and had heard that one such person was Duba Abaale, another who used to live in Jilo Tukena's village. The son of Duba Abaale received word about the collection and his father's photograph, coming along to the Jey Jey Centre to find us. Duba Abaale is now blind, but still has a sharp memory, and it was he who recounted how Paul was first introduced to those living in the *ola* Jilo Tukena (see above).

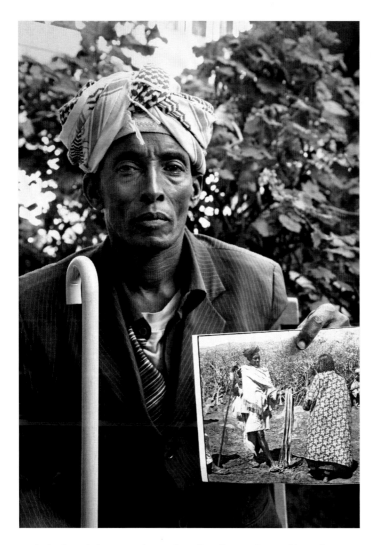

Figure 4.9 Guyo Bonaiya Dido, Jey Jey Centre, July 2010, holding a picture of his father, Bonaiya Dido.

Photo by: Kimo Quaintance. Bonaiya Dido photo reproduced by kind permission of the Pitt Rivers Museum. Classmark: 2008.2.2.393

Duba's facial features have hardly changed at all in the intervening years, as comparing the two images in Figure 4.10 makes clear. He recounted his fame as a swift runner (nicknamed *Barisa*, 'the flyer') and remembers taking messages from Paul back to Pat in town, and then returning with supplies of whatever Paul had needed.

The impact of the photographic collection and its 'ghosts' was such that networks stretching out from the Jey Jey Centre kept a continual stream of people coming to see us, constantly providing new contextual detail about the photographs and the biographies of those contained within. Such was the value of the photographic collection to the community that the usual dynamic of researcher tracking down subject of research in fieldwork was reversed. Collier and Collier describe how photographs can shift the dynamic between researcher and researched:

> Because photographs are examined by the anthropologist and informants together, the informants are relieved of the stress of being the subject of the interrogation. Instead their role can be one of expert guides leading the fieldworker through the content of the pictures. Photographs allow them to tell their own stories spontaneously. This usually elicits a flow of information about personalities, places,

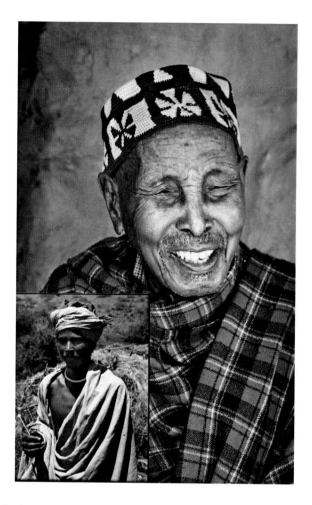

Figure 4.10 Duba Abaale, Marsabit, 2010 (Inset: his picture from 1952).

Photo by Kimo Quaintance. Inset reproduced by kind permission of the Pitt Rivers Museum. Classmark: 2008.2.2.4.

processes, and artefacts. The facts are in the pictures; informants do not have to feel they are divulging confidences. All they are doing is getting the history in order and the names straight'. (1986: 107)

In our case, people who came to the Jey Jey Centre to look at the pictures would often not even enquire about the nature of our research, becoming so absorbed in the process of finding individuals from long ago that they did not express curiosity about our motives (though we would explain our reasons as often as possible). While standard fieldwork often involves tense short-term exchanges (information for gifts or money), and the results of the research are not released until months or years later, the Baxter Collection acted as a type of social currency, producing an almost instant gratification on the part of those who came to view it, especially for those who found their relatives within. Again this reflects the great local worth of this collection of ethnographic photographs, and the notion that rather than coming merely to extract information about culture and history, by bringing the Baxter Collection we were in a sense repatriating an aspect of Borana culture and history.

Phase three – into the villages. The third phase of our trip involved being brought into villages around Marsabit by informants keen to show us events similar to

those photographed by Paul. We were able to witness three different naming sessions, one a *moogatii* (a naming ceremony for a child other than a first-born son); an Islamic naming ceremony (this shared many structural features with 'traditional' naming ceremonies, though was on a smaller scale); and, most importantly, a *gubbisa* which allowed us to photograph the same ceremony that Paul had covered many decades earlier (see above). Attending this *gubbisa* allowed us to produce a sequence of matching photographs to those taken by Paul at the *gubbisa* in the 1950s. With today's camera technology, however, we were able to cover more of the ceremony than Paul could, simply by virtue of being able to photograph in low light even without the use of a flash.

Comparing the 2010 photographs to those taken by Paul reveals far more similarities than differences. The principal components of the ceremony, the settings and the ritual objects in evidence were almost identical (compare Figures 4.2 and 4.11). In fact, in showing Paul and Pat Baxter the *gubbisa* photographs following the trip, they found the similarities impressive, although there was a major difference that intrigued Pat: the clothing. Back in the 1950s, Borana clothing was very different, with women wearing skins and men wearing cotton cloaks. Pat was especially taken by a picture of the young boy being named at the 2010 ceremony and the contrast between his western-style clothing and the age-old Borana ritual object of the *meedicha* (Leus, 1995: 450), a strip of skin cut from a just sacrificed ox, worn on the wrist 'to get the blessings of, and show participation in the ceremony' (ibid.).

At these ceremonies, photography proved an invaluable vehicle for building trust with members of the community, with the historical photos first serving

Figure 4.11a Ware Mama Boru, mother of Boru, (compare with Figure 4.2). Figure 4.11b Boru Bonaiya Galgallo and his meedicha.
Photos by Kimo Quaintance.

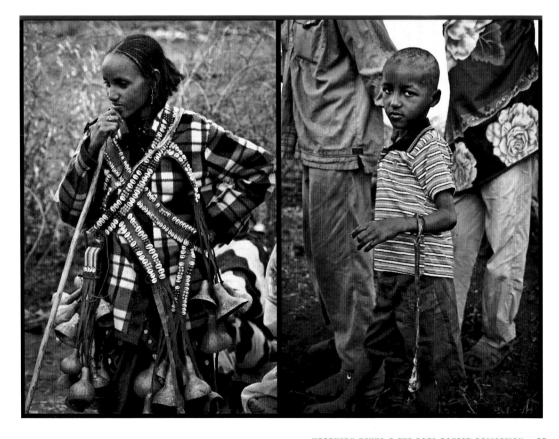

to rationalize our presence to those we encountered. In the most dramatic example, our arrival at the *gubbisa* generated an intense controversy, with one man angrily denouncing our local interpreter for bringing 'tourists' to photograph a sacred ceremony. Once we were able to explain ourselves and share the historical photographs, the same individual approached us to comment, 'Your work is very important to us ... thank you for bringing this history back to us. Please photograph anything you like and I will explain it to you.' Also, the father of the ceremony took great pride in the historical depth of the *gubbisa* ceremony, and was intent that we should document his son's ceremony as thoroughly as possible to complement Paul's work in the 1950s. He remarked that doing so 'is important for our history'.

Borana generally were keen to have such events recorded, and an interesting aspect of the *gubbisa* was the tape recording by a young man of elders singing. We were told that the younger generation feared such songs might die out with the elder generation, hence the need to preserve them, although similar recordings are also commodified in northern Kenya. Awareness of a monetary value of culture connects Borana with other groups throughout Kenya, and globally, as 'culture' becomes seen as a commodity with commercial value (Comaroff & Comaroff 2009). This emerged during our fieldwork when a local councillor expressed his wish that tourists could be attracted to such events in future, just as they are attracted to Maasai ceremonies in southern Kenya. New ways of utilizing 'culture' are in the air.

Stepping from historical to contemporary photography, we made a further leap in building trust at this same *gubbisa* ceremony when we turned our cameras over to attendees to document whatever they wished. In some cases, individuals abruptly switched from avoiding the camera when in our hands, to orchestrating group portraits when in the hands of those they knew and trusted. The empowerment of direct involvement in photographic creation, coupled with the instant gratification of digital displays for their images (which contrasts sharply with the time delay faced by Paul before he could show people his photographs), caused a nearly instantaneous desire for involvement in the process to spread it among members of the community. Reluctant subjects became eager participants and photographic access to all areas of the ceremony was granted. Furthermore, the photographic and video evidence to emerge from this process opened a fascinating window into what *they themselves* found valuable and worth documenting at such an event. While ceremonial regalia and ritual objects were recorded, photographs taken by participants also included a passing motorbike and an elder chewing the stimulant khat. Most of all, however, the photographs focused squarely on the other attendees, capturing numerous posed group shots, as well as more candid shots of subjects mid-conversation or in other activity. Individuals who had been unwilling to let us capture their images were captivated by watching friends and relatives transform from photographic subjects to photographers, with immediate digital evidence of their skills.

Symbolic of our acceptance at the *gubbisa* was that we too were given *meedicha* from the sacrificial ox to wear. Paul was also given *meedicha* at the numerous ceremonies he attended in the 1950s, and thanks to both the photo album of his pictures that we brought along, and our experimentation with photography at the event, we were also given this honour and treated as participants in this important rite in the life of a Borana child.

Paul's photographs, and the repatriation of collective memory and culture they represented, created a self-sustaining momentum of community interest and active assistance that allowed us to do far more effective research than would have been possible with non-photographic means in that time frame. Photographic repatriation proved an accelerant for the entire cycle of research, building trust, and community involvement, with the photographs themselves acting as a type of 'golden key' or 'social and cultural passport', noted by visual anthropologists such as Collier and Collier (1984) and Marion (2010). The collection encapsulated in visual form the relationships that Paul had built up over the course of his fieldwork between 1951 and 1953. With the photo album in hand, this ethnographic collection allowed us to tap into links forged almost sixty years earlier. Thanks to this legacy and the warm reaction to the project, we quickly generated a significant amount of material useful in contextualizing the collection, as well as a comparative visual record of aspects of life in Marsabit and northern Kenya in 2010 to complement that provided by the Baxter Collection.

As a function of Paul's anthropological method, his sporadic bursts of ethnographic photography have left a visual legacy of an era many Borana still look back on with nostalgia: a time before the troubles of the *shifta war* when culture was strong and food in plenty. The 1950s are still sung about by younger generations today as something of a 'golden age'.[9] The collection is certainly unique for this frontier region, especially given that the cameras of other photographers in the region – such as the Johnsons – were primarily turned on animals rather than people. As an anthropologist, Paul's gaze was almost invariably on people and the objects and places that they create and infuse with meaning, and it is because of this that his collection contains so many 'ghosts' for the people of Marsabit. Continued potential exists to return other images in the collection to Gabbra, Somalis and other communities whom Paul met in his fieldwork in the NFD, and plans are afoot to hold an exhibit of the pictures at a cultural centre being built in Marsabit to widen access to the images further.

As Wright (2004) maintains, understanding reactions to photographs requires a wider understanding of how photography is itself perceived. In this case, the reaction of people in Marsabit to the collection and to our own photographic practice emerged in a social context where photography is scarce: for all its acknowledged social and cultural value, photography remains a rare pursuit in the region. Few people have film cameras, and fewer still have access to a digital camera. Even were one to possess a camera, the cost of developing photographs in Marsabit is exorbitant. Whilst in Nairobi, decent prints can be had for a few shillings (equivalent to a few pence); in Marsabit the few studios that exist merely print low quality reproductions using a basic printer, charging 100 shillings for a single print – equal to the price of two loaves of bread. Few can afford to use such a service aside from the occasional studio portrait. We saw little evidence of other photography at events such as naming ceremonies: people suggested that photography is unusual at such

[9] Hassan Kochore, personal communication, October 2010.

events, unlike at more western-style marriage ceremonies in town. Wealthier people have framed portraits of family members in their houses, but for most, obtaining a good photograph of oneself or one's kin is a very rare occurrence.[10] Yet our research returning the Baxter Collection showed just how appreciated photography is in this frontier region, how engaged people can be in participating in it, and how powerful a medium for the preservation and documentation of personal and collective history it can be.

As with Schapera, Paul's photography in the 1950s was intended as 'purely a visual record, the illustrative stuff of the ethnographer's notebook' (Comaroff & Comaroff 2007: 11). However, it has proved much more than that, capturing 'enduring passions and interests, enduring relations, enduring ways of being in the world' (ibid.). Further effort needs to be expended to broaden access to the collection for those for whom it is most meaningful; with such effort, it can not only reconnect generations of Borana, but also help create connections between the worlds of source communities and those of western academic and archival institutions. In this case, such connections are built on the efforts of the ethnographer to understand another society, and the 'ghosts' of individual relationships, familial lineages and cultural practices captured by his camera almost sixty years earlier.

[10] While cameras are uncommon in Marsabit, camera phones are not, and these have become the major medium through which people take photographs and view them. Indeed, through this medium, many people are getting a taste of being photographers rather than photographic subjects. This was brought home to us in our research when a Rendille home guard in Marsabit refused to allow us to take a photo of him, and then proceeded, without asking permission, to take a picture of us on his camera phone. There is much to learn from research into photography's newer material forms: camera phones and digital images.

Bibliography

Aguilar, M. I. 1996. 'Writing Biographies of Boorana: Social Histories at the Time of Kenya's Independence', *History in Africa* 23: 351-67.

Anderson, D. M. & N. Carrier. 2009. 'Khat in Colonial Kenya: A History of Prohibition and Control', *Journal of African History* 50: 377-97.

Arero, H. W. 'Coming to Kenya: Imagining and Perceiving a Nation among the Borana of Kenya', *Journal of Eastern African Studies* 1 (2): 292-304.

Baxter, P. T. W. & U. Almagor (eds). 1978. *Age, Generation and Time: Some Features of East African Age Organisations*, London: Hurst.

Baxter, P. T. W. & A. Butt. 1953. *The Azande and Related Peoples of the Anglo-Egyptian Sudan and the Belgian Congo*, London: International African Institute.

Baxter, P. T. W. 1954. The Social Organisation of the Galla of Northern Kenya, unpublished DPhil thesis: University of Oxford.

—— 1965. Repetition in Certain Boran Ceremonies, in *African Systems of Thought* (eds) M. Fortes & G. Dieterlen, London: Oxford University Press.

—— 1970. 'Stock Management and the Diffusion of Property Rights among the Boran', in *Proceedings of the Third International Conference of Ethiopian Studies* (1966) 3: 116-27, Addis Ababa.

—— 1972. Absence Makes the Heart Grow Fonder, in *The Allocation of Responsibility* (ed.) M. Gluckman, Manchester: Manchester University Press.

—— 1978. Boran Age-sets and Generation-Sets: *Gada*, a Puzzle or a Maze? in *Age, Generation and Time: Some Features of East African Age Organisations* (eds) P. T. W. Baxter & U. Almagir, London: Hurst.

P. T. W. Baxter, J. Hultin & A. Triulzi. 1996. *Being and Becoming Oromo: Historical and Anthropological Enquiries*, Uppsala: Nordic Institute.

Bell, J. A. 2003. Looking to See: Reflections on Visual Repatriation in the Purari Delta, Gulf Province, Papua New Guinea, in *Museums and Source Communities: A Routledge Reader* (eds) Peers & Brown, London: Routledge.

Binney, J. & G. Chaplin. 2003. Taking the Photographs Home: The recovery of a Māori history,in *Museums and Source Communities: A Routledge Reader* (eds) Peers & Brown, London: Routledge.

Brown, A. K. & L. Peers with members of the Kainai Nation. 2006. *Pictures Bring Us Messages: Photographs and Histories from the Kainai Nation*, Toronto: University Press.

Cerulli, E. 1922. *Folk Literature of the Galla of Southern Ethiopia*, Cambridge MA: Harvard African Studies.

Collier, J. 1957. 'Photography in Anthropology: A Report on Two Experiments', *American Anthropologist* 59: 843-59.

Collier, J. & M. Collier. 1967, 1986. *Visual Anthropology: Photography as a Research Method*, Albuquerque: University of New Mexico Press.

Comaroff, J. L., J. Comaroff & D. James. 2007. *Picturing a Colonial Past: The African Photographs of Isaac Schapera*, Chicago IL: University Press.

Comaroff, J. L., J. Comaroff. 2009. *Ethnicity, Inc.*, Chicago IL: Chicago University Press.

Edwards, E. 2001. *Raw Histories: Photographs, Anthropology and Museums*, Oxford: Berg.

—— 2003. Introduction: Locked in 'The Archive', in *Museums and Source Communities: A Routledge Reader* (eds) L. Peers & A. K. Brown, London: Routledge.

Fratkin, E. & E. A. Roth. 2005. The Setting: Pastoral Sedentarization in Marsabit District, in *As Pastoralists Settle: Social, health and economic consequences of the pastoral sedentarization in Marsabit District, Kenya* (eds) E. Fratkin & E. A. Roth, New York NY: Springer-Verlag.

Fratkin, E. & K. Smith. 1995. 'Women's Changing Economic Roles with Pastoral Sedentarization: Varying Strategies in Alternate Rendille Communities', *Human Ecology* 23 (4): 433-54.

Haberland, E. 1963. *Galla Sud-Athiopiens*, Stuttgart: W. Kohlhammer.

Harper, D. 2002. 'Talking about pictures: A case for photo elicitation', *Visual Studies* 17 (1): 13-26.

Hogg, R. 1986. 'The New Pastoralism: Poverty and Dependency in Northern Kenya', *Africa* 56 (3): 319-33.

Johnson, O. 1997 [1940]. *I Married Adventure*, New York NY: Kodansha International.

Kratz, C. 2002. *The Ones That Are Wanted: Communication and the Politics of Representation in a Photographic Exhibition*, California: California University Press.

Leus, T. 1995. *Aadaa Boraanaa: A Dictionary of Borana Culture*, Addis Ababa: Shama Books.

Lobley, N. 2010. The Social Biography of Ethnomusicological Field Recordings: Eliciting Responses to Hugh Tracey's *The Sound of Africa* Series, Unpublished D.Phil Thesis: University of Oxford.

Marion, J. S. 2010. 'Photography as Ethnographic Passport', *Visual Anthropology Review* 26 (1): 25-31.

Mills, D. 2002. 'Anthropology at the end of the British Empire: The rise and fall of the Colonial Social Science Research Council 1944 -1962', *Revue d'Histoire des Sciences Humaines* 6: 161-88.

Morton, C. 2009. 'Fieldwork and the Participant Photographer: E.E. Evans-Pritchard and the Nuer Rite of *gorot*', *Visual Anthropology* 22: 252-74.

Muriuki, G. & N. Sobania. 2007. 'The Truth Be Told: Stereoscopic Photographs, Interviews and Oral Tradition from Mount Kenya', *Journal of Eastern African Studies* 1 (1): 1-15.

Peers, L. & Brown, A. K. (eds). 2003. *Museums and Source Communities: A Routledge Reader*, London: Routledge.

—— 2009. 'Just by Bringing These Photographs...': On the Other Meanings of Anthropological Images, in *Photography, Anthropology and History: Expanding the Frame* (eds) C. Morton & E. Edwards, London: Ashgate.

Poignant, R. 1996. *Encounter at Nagalarramba*, Canberra: Canberra University Press.

Reece, A. 1966. *To My Wife Fifty Camels*, London: Harvill Press.

Schlee, G. 1989. *Identities on the Move: Clanship and Pastoralism in Northern Kenya*, Manchester: Manchester University Press.

Smith, R. S. & R. Vokes. 2008. 'Introduction: Haunting Images', *Visual Anthropology* 21 (4): 283-91.

Witsenburg, K. & Roba, A. W. 2007. The Use and Management of Water Sources in Kenya's Drylands: Is there a link between scarcity and violent conflict? in *Conflicts over Land and Water in Africa* (eds) B. Derman, R. Odgaard & E. Sjaastad, East Lansing MI: Michigan State University Press.

Wright, C. 2004. 'Material and Memory: Photography in the Western Solomon Islands', *Journal of Material Culture* 9 (1): 73-85.

Young, M. W. 1998. *Malinowski's Kiriwina: Fieldwork Photography 1915-1918*, Chicago IL: Chicago University Press.

Memories of a Blue Nile home
The photographic moment & multimedia linkage

Judith Aston & Wendy James

This chapter is based on an ongoing collaboration between the authors. We first explore the role of photographs within what became a long-term, though intermittent, anthropological engagement by Wendy James in the turbulent regions of the Sudan/Ethiopian borderlands, especially with the Uduk-speaking people. Although only touching occasionally on photographs taken by local people, our case study offers what we believe to be a usefully different picture of the social relations of photography carried out in Africa from that of the classic ethnographic encounter. Moreover we argue that a creative use of today's digital technology, as being developed by Judith Aston, is opening up fresh possibilities for the circulation and exchange of pictures, old and new, between the original ethnographer and various members of the original studied community, both 'at home' and in various parts of what became their diaspora.

A pattern of give-and-take developed from the mid-1960s on between James and her informants as their paths crossed for a string of different reasons – including political upheaval (James 2000; 2007). Photography and photographs sometimes acquired real social agency during these years of intermittent contact. The significance of sending photos around became crucial with the destruction of the Uduk homeland in the late 1980s, and the multiple displacements of the people since. Exchanging pictures of a one-time 'home' between those who used to share a way of life there has now developed its own momentum. During this time too, what Richard Vokes in his chapter here calls 'village photography' began to emerge. It soon took on a very particular form or 'mode' of local practice as rural communities were variously displaced from home by conflict, a whole new generation growing up in refugee camps or finding permanent resettlement in the USA, Canada, and Australia. In his opening chapter here, Chris Morton highlights the 'relational' qualities that may underlie a set of photographs taken more or less at the same time and in the same place; here, we try to extend this concept, and to identify the kinds of relationality that may obtain over time – in this case half a century; and space – in this case, global space. We emphasize at the same time how James's photos from the beginning were often accompanied by moving images, and audio recordings closely interwoven with her writings, thus making the collection especially open to cross-linking and well adapted for multimedia presentation. In collaboration, we are therefore engaged in creating a multimedia archive, searchable not only for 'data' but for stories, including the story of the role of still photographs in the networks generated by James's ethnographic encounters.

Creative use of multimedia resources can add a 'three-dimensional' sense of reality to photographs as such. The diverse character of a modern ethnographic archive can lend depth to the understanding of photographs within it, those captured moments which in some cases clearly 'speak' to or illuminate each other. It can illuminate their changing significance and value for those 'local people' represented, and the beginnings, perhaps, of their own appropriation of

photographic practice; it can also suggest within its own spaces the presence of the ethnographer and her or his changing motivations. The potential of digital forms of dissemination to open up new audiences for this kind of work is obviously immense, along with the possibilities for engaging with diaspora communities who may be keen to add their own materials and participate in shaping an evolving archive.

A note on anthropologists and their 'archives'

Fieldworking anthropologists for at least a century now have tended to amass substantial numbers of photographs, among all the other evidence of their research. Only a very small selection get published in books, or returned to the people who were the object of study. In the old days, photos were developed back home and return visits to the same field area were quite rare. The question of what to do with the material has always been there, and many scholars of all kinds have deposited their photos in some kind of library or museum, or left them with family papers. They have typically been separated from academic papers and notebooks. The questions which present themselves to today's anthropologist wondering 'what to do with the material' are much more complicated than they once were, not simply because of the new technology but also because of the clash between the principles of opening up access on the one hand and confidentiality on the other, as Pat Caplan argued in a very pertinent article in *Anthropology Today* (2010). In today's often troubled world, this is a complex issue when archiving qualitative data relating to the ongoing lives of individuals and communities. The question of what the anthropologist of today should do with their archives has become quite urgent, for all these reasons, as Caplan pointed out with reference to her own material from Nepal and India as well as to the role of bodies such as the RAI, the ASA and the ESRC. These questions were followed up by Cat Davies in a subsequent column in *The Times Higher*, where she quoted some additional points made in her discussions with James (Davies 2010).

As for the older type of photographic collection, the recent volume edited by Christopher Morton and Elizabeth Edwards illustrates a whole range of new ways of adding depth to the historical and anthropological significance of photographic archives of the kind left by our predecessors – including the well-known figures of Boas, Evans-Pritchard, Layard, Haddon and Beatrice Blackwood, as well as others (Morton & Edwards 2009; see especially the editors' introduction). Here we see how the processes of assembling and reassembling photographic archives of the traditional kind itself adds historical interest to a collection, because each time new lines of interpretation are available and can be developed. It is also shown how the deliberate return of old photographs to remote communities, who see in them their own history, can be an important cultural and even political event – for example, in Peers and Brown's case of the 'visual repatriation' of some key 1925 photographs from the Pitt Rivers Museum to the Kainai people of Alberta. A parallel case is offered in the present volume by Neil Carrier and Kimo Quaintance in describing the response of people in northern Kenya to Paul Baxter's old photos. All these new ways of deploying images from the archive have implications for the changing character of the visual imagination of mainstream social anthropology itself, the need to get beyond the relative neglect of photography in its mid-twentieth

century heyday, and, in David MacDougall's lucid terms, move towards the new 'cinematic imagination' which followed the inspirational work of Jean Rouch (MacDougall 2009). Our contribution here is offered in the same spirit.

Today, taking pictures – or making recordings and even written notes – 'in the field' is vastly easier than it used to be, thanks to all the new gadgets. Even before the arrival of digital cameras, the fieldworker could come home with a variety of visual and audio material in addition to 'ordinary photos'. And it has also become much easier for ethnographers to return to the same field area, even repeatedly, after their initial trip. A tangible 'historical' quality may have accrued to their earlier material, in the eyes of their informants as well as their academic colleagues. The passage of time does seem to add, partly for this very reason, to the coherence of the records as a whole; and to pose the question even more sharply as to how that coherence can be preserved, and made relevant to a variety of audiences and to ongoing events.

Fortunately, there are, today, alternatives to the family attic or the departmental library stacks. Mike O'Hanlon, Jeremy Coote, and their colleagues at the Pitt Rivers Museum have pioneered the creative online archiving of both photographs and items of material culture from the southern Sudan region (broadly defined), as Chris Morton's chapter here illustrates. The images are presented elegantly in contemporary modes of information design, and are an invaluable resource accessible to anyone with computer facilities (*http:// southernsudan.prm.ox.ac.uk*). The Pitt Rivers is also sponsoring projects which bring old ethnographic films into view along with the contexts in which they were taken – see Alison-Louise Khan's Oxford Academy of Documentary Film project, 'Captured by Women' (*http://www.oadf.co.uk/blog/category/captured-by-women*). James's earliest cine footage from the 1960s is already associated with that initiative – as a part of the larger project of creatively archiving her materials as a whole. Online there are some striking examples of creative archiving which also offer possible models. There is the Sudan Open Archive of the Rift Valley Institute, for example (administered by Dan Large), focusing mainly on scarce or vulnerable written materials and the ephemeral literature of the development agencies (*www.sudanarchive.net*). Visual images at present, however, are limited to those already embedded in text as illustrations. Very different in style is the substantial and culturally focused website 'Mursi Online', built around the decades-long ethnographic work of David Turton among the Mursi of south-west Ethiopia (*www.mursi.org*). Here we can see film clips, photos, textual descriptions and analysis, with news of ongoing development issues; and as a real innovation, the site now includes contributions from two Mursi men themselves, who visited Oxford and were able to undertake some training in making videos and maintaining the site.

The project underway to create a multimedia archive of James's material draws on aspects of all these models. But we plan to go a little further in attempting to engage the subjectivities of informants, their own reflections on the past – including past photographs and films – along with the individuality of their memories and hopes, their musical enthusiasms, their interactions and silences in conversation with each other and with the ethnographer at different historical periods. It is hoped that future users will feel invited to enter a world they can empathize with despite its initial 'otherness' – a world of experiences which sound and imagery, in counterpoint to the written analyses of the scholar, can help make more accessible.

Wendy James learned to use a little box camera as a child, and as a teenager in the 1950s she was very impressed by the arrival of colour – in the form of film for taking colour slides, which her father and various friends and family took up enthusiastically as a way of recording their travels and giving presentations. (For a fuller discussion of the social history of the colour slide phenomenon and how it affected her, see James 2010.) Following her father to the Caribbean in 1959, and to East Africa in 1961, she took dozens of slides and gave talks about her adventures back home. By 1964, she had taken up a lectureship at the University of Khartoum in the Sudan, naturally packing a

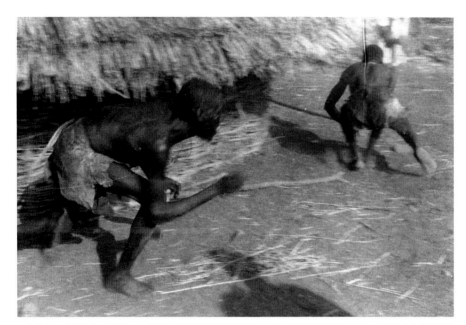

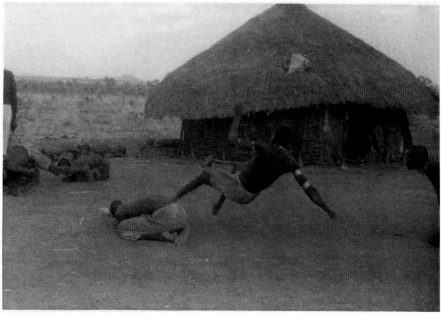

Figures 5.1a and 5.1b Black & white photographs of Diviners' Charade, near Chali (Blue Nile Province, Sudan) showing movement.
Photos by Wendy James, 1966.

camera and slide film. First taking touristic and personal shots, she continued with colour slides as her staple photographic technique in her first bouts of serious fieldwork in the Blue Nile Province, mainly among the Uduk-speaking communities. She was also able to use a good quality black & white camera from her department, and often allocated this to one of the students who sometimes came with her. From the start, in late 1965, she also used a small reel tape-recorder, for language learning and for collecting songs, music, and conversations. From the early days she was very conscious of *movement*, and tried to capture it in still photos (see Figures 5.1a, 5.1b). By 1966 she had borrowed her parents' Super8 home cine camera specifically to record scenes in the field involving patterned movement, such as dancing and ritual action. She often tried to link her stills, movies, and reel-tape recordings together, as ethnographic evidence of whole occasions. This was not only to back up her own memories in the course of writing up her research, but to enhance her teaching through presentation of images and sound recordings. At one point she did take pictures using film for colour prints, but the quality was not very good, though she had tried to photograph objects of different colours side by side in order to test and illustrate the range of colour vocabulary in the Uduk language.

The downside of concentrating on colour slides at this time, along with cine film, was of course that the images could not be given to the local people, or even shared with them – though James did often replay tapes, especially of songs and music, which were very much in demand. This was a remote rural region, left as something of a backwater after civil war began to spread from the south following the independence of the Sudan in 1956. Some anthropologists at this time were beginning to use Polaroid cameras, which meant you could print off the image and give it away on the spot, but James never took this up. Up to 1969, the last of her field visits at this period, the Uduk people were still not very familiar with printed photos. It is true that the former station of the Sudan Interior Mission (established at Chali in 1938, the missionaries however being deported in 1964) used to hold lantern slide shows, mainly to show biblical scenes. They also used to circulate leaflets with a few photos they had taken of church members and events, which would have been familiar to the small Christian and school-educated youngsters of the day.

Photography in the newly-independent Sudan was something of a sensitive issue, and one had to obtain camera permits. In the case of Ethiopia, where for a couple of trips in 1974 and 1975 James was attached to the Institute of Ethiopian Studies in Addis Ababa, one had to deposit copies of photos taken on research. Although this was tricky with slides she certainly complied on the first occasion, but on the second had to leave in a great hurry because of insecurity and took all her photographic loot with her. She had spent time with various groups in western Ethiopia, as before mainly taking colour slides and audio recordings, by this time on cassettes rather than 3-inch reels. The work was not finished because of the revolution of 1975-76, and she never had the chance to revisit the Komo, Mao, or Gumuz villages. She did publish a few pictures to go with articles, black & white converted from colour slides, but the audience for these never did reach as far as locals.

James's next extended stay in Africa was to the southern Sudanese city of Juba, where her husband, Douglas Johnson, was engaged on an archives project and she joined him with their two small children for a year from mid-

1982. Her project was to study the social history of urban life in the city and its connection with the rise of the colloquial dialect of 'Juba Arabic'. By this time, she was taking photos with colour positive film, mainly family shots which could be sent home to grandparents. She and her husband did have a brief but memorable trip with the children back to the Uduk villages of the Blue Nile, where she took just a few photos and later got colour prints made. These suddenly acquired a special importance later on when the villages were destroyed and people displaced by the outbreak of civil war again in May, 1983. For the same reason, James' and her family's time in the southern Sudan was cut short.

The ensuing twenty-two years of conflict affected the Blue Nile in a major way. The Kurmuk district in particular saw destruction of nearly all the rural settlements from 1987, including those of the Uduk people James had known. The majority of them fled to one displaced or refugee camp after another, for six years criss-crossing between the Ethiopian and Sudanese sides of the border, only in 1993 reaching a 'safe haven' of sorts at the newly-established refugee scheme of Bonga in Ethiopia. On first hearing of the upheaval, she went to Khartoum in 1988, presenting some copies of 'Kwanim Pa (James, 1979) and The Listening Ebony (James, 1988) to members of the Uduk community there, where the pictures attracted real attention. Of course the originals of the illustrations had been colour slides, converted to black & white by the publisher (though just one colour illustration as the frontispiece to her first book had been allowed, on the grounds that the colour contrast black/red was of symbolic importance). Giving out books creates a potentially open-ended audience for the illustrations inside them, and a relatively long life, even in rural circumstances. Villagers then tended to have great respect for books as such, though in the case of the Uduk their experience was mostly of biblical texts and stories, and hymn books.

In Khartoum, James was surprised and very interested to be presented in return with copies of colour prints taken by a couple of the Uduk men who had been down to the war front, documenting the situation for their own community, and no doubt for various patrons. Their photos showed the devastation of burned-out buildings and empty villages in the homeland (see Figures 5.2a, 5.2b; for further examples from this set see James 2007, Figures 5.6a, 5.6b, and 5.7, attributed to 'anon'). The only other pictures the people had themselves given her previously were occasional portraits taken by individuals on their travels. The late Joshua Abdalla, who was working in Saudi Arabia, sent her snaps from that country, for example touristy shots of himself on the back of a camel, posed against the desert hills. He also took photos of his family, and various mutual friends, from his visits back home – for example sending her such a set in 1982.

But when massive displacement overwhelmed the villages of southern Blue Nile, both to towns in the northern Sudan and across the border to Ethiopia (and later to camps in Uganda and Kenya), the taking and passing on of photos took on a new and grim value. In these circumstances, there was difficulty in finding out who might have lost their lives and who might have survived. Pictures of 'home', even when it is devastated by conflict, can take on a vital new importance for the displaced. Sending photos of individuals and family groups as between the various displaced communities became not only a way of keeping in touch, but also reliable information as to who might still

*Figure 5.2a
Colour photograph
of Chali sacked,
1987; the main
mission buildings.*
Photo by Anon.;
Presented to Wendy
James, Khartoum,
1988.

*Figure 5.2b
Colour photograph
of burnt dwelling,
Chali, 1987*
Photo by Anon.;
Presented to Wendy
James, Khartoum,
1988.

be alive, when, and where they were. As the scale of this second civil war increased, and during the fifteen years that most of the Uduk were living in the Bonga refugee scheme in Ethiopia (1993-2008) and in Kakuma in northern Kenya, the importance of still photos, and the role of those who could take them and get them distributed, was transformed.

At least one emissary of the SIM, the mission organization which had formerly worked in the southern Blue Nile, managed a couple of visits to those Uduk who made it to Ethiopia in the late 1980s, and took photos which were transmitted back to relatives in Khartoum. When James got to the displaced camp of Nor Deng near Nasir in the swamps of the southern Sudan, where

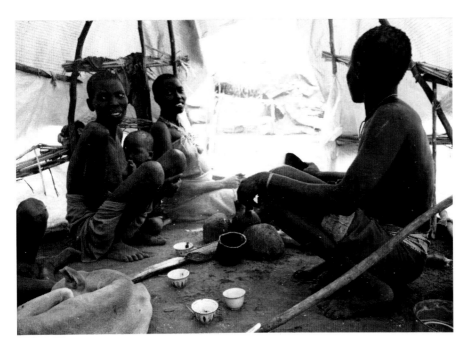

*Figure 5.3a
Colour photo-
graph inside
William Danga's
shelter, at the
displaced camp
of Nor Deng near
Nasir, Upper Nile.*
Photo by Wendy James,
August 1991.

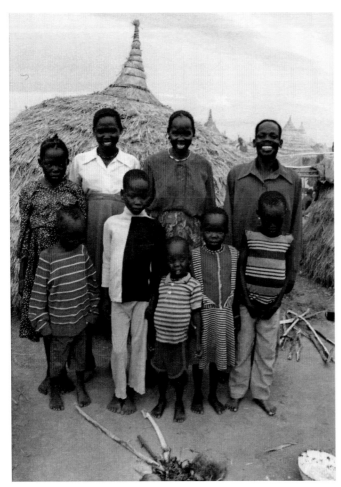

*Figure 5.3b Family in Sunday best, Nor Deng.
Colour photograph taken on request, to be sent
to relatives in Khartoum.*
Photo by Wendy James, October 1991.

she did two reports for the UN in August and October 1991, she deliberately took photos not only as evidence of what the conditions were like there, but as evidence of *who* was there. The people themselves wanted her to do this, as they wanted the world to know about their situation. A large number asked her to take photos of them, their kids and families, in 'Sunday best' mode, and send copies to Khartoum (for the contrast between James's basic photographs documenting a desperate situation, and the happier style of family portraits the people wanted to reassure their relatives, see Figures 5.3a and 5.3b). James was taking ordinary colour snaps, and got multiple copies developed in Nairobi on the way out. The quality of these from the first visit was not good, perhaps because of the hot damp weather where she had been camping in Nor Deng, or perhaps because the film processing was not of the best. But she arranged for SIM-connected people in Nairobi to send copies of the family photos back to Khartoum, through church links. She also sent copies of cassettes with recorded messages from relatives.

By mid-1992, the Uduk refugees in Nor Deng had made a dash back to Ethiopia; and in January 1993 James had the opportunity to work with the Disappearing World team of Granada TV, making one of the three ethnographic documentaries they planned to carry out that year in war zones (MacDonald 1993). The invitation came just after the new Ethiopian government of the day had agreed with the UNHCR to allow those Sudanese refugees originally from the Blue Nile to remain in the country, and to set up a new semi-permanent settlement scheme for them. The Disappearing World team made the documentary in a transit camp called Karmi near Gambela. In years gone by, James would not have dreamed of taking a film crew into the field – considering it far too intrusive – but the Uduk in exile welcomed the film crew, again wanting the world to know about their situation. During the course of filming, a violent incident occurred between the Uduk and groups of new arrivals in the camp, mainly Nuer from the southern Sudan. Granada filmed a considerable amount of the fighting and hostility which ensued, but in the end did not include these scenes of tension and violence in the finished film. This was frustrating, but it led James to ponder how the records could be further used. She did write an article on the basis of this experience, not only marking her own renewed interest in a 'cinematic' approach to anthropology, but leading her into collaboration with Judith Aston and the way she was developing the potential of digital technology for anthropology (James 1997; Aston 2010).

Orphans of Passage, the completed Disappearing World film (MacDonald 1993), itself showed how visual images, including stills, could be treated in a time-sensitive way, reflecting memories of past events and the imaginations of other spaces – one-time homelands, now deserted, and future homelands, to which the people might return. Not only in the course of filming, but also in the editing process, Bruce Macdonald drew on several layers of existing imagery, some provided from James's own archive, and some – printed pictures – in circulation in the community. Martha Ahmed describes in the film how she received a photo from Kenya of her daughter with a baby son, the picture showing that her daughter had had an operation on her leg. MacDonald was keen to incorporate some of James's silent footage and audio recordings from the 1960s, to provide visual and musical depth, and also some of the biblical illustrations from the former missionaries along with readings from the

scriptures on wind-up cassette players that were already in circulation.

The war years saw other photographic projects in which the Uduk have left traces; many aid agencies of course would routinely take pictures, along with a few journalists; and the SPLA rebel forces also employed their own cameramen at times. One quite lengthy video taken by the SPLA itself shows some official speeches and discussions in the major refugee camp of Itang, near an SPLA training base in Ethiopia, as the Mengistu regime drew to a close (SPLA 1991). The news then arrives that Addis Ababa has fallen, so the fighters, their families and the masses of refugees return to the Sudan. A group of Uduk, mainly women and children, preparing a pan of snails to eat, are seen and heard briefly as they are packing up to join the long exodus through flooded landscape back to the southern Sudan. Material of this kind obviously adds enormously to the 'story' of people's life and death in a war zone, and we hope will be systematically sought and preserved one day.

In later visits to the scheme at Bonga, in 1994 and 2000 (on both occasions to prepare official reports, for the UNHCR and for a Dutch NGO respectively) James took her own Hi8 video camera (discreetly and without formal permission); and as a result she has a large archive of footage. Video seemed to combine the best of visual testimony with the spoken recordings that she had always treated as a basic resource in her research. She was able to film a long interview with Martha about letters and photos being sent in both directions, from Bonga in Ethiopia to Kakuma refugee camp in Kenya where Martha's daughter and other women abandoned by their guerrilla husbands had settled. With this kind of evidence in hand, including the photos, family reconciliation was being organized through the UN and the International Red Cross.

Originally there were no facilities in the refugee camps to show videos, but James happened to be there on the first occasion that video equipment did show up in Bonga, for educational purposes, about AIDS, and landmines and so forth; and it did happen that she had a brought a copy of *Orphans of Passage* with her. She spread the news and gathered together as many people as possible who had actually figured in the film, and showed it to them, along with a couple of teachers and Ethiopian administrators. There was surprisingly little 'feedback' or discussion afterwards; the people were not yet used to moving film. Moreover, the pace is admittedly very fast in places, scenes being intercut and alternated. The English voice-over, used in places as an experimental variation from the method of subtitling, which the director decided would convey more nuance and emotional tone to the way people were speaking, may ironically have obscured the sound and nuances of their own language to the participants themselves.

It has become clear to us how important printed photographs have been, especially in pre-digital times, as a vital link in people's memory and their consciousness of increasingly distant networks linking kin and neighbours. It is worth pondering the materiality of still photos, by comparison even with video: printed photos provoke conversation, as Elizabeth Edwards has pointed out (see for example Edwards 2003). There is time to discuss who is who; they can be put away, and brought out later on to check. They are portable. You don't need special equipment, or electricity, to look at them. They seem to 'belong' to you in a way that the ephemeral images of a moving film cannot. You can if you wish keep photos secret, but watching movies in the old days was a shared activity.

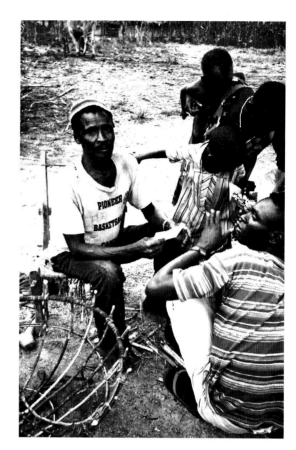

Figures 5.4a and 5.4b
Colour photographs of Chief Chito
and others in Bonga refugee scheme,
Ethiopia, receiving photos sent by
relatives from Salt Lake City.
Photos by Wendy James, August 2000.

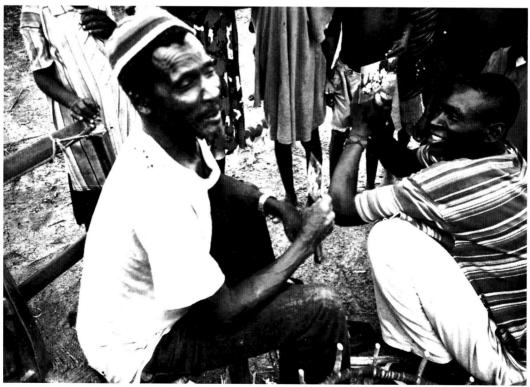

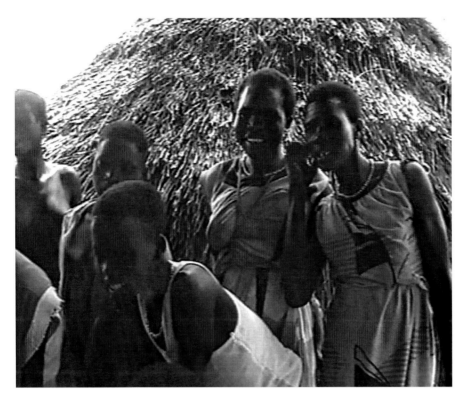

Figure 5.5 Still image from video taken by Wendy James. Women refugees in Bonga gather round to enjoy a glimpse of the pictures of the Diviners' Dance, published in black & white in The Listening Ebony *but created from James's original colour slides. August 2000.*

During James's visit to Bonga in 2000, a young American teacher had shown up with a set of photos she was to deliver from a young man, Awad Chito from Salt Lake City, recently resettled from Bonga. They went over to visit his father, Chief Chito, and were there as he opened the envelope and saw the photos of his son and a few others. He said very little, except that this was a 'very green place indeed', but was clearly moved.

On the same visit, James took interesting footage of people reminiscing over the diviners in the old days as they pored over photos in her book *The Listening Ebony*. This scene provided a very suggestive link between past images and their current value, as she filmed people marvelling at the old pictures (Figure 5.5), and we discuss this further below as a key example of how multimedia methods can illuminate the way that people value the tangible quality of printed images they can touch and feel. James was one of the last in her family to obtain a mobile phone, but it did enliven her recent visit to the Sudan (Khartoum in 2008) and her most recent trip to visit Uduk resettled in the USA (Tucson, Arizona, 2010). In Khartoum, she was attending a conference organized by her former department in the University, but managed through using her new gadget to get in touch with several of her old friends from the Blue Nile, and to visit one of the outlying suburbs where quite a number of Uduk and others were still living. There had been a peace agreement in 2005, and most of the displaced population, both from Khartoum and from the international camps, had returned 'home' between 2006-08. In Tucson, people were very keen to see her old clips, and she did take a few shots of the occasion on the iPhone, discussed and illustrated below.

A number of those resettled in the USA have now had the opportunity to revisit their homeland. Some took part in fact-finding or survey trips organized

by various aid agencies – Fig. 25 in James's most recent book (2007: 300) is a photo taken by Martin Ebed, from Salt Lake City, of Uduk men in SPLA uniform as part of the Joint Integrated Units set up by the peace agreement. Others were taken by private visitors, and most recently some of these have started taking digital video footage. Sebanaya Kengi of North Dakota was kind enough to circulate copies of his footage from a visit at Christmas 2008; this is not so much a documentary record of the situation, as a medium for the continuing exchange of warm greetings between families – the returnee refugees from Ethiopia now 'home' and waving, speaking, smiling via the camera to their kin in the USA and Canada, whom they might in fact never see again. This kind of material, we hope, will one day find its place in a continuing photographic record of shared memories relating to the loss of a common home and the continuing uncertainty over its future.

Aston's ideas have certainly shaped the way James now sees the potential significance of the photographic records she has collected over the years, and the possibilities for their deployment which would follow from their inclusion in a comprehensive, searchable, but still living archive.

Framing and exchanging photographs through multimedia

Aston was first struck by the potential of multimedia methods to enhance the life of images when working as a research associate on the Rivers Video Project in the late 1980s. This project was set up by Alan Macfarlane in the department of Social Anthropology at the University of Cambridge. Aston developed insights from this work in her doctoral studies from 1994, which considered the potential of interactive multimedia for communicating anthropological ideas and arguments (Aston 2003). Our collaboration began through the University of Kent's *Experience Rich Anthropology Project* (*http://era. anthropology.ac.uk*) as we began to explore computer-based possibilities through which to integrate photographs and other images recorded in the field with academic discourse (see Aston 2010 for a discussion of this work and the multimedia methods that have evolved out of it).

The website we produced to accompany James's most recent book on the way that war came to the Blue Nile region, and especially to the Uduk, illustrates something of the quality of the images we are working with. However, it is limited to video clips from the refugee settlement of Bonga (1994 and 2000), plus a few older cine clips and audio recordings from the 1960s and a small handful of photos (James 2007; Aston & James 2007, *www.voicesfromthebluenile. org*). Given the ongoing political tensions in the region we could not include interviews on topics that might touch on sensitive matters relating to individuals, nor on political issues as such. Given that these issues are ongoing, we are planning an archive with two levels of access – publicly available access to non-sensitive materials, with restricted access to the more sensitive materials. Alongside the major plan, we are producing a series of experimental prototypes which will illustrate a variety of techniques for user-friendly searching of the material, according to key themes, and will be presented online.

We are in a position today, thanks to the new technology, to extend the geographical reach, lifespan over time, and social agency of the kind of photographs taken by anthropologists in Africa. We have embarked on the initial stages of a project using James's audio-visual material to showcase the

potential of multimedia methods to give a new lease of life to archival images, including the kind of photographs which so often get dusty and forgotten. If copies of photos are presented to their subjects back in the villages, they will be treasured as objects marking special moments of the past; but in rural conditions they are likely to fade or disintegrate before long. This is where the promise of multimedia methods for evoking past moments as captured in photos becomes so powerful. Where film or audio recordings, and a continuously evolving stream of reminiscence and commentary can be added to the photographic moment, a newly living environment can be created, and recreated, around that moment and its links with others. By contrast, a film subjects its internal images to the rigour of temporal editing and narrative line; while multimedia methods can enable the same materials to be combined, recombined and juxtaposed in newly experimental and multifaceted ways. Users can potentially pursue a variety of themes and perspectives in exploring materials archived in a digital database. The still moments represented by photographs in such a context can be brought into relationship with each other through flexibility of juxtaposition with moving images and recordings of song, music, and conversation. At the same time, multimedia methods can be used to enhance the kinds of reflexivity inherent in the context of fieldwork itself, as well as providing space for the ways that reflection and interaction may change in emphasis over time. Ideally, an open-ended digital archive could be arranged around photographs in such a way as to allow them to be quiet turning points in the unfolding story itself, as people are seen and heard responding to the photos of particular occasions in the past. We are therefore working both on incorporating context and commentary into the archive itself, and on highlighting the reflexive character of the research process and the changing relationships between James and the people she has come to know well in the field. In recent years, there has been much discussion about how new technologies such as the Internet are opening up new audiences for academic archives and enabling users to interpret these materials according to their own interests and concerns (for example at the 2010 World Oral Literature Project workshop: *http://www.oralliterature.org/research/workshops.html*). Our aim is to respond to this shifting context, whilst at the same time making sure that there is sufficient narrative incorporated into the archive for users to gain a sense of the circumstances in which the recordings were made and of the anthropological intent that underpins them.

In order to incorporate lines of narrative or 'story-telling' into the planned audio-visual archive, we have been experimenting with what we call 'authored pathways' through which links would be made across elements in the collection. On the basis of an initial selection of digitized slides, photos, audio recordings, cine and hi-8 footage, we have developed prototypes for such guided tours or 'authored pathways' using Macromedia Director and Adobe Flash software. In this sense, we have started to curate these materials, selecting records to digitize which fit with Aston's interface ideas and with our combined aim to encourage people to empathize with the 'stories' that lie behind individual images. The experimental interfaces that Aston has been developing (as illustrated in Aston 2010) are designed to be aesthetically engaging and to enable fluid interaction between different media components. The interfaces used currently require specialist software, up-to-date computers and fast broadband speeds; they do not yet, therefore, conform to web accessibility requirements, but we are working on this problem for the experimental prototypes. However, the larger

archive project will aim at flexibility, so the material remains permanently stored for the future, and potentially accessible through changing forms of investigation and therefore interpretation. A key challenge is in designing the 'middleware' to enable seamless integration between the archive and the potentially changing 'authored pathways' through which selection and association of images can be made. Aston is receiving help with this task from Paul Matthews, a colleague in the computing department at the University of the West of England. General digitization and cataloguing is under way with the help of Alison-Louise Kahn and the Oxford Academy for Documentary Film. This work has stimulated our ongoing conversations about the value of multimedia methods and has led to presentations at a variety of workshops and conferences.[1]

Our collaboration over the years has made clear to us both the changing contexts in which images may be produced and circulated, especially in conflict zones where quieter local memories can be brutally cut across by unexpected events. Sometimes these events stimulate the production and circulation of images of a rather different kind. As the Uduk, for example, lost their homes and many lives as a result of the Sudanese civil war as it escalated in the 1990s, they became better known to the outside world as a Christian ethnic group in desperate need, and the humanitarian agencies began to promote images based on this perception. James noted in 1999: 'It is highly ironical that, while academic anthropology has self-consciously tried to move towards a recognition of openness, hybridity, and multiplicity in collective and personal identities, the Uduk have been forced by the violent circumstances of the modern world into the straightjacket of a 'closed' community publicly defined ... in terms of national, ethnic, and religious identity.' She pointed out that this was a process 'on which they consciously reflect' (1999: xvi-xvii). The larger archive we plan to create will include some of the images produced for humanitarian fund-raising projects, NGO reports and so on, as a contrast to the more intimate portrait of individual experience, reflection, and the generation of shared memories which James' photographs and associated recordings reveal.

We have come to share a view of the importance of situating James's materials in the wider historical and regional context, to avoid falling into the trap of creating an archive which essentializes the Uduk as a particular 'tribe' or 'culture' fixed in time and place. A focus on her own shifting engagement with events shaping lives both in the Sudan and in western Ethiopia will provide one important storyline which can be followed through the material. Other guided 'pathways' which the user will be able to follow through the archive as they make their own selections from the database will emphasize stories and conversations in the voices of the people themselves. It is here that we are already finding ways to make some of the still photographs into 'resting points'; unlike film or audio clips which slip by at their own speed, still images can be kept in view and reflected on at leisure, even by the user

[1] Those addressed by us jointly have included a conference on Sound and Anthropology (St. Andrews, 2006), and the European Association of Social Anthropologists (Bristol, 2006). Those addressed by Aston alone include EASA (Ljubljana, 2008), a conference on Visualising Migration and Social Division (Paris, 2009: see Aston 2010), a symposium on the ethnographic film-maker Jean Rouch (Paris, 2009: see Aston 2009), a workshop on Interactive Storytelling as part of the International Symposia on Electronic Art (Belfast, 2009), and the Documentary Now! conference (London, 2010). Aston and Matthews addressed the World Oral Literature Project conference (Cambridge, 2010: see Aston & Matthews 2010).

of a digital archive. And within the archive itself, we are including scenes and discussions where the people themselves are reflecting on old photographs and reinterpreting these as part of their own ongoing 'story'.

Example: the photograph as a key point of reference in the multimedia archive

The archival material we are working with offers a very good illustration of the point we wish to make here: that multimedia presentation can point to the importance, indeed social agency, of still photographs in the life of a community. From James's records we have been able to capture conversations around evocative photos among people displaced to the refugee camps, and also show how people in the North American diaspora respond to images which help to keep memories of a lost home alive.

Our key example, introduced at the Anthropology and Photography workshop (Oxford, 2009) which led to the present volume, is the clip mentioned above, recorded in Bonga in 2000, of people reminiscing over the diviners in the old days as they pored over photos in *The Listening Ebony*. The photos printed there in black and white were originally taken as colour slides in 1969. In the clip we see William Danga getting out his new paperback edition (1999) of the book to show a circle of interested neighbours who happened to be reminiscing about the (now defunct) diviners and their dance ceremonies. Using techniques of juxtaposition, Aston first placed the photos of the diviners' dance as reproduced in the book alongside the clip of people looking at these photos. She then demonstrated an interactive interface which enabled users to scroll through the photos while watching the video. She then played a recording of James explaining how the two elements related to each other, using a keyboard command to turn this commentary on/off as wished (screenshot 1: Figure 5.6). The inspiration for this fluid interface came from computer game protocol, in which the keyboard can be used to navigate around environments and scroll through sequences of photographs, thus avoiding a cluttered screen. At the next stage, Aston juxtaposed the original 1969 colour slides of the diviners' dance alongside cine footage and reel-to-reel musical recordings taken at the same event, again with an interface to enable users to move fluidly between these elements and to listen to James's commentary (screenshot 2: Figure 5.7). Finally Aston then showed how one could move between the Hi8 video clip of people discussing the pictures in the *Listening Ebony* and the old cine clip of the diviners' dance, plus audio (screenshot 3: Figure 5.8). Watching the interaction between the moving image clips one could see why one woman identified a certain diviner from the old days as his present-day son – they certainly do look alike – but others put her right on this. This example itself suggests, for the user of today, how strikingly the digital copies have preserved a sense of the materiality of their analogue counterparts, through the contrasting quality of the sound and the visual differences as between the cine footage and the hi-8 recordings. This underpins, for us, a sense of the passage of time within the memories that we wish to convey.

Our example illustrates well the point made by MacDougall about the distinction between still and moving images, where he argues that 'video is evanescent ... constantly tracing images that just as quickly disappear from the screen ... (whereas) ... still images ... give us moments when the future is about to unfold. They carry the weight of the unknown future within them and become larger statements about society, history and human experience' (as quoted in a 2009

Figure 5.6 Screenshot 1 by Judith Aston. To the left, photo by Wendy James, now Fig. 10b in The Listening Ebony, *made from a colour slide (original taken 1969). To the right, still shot from video taken by Wendy James, showing refugees in Bonga enjoying the pictures in the book. August, 2000.*

Figure 5.7 Screenshot 2 by Judith Aston. To the left, the Dance in movement: Super8 cine clip of the Diviners' Dance by Wendy James. To the right, a scrollable sequence of colour slides taken on the same occasion. Below left, an audio recording of the music. Originals taken Bellila, near Chali, July 1969.

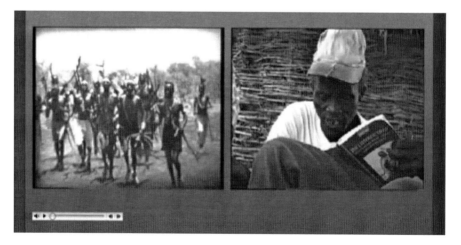

Figure 5.8 Screenshot 3 by Judith Aston. To the left, a cine clip and audio recording from 1969, suggesting what memories might be in the mind of Chuna Hada, shown to the right in a video clip, as he examines the printed photos of the Dance. August 2000.

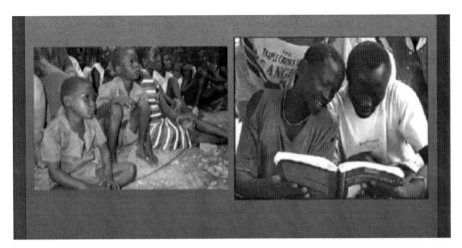

Figure 5.9 *Screenshot 4 by Judith Aston. To the left, colour photograph taken by Wendy James in Bonga, 1994, showing passive reactions by refugees to the documentary film* Orphans of Passage. *To the right, still shot from video, showing lively reactions to the printed book photos. August 2000.*

Figures 5.10a and 5.10b. *Digital image (taken on an iPhone) of Jackson Madut and friends in Tucson, Arizona, enjoying scenes of the Dance from our 2007 website (voicesfromthebluenile.org).*
Photo by Wendy James, April 2010.

Figure 5.10c. *Digital image (taken on an iPhone) of a scene from our website. Images of the Dance from 1969, recycled into a 1988 book, were obviously fascinating to the Uduk refugees in Ethiopia; and this shot (see Fig. 5.9 above) was very popular with yet another generation of the displaced in Tucson, Arizona.*
Photo by Wendy James, April 2010.

exhibition on *Gandhi's Children* at the Cambridge Museum of Archaeology and Anthropology). The kind of multimedia presentation described above certainly backs up this insight; but in addition, we would point out that the interfaces Aston is developing also allow for the possibility of fine-grained analysis of moving images themselves, on a frame-by-frame basis. In this way, the moving image clips become less fleeting and more 'photographic' in nature, especially as they can then be printed off onto paper.

Completing her presentation, Aston juxtaposed photographs of some of the refugees rather solemnly watching James's Disappearing World film in 1994, with the 2000 video clip of people responding in a very lively way to the photos in *The Listening Ebony* (screenshot 4: Figure 5.9). The film show, made possible through collaboration with the authorities in the refugee camp (who had just hauled in a VCR for educational purposes), was received very passively; it contrasted sharply with the informal domestic context in which the photographs were brought out. More recent photos, however, taken by James on her iPhone, document members of the Uduk diaspora in Tucson, Arizona, looking at our website on her laptop; they show that moving images displayed on a computer screen can provoke as much lively response as still images (Figures 5.10a, 5.10b, and 5.10c).

In conclusion, and looking forward

By the early 2000s, still photos and audio cassettes from the refugee camps for Sudanese in Ethiopia were circulating freely among the diaspora in America (as also in Canada and Australia), keeping them in touch with people back 'home', though in the case of the Uduk the homeland itself was largely empty of civilians. Facilities in towns and later in the camps made it possible for some to communicate by phone with Khartoum and occasionally with kin elsewhere through international calls. By 2008 or so, following the peace agreement of 2005, the vast majority of the refugees from the Ethiopian camps, including the Uduk, had returned 'home', and as we have sketched above, all these means of keeping in touch over both time and space had multiplied.

The new digital techniques, including cameras, mobile phones, computers and most recently the internet have quite transformed the possibilities for visual self-representation and maintaining relationships among the still scattered, and scattering Uduk as they seek education and employment wherever they can. On James's brief visit to Khartoum in 2008, she was able to give some assistance to a couple of people from the Blue Nile interested in taking pictures and video themselves. Many of those resettled in the USA are seeking access to visual materials from their own history – including evidence of their lives in some of the more difficult circumstances of the war zone itself and its periphery (though friends have said they specifically do not want this kind of material to be available to all comers). The plan of creating an archive of ethnographic materials, as an anthropologist's professional obligation, and inevitably mainly for academic use, has been transformed by the possibilities of the digital age. An important part of this transformation is the opportunity for the people themselves to engage with it and add to it, at least in those places where there is the basic infrastructure of electricity and computers with internet access – not to mention the equally desirable conditions of peace and prosperity which have been so elusive in recent decades. These still seem a little fragile from the perspective of the old Sudan, now divided into two different nation-states, the Uduk homeland sitting directly

on the 'northern' side of the frontier with South Sudan (and, as of late 2011, again overwhelmed by war). Our case study seeks to enlarge, in a variety of ways, the general theme of 'photography in Africa', to engage with the realities of social and political history in Africa as the technology and social relations of photography themselves have changed, and to encourage others to think imaginatively about the future possibilities for creative deployment of the new techniques of multimedia.

Bibliography

Aston, J. 2003. 'Interactive multimedia: an investigation into its potential for communicating ideas and arguments'. Unpublished PhD thesis, London: Royal College of Art.
——— 2010. 'Spatial montage and multimedia ethnography: using computers to visualise aspects of migration and social division among a displaced community', *Forum: qualitative social research*, 11: 2. http://www.qualitative-research.net/index.php/fq5/issue/view/34
Caplan, P. 2010. 'Something for posterity or hostage to fortune? Archiving anthropological material', *Anthropology Today* 26 (4): August 13-17.
Davies, C. 2010. 'Research intelligence – Imparted wisdom: Researchers of all stripes should consider the implications of sharing their data', *The Times Higher Education Supplement* (9 September 2010).
Edwards, E. 2003. 'Talking visual histories'. In *Museums and Source Communities: A Routledge Reader* (eds) L. Peers & A. K. Brown. London: Routledge.
James, W. 1979. *'Kwanim Pa: the Making of the Uduk People. An Ethnographic Study of Survival in the Sudan-Ethiopian Borderlands*. Oxford: Clarendon Press.
——— 1988. *The Listening Ebony: Moral Knowledge, Religion and Power among the Uduk of Sudan* [Paperback edition with new Preface, 1999]. Oxford: Clarendon Press.
——— 1997. 'The names of fear: history, memory and the ethnography of feeling among Uduk refugees', *Journal of the Royal Anthropological Institute*. N.S. 3 (1) 115-31.
——— 2000. 'Beyond the first encounter: transformations of "the field" in North East Africa'. In *Anthropologists in a Wider World: Essays on Field Research* (eds) P. Dresch, W. James & D. Parkin. Oxford: Berghahn.
——— 2007. *War and Survival in Sudan's Frontierlands: Voices from the Blue Nile* [Paperback edition with new Preface, 2009]. Oxford: Oxford University Press.
——— 2010. 'Reflections on, and of, the "Slide Show" in my life', *Anthropology and History* 21 (4) 499-516.
MacDonald, B. (Director) 1993. *Orphans of Passage*, in Disappearing World Series, Granada TV (Broadcast: 18 May 1993).
MacDougall, D. 2009. 'Anthropology and the cinematic imagination'. In *Photography, Anthropology and History* (eds) C. Morton & E. Edwards. Farnham: Ashgate.
Morton, C. & Edwards, E. (eds). 2009. *Photography, Anthropology and History*. Farnham: Ashgate.
Peers, L. & A. K. Brown. 2009. '"Just by bringing these photographs...": On the other meanings of anthropological images'. In *Photography, Anthropology and History* (eds) C. Morton & E. Edwards. Farnham: Ashgate.
SPLA (anon). 1991. Video footage of Itang and the forced return to the Sudan (Copy made available to Wendy James).

Websites

Aston, J. 2009. Direct cinema and a making of the 'real': polyphonic narrative, spatial montage and cinema-sincerity. Conference on Jean Rouch, Paris 2009: http://www.canal-u.tv/video/cerimes/projet_jean_rouch_j3_4_communication_2_version_anglaise.6001 Dr. Judith Aston. Paper available at: http://core.kmi.open.ac.uk/display/1347993
Aston, J. & P. Matthews, 2010. Multiple audiences and co-curation: linking an ethnographic archive to contemporary contexts. In: http://sms.cam.ac.uk/media/1092085.
EXPERIENCE RICH ANTHROPOLOGY: http://era.anthropology.ac.uk
MURSI ONLINE: www.mursi.org
OXFORD ACADEMY OF DOCUMENTARY FILM: http://www.oadf.co.uk/blog/category/captured-by-women/
PITT RIVERS MUSEM ON SUDAN: http://southernsudan.prm.ox.ac.uk
SUDAN OPEN ARCHIVE: www.sudanarchive.net
VOICES FROM THE BLUE NILE, Aston & James 2007: www.voicesfromthebluenile.org
WORLD ORAL LITERATURE PROJECT: http://www.oralliterature.org/research/workshops.html

Picturing the Nation
Photography, Memory & Resistance

Emptying the gallery
The archive's fuller circle

Erin Haney

While the 'House of the Good Ladies' (*Awula Kpakpa We*) in Accra is an ancestral home for a pre-eminent west African photography lineage, the Lutterodts, only a taste of seven decades of family studios' history remains materially intact within its walls. Sturdy picture ledges encircle the rose-coloured sitting room where visitors are welcomed, but they are empty. They once held the family's enormous framed portraits of Lutterodt family members, old images worked in albumen and overlaid in crayon.[1] Some of the missing photographs were borrowed for rephotographing but never returned; others portraits are now stowed in private rooms. The photographic repositories of other kinds from Lutterodt studios are irretrievable: when space in the house became tight, wooden crates containing thousands of glass plate negatives from family-owned studios were thrown into the sea.

The absence of photographic records from cumulative Lutterodt studios, the kind of objects which would further buttress their record of wide-ranging and exceptionally long-lived practice beginning in the 1870s, raises provocative questions for photographic historians. What can be adequately said of the 'total' archive of photographic history in Africa, if a wide expanse of images by African photographers cannot reliably be located in 'vintage' prints, glass plate negatives, and the other objects which predominate in the early Euro-American photographic material record? While we come to grips with a fuller sense of the total photographic archive – by which I mean the complete breadth of photographic production globally, lost or extant – more and more evidence of historical photography of the nineteenth and early twentieth century across a variety of registers in Africa is emerging. Their decayed and elusive material forms are in striking contrast to the preserved states of many Euro-American, colonial-era collections of photography of Africa; yet this does not warrant their exclusion from serious engagement.

Evoking an expansive version of African photographic archives leaves behind notions that early photography in Africa pivots on colonial interaction, or cultural contact inscribed by conflict. These presumptions about early photography are undergirded by our current historiography and infrastructure. The narrow view that photographic technology was transferred from anthropological, colonial administrative, missionary, and European commercial photographers to African recipients poses the most essential questions for the medium's earliest days in Africa. Infrastructure supports easy access to great numbers of images valorized in European and American collections, but only scant evidence of photographic images is accessible in official African archives. If, instead, we recalculate that photography is foremost a matter of the contexts in which it became relevant locally, then surely the kinds of

[1] This paper is based on research on family and civic collections of photographs in southern Ghana, surveying material from 1996, 1997-98, 2001-2, and 2005, as well as a number of archives in Europe and the US (SOAS, 2004).

archives, collections and circulations must acknowledge the different orders and processes which occur in Accra as well as in Basel.

A consideration of photographic collections in the cities of southern Ghana, primarily Cape Coast and Accra and surrounding towns, but holding true more broadly, demands a consideration of 'archive' larger parameters. This allows one to consider the circulations and reconfigurations as assets rather than as detriments to a photograph's ontological status. This is important to bear in mind especially in this case, because photographic history is informed by the pre-colonial urban emergence of the media here and in many other African sites. Therefore I suggest that it is the collections of family photographs that are among the country's most compelling archives. They are kept in ways which side-step the unreliability of those institutions meant to preserve photographs, such as national archives, royal structures and official archives. Family archives also exist and are in their own ways resolutely political. They are far more democratic, eclectic and intense than the few images lodged in Ghana's national structures.

First, these family archives are geared towards a micro-level of public, familial, and personal memory and historiography, with implications for the felt senses of history and politics not circumscribed by nation. Second, such archives are the sum of performances surrounding photographs, other images, and texts. Within them, photographs are prized, reproduced, spoiled, and reworked: they are in themselves a series of diachronic engagements by many people besides photographers. Third, the surge in the marketing and monetization of old studio archives that arose during the independence commemorations in Ghana, such as the publication of part of Accra's *Deo-Gratias Studio* archive, is a strategic visual valorization. Unfortunately, this particular movement into the public sphere was marked by extraordinary losses of private and public knowledge. Surely the emergence of increasing number of archives from Africa into a wider visual economy could be accomplished without their substantial transfer to Europe, sale into private hands, or their decline as a result of limited resources for their preservation.

On early photographic archives in Ghana

Photography's first official exhibitions in France and England have been framed as the consequence of cultural demands: the social and historical conditions that produced the '*desire* to photograph' as Geoffrey Batchen put it (1991).[2] Although the imperative to capture a moment or to immortalize a person has been characterized as driven by the rapid changes of the late eighteenth and early nineteenth centuries, an era of unprecedented movement and rapid change, western Europe was not the sole location or the sole driver of these developments. The assumption that photographic technologies were transferred to west African practitioners in the 19th century tends towards a reductivist Europe-to-Africa circulation. The ways in which these formulations evoke a non-linear sense of archive, the taking up of photography within local and cosmopolitan notions in west Africa, in some cases undermine photography's permanent or 'for the future' status.

The establishment and migration of west African photographers like the

[2] See also Flood and Strother's fascinating editorial and related articles (2005).

Lutterodts reveals that the demand for photography was well placed in a variety of locations before colonial capital-building began. Other conditions were much more important for the patterns of photographic patronage in west African cities.[3] Among these were longstanding trading patterns and the rise of an elite merchant class and intelligentsia, the extent of elite Accra and Cape Coast families educating their children in European and west African capitals and the network of African and European photographers in west African cities from the 1840s. Indeed, it appears that the strength of the Lutterodt's studio system, with a constant base in Accra, was to capitalize on the patronage of these urban elite classes, as well those of waged local migrations within west Africa and central African cities. Patronage proved reliable for the Lutterodts and many others, certainly more enduring than the shifting colonial spheres of influence in some of those spaces at the close of the nineteenth century.

The endurance of the Lutterodt studios seems to have derived in part from the practice of strategic iconoclasm. The family's studios and itinerant practices originated with Gerhardt Lutterodt in the 1870s, and eventually ranged from Freetown to Duala and Clarence (present-day Bioko, Equatorial Guinea) through to Luanda, Angola, and neighbouring port towns. The studio's thoroughly cosmopolitan practice required travelling as lightly as was possible, and glass plates were heavy, fragile, and hard to store. Scraping emulsion off glass plate negatives made their reuse possible. Glass plate in coastal cities at least through the 1840s because of the quality of image it afforded, it was easily retouchable, and the generous scale allowed for clarity and deep tone definition. So while Gerhardt was remembered by his descendants for relentless travel and wide-ranging photographic documentation, his landscapes and views of west African cities are rarely found. Portraits in the cities through which the Lutterodts passed were one-off commissions, so that keeping the plates intact made little sense. Few unattributed portraits and exceedingly few of this landscape photography remain in family collections, although some by the family appear in travel accounts, academic expeditions, and those by missionaries in the 1890s.[4] Some other works by Gerhardt appear in European and American holdings of colonial albums.[5]

Subjecthood and markets determine what kinds of images have been kept, and in which kinds of collections. One of Gerhardt Lutterodt's studio stamps of 1890 reads 'Esto Perpetua' ('may it live forever'); another undated cardmount from Erick Lutterodt's *Accra Studio* assured customers that 'All Negatives Kept, Additional Copies can always be had'. The conditions of studio practice rendered these ideals at times impractical, but the striving for photography's accessibility and endurance against ephemerality remains.[6] This suggests a whole range of iconoclasm and loss has occurred which we are only beginning to consider.

[3] See Schneider (2010, and other articles in this volume) for his work on one of the earliest known photographers, F.W. Joaque.

[4] For a fuller account of these activities see Haney, forthcoming 2013, in *Portrait Photography in African Worlds*, (eds) E. Cameron and J. Peffer, Indiana University Press).

[5] The Eliot Elisofon Photographic Archive, National Museum of African Art holds a few by Lutterodt studios; others are held in private collections.

[6] Based on research from 1996 to 2005. Imagery from other albums and archives abroad, as well as publications, are other sources of imagery by early African photographers, while new sources will undoubtedly materialize.

Archives after institutions

In the first decade of Ghana's independence in 1957, photographs captured the robust political and ritual activity enacted by Gã royal authority in the sacred spaces of the nations' capital. Public spectacles of holidays and festivals in Accra were kinds of local ritual authority not contiguous with the national statecraft of Nkrumah and other pan-Africanists. The photographic record emphasizes the importance of these popular and royal efforts, taking place just down the road from the seat of national government.

While there have always been numerous photographs of royal authority by the studios of Accra, display of such portraits tends to isolate and feature one great image, a prestigious object in its own right. But in the past fifty years (perhaps even longer) images of royal accomplishment proliferated, and the central spaces have emptied. For example, the collection of photography surrounding *Mantse* Dowuona V is kept in his grandson Ben Dowuona's house. It embodies an intense visual and material proliferation of Gã ritual ceremony, compiled in albums and stacks of images by families of royal members. Among these are formal portraits, turning on a visual logic of personal and royal display. These are interleaved with photographs of festival participants alongside kings, queen mothers, officials and attendants in parades, dancing, and offering festival foods around town during *Homowo*, the thanksgiving festival. The visual language of these serial albums details the iconographies of festival celebrations, while the seriality and range of subjects depicted borrows from the rapid-fire journalistic coverage of the international press.

Figure 6.1
Mantse *Nortei Dowuona V and Queen Mother Korle Dowuona parading under state umbrella,* Homowo *procession, Accra, 1965.*
Unknown studio. Reproduced by kind permission of Ben Dowuona.

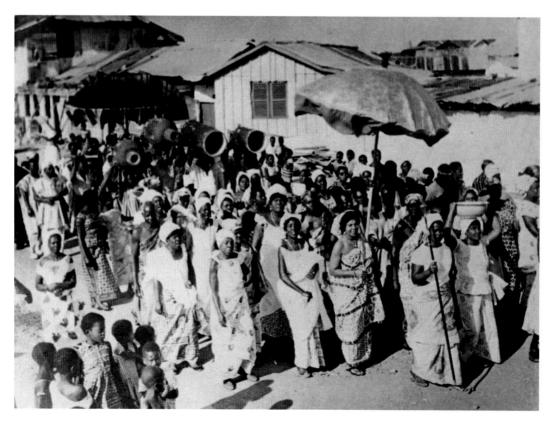

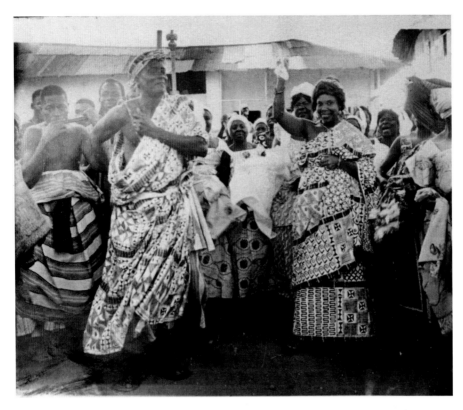

Figure 6.2
Mantse *Dowuona*
V and Queen
Mother Korle
Dowuona dancing,
Accra, c.1965.
Unknown studio.
Reproduced by kind
permission of Ben
Dowuona.

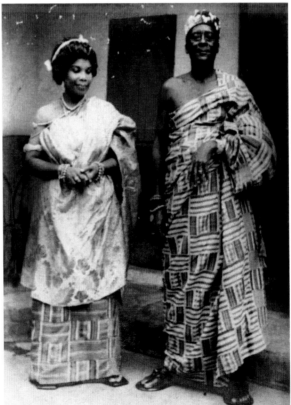

Figure 6.3
Portrait of Mantse
Dowuona and
Queen Mother
Korle Dowuona in
ceremonial attire,
Accra, 1965.
Unknown studio.
Reproduced by kind
permission of Ben
Dowuona.

This image proliferation suggests a turn towards a kaleidoscopic and encompassing effect. Earlier royal archives tended towards investments in singular, grandiose portraits of each successive king. By the time of independence, vast photographic series record gatherings, community leaders and participants, in a more encompassing vision of civic engagements and ritual/political participants.

It is difficult to date with precision the loss of royal archives' pride of place in Accra's royal palaces. Members of the royal Osu lineages with whom I spoke remember impressive portraits of the past *mantsemei* (kings) displayed in a room of the palace where public deliberations were conducted. 'Formerly, all the old men could come in and sit down and talk, and no one would disturb anything there.'[7] More recently, the Osu palace room remained locked, following the shocking theft of several portraits. Albums and large portraits of each king came to be collected by family members after a king's death. A long interregnum and the decline of the palace as a central authority coincide with the consolidation of royal archives into familial and lineage collections.[8]

Osu *Mantse* Dowuona V ruled during the first decade of Ghana's independence. His grandfather's archive is partly displayed (the grander portraits) and the rest stacked in albums for each year's royal ceremonies.

For all this careful image generation, cataloguing and keeping, this collection's intensity and seriality was enriched by the accounts of the grandson and other family members who considered themselves familial and royal historians. The focus of this sizeable collection was ostensibly one man's royal presence, but it implicates much more: the larger Dowuona lineage; the ties between Accra's leaders and achievements, and the prerogative of royals and elders to promote the interests of Osu people. For centuries, *Mantsemei* have been symbols of indigenous authority and important arbiters. Their negotiations and interests are driven by resolutely local concerns, which for outsiders seem marginal compared to the prerogatives of national governance. Such histories fall outside the narratives of the state and increasingly this role is moved by more local photographic archives, driven by individuals and families, which document and shape their senses of past and future political strategy.

Imbricated archives

The political performances that photography enabled are rarely inscribed in official Ghanaian histories but they form a fundamental stream of civic history in familial collections. This is a strand of evidence found in documents and by orality. For instance, photographs offered a vision of Gold Coast anti-colonial activity in London by early nationalists, who are equally remembered also as figures of local achievement. Dr. Benjamin William Quartey-Papafio was the first Gold Coaster to become a doctor in 1886, and was awarded the OBE by Governor Guggisberg. Among the most important records held by his granddaughter was a portrait of a Gold Coast deputation to London in 1911, of which Dr. Quartey-Papafio was a party. Each holding a staff of traditional office, four notable nationalists went to the Colonial Office in London to protest

[7] Personal interview, Margaet Ocaley Mensah, 5 April 2002.
[8] Personal interview, Ben Dowuona and Margaret Ocaley Mensah, 5 April 2002; personal interview, registrar's office for the Ga Mantse Palace, Mr. Tetteh and Mr. Nii Biobio Amugi, (translated by Mr. George Hansen) 19 April 2002, Accra; in these contexts, photographs and kingship regalia were particularly valued.

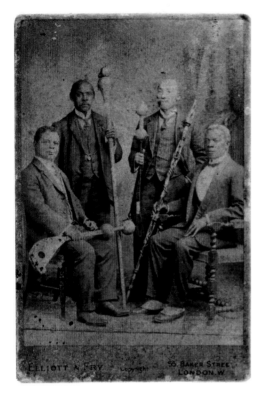

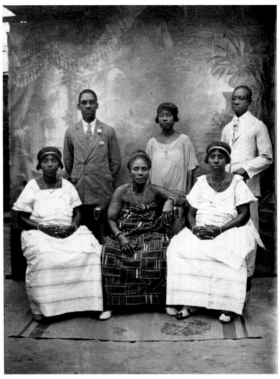

Figure 6.4 Gold Coast deputation to London, 1911.
E.J.P. Brown, T.F.E. Jones, J.E. Casely-Hayford, B.W.
Quartey-Papafio, Cardmount, 'Elliott and Fry'.
Reproduced by kind permission of Dorothy Quartey-Papafio.

Figure 6.5 Mami Teshie House and family, 1927. Cardmount,
'The Accra Studio'.
Reproduced by kind permission of Vida and Jemima Bruce Sackey.

against a Forest Bill that would increase British Crown claim to Gold Coast lands.[9] As members of the Aborigines' Rights Protection Society, supported by the actions of many lawyers, chiefs, journalists and proto-nationalists, they presented their case at the Colonial Office in England as well as in the Gold Coast. This portrait, taken by the prominent London studio Elliot and Fry, was an important memento and proof of the way they represented themselves on behalf of Gold Coast people.

These kinds of portraits are integral documents of family collections of papers, summaries and other historical assessments describing local nationalist achievement. They were probably distributed strategically to advertise their collective political endeavour. This self-conscious positioning and use of portraiture to mark out these events in England for international audiences is similar to the uses of photography by other deputations to Europe (many such images exist for archives of material from Nigeria and Madagascar). Their retention in familial, as opposed to official collections, is fortuitous and deliberate.

The sporadic record of carefully kept images cannot be limited to the figures deemed worthy by judgment of a national archival collections, or post-colonial frames of reference, because so much might be lost within the bounds of those

[9] Personal interview, Dr M.A. and Mrs Dorothy Barnor, Accra, 12 and 16 April 2002; members of the deputation included Emmanuel Joseph Peter Brown, T.F.E. Jones, John Ephraim Casely-Hayford and Mr Quartey-Papafio; Haney (n.d.: 152-156).

terms. A case in point is the well preserved portrait of a family in James Town, 1927, of Mary Briandt, also known famously as Mami Teshie House.

The portrait taken by Erick Lutterodt's *Accra Studio*, 1927, situates her and five of her children in the courtyard of the house that she built. It was eventually named after her, embodying her enormous success as a trader.

The granddaughters who currently keep this image recalled story after story of Mami Teshie House: of her hard work, the amount of people she employed in Accra, the number of her children and, despite her wealth, her preference for simple things. Now elderly, they remembered their neighbours from all parts of the world in their James Town area, and how well people treated each other in daily life. One daughter in the portrait married the first Speaker of Parliament, Lawyer Quist, who had a long career in the colonial and independence governments. When he was awarded the OBE, she accompanied her husband to Buckingham Palace.

Such narratives stray far from the formal components of the image. The photo, so well-preserved, is itself nestled in an ephemeral narrative web of orality. Personal and familial achievement, individual innovations in trade, the dimensions of local politics and patronage, the loss of family members, all of this the photograph evokes, aspects of which are only loosely tied to its apparent surface. Great wealth is evident not only in the portrait's subjects and their fine attire, but also the facts of the prestigious commission and the means to keep it safe over eight decades. However, these factors only obliquely suggest the family account of Mami Teshie House's pervasive influence and generosity, reflected in her gifts of money, the way she helped people in need, provided jobs, and sheltered her large family in the house she built. Such contexts do more to complicate the picture of divisions between citizens: elucidating relationships between elite families and a larger web of marriage, interactions between Ghanaian and British in the latter decades of colonial rule. The sense of achievement ripples out through in the present-day geography of the town. This great woman's role was succinctly summed up: 'When she died, all Accra was shaking.'[10] This recollection of social interaction in the past is vital, because it complicates our sense of resistance to colonialism, to local agency, and to the structures of public and family memory, often dismissed as micro-history. As Morton and Edwards put it, 'The archive is then an active historical process rather than a static and unchangeable entity' (Morton & Edwards, 2009). Furthermore, the archive of images is enlivened by the performances of its owners. Even while these in family collections are often radically inaccessible, they foment localized forms of memory and networked public memory.

Ephemerality, loss and photographic dynamism

The National Archives of Ghana have very few accessible collections of photographs. The official photography repository, the Ghana Information Service, holds images (but rarely accompanying information) that deal with the post-independence era. The place of official national archives as repositories of texts and records tends to trump the more fragile media such as film and image. It is commonplace in many parts of the world to consider the political backing of any official archive in a resource-poor place, especially given the periods of state-sponsored iconoclasm in Ghana, in living memory.

[10] Personal interview, Jemima and Vida Sackey, 11 and 14 November 2001, Accra.

The photographer and filmmaker Charles Owusu, who headed a unit within the Ghana Film Industry from 1965 to 1970, remembers making his way to the prisons immediately after getting news of the coup that deposed Kwame Nkrumah, in order to interview the newly released political prisoners jailed under Nkrumah's reign.[11] Owusu's documentary film, *Suddenly Freedom*, was completed in 1967, and he considers it his most important work. Owusu's film was destroyed in the bonfires with other footage, papers, and other documents associated with Nkrumah's presidency. The national broadcaster GTV also burned much of its material concerning the first presidency after the coup. Looking back, Owusu remarked that military dictatorships tended to stage these public displays of iconoclasm. The impulse to purge records associated with earlier governments is very strong and massively contested. The origins and endurance of photographic archives in familial collections attest to the danger of letting someone else keep important images and objects.

Iconoclasm derives from a variety of motives, but here it also underscores the importance of photography and film as documents of great evidentiary value. For this reason, their durability is hoped for in spite of precarious conditions. That photographs are so ephemeral caused much consternation to the owners of collections with whom I met. Their collections are ample evidence that photographs were proliferating in an attempt to recreate and fortify the body of decaying images. Many collections held two versions of some important images: one, the decayed 'original', and the other a rephotographed version that masked evidence of the first images' damage (Haney, ibid.).

Ephemerality was only one of the conditions which initiated a remaking or altering of an old photograph. There are all sorts of reasons for diachronic engagement by people who are not photographers. Instances include the rephotographing of a group portrait, cropping it to create a portrait of only one subject; remaking a chiefly portrait into an image suitable for an obituary announcement, or cropping images to remove traces of a former wife or in a ritual context (Haney, ibid.; Haney, 2010a; 2010b). If the reasons are highly idiosyncratic, the methods are widespread, involving rephotographing and retouching, and more recently, scanning and photoshopping. So to take on board the intensity and multivalence of these kinds of archives seriously is to place less emphasis on the significance of an 'original' or 'vintage' photograph, but instead to see those transformations from older photographs as integral to a photographic circulation with no fixed status, and without the privileging of any one image per se.

For example, the reprinting of a battered albumen print with extraordinary detail as a black-and-white print in much larger dimensions is accompanied by an oral or written account of the owners' choices of adjustments and engagements with that image. To judge the photograph as a singular object misses the point. So too, does a critique of the image on its formal qualities in these contexts. These documents were possibly never meant to be fixed or to be kept unchanged. Ralph Sutherland evoked this volatility in the ontological status of the photograph, when he considered the independence-era archive of Ghanaian photographer Willis Bell. Sutherland judged that while contemplating these images and the very fact of their collection, each one 'carries the weight of its historical moment while speaking to...contemporary times so that the time past is to be looked at...not as a fixed history but as a living and dynamic force'.

[11] Personal interview, Professor Charles Owusu, 17 April 2002, Accra

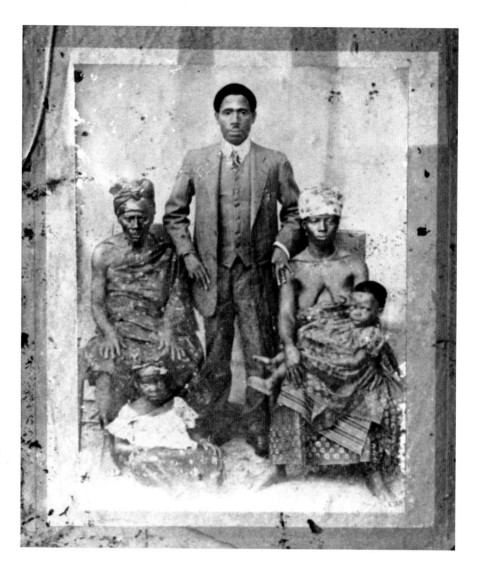

Figure 6.6
Retouched
portrait of Robert
Abbeyquaye with
his mother, wife,
and children,
c.1905.

Unknown studio.
Reproduced by kind
permission of Samuel
Abbeyquaye.

Ways forward, beyond preservation

The loss, destruction and occasional wholesale selling of such collections has
provoked new waves of concern, with various attempts to fund, survey and
preserve the remaining stores of images from old and defunct studios in Ghana.
Shortly before his death in 2009, the former Director of the National Museum,
Professor Joe Nkrumah, envisioned a future National Photograph Archive
that would preserve and conserve collections of notable studios, to be kept
as treasures of 'National Heritage of Art and Culture' (Vanderpuije, 2007).
Would these collections include the work of contemporary photographers such
as Willis Bell, Gerald Annan Forson, Felicia Abban, Abel Gayvolor in this
'permanent Home – a national institution'? What would preservation and
access mean if one imagined access on a local and international scale, rather
than couched in the terms of national heritage?

The lack of community institutions is rarely mentioned in the recent
narratives on national patrimony and commemorative events which Professor
Nkrumah described. The anniversary of Ghana's fifty years of independence

and more recent celebrations have evoked a diverse, if nostalgic nationalism in turning to the imagery of Ghana's colonial and independence-era past. Part of this included the publication and exhibition of a portion of the archive by Accra photographer J. K. Bruce Vanderpuije (1899-1989).

The publication of portions of his *Deo-Gratias* studio archive on the 50th anniversary of Ghana's independence brought to larger attention a photographic oeuvre of creative and historical value. At the same time, its publication marked a significant photographic loss, despite people's best intentions.[12] The collection's emergence into the public sphere imbued it with meaning as a treasure which had been lost, then found. In fact, several organizations and individuals in Accra worked in concert over many years to collaborate with the Vanderpuije family in order to bring glimpses of this astonishing archive to the public eye.[13] Many people knew that this studio archive, kept safe by the photographer's descendants, held a comprehensive and unprecedented pictorial account of Accra, as a colonial and national capital city from the 1920s to the 1970s. Vanderpuije's excellence as a studio photographer and recorder of civic and personal events was renowned. Further, as the studio retained a certain long-lived distinction at the turn of the twenty-first century, when it operated under the direction of his son Issac Hudson Bruce Vanderpuije, the archive was presumed intact. A well-respected, thoughtful and charismatic man, the former Vanderpuije possessed a prodigious knowledge of history, current events, personalities and communities that was inextricably bound up with the wide range of occasions he was commissioned to portray. When he died, it would soon became clear that the bulk of information about his wide-ranging patronage was irrevocably lost and that family members knew little about his insights into a wide range of important events and significant people, particularly in his earliest subjects. While this loss may be commonplace, a more unfortunate aspect of the recent publication was the failure to elicit public contributions for narratives to illuminate the archives in a multivalent, compelling, and personally inflected manner.

The unintended effect of unveiling the *Deo-Gratias* archive as fragmented and lacking context, formally beautiful but now slightly decayed, suggests an approach driven by the demands of the international market. Here there are similarities to other photographic resurrections of anonymous and picturesque elites detached from most of their social, historical or critical narratives. As the *Deo Gratias* entered the public sphere, it slipped into a presentation inviting a universalist, formalist appreciation, as another archival 'burden' for the rising international art market in 'African photography'. This is nothing new, yet does very little for the subjects, photographers or their descendants. This approach has fuelled the rapid increase in the sale or theft of private family albums and collections for collectors in Europe and the USA, a trend which pleases the select few who are the prime financial beneficiaries.

[12] *Ghana Photos Memories,* ibid. an effort supported by the French Embassy for the 50th anniversary of Ghana's independence, and later exhibited at the Ghana National Museum and at the Musée du District de Bamako, Mali for the *Rencontres de Bamako* photography biennial festival in November 2009.
[13] Such efforts included queries by the members of Kuffuor's government, by the Dutch embassy, the British Council, and a number of historians. Personal interviews: Yao and Marita van Landewijk, 22 March 2002, Herman Chinery-Hesse 24 March 2002, C. and M. van der Puije 20 March 2002, Issac Vanderpuije 20 March 2002, Mije Barnor and M.A. Barnor, 12 April 2002. Tobias Wendl (1999) managed successfully to publish and exhibit a few of J. K. Vanderpuije's images.

Professor Nkrumah decried the loss that accompanied the publication, invoking the old chestnut of Ghanaians' 'culture of no maintenance' (Vanderpuije, 2007: 11). An investigation into the more fragmented family archives reveals that often, the opposite is true. Photographs as documents of important political movements and people, of early nationalists, of powerful local leaders and pillars of the community, are indeed often well preserved and highly valued. The situation has changed, and probably began its rapid ascent with the introduction of new markets in Europe and the US for African photographers' personal collections, stimulated by *Revue Noire*'s research and acquisition of photographs in the 1990s.[14] Following quickly on the heels of such research, new markets and expanding circuits of photography (such as the biennial festival of photography in Bamako, Mali, which has maintained an interest in the recognition of older photography), there have been new efforts to solicit funds and set up projects for photographic preservation.[15] Meanwhile, sales of African studio archives meet with intensifying demand in London and Brussels.[16]

To investigate the long history of photographic creation in Ghana and elsewhere is to grapple with dwindling resources: of the circumstances of disappearing and elusive images, of past and future losses, and of iconoclasms as well as the many attempts at recovery. The texture found among the photographic, oral, and written legacy set in family archives is integral to our expanding sense of the archive proper. Certainly, preservation for its own ends is not a reasonable ideal. Should we consider the demise of photographic archives inevitable, or does it matter? Even if in Ghana photographs have long been considered to be enduring, the burden of the archives suggests that they are only worth the effort for certain people. One possibility might be to preserve family collections and studio archives by duplicating them for families, while formulating some new access for regional collections. Thus they might be preserved but also circulated, discussed, published. Some kind of loss is inevitable, built in, and even invited by the multisensory nature of the medium. We might let our fancy for beautiful images or the current post-colonial photophilia to evoke new understandings of larger photographic ontological statuses. Even an incoherent and idiosyncratic attempt to visualize a more open, more publicly accessible, and more intense kind of joint archive is one way to work past the problematic of archives being sold short. It all

[14] Many scholars and collectors have, since photography's inception, collected the work of African photographers; notable moments in recent record pertaining here include Susan Vogel's collection of Keïta images which were exhibited anonymously in *Africa Explores*, (1991) New York; Magnin and Pigozzi's removal of some of Keïta's archive from Bamako to Switzerland shortly thereafter; the work of collector middlemen who buy albums for sale by dealers in European and UK galleries; and the research and collection efforts by *Revue Noire* beginning around 1995, which later materialized as a corpus of diverse photographs for sale, en masse, offered to museums and private collectors in December 2005.

[15] Big funding support for projects from all over the continent are too numerous to name, but a few interesting projects include Getty and Mellon support of archiving initiatives in South Africa, Senegal, Nigeria, EU support for many initiatives in Mali, British Library support for efforts in Liberia and Cameroon, and a number of sources for the Arab Image Foundation which holds material from north Africa. Significant efforts to create local and national photographic archives in Benin, Senegal and Mali suggest that partnerships may be fruitful to valorize and keep such archives in the country, and all of these are worth watching.

[16] Such as Pierre Bergé & associés auction, *Photographies Africaine*, Brussels, 23 March 2010, included contemporary and modernist work, as is likely to be the case also for *Paris Photo* fair, 17–20 November 2011, *From Bamako to Cape Town, a spotlight on African photography*.

depends on who is being asked. Still, the question may have different answers in the future. As some would say, the future is the whole point of making a photograph.

Bibliography

Batchen, G. 1991. Desiring Production Itself: Notes on the Invention of Photography, in *Cartographies: Poststructuralism and the Mapping of Bodies and Spaces*, (eds) R. Diprose & R. Ferrell. Sydney, NSW: Allen & Unwin.

Flood, F. B. & Z. S. Strother. 2005. 'RES: Anthropology and Aesthetics', *Permanent/Impermanent* 48 (Autumn): 5-10.

Haney, E. 2004. 'If these walls could talk! Photographs, photographers and their patrons in Accra and Cape Coast, Ghana, 1840-1940'. Unpublished PhD thesis, University of London.

—— 2010a. 'Film, Charcoal, Time: Contemporaneities in Gold Coast Photographs', *History of Photography* 34 (2): 119-33.

—— 2010b. *Africa and Photography*, London: Reaktion.

—— forthcoming. 2013. *Portrait Photography in African Worlds* (eds) E. Cameron and J. Peffer, Bloomington IN: Indiana University Press.

Morton, C. & E. Edwards (eds). 2009. *Photography, Anthropology and History*, Farnham: Ashgate.

Schneider, J. 2010. 'The Topography of the Early History of African Photography', *History of Photography* 34 (2): 134-46.

Sutherland, R. 2009. *Ghana Through the Lens, A Photo Journey By Willis Bell*, (eds) A. Bremer & E. Sutherland-Addy. Berlin: Goethe-Institut.

Vanderpuije, B. J. K. 2007. *Ghana Photos Memories*, Paris: Filigranes Editions.

Wendl, T. 1999. *Snap Me One! Studiofotografen in Afrika*, (eds) T. Wendl & H. Behrend. Munich: Prestel.

7

'Ça bousculait!'
Democratization & photography in Senegal
Jennifer Bajorek

The definition of a popular photography is elusive, whether by popular we mean a photography that is of and by 'the people', or one that becomes democratized or vulgarized, making itself available to ever larger numbers of people. The question of photography's democratization takes on a special significance in African contexts, where until very recently scholarship was preoccupied with the role of photography in colonial and imperial projects.[1] Such analysis remains an important precedent for any approach to the history of photography in Africa. However, it has tended to overlook local photographic practices 'which flourished from a very early date' and to ignore photography's place in African creative traditions. Thanks to a new wave of scholarship that has begun to explore the complex trajectories of the photographic images and archives that arose from these practices and traditions, the study of photography in Africa has become increasingly central to histories of the field that are becoming truly global in their reach – like photography itself.[2]

My recent research has focused on photography in the 1950s and early 1960s in Senegal. I have been particularly interested in the aesthetics and politics of photographs and photographic practices that spanned the pre- and post-independence decades. My approach is developed within a broader theoretical framework in which photography is never just a collection of images or an image-making technology, but a historical force in its own right. More than just a reflection of reality or of lived experience, photography cannot be confined to the sphere of the image or even – African histories are particularly revelatory here – to the field of the visual. In keeping with this insight, which strongly parallels those of Walter Benjamin and nonetheless intersects with specifically African concerns, my research explores photography's contribution to broader processes of decolonization and post-colonial state formation. There is increasing evidence that photography played a significant role in popular political movements in urban centres in the AOF (l'Afrique Occidentale Française or French West Africa), and that it has played a rather more ambiguous role in the exercise of power by decolonizing and nascent post-colonial states. Building on this evidence, my research explores photography's place in the collective assertion of Africans' rights to political self-determination in the years leading up to and following independence and asks what photography might have still to contribute to processes of aesthetic and visual decolonization in the present.

[1] See Alloula (1986) Geary & Lee-Webb (1988) Geary & Pluskota (2002), Landau & Kaspin (2002) and Ryan (1998). For discussions of photography and race in a range of historical and cultural contexts, many of which are informed by the legacies of European colonial and imperial projects in Africa, see Mirzoeff (2003), Poole (1997), Sekula (1989), Willis & Williams (2002). For more recent discussions of photography and race as the dyad plays out in contemporary art and new media, see Dyer (1997) and González (2003).

[2] See, in particular, Buckley (2005, 2006, 2008); Edwards (2001); Haney (2010); Nimis (1998, 2003, 2005); Ouédraogo (2002); Werner (2001). For an elegantly presented and meticulously researched account of the early history, see, in particular, Haney's first two chapters.

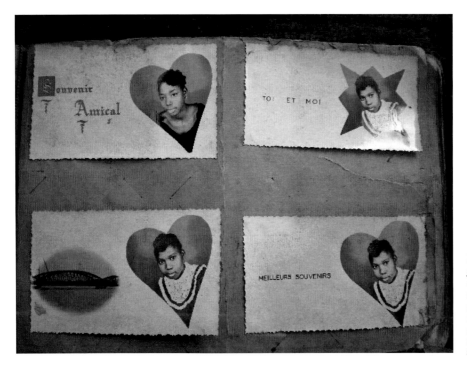

Figure 7.1 Page from a sample album, studio of Doudou Diop, Saint-Louis, Senegal.

Reproduced by kind permission of the Diop family.

This essay, which I present as a series of research notes, draws on two sources: first, material from the illustrated magazine *Bingo*, which was published out of editorial offices in Dakar for a pan-African readership from 1953 onwards and printed a large number of photographs in every issue. The second is interviews I conducted with photographers of the independence generation or with their families in Senegal.[3] In both cases, the materials presented include not only photographs but a discourse about photography. The photographs in *Bingo* were published in a magazine destined for mass circulation in Africa and beyond, whereas the photographs I have discussed with photographers and their families were intended for display in private homes and family albums, for exchange between friends, family, and lovers, sometimes living in the same city but often living abroad; or for use in administrative and government documentation. The two bodies of material, although in other ways very different, allow us to explore spaces of exchange and of experience tied to photographic practices that may in several senses be understood as 'popular'.

[3]Although my focus here will be on Senegal, my research is informed by limited comparative work in other sites. In addition to field research and interviews conducted with photographers, families, collectors, and institutional officials (museum and archive professionals) in Dakar and Saint-Louis in the winter of 2007 and summer of 2008, I did field research and conducted interviews with photographers in Porto-Novo and Cotonou in the Republic of Benin, in July and August of 2009, and with photographers from Mali and from other parts of Africa in Bamako, Mali, in November of 2009, during the 8th edition of the *Rencontres de Bamako*, a photography biennial held in Bamako since 1994. All of these conversations and experiences have shaped my approach to my material and my understanding of the relevant history. Archival research carried out in institutional archives in Senegal, Benin, and France has also informed my understanding and approach. I consulted *Bingo* in the Bibliothèque Nationale de France in January of 2011. I am deeply indebted to Toby Warner for suggesting that I look at the magazine, and for alerting me to its practice of publishing reader submissions.

1. 'Sous son vrai visage'

In the inaugural issue of *Bingo*, published in February of 1953 and described by its editor, Ousmane Socé, as the first illustrated monthly produced for Africans by an African resident in the AOF [4] – the magazine was subtitled *L'Illustré Africain* (The African Illustrated), and eventually *Le Mensuel du Monde Noir* (The Monthly of the Black World) – it was possible to read this call for submissions:

> *Bingo* is the reflection of African life. Its aim is to capture in images the present-day activity and immortal beauty of black Africa. Read it; get the word out. Write and tell us what you think, what you would like to see in its pages. Participate in its life by sending us your photos. [5]

It is significant that this call for participation was published in the very first issue. It is an explicit premise of the magazine that it will publish as many photographs as possible: 'Our objective first and foremost is to give as much space as possible to images of contemporary life'.[6] Even more significant – extraordinary even – is the fact that so many readers responded to the call.

At first glance, the first few issues may leave us doubting as to whether reliance on reader submissions could achieve the stated objective. In *Bingo* No. 1, Socé is pictured on the editorial pages in a portrait credited to 'Studio Harcourt'. In *Bingo* No. 5, published in June 1953, a portrait of Lamine Guèye (then Mayor of Dakar) is included. We learn from this image also from Harcourt, that the studio patronized by the magazine's editor and one of Senegal's most prominent politicians in Paris. Similarly, in the first issue, the credits to photographers with addresses in Dakar and in other African cities are published in a block paragraph on the final page. The list consists mainly of French surnames. The remaining photographs were furnished by the colonial information service and several well-known European press agencies:

> A. Martin; Information Service of the Governor General; Information Service of the Cameroon Delegation; Photos Peroche in Dakar; H. Lacheroy; Interpress; Photos Simon-Huchet; Y.M. Pech; Labitte (Dakar); Agence Diffusion Presse; Cameroon Information; Peroche; Record; Keystone.[7]

In contradistinction to the French dominance of these early credits, all of the photography studios advertised in the magazine appear to be in the hands

[4] Ousmane Socé Diop (b. 1911, Rufisque, d. 1973, Dakar) was a well-known Senegalese writer and politician. *Bingo* had its editorial offices in Dakar, but the magazine studiously avoided territorial and cultural identification with Senegal. It sought instead to cultivate a pan-African image, covering matters of interest to a broader francophone African readership. This included Africans living abroad, and, importantly, troops stationed in Algeria and Indochina. 'This magazine is the first fully illustrated publication edited by an African from French West Africa for Africans' [*Ce magazine est la première publication entièrement illustrée éditée par un Africain de l'Afrique Occidentale Française pour les Africains*] (*Bingo*, No. 1, Février 1953: 26).

[5] '*Bingo est le reflet de la vie Africaine. Son but est de fixer par l'image l'activité actuelle de l'Afrique noire et sa beauté de tous les temps. Lisez-le; faites-le connaître. Ecrivez-nous pour nous dire ce que vous en pensez, ce que vous désirez y trouver. Participez à sa vie en nous envoyant des photos*' (*Bingo*, No. 1, Février 1953, inside back cover).

[6] '*Nous nous efforcerons tout d'abord de donner toute la place à l'actualité par l'image. Mais l'on nous a demandé aussi de la lecture : des contes, des nouvelles, et de l'histoire...*' (*Bingo* No. 1, Février 1953: 26).

[7] '*A. Martin; Service d'information du gouvernement général; Service d'information de la délégation du Cameroun; Photos Peroche à Dakar; H. Lacheroy; Interpress; Photos Simon-Huchet; Y.M. Pech; Labitte (Dakar); Agence Diffusion Presse; Cameroun Information; Peroche; Record; Keystone*' (*Bingo* No. 1, Février 1953: 26).

of African proprietors.[8] Where the proprietor is not mentioned, local ownership may be surmised from the studio name or address – in this case in Dakar:

> Photo-Mello. 16 bis Bd. de la Gueule Tapée, Tel. 67.20. All types of photos. Expeditions throughout French West Africa. Portraits-Enlargements. Photos taken in your home, by appointment.[9]

> African-Photo: Hadj Casset Gnias [well-known Senegalese photographer, Mama Casset]. Avenue Blaise Diagne (angle 31), Telephone 71-45. B.P. 7003. Dakar-Medina. Everything for photography. Portraits-Enlargments. Photographic reportages. Photo buffs. Expeditions to the interior.[10]

Furthermore, if one examines the credits over the magazine's first year of publication, the list expands to include a dizzying array of photographers, many of whom we know to be African. The first credits to photographers with African names appear as early as *Bingo* No. 3, published in April 1953. In an essay on 'Aspects of Muslim life', there are photographs attributed to 'Photo Bâ'. In the list of credits at the end of No. 3 appears the name 'Photo Mix' – very likely the trade-name of the well-known Senegalese photographer Mix Guèye. In the photo credits for the whole of 1953 (over 11 issues), there are many African photographers represented, as well as an impressive geographic range, covering nearly a dozen cities and territories, in the AOF and beyond:

> 'Photo-Ciné Abidjan'; 'Congopresse Van Den Heuvel'; 'Congopresse Da Cruz'; 'Photo Almasy'; 'Photo Cocheteux' [French photographer employed by the colonial administration whose ethnographic photographs are, today, a mainstay of local institutional archives throughout the ex-AOF]; 'Baby-Photo Dakar'; 'Photos Hid Rufisque'; 'Photo Bel-Ami Cotonou'; 'Photo-Sénégal S.N. Cassett' [Dakar studio of Salla Casset]; 'N'Diaye Cheikh'; 'Photo Djams Dakar'; 'Faïz Fetouni'; 'Jean Morin'; 'Olympia Photo Yitka Kilian' [Studio associated with readers in Rufisque]; 'Cliché Jendot, Dakar'; 'Photo N'Diassé M'Baye, Thiès'; 'Tropical-Photo'; 'Electric-Photo Dominique'; 'Photo Lefèvre, Kaolack'; 'Provence Photo, Fréjus' [The only metropolitan studio represented, outside Harcourt, see above]; 'Radio-Photo T. Chanine, Conakry'; 'Drumphoto' [Photo section of the well-known South African magazine]; 'IFAN – Adandé' [Almost certainly Alexandre Adandé, the well-known Beninese scholar and politician and the founder of an ethnographic museum in Porto-Novo].

[8] Studios in French hands appear not to have advertised in *Bingo*. This was very likely due not to the magazine's policies or to segregationist sentiment on the part of the European community in Dakar but rather to the fact that French-owned studios were already advertising elsewhere. I have discussed the more general commercial environment as well as questions of access to markets by African photographers with several Senegalese photographers, and we did occasionally discuss the practices of French-owned and Lebanese-owned studios. We did not discuss print advertising, however. The point merits further research. The point merits further research. Erika Nimis has done important research on the limited opportunities for advertising in the commercial guides and *annuaires* in the AOF as compared with the situation for African photographers in British-controlled territories (Nimis 2005: 120–21.)

A further note about advertisements: Despite the magazine's pan-African and internationalist mission, the bulk of products and services advertised in the very early years seem to be Dakar-local. European-owned businesses, including those with regional offices in other colonial territories or headquartered in metropolitan France, did advertise in *Bingo*, and there is a noticeable surge, post-independence, in advertisements for consumer products with international brand recognition, such as Gitanes and Lucky Strike, Bosch, Telefunken, Grundig, Shell, Mobil, and BP (motor oils), Kodak, Leica, and Agfa.

[9] '*Toute la photo. Expéditions dans toute l'AOF. Portraits-Agrandissements. Photos à domicile, sur rendezvous*' (*Bingo* No. 1, Février 1953).

[10] '*Tout pour la photo. Portraits–Agrandissements. Reportages photographiques. Travaux d'amateurs. Expéditions à l'intérieur*' (*Bingo* No. 1, Février 1953).

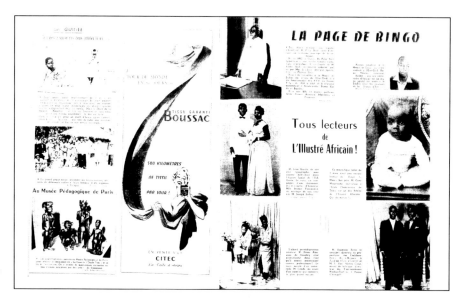

Figure 7.2 'La Page de Bingo', composed of photographs submitted by the magazine's readers (August 1953).

This expanded list is significant. It suggests that *Bingo*'s readers did indeed 'get the word out'. In so doing, they not only responded to Socé's inaugural exhortation but affirmed the timeliness of the magazine's mission: to create an illustrated monthly by and for Africans, in which readers would engage in photographic exchanges and related practices of looking, interpretation, and aesthetic judgment under the banner of a specifically black African modernity. Readers who sent in their personal portraits from Abidjan, Conakry, and Cotonou, as well as from cities closer to home, expressed their ready grasp of and enthusiasm for an African identity that could be both envisioned and shared via photography across great distances and linguistic and ethnic divides. Equally telling are the advertisements for cameras, film, photographic papers, and other supplies (Figures 7.5 and 7.6).

It is reasonable to assume that the first readers to submit their personal portraits for publication in the magazine drew on existing archives, and that the studios they patronized had been established well in advance of the magazine's 1953 launch. The photographers who owned and worked in these studios, their clientele, and the communities (largely urban) in which they were located were already articulating and documenting a specifically African and self-consciously modern identity that could be envisioned and shared, with and through photography – in Abidjan, Conakry, Congo, Cotonou, Dakar, Kaolack, Porto-Novo, Rufisque, South Africa, and Thiès – before Socé issued his call.

The magazine's presentation of the materials submitted by readers was eclectic. Throughout the 1950s, many of these were grouped together, with or without captions, on a page called 'La Page de Bingo' (Figure 7.2). The page made no effort to draw out themes or impose coherence on the variety of genres, subject matter, and geographic locations represented. All of these, plus the photographs' dimensions, vary wildly. There are baby pictures ('This magnificent three-month-old baby is not a *Bingo* reader yet.... But ... His father, Mr Moustapha Cissé, a teacher at the École Clemenceau, in Thiès, is a faithful reader of the African Illustrated. You can't beat that!'); a civil servant in uniform standing behind his marriage register having just presided over 'his thirteenth marriage in a single week'; a double portrait of two Senegalese

brigadiers stationed in Casablanca; a group portrait of a large group of friends at the airport, gathered to see off one Mr Moussa Touré on his voyage to France; all are represented alongside passport photos and more conventional portraits, including a couple who have attended a Christian wedding, and portraits of businessmen in both European and African dress. The motto, 'All readers of the African Illustrated' ('Tous lecteurs de L'Illustré Africain'), appears in a spare yet elegant typeface under the title or centred amongst photographs in the middle of the page, underscoring that the only possible, or necessary, coherence that could be imposed on or derived from these photographs is the fact that they are all reader submissions. By the late 1960s, 'La Page du Bingo' appears to have been not only renamed ('Club Bingo') but moved to the magazine's back pages, where it became part of a subscription campaign (Figure 7.4).

Other photos were published together with readers' letters. The latter express delight in and approval of the magazine as a whole and offer commentaries on specific articles and features. (Imagine a cross between the 'letters' page of a major newspaper and a fanzine, or better still, the blogs now maintained by the mainstream media that present readers' electronic contributions, but instead illustrated with a full-length professional portrait of the letter's author, taken with a box camera in a 9x12 cm format, rather than the ubiquitous thumbnail.) In its content as in its larger concept, *Bingo* was identified with a progressive social and political agenda, and this is reflected not only in its editorial direction but also in the commentaries of its readers. Topics such as African emancipation and modernization are explicitly and enthusiastically treated. The magazine routinely ran annual or semi-annual features on polygamy (condemned from the standpoint of both feminist and economic analysis), dowries, state-sponsored education, and infrastructure projects from what would have been considered a progressive, or pro-modernization stance. One-off investigative reports focused on such highly mediatized cultural phenomena as the vogue for mini-skirts or mini-dresses (always a hit on the letters page) and bi-racial couples. *Bingo*'s readers invariably responded. A 1961 feature on 'dominos', or bi-racial couples, includes a profile of actress Marpessa Dawn.[11] Cinema is a major preoccupation, and a two-page spread published in 1960 presented readers' responses to a survey about their movie-going habits. Their answers to detailed and probing questions (verging on the ethnographic: 'How many times a month do you go to the cinema?' 'What percentage of your budget do you spend there?' 'Do you only go in your neighbourhood?' 'Why do you go to the cinema?' 'Do you believe that cinema has a social function?' 'African cinema is dawning; what do you hope it will accomplish?') were accompanied – of course – by the respondents' photographs.[12] Interspersed with profiles of African political leaders such as Modibo Keïta and Sekou Touré ('Jeune syndicaliste, fondateur de la CGTA devenu Vice-Président du Gouvernement de Guinée') and the election of representatives to the African territorial assemblies are semi-regular features on such questions as to whether or not African women should study and work abroad ('Should African women go abroad to further their careers?'). The answer is, unequivocally, 'Yes', although the question appears somewhat perversely to have been discussed largely among men.[13]

[11] 'Ces couples qu'on appelle "dominos"' (Bingo No. 101, Juin 1961: 28-31).
[12] 'Pourquoi allons-nous au Cinéma?' (Bingo No. 91, Août 1960: 35).
[13] Socé was himself educated in Paris and was among the first generation of Senegalese intellectuals and politicians to attend university there.

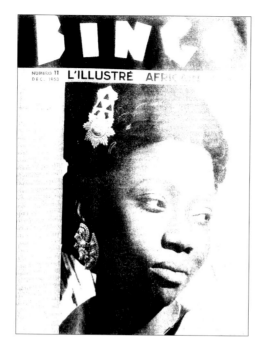

Figure 7.3 Front cover of Bingo *featuring a cropped and enlarged portrait of Mrs N'Doye, née Seck, of Rufisque (No. 11, December 1953).*

Photo by Olympia Photo Yitka Kilian, Senegal.

Whether their avowed topic is political leaders, movies, or mini-skirts, many of the letters intimate that their authors are bracing themselves for a critical epoch in Africa's future. None, however, goes so far as to voice openly anti-colonial sentiment. When a reader in Thiès raises the question of political parties and his concern about the magazine's possible party affiliation, Socé is careful to respond by emphasizing unity and the general benefit to all Africans of *Bingo* as an expressive platform. In March of 1953, we read this from Mr Amadou Diop, of Thiès:

> I really enjoyed the first issue of *Bingo*. Its time has come, and I would like to welcome it with open arms. Also, I hope you will allow me to ask you a question. Are you using this magazine to promote a particular politics? You are a party leader.[14] Is *Bingo* a party organ? I would like your assurance on this point. If it is not too much trouble, I would like to have a response. Sincerely... . (*Bingo* No. 2, March 1953: 3)

Socé's response was published directly:

> Dear reader: Your desire to find in *Bingo* an apolitical magazine with the sole concern of serving the interests of black Africa is entirely justified. I will tell you what led me to undertake its publication. First of all, its absence was conspicuous, for there are magazines of this genre in all of the British territories.
>
> What is more, Africa is going through or ought to be, in the second half of the 20th century, a decisive phase in its historical destiny. For those of us who are African, the only viable solution is one predicated on the primacy of autochthonous interests. *Bingo*, by capturing in images and in words both our past – of which we have no archive – and our present evolution, must affirm the dignity of the black

[14] Socé was connected with the Senegalese socialist party. Closely identified with Lamine Guèye, who forged alliances between his socialist party in Senegal, the French Section of the Workers' International, or SFIO, and burgeoning socialist movements elsewhere in the West African territories, the Senegalese socialists were the principal political antagonists of the Bloc Démocratique Sénégalais, or BDS – Léopold Senghor's party.

man, help him to know who he is and to prepare, for himself, an equitable future. That is its sole ambition.[15]

Such high-minded commentary makes for an extraordinary frame in which to situate our readings of these, or any, photographs.

A smaller but no less fascinating subset of readers' photographs was printed on the magazine's front cover. A single portrait – ideally of a young, well-coiffed married woman, always with several children and occasionally a career outside the home – graced the cover of each issue for the better part of a decade. The cover images were cropped and enlarged to enhance compositional focus and highlight details of the subject's face and hair. They were accompanied by a caption on the contents page. These images command our attention because they were singled out for aesthetic reasons, allowing us to discern certain principles of selection, and because the style and content of their captions provide an alternative discursive frame. Even when these captions do not depart from or directly contradict the more high-minded commentary typical of the exchanges on the letters page, they furnish a different order of detail: about the subjects' lived experience and aspirations and about the editor's perceptions of the types of information and of meaning that a photograph can convey.

In *Bingo*, No. 11, published in December 1953, a portrait of a Mrs N'Doye ran on the cover (Figure 7.3). The image has been cropped and enlarged to highlight the angle of the subject's pose and draw attention to her hair, hair ornament, and the intricate bijouterie of her earring. She looks, modestly but perhaps also coyly, away from the camera, her eyes following the diagonal that organizes the photograph's composition, and by extension the cover of the magazine. The caption reads:

> Portrait of Mrs N'Doye, née Fatou Seck, of Rufisque. Daughter of Babacar Seck and Diass Samba, she is the very ideal of Wolof beauty. She still lives in the Merina, where she was born and where, in 1947, she married Mr Abdoulaye N'Doye, who works at the Central Post Office in Dakar, as a telegraph operator for South American cables. The couple have three children: Mamadou, Ousmane, and Kardiata. Mrs N'Doye, an excellent housewife, speaks French very well and is fond of dancing and the cinema. Her dream is to see Paris. An avid reader of *Bingo*, her only complaint is that it does not have enough pages! Photo credit: 'Olympia Photo Yitka Kilian'.[16]

[15] De M. Amadou Diop, de Thiès: 'J'ai beaucoup apprécié le premier numéro de Bingo. Ce magazine vient à son heure, et je voudrais le saluer comme un ami. Aussi, me permettrez-vous de vous poser une question directe: Poursuivez-vous derrière cet illustré une politique? Vous êtes un chef de parti. Bingo est-il un instrument de ce parti? J'aimerais en avoir le cœur net. Sans trop vous importuner, j'aimerais bien avoir une réponse. Veuillez agréer...'

Réponse: 'Cher lecteur, votre souci de trouver dans Bingo un magazine apolitique et uniquement soucieux de servir les intérêts de l'Afrique noire est pleinement justifié. Je vous dirais donc ce qui m'a décidé à en entreprendre la publication. D'abord, son absence était une lacune, car des magazines de ce genre existent dans tous les territoires britanniques.

'Par ailleurs, l'Afrique traverse et doit traverser au cours de la seconde moitié du XXe siècle une phase décisive de son destin historique. Or, pour nous autres, Africains, la seule solution valable est celle qui aura comme principe d'action la primauté des intérêts autochtones. Bingo, en fixant, par l'image et le texte – notre passé – dont nous n'avions aucunes archives – et notre évolution présente, doit affirmer la dignité de l'homme noir, l'aider à se connaître et préparer, pour lui, un avenir équitable. C'est là toute son ambition'. Signé Ousmane Socé.

[16] 'Portrait de Mme N'Doye, née Fatou Seck, de Rufisque. Fille de Babacar Seck et de Diass Samba, elle incarne toute la beauté ouolof. Elle habite toujours le quartier de Merina, où elle est née, et, en 1947, a épousé M. N'Doye Abdoulaye, qui travaille à la Grande Poste de Dakar, comme opérateur-télégraphiste aux câbles sud-américains. Trois enfants sont nés de ce couple : Mamadou, Ousmane et Kardiata. Mme N'Doye, excellente ménagère, parle fort bien le français, elle aime la danse et le cinéma. Son rêve et de connaître Paris. Lectrice assidue de « Bingo », elle ne reproche à notre illustré que de n'avoir pas assez de pages!' ('Olympia Photo Yitka Kilian') (Bingo, No. 11, Décembre 1953: 3).

Figure 7.4 'Ils sont membres du Club Bingo'. By the late 1960s, under the editorial direction of Paulin Joachim, the focus on reader submissions appears to have been dropped, and the majority of readers' photographs appear in passport format in the magazine's back pages (No. 182, March 1968).

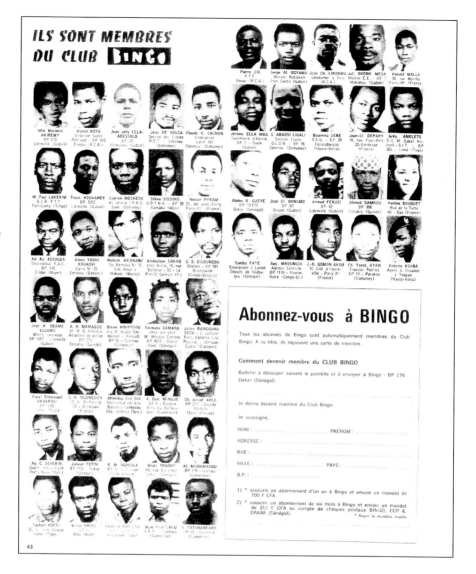

On the one hand, the caption, which clearly draws on information provided by the reader but has just as clearly been redacted, is so hyperbolic in its expression of bourgeois fantasies and assimilationist values ('Her dream is to see Paris'; 'She is fond of dancing and the cinema') that it seems almost a caricature of the image of the *évoluée*, and to risk undercutting Socé's insistence on African self-determination. At the same time, many of the qualities evinced in this description of Mrs N'Doye's accomplishments and those of *Bingo*'s other cover girls (advanced education, connoted by literacy and the ability to speak French; disposable income, connected with her husband's employment in the Central Post Office; leisure) were the conditions of possibility for organizing of a growing African middle-class and educated elites in labour unions and political parties in the post-war period, which saw such organizing take place on an unprecedented scale. These were the means by which, in Senegal in particular, Africans working in the middle and lower ranks of the colonial administration

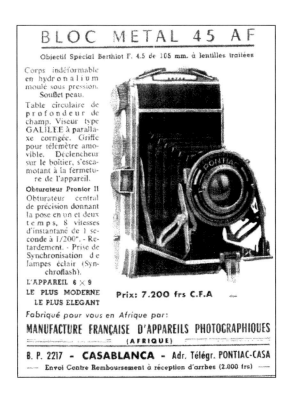
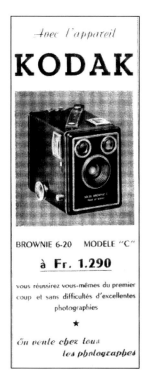

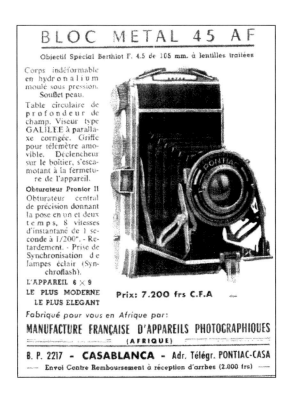

BLOC METAL 45 AF

Objectif Spécial Berthiot F. 4.5 de 105 mm. à lentilles traitées

Corps indéformable en hydronalium moulé sous pression. Soufflet peau.

Table circulaire de profondeur de champ. Viseur type GALILEE à parallaxe corrigée. Griffe pour télémètre amovible. Déclencheur sur le boitier, s'escamotant à la fermeture de l'appareil.

Obturateur Prontor II Obturateur central de précision donnant la pose en un et deux temps, 8 vitesses d'instantané de 1 seconde à 1/200". - Retardement. - Prise de Synchronisation de lampes éclair (Synchroflash).

L'APPAREIL 6 × 9
LE PLUS MODERNE Prix: 7.200 frs C.F.A
LE PLUS ELEGANT

Fabriqué pour vous en Afrique par:

MANUFACTURE FRANÇAISE D'APPAREILS PHOTOGRAPHIQUES
(AFRIQUE)

B. P. 2217 - CASABLANCA - Adr. Télégr. PONTIAC-CASA
Envoi Contre Remboursement à réception d'arrhes (2.000 frs)

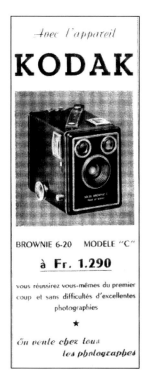

Avec l'appareil

KODAK

BROWNIE 6-20 MODELE "C"

à Fr. 1.290

vous réussirez vous-mêmes du premier coup et sans difficultés d'excellentes photographies

★

En vente chez tous les photographes

Figures 7.5 and 7.6 Advertisements for the Pontiac Bloc Metal AF 45 and the Kodak Brownie camera. Both ran in Bingo *in the 1950s.*

would come together to define for themselves the terms of their modernity and forge, to borrow Socé's phrase, 'an equitable future'.

This point is essential to research on photography in this period, for it suggests a material as well as ideological connection between the democratization of photography and democratization in a more conventional political sense. The exponential growth of waged labour in African urban centres in the immediate post-war period was, it is now widely acknowledged, a critical factor in the struggle by Africans for self-determination – first in the name of greater autonomy and the Africanization of government in states that would remain part of the French Union, and, eventually, in the conquest of independence.[17] The projects of the labour unions and of African political parties were political in every sense of the word. These projects were not without a corresponding aesthetic one, with which portraits of cultivated matrons, who spoke excellent French and dreamt of seeing Paris, were not at odds.

Above all, it was the timeliness of an illustrated magazine that could facilitate this aesthetic expression of autochthonous interests that *Bingo*'s readers affirmed. Their ready participation in response to Socé's call for submissions, and their embrace of collective interpretive practices and a critical discourse about photography, suggest that the interpretive complexity and political polyvalence of the photographic image, even a simple photographic portrait, was not lost on them. Consider, finally, the remarks made in a letter by Mr Nabbie Yaya Camara from Conakry, an employee of the finance department of the Chemin de Fer de Conakry-Niger, and a theorist of Afro-pessimism to rival our contemporaries: 'I read very avidly Nos. 1 and 2 of *Bingo*, the African

[17] See Cooper (1996), Johnson (1971), Meillassoux (1968) , and Schachter Morgenthau (1964).

Illustrated. Because for unscrupulous journalists Africa is a bastion swarming with frightful savages. Because degenerate reporters seem to have made it their mission never to show our land in its true image'.[18] A simple portrait, the collective interpretive practice of *Bingo*'s readers clearly demonstrated, could be elevated to a higher plane and to a new kind of collective significance by virtue of its circulation in a mass context, to become the 'true image' ('*vrai visage*') of Africa.

Only on the surface is there any contradiction in the position of a waged employee of the colonial administration who is sharply critical of the images of Africa and Africans favoured by that system, to the point of calling for a revolution in the global image ecology. His participation in that system – including, specifically, his literacy and his access to cash wages (*Bingo* was selling for 40F c.f.a.) – was the material and ideological condition of that system's transformation, just as it was the material and ideological condition of photography.

2. '*Toute la ville est venue*'

L'heure de la descente, 18.00h (6.00 pm), Saint-Louis du Sénégal, Rue de MTOA, 1956. Doudou Diop, an accountant in the French army and, in his off hours, a wildly successful photographer, returns from the barracks complex to his home in a neighbourhood called Sor and prepares to open his studio for the evening. The hour marks the end of the working day for those who work for wages and at fixed hours. Almost invariably, in Saint-Louis and in other cities in the AOF, *les salariés* are employed by the colonial administration – like Diop. Connoting a high level of education and literacy in French, such employment confers status and guarantees a steady stream of cash. Occasionally, *les salariés* work for small manufacturing concerns, such as the famous cigarette factory from which the street takes its name: Rue de MTOA – *Manufacture de Tabacs de l'Ouest Africain*. Somewhat confusingly to my mind, however, the factory is located in the modern capital, Dakar, and not, where the street is, in Saint-Louis. I would learn of the significance of this place-name from the driver who had brought me to Saint-Louis from Dakar in December of 2007, on the occasion of my first visit to Diop's family. The photographer is now deceased, but I was fortunate enough to be able to look at what remains of his personal archives in the company of his son, Guibril André Diop, who had come to Saint-Louis from Dakar a week or so prior for the Tabaski celebration. We looked not only at the extant prints in the photographer's sample albums (Figures 7.1 and 7.10), but also at his cameras, and at the copious and meticulous records that he had kept of his studio activities. On the second day of my visit to Diop's home, I was also able to interview the photographer's wife.[19]

The disorientation caused by the reference of the place-name, of a street

[18] *De M. Nabbie Yaya Camara, Finances CFCN [Chemin de Fer Conakry Niger], Conakry: 'C'est avec avidité que j'ai lu les Nos. 1 et 2 de Bingo, l'illustré africain. Parce que l'Afrique est pour des journalistes sans scrupules un bastion où fourmillent, tels des vers, d'affreux sauvages. Par ce que des reporters tarés semblent se donner pour consigne de ne faire connaître notre pays sous son vrai visage'* (Bingo, No. 3, Juin 1953: 3).

[19] References to conversations with Guibril André Diop are to personal interviews with the photographer's son conducted in his parents' home in Saint-Louis, Senegal, on 26 and 28 December 2007. I have kept in touch with André Diop, who is a sculptor who has travelled and exhibited extensively both at home and abroad, and we have had occasion to revisit our conversations at later points, including in July of 2008, when I visited him in his studio in the Village des Arts complex in Dakar. Interviews were conducted in French.

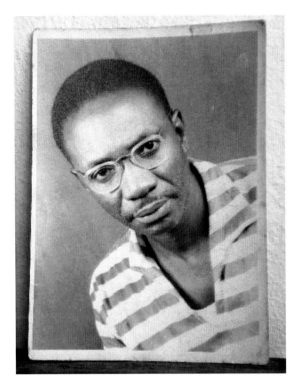

*Figures 7.7 and 7.8 Portrait of
unidentified sitter in striped shirt
and eyeglasses. Verso, showing the
photographer's stamp, or cachet,
and date.*

Photograph by Doudou Diop, Saint-Louis,
Senegal, 1961. Reproduced by kind permission
of the Diop family.

in one city to a factory in another, presaged the disorientation I would feel
several months later, in 2008, when I was taken on a tour of the city by
another photographer, Adama Sylla (who, incidentally, remembered being
photographed by Diop as a boy.) Adding to my sense of confusion on both trips
was my inability to distinguish clearly between what belonged in Saint-Louis –
which families, and which photographs – and what belonged in Dakar.[20] The
sense that it was not always possible to distinguish between the two cities'
histories could be traced to the stories I had been told in my very first days
in Dakar, in 2007, about the fierce pride of the old Saint-Louisian families,
whose walls were 'covered with photographs'. Despite the geographic distance
and cultural differences that supposedly set the Saint-Louisians off from other
Senegalese, the best and brightest of these families had been relocating to

[20] It is difficult – at least for me as an outsider – to unpack the cities' competing legacies as capital
cities at different points in Senegal's history, and to distinguish clearly the dates and experiences
behind the rise and fall of their fortunes at different points. Both cities were founded, at least in
their modern form, by the French, and both were capital cities of the French colonial territory of
Senegal, with all of the complex cultural and political baggage that this entails. Saint-Louis was
the seat of French power in Africa from the seventeenth century onward and throughout the peak
years of the Atlantic trade, in which the city's African and creole (or *métis*) residents were active
and through which they amassed considerable fortunes. In the nineteenth century Saint-Louis
was the capital both of Senegal and, from 1895, of the AOF, as well as, for a spell, the capital of
Mauritania. The capital of the AOF was transferred to Dakar in the early twentieth century, at
which point government as well commerce and concentrations of capital had already begun to
move south. In the late colonial period, Dakar became the more important city, due to its proximity
to peanut growing regions and its deepwater port. In the late 1950s, the capital of Senegal (as
distinct from the AOF) was also transferred to Dakar, where it remains. Contemporary Senegalese
and scholars of Senegal have begun to refer to Touba, the birthplace of Cheikh Amadou Bamba,
the spiritual leader of the Mourides, and a hub of black-market trading activities controlled by the
Mouride brotherhood and a site of extraordinary wealth, as Senegal's 'new' capital. It exceeds the
scope of this essay to discuss this development at any length.

Dakar for economic reasons for several generations. I soon learned that the precise decade and nature of a given migration of one or another branch of a Saint-Louisian family could be difficult to ascertain: even families that moved to Dakar with the transfer of the capital of the AOF in the early twentieth century have maintained a Saint-Louisian identity. I also learned that the dates and reasons for a given family's migration could be a determining factor in the location, or relocation, of their photographs. It is not difficult to walk into a house in Saint-Louis, whose walls *were* once covered with photographs, to find that these photographs have themselves migrated – to Dakar, Thiès, Kaolack, Abidjan, Paris, Rome, Atlanta, or Washington, DC. Which photographs and where depend on whether it was in 1902 or in the 1960s. The oldest photographs that I have seen from Saint-Louis, taken in the city of people known to be resident there, I saw in Dakar.

On the tour I took with Sylla in 2008, photography was at once our guide and the reason for our disorientation. As we went house to house in the formerly grand quarter at the northern end of the island, we carried a stack of portraits in our taxi on the seat between us, which we matched to the houses where their subjects had once lived. Many of these subjects were descendants of Saint-Louis's wealthy merchant families from an earlier era. Their relationship to an earlier period in the city's history – as well as to an earlier period in photography history – was often made the object of multiple and layered visual inscriptions, in the photographs themselves. In more than one of the portraits – taken in the interwar years and some in the early 1950s – the subjects were posed so that other photographs were visible in the background, many of these dating from the first decades of the twentieth century.

Most of these older photographs, particular those predating WWI, are gone now. Those that survive do so only because they have been re-photographed several times. Someone commissions a reproduction, and the photographer who makes it keeps the negative, even a print or two for himself – because he is both pleased with his work and uses it as a sample to show to future clients. Fifteen or twenty years later, someone commissions a reproduction of this print, and the process is repeated.[21] These are the photographs that have survived as physical or material objects – the type of photograph of which it can be said, 'We carried it in our taxi on the seat between us.' They often bear visual evidence of multiple photographic moments and events. Memory accrues each time that the photograph is re-photographed, to the point where it threatens to eclipse the image. Other photographs survive only in memory: those that have been lost, destroyed, stolen or sold off to European and North American collectors, or succumbed to the passage of time. Such photographs seem simultaneously to affirm and deny our understanding of photography as a technology of memory.[22]

For reasons connected with the history of migration from Saint-Louis to Dakar or elsewhere, and for reasons connected with the temporal complexities

[21] I have written at length about the circulation and reproduction of photographs within the city of Saint-Louis, and about photography as a culture of reproduction in Senegal more generally, in Bajorek 2010.

[22] See the beautiful essay by the famous Senegalese writer, Aminata Sow Fall, in which she recounts the experience of having her portrait taken by the legendary Saint-Louisian photographer Meïssa Gaye when she was a child. The essay is called, suggestively, 'Vague Memory of a Confiscated Photo' (Sow Fall 1999). As the title suggests, Sow Fall does not have her photograph anymore.

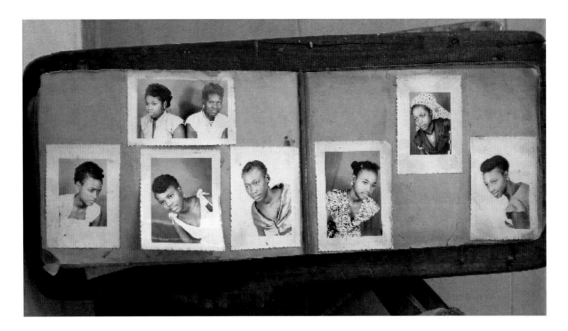

introduced by the multiple and layered visual inscriptions produced by re-photography, it is not always easy to draw a clear line between the images and practices that were typical of studio photographers working in the 1950s in more 'popular' neighbourhoods such as Sor in Saint-Louis, or the Medina in Dakar, or Bamako-Koura in Bamako, French Soudan, and those of an earlier period. To be sure, there were technical differences between the more popular photography of the 1950s and that of the studios that were patronized by the merchant aristocracies and political elites of the nineteenth-century coastal entrepôts. There were different cameras and formats to consider as well as differences in the availability of film and developing and printing products (in the earliest days, glass plates and various emulsions) in different locations. There were also differences in photographers' social and economic classes, and different levels of education, training, and participation in systems of artisan apprenticeship and caste. The same holds for the question of socio-economic class with regard to their clientele. Yet, in Senegal at least, these two periods continue to talk to one another, in living memory and in the photographs themselves: earlier photographs are visible in later photographs, and later photographs carry secret histories, and visible traces of the complex trajectories they have followed. In both contexts and at both historical moments, photography had aesthetic and political dimensions that were intimately bound up with other aesthetic and political phenomena of the day. When photographs from one or both periods have gone missing but are remembered, it is the tie binding the photograph to the events of the day that is most vividly remembered.

In the sandy street outside Diop's studio, there is movement and the sonorous exchange of greetings. Friends, neighbours, family – all clients – begin to gather. They have come to have their pictures taken, or to accompany their friends. Some are there to claim the pictures that were taken a day or two before. By the 1950s, common practice dictated that the client pays in advance for the prints: two or three, depending on the camera, the availability of photo papers,

Figure 7.9 Page from sample album, studio of Doudou Diop, Saint-Louis, Senegal. In 2007, Diop's sample album was intact and did not show signs of visits from collectors, who frequently purchase prints directly from photographers' sample albums, leaving only shadows.

Reproduced by kind permission of the Diop family.

and the photographer's skill.[23] The photographer then printed as soon as he could, usually upon closing the studio, overnight. Most photographers working in Senegal (the same practice has been documented in Mali and Benin) made contact prints, using an enlarger, through the 1950s. In earlier eras and in rural areas, where electricity was not available and photographers relied on solar enlargers, it would not have been possible to print at night. As a larger selection of chemicals (referred to in French by the photographers I interviewed as *des produits*) became more widely available and more affordable in the late 1950s, printing became more sophisticated. As printing moved away from the contact, it became a space of greater playfulness and experimentation (Figure 7.10).

Seydou Keïta opened his studio in Bamako-Koura, Bamako, French Soudan, at least a decade earlier than Diop in Saint-Louis, although the two men belonged to the same generation (Keïta opened his studio in the 1940s, whereas Diop was not launched fully in professional practice until the second half of the 1950s; Diop was born in 1920, Keïta in 1921). Bamako was, at that time, the capital of the French Soudan.[24] Keïta reported to André Magnin that at busy times, such as Saturdays and holidays, he stayed up printing, in Mountaga Dembélé's darkroom, until dawn.[25]

In Sor, it was Diop's wife, Ndèye Teinde Dieng, who did the printing.[26] Because Diop had to rise early in the morning to go to his army job, he trained his wife to print. Before going to sleep each night, he would develop the film and start the printing process. She would relieve him for the late-night shift. In 2007, Ndèye Teinde Dieng described her work to me through a translator.[27] She recalled in detail and with evident fondness the different temperatures at which she washed the various papers: one temperature for matte, another for glossy. When she was finished, she would hang the prints out to dry in the various nooks and crannies of the studio, wherever she could find space. The clients would return to pick them up, usually on the evening of the next day.

Ndèye Teinde Dieng's technical skill as a printmaker was exceptional for a woman of her generation. She was born in 1930. My driver, who was in his fifties (and so of the same generation as Ndèye Teinde Dieng's own children), was astonished to hear a woman speak of her experience with such a highly technical process. He overheard us talking when he came into the courtyard

[23] The two- and three-print figure is widespread in published scholarship on photography history in the AOF. See Keller (2008, 2010) and Nimis (1998, 2003, 2005).

[24] There is a long and well-documented history of trade, migration, and intercultural exchange both between the peoples of Senegal and present-day Mali and between the cities of Saint-Louis and Bamako in particular. This history has doubtless influenced photographers and photography in both places. Keïta told André Magnin in a published interview that his first camera, a Kodak Brownie, was brought back by an uncle from Senegal in 1935 (Magnin 1997: 9). Another well-known photographer who ran a successful and popular studio in Bamako, Abderramane Sakaly, was born in Saint-Louis and trained as a photographer there (Revue Noire's *Anthology* speculates that he trained under Meïssa Gaye) before establishing himself in Bamako in 1956 (Saint-Léon *et al.*, 1999: 115).

[25] Magnin 1997: 9.

[26] Personal interview with Ndèye Teinde Dieng, Saint-Louis, Senegal, 28 December 2007. To my knowledge, Diop had only one wife. This is important to mention in a Senegalese context, where the 'traditional' family structure is still common.

[27] Personal interview with Ndèye Teinde Dieng, Saint-Louis, Senegal, 28 December 2007. Ndèye Teinde Dieng understands French, but like many women of her generation, she cannot speak it. I asked her questions in French, and she responded in Wolof. Her responses were then translated into French by her son André.

to rest in the shade. He told me later, on the long drive out to the university dormitory complex where I was staying, that he had never met a Senegalese woman of her generation who had acquired this level of technical skill in any area. Not by a long shot a feminist – he had passed the time, for several hours during the drive from Dakar, dispensing a lecture on gender roles – he could not hide his admiration for Ndèye Teinde Dieng. André Diop himself confessed that although he knew that his mother had helped his father in the studio, he had not been aware of the extent to which she had been involved in the technical work of printmaking until he heard her speak of it that day.

With nostalgia and the memory of boyish glee, André described to me his own job in the studio, starting from the age of five or six: giving out numbers to the clients waiting in the line that formed outside the studio on the busiest days. André is, of course, a grown man now – tall, distinguished, with graying hair and children of his own (he was born in 1953) – but as he spoke of the waiting clients, in 1958 or 1959, it was easy to imagine him there, a young child thrilled by the heady sense of responsibility as he threaded his way through the crowd. In her early essay on Saint-Louisian photographers, Frédérique Chapuis gives astonishing numbers for the clients waiting in line in the street outside Diop's studio. She says that by 19h (or 7.00 pm) there could be up to 50 clients waiting to have their pictures taken. She also explains that clients were given a numbered receipt, which they would then use to claim their prints.[28] More than once in our conversation, André Diop emphasized the number of clients, and described the scene in the street outside: *'Toute la ville est venue'. 'Ça bousculait!'*

Sor was at the time, and remains, what in French is called a 'popular' quarter, although it is difficult to translate the term in this context. It would be misleading to translate it as 'working class', which is perhaps the most common translation in English, because the term can be applied only impressionistically in a colonial African context, and because Saint-Louis was never really an industrial capital, even by African standards. The separation of its population into working and capitalist classes did not take place according to the same logics that it did in the metropolis, nor was the city organized according to the same spatial and racial distribution as other colonial capitals. Judging from their photographs, which survive as prints arranged by Diop in sample albums, many of his clients appear to have been *salariés*, employees of the colonial administration: for example, in the army or the customs service (Figure 7.10).[29] Their lives were bound up in the rhythms of administration, like the photographer's. Many of his clients might be more accurately called middle-class or 'white collar' employees rather than working class (Figure 7.7). Such descriptions, however,

[28] Chapuis (1999: 58). Frédérique Chapuis was lucky enough to visit Diop's studio while the photographer was still living. It is possible that either Chapuis or I have misunderstood the purpose of the *'petits bouts de papier'* that were distributed to clients: were they numbers marking the client's place in line (as André told me) or were they rather receipts (as Chapuis describes)? It is equally possible that both systems were in place at different points in time or even simultaneously.
[29] Meïssa Gaye, whom Chapuis identifies as 'the oldest known photographer of Senegal and perhaps all of West Africa' (1999: 49) was himself a customs agent who had already been working as a photographer in Saint-Louis until he was posted to Guinea-Conakry in 1912. He then held various positions in the colonial administration throughout the AOF until 1929, when he turned full time to photography, opening his first studio in Kaolack and eventually returning to Saint-Louis (ibid.: 54). The account of Meïssa Gaye's career that I was told by Bouna Medoune Seye gave significantly different dates. For example, he told me that Meïssa Gaye was born in 1906. Personal interview with Bouna Medoune Seye, Dakar, Senegal, 24 December 2007.

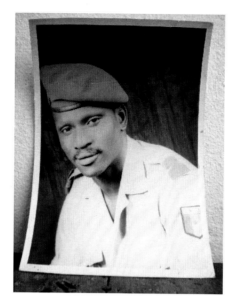

Figure 7.10
Portrait of
unidentified
sitter in military
uniform.
The original
photograph was
colorised by
'vaccinostyl', a
process invented
by Diop, in
which pigment
is applied to the
finished print
with the tip of
a hypodermic
needle.
Photograph by Doudou
Diop, Saint-Louis,
Senegal, c. 1960.
Reproduced by kind
permission of the Diop
family.

can be misleading, and we must resist the temptation to map them onto European models of industrialization and Eurocentric frameworks for understanding class struggle.

This is not to say that class struggle is not a relevant concept in the Senegalese context: the consequences of the Dakar-Niger railroad strikes of 1947-8 were far-reaching and are the stuff of legend.[30] Labour organizing, first in the metropolitan context of the SFIO (the French section of the Workers' International) and later in the context of the local trade union movement which led to the formation of UGTAN (the General Union of Workers of Black Africa), was a major factor in the articulation of African political demands and a prime mover of decolonization. In keeping with this more general observation, the story of political organizing in post-war Senegal is often told as a shift in the balance of power from educated elites – many of whom were already members of political elites associated with Senegal's unique constitutional history and longstanding electoral institutions – to a broader mass of waged labourers who came increasingly to participate in party politics after the passage of the 'Loi de Lamine Guèye' in 1946. This shift was aligned with more general geo-political trends. As Ruth Schachter Morgenthau suggests, political parties 'could take root in Africa only after the Second World War had marked a new stage in international politics, indicating that the colonial era was over'.[31]

At the same time, post-war developments in Senegal must be understood in relation to the country's unique political history. In the words of Kenneth Robinson: 'The constitutional evolution of Senegal has ... been very different from that of other parts of French Africa and its political history has in consequence been much longer. It therefore constitutes, in many ways, a "special case" for the student of African politics'.[32] Special case or no, the story of Senegalese political history in the post-war period is incontestably that of the increasing diversification of African actors in the political arena, and the extension of the franchise to an ever broader and more diverse electorate, which would give rise to multiple and significant political parties pre-independence. Robinson has described the trend towards diversification:

> In Senegal the *originaires* of the four communes had ... enjoyed before the war the right to vote on the same basis as Frenchmen (i.e. adult male suffrage) and they retained it (even if not otherwise eligible under the post-war electoral laws) provided their names were on the register before the enactment of the electoral law of 1946.

[30] Among the most famous depictions of the railroad strike is Ousmane Sembène's 1960 novel, *Les bouts de bois de dieu* (translated into English as *God's Bits of Wood*). For an in-depth scholarly treatment of the role of the labour question and labour unions in decolonization in Africa, see Cooper (1996).

[31] Schachter Morgenthau (1964: xvii-xviii).

[32] Robinson (1960: 306).

Their importance declined rapidly with the extension of the franchise and even in 1946 they were outnumbered by the new voters.[33]

Where issues became divisive enough to pit the interests of Africans already in positions of relative power (the educated elites) against those who were rising to it (the mass of waged workers), scholars have described the conflict as between a more popular politics, focused on more or less classic labour union issues (wages, length of the working day, family allowances and other benefits) and the politics of the educated elites. At the same time, the published histories emphasize the confluence of interests of both groups in the extraordinary social and political ferment that gave rise to the political parties. With the expansion of the electorate and through a series of successive legislative reforms in the decade from 1946 to 1956, the risk of true polarization between these two groups seems to have diminished in the years directly preceding independence.[34] Both groups were urban, and urbanization and the activity of the labour unions were closely linked.[35] Further, socialist sentiment was more likely to have been nurtured in those with the highest levels of formal education, and the finer points of socialist doctrine were most passionately embraced and promoted by those who had been educated in the metropole.

Similarly, the expansion of the educated classes came to close rather than aggravate the gap between waged labour and the elites in whose hands the access to power afforded by the pre-1946 electoral institutions, however limited, had previously been concentrated.[36] As Robinson explains, all of these factors combined with the unique conditions already in place in Senegal – the diminished political influence of traditional leaders, the influence of the Muslim brotherhood, the absence of a new rural class of wealthy planters, and the pre-war experience of Western political institutions by the older colonial elite – to produce scope 'for the development of political parties transcending local or ethnic ties'. In the mid-1950s, the union leaders and the newer and increasingly broader swathe of the intelligentsia, joined forces with these existing parties, which had already transcended linguistic and ethnic particularisms to form the first mass parties.[37]

In this highly specific configuration, assimilationist values, such as those exemplified in the caption to the portrait of Mrs N'Doye that we saw on *Bingo*'s cover and glimpsed in the pages of Doudou Diop's sample albums, were not necessarily at odds with the progressive and even radical politics embraced by an increasingly large number of Senegalese in this period. It is worth noting,

[33] Ibid.: 298-99.

[34] 'The full effect of the extension of the franchise in 1951 (national assembly elections) and 1952 (territorial assembly elections) was not reflected immediately in the size of the electorate, partly because of the administrative problems involved in adding the new voters to the register. The electorate was, nevertheless, greatly enlarged, and it continued to grow until the elections to the National Assembly in 1956, the last to be held on a restricted franchise, when it was approximately 36 percent of the estimated population' (Robinson 1960:299).

[35] 'The most significant consequence of the economic impact of colonial rule is to be sought in the growth of towns and the development of a substantial urban wage-earning population, increasingly organized in trade unions, which form the most important and dynamic of the new social groups' (ibid.: 289).

[36] 'There is also a relatively large 'educated' elite, many employed in the lower and middle ranks of the administration and commerce and for long assimilationist in ideology. Since the Second World War the numbers of this elite have grown with the increased provision of schooling, and its reinforcement by a much higher proportion of Africans educated in France at university or professional levels, and it has become increasingly aware and resentful of colonialism' (ibid.).

[37] Ibid.

as a reference, that the franchise was extended to the entirety of Senegal's population in 1957 (the first elections to be held under conditions of universal suffrage were the elections to the new Territorial Assemblies in March 1957). The decrees that implemented these changes as a result of the so-called *loi-cadre*, which was passed in the French National Assembly in June of 1956, were submitted to the French Parliament in December of 1956.[38] The oldest document I saw in the Diop household was dated 18 September 1956. It was not a photograph but a letter from 'France Photo' in the Parisian suburb of Neuilly-sur-Seine announcing their most recent catalogue and the fact that Diop could expect a visit from their traveling salesman (*commis ambulant*) in December of that year (Figure 7.11).

At one point, I ask André about the price of a photograph. Were his father's photographs really so affordable for such a large number of people? Friends with whom I discussed this same question in Dakar a week or two earlier had already expressed their disdain for the Saint-Louisians who in their opinion remained, even today, a bit too enamoured of the French, and who had been flunkies of the colonial administration. While looking at the photographs of men in uniform and elegant women in the latest fashions in Diop's albums, it is easy to lose sight of this more nuanced historical analysis of the post-war political ferment and see things from the point of view of the Dakarois, particularly that of the younger generation. In a casual conversation about the price of a photograph I had in Dakar, a friend had used a simple phrase that seemed to fill with ineffable meanings as he intoned it, bitterly, over and over: '*Ce n'était pas à la portée de tous*'. Rivalries between Dakarois and Saint-Louisians can indeed be bitter, for all the reasons I cited earlier, and it is difficult to separate root causes of contemporary tensions and disaffection from those of more historic ones. Throughout our meetings, however, André insisted that his father's photographs' were affordable: '*C'était à la portée des gens*' (literally, 'It was within reach', or 'People could afford it'). How else to account for the crowds? '*Toute la ville est venue.*' '*Ça bousculait!*'

I had been waiting to ask this question, about prices and the economic threshold of studio patronage, for a long time. Years before I travelled to Senegal, I had been baffled by the figures cited in the literature on Keïta. Magnin reported that Keïta had between 30,000 and 70,000 negatives before he took away his first carton of them to Europe in the 1990s.[39] At the zenith of Keïta's studio career in the 1950s, the population of Bamako was approximately 100,000.[40] Could one photographer really have photographed 70 per cent of the city's population? In many respects, we may conclude that Keïta's case is exceptional: he meticulously kept all of his negatives and maintained them in excellent condition; he routinely stamped his prints with a cachet. Given the state of current research, which is imperfect, we know of no other photographer working in the AOF in this period who handed down an archive as intact as Keïta's. Even if he had photographed only 30,000 people in his lifetime, the figure would be astonishing in a city of 100,000.[41]

[38] Ibid.: 293-4.
[39] Magnin (1997:7).
[40] Ibid. This figure is corroborated by Lamunière (2011) and Meillassoux (1968)
[41] See Firstenberg 2001; Keller 2008 and 2010; Lamunière (2011); and Magnin (1997). This question came up at the annual meeting of the African Studies Association in 2006, where I had the occasion to discuss the prices of photographs in other cities in Africa with other scholars at the panel on 'Transcultural Aesthetics'. I am deeply indebted to Leslie Rabine, who was present

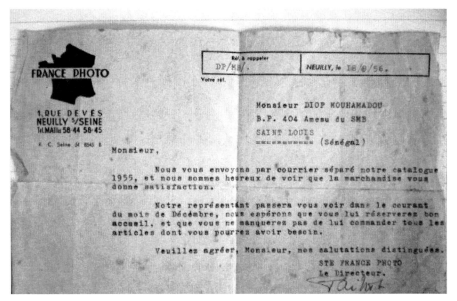

André told me that his father charged 50F c.f.a. for one shot, with the client receiving two prints for that price. According to the published record, the prices charged by Keïta in the 1950s were significantly higher.[42] The challenge of working with Franc c.f.a. prices in the region in this period is, firstly, that there is little documentation to provide a solid basis for comparison against essential foodstuffs or common retail goods. Similarly, there are few available figures for how much a given family or group having access to cash wages would have spent on ordinary versus luxury goods, and what proportion of those wages would have been considered disposable.[43] Add to which, it remains a question

[41] cont. at that discussion and reminded us that questions of access were further complicated by the fact that Keïta photographed the same sitters on repeated occasions. But evidence of repeat visits from a smaller client pool (rather than fewer visits from a larger client pool) only requires us to rephrase what is essentially the same question – how it is that hundreds of people living in or passing through Bamako in the 1950s could afford to be photographed by Keïta more than once.

[42] Magnin (1997) details Keïta's prices as follows: in the early years he charged 25F for a 6x9 cm print, 100F for a 9x12 cm print, and 150F for 13x18 cm, whereas in the 1950s, prices were significantly higher – 300F for a photograph taken in natural light, 400F for a photograph taken using electric light (to offset the cost of the electricity) (1997: 10-11).

[43] The most important source I have found on this question, with reference to Bamako, is Meillassoux (1968). References to prices and wages throughout the AOF can be found in the two important volumes edited by Becker et al., (1997). Preliminary research in the publicly accessible digital resources detailing historical prices and wages – such as the 'List of Datafiles of Historical Prices and Wages' maintained by the International Institute of Social History (IISH) – suggests that historical price and wage data for African cities have rarely been compiled, or, if they have been compiled they have not yet been made available online. (As of 31 December 2010, Cairo is the only city in Africa for which comprehensive price and wage documentation is available on the IISH site.) *Bingo* would be an invaluable resource for contextualizing prices and wages in this part of Africa, as the magazine often carried advertisements with Franc prices listed, many of them for cameras and photo supplies. I came to *Bingo* relatively late in the course of writing this essay and have not had the opportunity to reflect in any sustained way on these figures.

[44] The Devès family was one of the Bordelais merchant families who accumulated significant wealth through trade with Senegal, and who left their legacy in, among other things, a *métis* branch of the family native to Saint-Louis. The Saint-Louis Devès were extremely distinguished and powerful in the economic and political life of the city throughout the nineteenth and twentieth centuries. Johnson (1971) reports that the Bordeaux Devès clan refused to acknowledge their Saint-Louisian counterparts, although the two routinely engaged in joint business ventures in Senegal. Johnson (1971: 94; 229 note 2).

whether a portrait can be considered a luxury good. Given the elevation (as in *Bingo*), of photographic portraits of ordinary women and men to a higher plane of significance, allowing them to index the zeitgeist, the photograph appears to be less and less a luxury. It may well be the case that a greater number of Saint-Louisians were able to afford having their portrait taken as compared with Dakarois (as my friend had suggested) because a greater number of Saint-Louisians had historical ties to colonial administration. But by the 1950s this trend would have been reversed, and both cities would have reflected Senegal's higher rates of urbanization, more significant proportion of wage-earners, and higher *per capita* incomes as compared with other territories of the AOF.[45]

In the end, André Diop seemed less concerned with the number of clients that could be found waiting in the street outside his father's studio, than their mood. I am therefore tempted to translate his remarks – '*Toute la ville est venue*', '*Ça bousculait!*' – with emphasis not only on the number of clients ('There were lots of people') but also on this feeling connected with photography as an event, on the studio as a scene, and the mood: 'It was bustling', and 'Everyone was there.' Scholars of the history of photography in Africa have often described a social dimension that determines the photographic experience, both inside and outside the main space of the studio.[46] Arguments for African exceptionalism have raised this social dimension as evidence of a specifically African 'photographic experience', although they have rarely situated it concretely in relation to political developments of the day.[47] Although the studio was very often (as it was in Diop's case) located in a domestic space, this in no way confined it to the realm of the 'private', with all the supposedly apolitical connotations this entails.

Imagine that you are in the street, rue de MTOA, at the end of the working day. Even if you are not on your way to have your picture taken, once you meet a friend, an acquaintance, a *tante* or *ton-ton*, someone linked to your family on his or her way to have a picture taken, you are inclined to ask about it. You may even be inclined to comment on his or her appearance and other aspects of the circumstances surrounding the occasion. If the person you meet is on the way to claim a photograph he or she had taken recently, you may even be asked to accompany him or her to the photographer's studio. Sooner or later – perhaps at this very moment – it will be your turn. Someone will ask you about your photograph. He or she will comment on your appearance and advise you as to how best to present yourself, offer his or her thoughts on the best angle for your dress, your jacket, your boubou, the best way to present your jewelry or your hairstyle, his or her thoughts on the best pose. There emerges, both in the studio and in the street outside it, not only a photographic experience but a public culture of photography. Even before the photograph is published, perhaps in a magazine like *Bingo*, it

[45] With the exception of Côte d'Ivoire, which by 1960 had surpassed Senegal in the wage earning proportion of its population: 'About a quarter of [Senegal's] population live in towns, a much higher proportion than elsewhere in French West Africa: of these about two-fifths live in Dakar [...] The proportion of wage earners in the African population was for many years considerably higher than in the rest of French West Africa, though since the war the Ivory Coast has caught up and is now outdistancing Senegal in this respect. In 1955 about a tenth of the adult African population of Senegal were wage earners and the Labour Department estimated that more than half of them (55,000) "followed the instructions" of a trade union' (Robinson 1960: 282).
[46] See Oguibe (2001) and Pivin (1999).
[47] An important exception is Okwui Enwezor's *Short Century* (2001) which includes photographic portraiture among the visual and aesthetic objects it considers in relation to African independence and liberation movements.

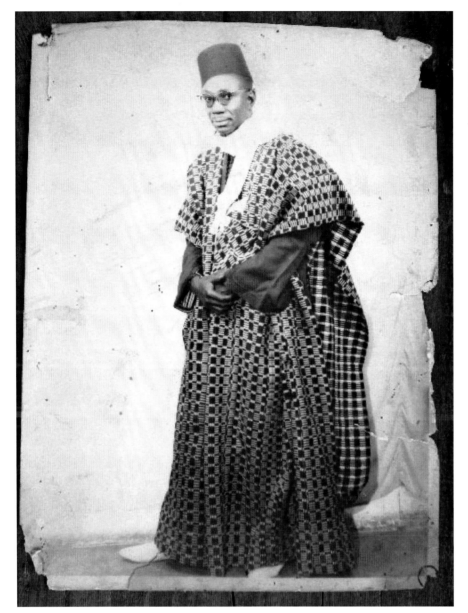

*Figure 7.12
Self-portrait,
early 1980s.
Photograph by
Doudou Diop,
Saint-Louis,
Senegal,*
Reproduced by kind
permission of the Diop
family.

is an occasion for public exchange and bears traces of the public exchanges that preceded it.

The photographer's son spoke of such exchanges. He repeated how crazy his father was about taking, and making, pictures: '*Il était passionné d'images*'. He emphasized the pleasure that his father took in reflecting on the enjoyment his images gave to others. Diop had a saying, a kind of adage that captured what he believed was happening in his studio: '*On se voit. On se plaît. On se photographie*'. The adage might be roughly translated: 'You see yourself [you are seen]. You like it [you are pleased]. You are photographed'. André presented his father's adage, philosophically, to me as a kind of conceptual-aesthetic triangle, sketching the diagram carefully on paper. *On se voit* is at the bottom left-hand corner. *On se plaît* is at the bottom right. *On se photographie* is at the

top. André seemed to be suggesting that people came to his father's studio not just to be photographed, but to see and be seen, and to take pleasure in both.

As I sat with André, photographing his father's photographs and, when we broke for coffee, shooting video of his mother (low-res video shot from a mobile phone), talk inevitably turned to his camera and to the availability of supplies, especially papers.[48] He ordered from the catalogues of vendors in Paris, and ultimately directly from Kodak, represented by the *commis ambulant* mentioned above. Literacy, both conventional and financial, would have been a requirement of Diop's accounting job and both clearly aided him in his work as a photographer. He kept files of all of invoices, receipts, bills of lading, and documentation of customs clearance for orders placed with France Photo and Kodak-Pathé (Figures 7.13, 7.14 and 7.15). I found myself, somewhat unexpectedly, photographing sheaf after sheaf of these Kodak orders. André told me proudly that his father was *le numéro un* for Kodak in the region: their best client, and the one who placed the largest orders. Even as I tried to impose some sort of reasoned calculus on the orders of photo paper – Kodak Kodura, with dimensions listed at 12.7 x 17.8 cm or 5 x 7 inches, and packaged in 100-count boxes, was ordered in lots of 30 (at two prints per client, how long would 3,000 sheets have lasted?) – I began to understand that Diop's dealings with Kodak extended beyond the purchase of basic supplies necessary for the day-to-day running of his studio to open up new avenues of technical experimentation, creativity, and playfulness.

In conversations with André and with another Senegalese photographer, Bouna Medoune Seye, who knew Diop well, I learned that the photographer had been successful enough in his studio business to be able to afford a motorcycle. He could also afford the latest movie cameras, and, in the 1960s, he experimented with shooting 8mm film from his motorcycle.[49] He liked to perform these motion picture experiments while cruising past the square on the island (Sor is on the mainland) where the military cadets sometimes paraded, and while crossing the Pont Faidherbe. Later on, he experimented with a 16mm movie camera, for which he tried to invent sync sound. These and other stories colorfully illustrate the photographer's love of invention (or was it bricolage?) and technical experimentation. They also establish in no uncertain terms, and in material terms, the extent of his professional success.

Man with a movie camera...and moto

In the years since those first conversations with André Diop and Ndèye Teinde Dieng about Diop's studio practice, I have struggled to understand in a more nuanced way the rhythms of his practice, how they were influenced by his day job in the colonial administration and by the rhythms of his clients' workdays, and how all of these factors contributed to the social dimension and

[48] Diop's first camera, according to André, was a 6x6 format Rolleiflex. Subsequently, he worked with a Yaschica. Both cameras used 12-exposure films. Chapuis reports that he purchased his first camera in 1952 (1999: 58). The earliest photographs I saw in Diop's family home in Sor dated from 1954. Diop date-stamped all his prints.
[49] I am deeply indebted to Bouna Medoune Seye for facilitating my introduction to André Diop in December of 2007. Medoune Seye told me that Diop, the photographer, had experimented with different ways of fixing the camera to a bracket on his motorcycle. Personal interview with Bouna Medoune Seye, Dakar, Senegal, 24 December 2007.

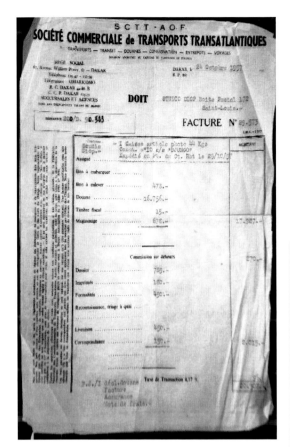

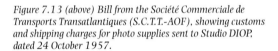

Figure 7.13 (above) Bill from the Société Commerciale de Transports Transatlantiques (S.C.T.T.-AOF), showing customs and shipping charges for photo supplies sent to Studio DIOP, dated 24 October 1957.

Figure 7.14 (top right) Detail, portion of Kodak-Pathé bill, dated 21 July 1967, from the studio of Doudou Diop.

Figure 7.15 (right) Detail, portion of Kodak-Pathé bill, dated 21 July 1967, from the studio of Doudou Diop.

public nature of the scene both inside and outside the photographer's studio. Above all, I have wondered how all of these factors must have contributed to both the photographer's and his subjects' experience of, and understanding of, photography. It is not entirely clear to me how these rhythms square (or don't) with the photographer's love of invention and experimentation, a love that he of course shared with photographers everywhere, and which nonetheless seems to me (and not only to me) to have had a special significance in Senegal in the 1950s.[50] It is impossible, after hearing the stories I have heard about Diop, not

[50] I have a vague memory – I have not yet found the passage in my notes – that Medoune Seye, who also works in film and video, has made a documentary about Diop and his adventures with a camera on his 'moto'.

to imagine him cruising over the Pont Faidherbe on his motorcycle, shooting with a movie camera attached to a bracket on his bike as he goes. Equally vivid are the images I can conjure up in my imagination of his experiments with sync sound, or of him gently scraping the surface of the B&W prints with a vaccination needle in his ingenious colourization process (Figure 7.10).

I have sometimes wondered what the equivalent of this kind of invention and experimentation would be, or was, from the standpoint of the photographic subject. It is possible to ask this question with an individual subject in mind: the man who comes to be photographed on a particular occasion or in a particular uniform, the woman who commissions a portrait because she has a new dress or her hairstyle has changed. Such subjects are clearly capable of grasping what photography can be or can do with a playfulness and love of experimentation of an order that goes much deeper than that of the image. This may well be what many scholars mean when they refer to the portrait as a technology of the self. But this is not necessarily the most interesting way to ask the question, for it is too limited to imagine photography as a document of the individual. This is all the more so given the public nature of photography and the dynamic public exchanges that we have seen it engender in Senegal and other parts of Africa in this period. Further, photography clearly and explicitly had had an association in the minds (and letters, and photographs) of *Bingo*'s readers, for example, with the articulation and documentation of a new and decidedly modern African identity and with the assertion of a collective political will. Elsewhere in my writing on this material, I have begun to explore little innovations, here and there, that may elucidate this question.[51] I have come to wonder whether it was not precisely their grasp of this association between photography and collective experience, and therefore, in this instance, between photography and democracy, that was the principal innovation of the photographic subject in this part of Africa at this point in time.

Bibliography

Alloula, M. 1986. *The Colonial Harem* (trans.) M. Godzich & W. Godzich. Minneapolis MN: University of Minnesota Press.

Bajorek, J. 2010. Photography and National Memory: Senegal about 1960, *History of Photography* (eds) S. Ogbechie & J. Peffer, Special Issue, 34 (2): 160-71.

Becker, C., S. Mbaye, & I. Thioub (eds). 1997. *AOF: réalités et heritages: sociétés ouest-africaines et ordre colonial, 1895-1950*. Dakar: Archives Nationales du Sénégal. 2 vols.

Buckley, L. 2005. 'Objects of Love and Decay: Colonial Photographs in a Postcolonial Archive', *Cultural Anthropology* 20: (2) 249-70.

—— 2006. Studio Photography and the Aesthetics of Citizenship in The Gambia, in *Sensible Objects: Colonialism, Museums and Material Culture*, (eds) E. Edwards, C. Gosden and R. B. Phillips. New York: Berg Press.

—— 2008. 'Gridwork: Gambian Colonial Photography', *Critical Interventions: Journal of African Art History and Visual Culture* 2: 40-55.

Chapuis, F. 1999. The Pioneers of Saint-Louis, in *The Anthology of African and Indian Ocean Photography*, (eds) P. M. Saint-Léon, N. Fall, N. & J-L. Pivin. Paris: Éditions Revue Noire.

[51] For example, I explore the practice of couples who '*se mariaient à photo*'. Anticipating today's 'mail-order' (or Internet-ordered) brides, the practice was directed at African soldiers who were stationed far from home, particularly in French Indochina. Soldiers were considered to be particularly desirable husbands and there was a lack of marriageable men throughout the war years. I saw examples of photographs whose exchange had sealed such marriages in Diop's samples album in Saint-Louis. Adama Sylla also described this practice. It is possible to read letters from soldiers soliciting the photographs of marriageable women in the back pages of *Bingo*. I treat this practice at greater length in my book manuscript.

Cooper, F. 1996. *Decolonization and African Society: The Labor Question in French and British Africa*, Cambridge: Cambridge University Press.

Dyer, R. 1997. *White: Essays on Race and Culture*. London and New York: Routledge.

Edwards, E. 2001. *Raw Histories: Photographs, Anthropology, Museums*, Oxford: Berg.

Enwezor, O. (ed.), 2001. *The Short Century: Independence and Liberation Movements in Africa, 1945-1994*. Munich, London & New York: Prestel.

Firstenberg, L. 2001. Postcoloniality, Performance, and Photographic Portraiture, in *The Short Century: Independence and Liberation Movements in Africa, 1945-1994* (ed.) O. Enwezor. Munich, London & New York: Prestel.

Geary, C. & V. Lee-Webb. 1988. *Delivering Views: Distant Cultures in Early Postcards*, Washington, DC: National Museum of African Art, Smithsonian Institution.

Geary, C. & K. Pluskota. 2002. *In and Out of Focus: Images from Central Africa, 1885-1960*, Washington, DC: National Museum of African Art, Smithsonian Institution.

González, J. 2003. Morphologies: Race as a Visual Technology, in *Only Skin Deep: Changing Visions of the American Self*, (eds) C. Fusco & B. Wallis. New York: International Center of Photography/Harry N. Abrams.

Haney, E. 2010. *Photography and Africa*, London: Reaktion.

IISH List of Datafiles of Historical Prices and Wages. International Institute of Social History. Last updated December 11, 2009. http://www.iisg.nl/hpw/

Johnson, G. W. 1971. *The Emergence of Black Politics in Senegal: The Struggle for Power in the Four Communes, 1900-1920*. Stanford, CA: Stanford University Press.

Keller, C. 2008. 'Visual Griots: Social, Political, and Cultural Histories in Mali through the Photographer's Lens'. Doctoral dissertation, Indiana University.

—— 2010. 'African Photography, Visual Griots in Mali and Beyond', *Africa Past and Present*, 37, January 29, 2010. African Online Digital Library. http://afripod.aodl.org/

Lamunière, M. (ed.), 2011. *You Look Beautiful Like That: The Portrait Photographs of Seydou Keïta and Malick Sidibé*, Cambridge, New Haven & London: Harvard University Art Museums/Yale University Press.

Landau, P. S. & D. Kaspin (eds). 2002. *Images and Empires: Visuality in Colonial and Postcolonial Africa*, Berkeley and Los Angeles: University of California Press.

Magnin, A. 1997. *Seydou Keïta*, Zurich, Berlin & New York: Scalo.

Meillassoux, C. 1968. *Urbanization of an African Community: Voluntary Associations in Bamako*, Seattle: University of Washington Press.

Mirzoeff, N. 2003. The Shadow and the Substance: Race, Photography, and the Index, in *Only Skin Deep: Changing Visions of the American Self* (eds) C. Fusco & B. Wallis. New York: International Center of Photography/Harry Abrams.

Nimis, E. 1998. *Photographes de Bamako de 1935 à nos jours*. Paris: Éditions Revue Noire.

—— 2003. *Félix Diallo, photographe de Kita*. Toulouse: Toguna.

—— 2005. *Photographes d'Afrique de l'Ouest: L'expérience Yoruba*. Paris and Ibadan: Karthala.

Oguibe, O. 2001. The Photographic Experience: Toward an Understanding of Photography in Africa, in *Flash Afrique!* (eds) T. Mießgang & B. Schröder. Vienna and Göttingen: Kunsthalle Wien and Steidl.

Ouédraogo, J-B. 2002. *Arts photographiques en Afrique*, Paris: L'Harmattan.

Pivin, J-L. 1999. The Icon and the Totem, in *The Anthology of African and Indian Ocean Photography* (eds) P. M. Saint-Léon, N. Fall, & J-L. Pivin. Paris: Éditions Revue Noire.

Poole, D. 1997. *Vision, Race, and Modernity: The Andean Image World*, Princeton: Princeton University Press.

Robinson, K. 1960. Senegal: The Elections to the Territorial Assembly, March 1957, in *Five Elections in Africa* (eds) W. J. M. Mackenzie & K. E. Robinson, Oxford: Oxford University Press.

Ryan, J. R. 1998. *Picturing Empire: Photography and the Visualization of the British Empire*, Chicago: University of Chicago Press.

Saint-Léon, P. M., N. Fall & J-L. Pivin (eds). 1999. *The Anthology of African and Indian Ocean Photography*, Paris: Éditions Revue Noire.

Schachter Morgenthau, R. 1964. *Political Parties in French-Speaking West Africa*, Oxford: Clarendon Press.

Sekula, A. 1989. The Body and the Archive, in *The Contest of Meaning: Critical Histories of Photography*, (ed.) Richard Bolton. Cambridge MA: MIT Press.

Sembène, O. 1960. *Les bouts de bois de Dieu*, Paris: Le Livre Contemporain.

Sow Fall, A. 1999. Vague Memory of a Confiscated Photo, in *The Anthology of African and Indian Ocean Photography*, (eds) P. M. Saint-Léon, N. Fall, N. & J-L. Pivin. Paris: Éditions Revue Noire.

Werner, J-F. 2001. 'Photography and Individualization in Contemporary Africa: An Ivoirian Case Study', *Visual Anthropology* 14 (3): 251-68.

Willis, D. & C. Williams. 2002. *The Black Female Body: A Photographic History*, Philadelphia: Temple University Press.

8

'A once & future Eden'
Gorongosa National Park & the making of Mozambique[1]

Katie McKeown

The cover of the inaugural edition of the quarterly magazine, *M de Moçambique* (or *M*) features a glowing pink sunset over a vast floodplain with an inset photograph of an adolescent male lion and the word 'Gorongosa' in letters larger than the magazine's title ('Gorongosa' 2010). Launched with the goal of disseminating 'information about Mozambique, showing our natural beauty and the good shape of our tourism, our culture and our sport', *M* is published in Maputo, the country's capital, and circulated throughout Mozambique, South Africa and Portugal, with articles translated in both English and Portuguese. Gorongosa National Park, located in the centre of the country, is presented here as a showpiece of Mozambique's natural beauty and tourism opportunities. However, the Park is portrayed as more than a national asset, as a vector for peace and prosperity in the country, a story of rebirth in the aftermath of civil strife. Gorongosa was Mozambique's first National Park under Portuguese rule but became a theatre of struggle during the armed conflict that followed the country's independence in 1975. Subsequently, Gorongosa's restoration has become an important project for the independent Mozambican state, albeit through the monetary and administrative assistance of American entrepreneur, Greg Carr. *M*'s cover story is only one example of a recent surge in media attention surrounding this restoration project, each featuring images that have become quintessential icons of Gorongosa, and, in turn, emblems of the country's prized natural attributes.

The landscape of Gorongosa has been embedded in processes of constituting different Mozambican territories, nations and states at different points in time. In complex ways, photographs have played a critical role in framing this region's recent history, bridging a gap between Mozambique's colonial past and post-conflict present. In this chapter, I will look at photography's role in establishing and promoting this space as an essential asset of the Mozambican 'state' over three different periods. Throughout the late colonial era, the civil war, and the reconstruction effort, photographic representations of Gorongosa have been entangled with political imaginings.

Gorongosa was declared a National Park in 1960, and over the following 15 years, the region became known as one of Africa's premiere wildlife destinations. Located 115 kms from the city of Beira in Mozambique's Sofala province, Gorongosa rivalled South Africa's Kruger National Park in species diversity and wildlife density, and attracted regional and international visitors, including Hollywood stars and other celebrities. In this period, Gorongosa was imagined as an African Eden, exemplified in contradictory images of tourist access and wild landscapes that circulated globally in newspapers, magazines, and visual monographs. These images served to legitimate the late colonial Portuguese state as a necessary agent of conservation in a threatened environment. Furthermore, photography helped to make

[1] The title comes from a recent article about tourism in Mozambique; see Cohane, 2007.

Gorongosa one of the principal emblems of the Portuguese colony.

Soon after the country gained independence in 1975, Gorongosa was overtaken by RENAMO, the opposition to the new Mozambican government that was backed by neighbouring Rhodesia and later South Africa. The area became a strategic base for rebel activity and a site for political negotiation. In 1983, RENAMO claimed Gorongosa as the 'Capital of Free Mozambique', implicating the territory in its own process of state making and nation building. Although media access to the area was restricted for most journalists, some photographers were allowed to document it. The subsequent images offered a new lens on a 'wild' Gorongosa, portraying a militant state of camouflaged soldiers, made to be heroes or demons depending on the political leanings of the publication that featured the photographs.

Gorongosa's wildlife population was decimated during the war, and neighbouring communities were left devastated. American entrepreneur Greg Carr has thus pledged $40 million towards 'restoring Gorongosa to its former glory', a project that has been touted as 'perhaps the most ambitious park restoration ever attempted'. Gorongosa has again become a media darling, described as a 'Paradise regained' with Carr as the saviour of this 'Once and future Eden' (Doucette 2009; Cohane 2007; Shacochis 2009; Plácido Júnior 2006). As seen in the M article, Gorongosa has become an emblem of the post-conflict Mozambican state's hopes of boosting its economy through tourism. In turn, promotional photographs once again depict Gorongosa as a wilderness ripe for tourist exploration.

The labelling of Gorongosa as one of Africa's Edens is unsurprising given the persistent designation of this title to tourist destinations across the continent. Such metaphors have been embedded in conceptions of Africa as far back as eighteenth-century exploration narratives, and informed early conservationist agendas and National Park planning (Grove 1995; Neumann 1995: 154). Myths of African landscapes as wild and pristine have facilitated protectionist projects that have excluded African people from environments that sustain their livelihoods (Adams & McShane 1996). Visual representations of these 'wild' areas have helped to obscure the historical presence of people in 'pristine' landscapes. In contemporary wildlife documentaries and travel articles, Edenic imagery still aids in belying complex histories of land tenure.

Scholars have written about the various ways that statecraft has revolved around processes of territorialization, land policies and control of natural resources (Alexander 2006; Moore 2005; Mosse 2003). Neumann writes, 'Proprietary claims and the process of mapping, bounding, containing and controlling nature and citizenry are what make a state a state. States come into being through these claims and the assertion of control over territory, resources, and people' (2004: 185). Conservation practices have been particularly important in the management strategies of imperial powers as well as in those of post-colonial governments.[2] Maano Ramutsindela writes, 'The use of state land in developing national parks served to extend the state's authority over products of nature and to determine the rules by which those products could be accessed' (2004: 79). Visual and literary representations of the environment have created and authorized areas of 'wilderness', which have, in turn, impacted on the perceived value of environmental resources as well as management policies.

[2] See for example Neumann (1998); Duffy (2000); Dan Brockington (2002); MacKenzie (1990); Anderson & Grove (1987); Rajan (2006); Beinart & MacGregor (2003); Brooks (2005).

Discourses of preservation, fragility, and scarcity have allowed states to 'freeze specific landscapes for eternity' through the establishment of national parks, in which states have performed 'the authoritative encoding of land for all time' (Dunn 2009: 436). Such timeless statescapes, despite representing and reproducing state power, remain sites of contestation through conflicting claims to authority. Photographs perform analogous work in encoding state territories, national landscapes, and all the resources they hold. Although the meaning ascribed to images may change over time, their content remains the same, appearing timeless, objective and scientifically sound. Duffy (2000: 2) contends that neutral, scientific descriptions of environmental issues have masked the political nature of conservation policy. Environmental photographs in Southern Africa have also obscured the contested nature of landscapes, privileging particular ways of seeing 'wild' spaces.

In this chapter, I will explore the various ways that photographs of Gorongosa have been used to imagine different 'states' in Southern Africa. I will look at how images were implicated in Portuguese colonial propaganda in the decades immediately preceding independence and how those images have been refigured in contemporary media. I will explore the ways that photographs of Gorongosa, circulated in both national and international media during the years in between, became representative of a RENAMO 'nation'. In his book, *Seeing Like a State*, James C. Scott describes various processes through which states render their territories, subjects and resources legible, simplifying complex realities in the service of management and control (1998: 2-3; 79). In Gorongosa, photographs acted as a tool of legibility, facilitating a simplified understanding of the landscape in the service of constituting various Mozambican states and nations.

A 'wild sanctuary' in colonial Africa

Gorongosa had already begun to capture the visual imagination of travellers long before it was declared a National Park in 1960. Before East African territories opened up to big game hunting, the area had been a well-known hunting destination, accessible early in the twentieth century via a railway that stretched from the port of Beira through to Salisbury in Rhodesia (Varian 1953: 77). When approximately 1,000 km² was dedicated for the Gorongosa Reserve in 1921 under the jurisdiction of the Portuguese concessionary Companhia de Moçambique, this measure was meant mainly to protect stockpiles of game that could be hunted by notable visitors, such as travelling British officers and the President of Portugal, rather than to provide complete protection for wildlife (Rosinha 1989: 22). A 1938 pamphlet published by the Central Statistics Division lauded Gorongosa's hunting opportunities (ibid: 222):

> If Africa is indeed a hunter's paradise, Mozambique is one of the most privileged spots of this paradise... The territory owned by the Mozambique Company, of all the territories in the colony, enjoys the reputation of the best game. These lands are, in fact, the celebrated 'tandos' or 'dambos' of Gorongosa – endless plains where wildebeest, zebras, lions, buffalos, elephants, and scores of species of antelope number in the thousands. It is the zone of the colony most frequented by foreign tourists, lovers of this sport, and the region where the hunter, above all, has the opportunity to give a good show.

Ten years later, in *Gorongoza, Grass, and Game*, Basil Lecanides, a long-time Mozambican resident of Greek descent, chronicled stories of the Mozambican

bush with the aim of showing his readers 'as clearly and truthfully as possible the variety and wealth of the fauna of Manica and Sofala, and the swift destruction that is being wrought upon it' (1948: 11). He condemned 'not the sportsman who shoots for his own gotten trophy or for the pot' but instead 'the man who shoots for monetary gain, and whose greed for gold from the carcasses of antelope and elephant will never be satisfied' (ibid: 10). The accompanying stories and photographs were thus intended to provide 'a little of the magic and charm of the colony of Moçambique' not only for posterity but also with the intention of altering popular opinion on the value of wildlife.

In an addendum to the book, Lecanides called specifically for the designation of Gorongosa as a National Park, which would afford its wildlife permanent protection from 'native tribes and unscrupulous hunters'. He wrote, 'The future of the wild life of Mozambique depends on the speedy proclamation of certain areas as National Parks', calling the Gorongosa Game Reserve 'one of the greatest national assets of Mozambique' (ibid.: 73). Furthermore, 'Nowhere else in Africa can such herds of game be seen under conditions so truly representative of primeval Africa' (ibid.). This 'primeval' conjecture is dependent upon human absence in the landscape, evidenced in a description that deems Gorongosa 'unsuitable for settlement by either Europeans or Africans' and therefore, 'No human habitation will be found on these vast plains' (ibid.: 75). In the same year that Lecanides's book was published, the Portuguese government began to relocate communities from those very same uninhabited plains (French 2009: 198).

Throughout history and even in contemporary conservation planning and rhetoric, African people and wildlife have been posed in opposition to each other. Colonial beliefs have been echoed in the work of modern-day conservationists as African people have been excluded from environmental initiatives in the preservation of imagined Edens. Adams and McShane (1996) have blamed the failures of Western conservation efforts on this 'myth of Wild Africa' perpetuated by travel accounts of colonial encounters and reinforced in literary and pictorial images of the continent. They argue that dominant images have created an Africa in need of taming by culturally superior experts, with African people depicted as savage, destructive or naïve to conservationist imperatives. Similarly, Neumann's work on the landscape imagery of the Serengeti locates the roots of present conservation struggles in colonialism and 'European ideals of the scenic African landscape' (1998: 3). These ideals pictured the landscape as untamed, untouched and often void of African people.

Todd French correlates the establishment of Gorongosa National Park with the making of wilderness, fermenting an ideology that excluded indigenous people from 'wild' places (2009: 196-8). By the 1960s, this area was imagined to be one of Africa's longstanding people-less paradises. The author of a 1964 *National Geographic* article likened his first encounter of Gorongosa to discovering 'a world as pure as the first dawn', teeming with wildlife and void of human inhabitants (Wentzel 1964: 230). A monograph published that same year describes the park as 'an enchanted paradise that has not yet known the tragedy of original sin' (d'Eça de Queiroz 1964: 17). This Edenic conception is precisely what encouraged tourists to visit. In his photographic essay on a Gorongosa safari published that year, João Augusto Silva wrote, 'In this inviolable sanctuary the buffaloes may stroll by in the complete freedom

of bygone days and offering, to modern man, the most magnificent spectacle of peaceful harmony that is possible to enjoy on this troubled planet' (1964: 74).

For Gorongosa, like many other African environments, photographs became a means to celebrate a territory's natural beauty, exported back home and abroad in magazines and pictorial monographs. A publication entitled, simply, *Moçambique*, by Frederic P. Marjay, a prolific writer on the Lusophone world, features a colour photograph of two elephants on the cover and numerous images of Gorongosa within its pages (1963). The photograph below is accompanied by the caption, 'On the way to Gorongosa across the Pungue into the unknown' (ibid.: 60). It shows the southern border of the park which acted both as a passageway for tourists entering the park and as a barrier to local communities. During the 1960s and 1970s, pontoons would carry tourists in their cars across the Pungue River where they would soon encounter Gorongosa National Park's main camp at Chitengo. The visual disparity between the southern and northern banks are striking, emphasizing the untamed world beyond, into which tourists alight. This is the only photograph of Gorongosa in Marjay's *Moçambique* that includes a human subject, suggesting that the human's role in this photo is to illustrate an imagined dichotomy between inhabited land and pristine wilderness. Marjay writes,

> Once landed on the other side, we continue to drive to the camp, rising always through a dense forest, full of silences, which takes us away from civilization. It imposed upon us the impression that we felt we were sinking into a world strange and unknown where we were faced with creation itself in its virginal purity (ibid.:26).

Photograph 8.1 represents the visual distance between the Park itself and its surrounding environment, which serves to exaggerate the wilderness experience of tourists. Another author describes the passage across the Pungue as 'a touch of old-time adventure well fitted to the psychological effect generally sought. A quiet American businessman will feel himself a sort of Stanley – a fashionable couple from Lisbon will think with pride that they are repeating the prowess of Ivens and Capelo' (d'Eça de Queiroz 1964: 60).

Scholars such as David Bunn[3] have written about the importance of visuality in framing tourists' experiences of national parks in Southern Africa. Bunn describes how the creation of photographic opportunities shaped the plan of Kruger National Park, with professional wildlife photographers being some of its very first visitors (2003: 199-218). He writes that the placing of waterholes on thoroughfares, for example, allowed for the privileging of particular gazes: intrusion upon natural Edens and access to predatory points of view. In allowing viewing access to such spaces, the park's architects presented visitors with a cross-section of game driven to a place by the primary needs of environmental influence and biology. Kruger not only capitalized on the production of tourists' visual expectations but also influenced new ways of looking at wildlife. Rasool and Witz have echoed this analysis in describing Kruger as 'a world of images, selling itself through carefully selected animal shots and inviting the tourists to recreate these images with their own cameras' (1996: 335-71).

Imagery of Gorongosa National Park in its early years served not only as a window into its landscape, but also a glimpse into the Mozambican

[3] See for example Bunn in Beinart & MacGregor (2003: 199-218) and Brooks (2005).

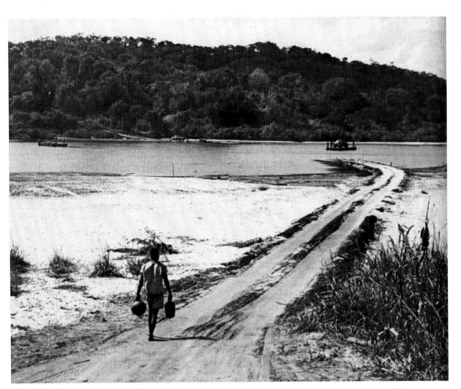

Figure 8.1 Illustration from Frederic P. Marjay's Moçambique *(Lisbon, 1963).*

Photo by Corrado Cappeletti Uzbezio, Gorongosa National Park Archive.

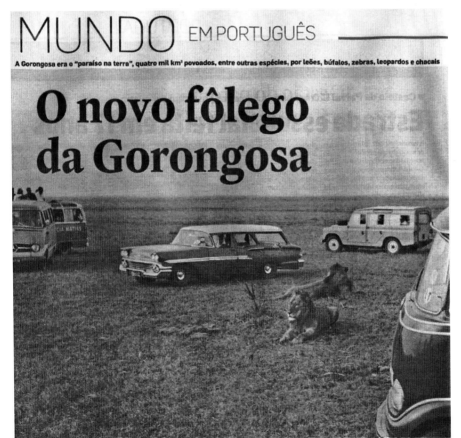

MUNDO EM PORTUGUÊS

A Gorongosa era o "paraíso na terra", quatro mil km² povoados, entre outras espécies, por leões, búfalos, zebras, leopardos e chacais

O novo fôlego da Gorongosa

Figure 8.2 'The new breath of Gorongosa,' from Diário de Notícias *(Lisbon, 29 June 2008). This photograph was first published in a booklet commemorating Portuguese President Américo Thomaz's 1964 visit to the colony.*

Reproduced by kind permission of Arquivo Diário de Notícias.

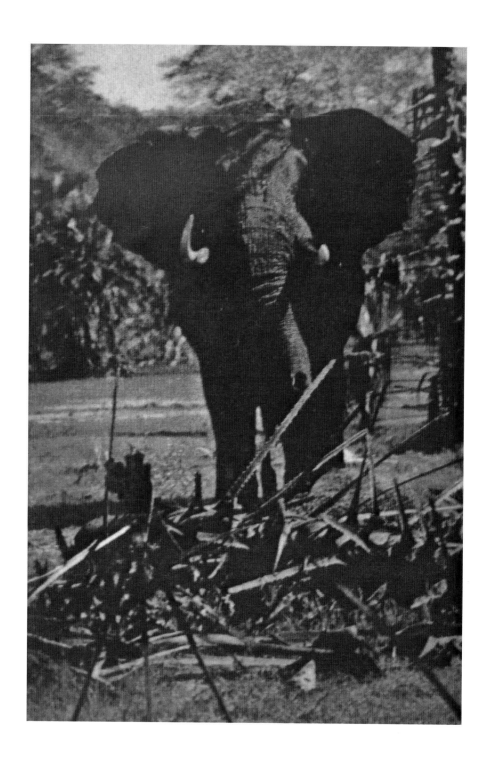

Figure 8.3 From Volkmar Wentzel, 'Mozambique: Land of Good People', National Geographic Magazine (1964). Printed with the caption, 'Trumpeting elephant in Gorongosa charged the author, who snapped this picture as he abandoned his movie camera and fled'.

Located in the Gorongosa National Park Archive, and reproduced by kind permission of National Geographic magazine.

colony. Director of the Veterinary Department of Manica and Sofala and Park administrator from 1965 to 1968, Dr Armando Rosinha claimed that tourism became a dominant concern in Gorongosa in the early 1960s, contending, 'The Park was made to be like a "shop window" for the Colony, and not one official visitor to Mozambique passed through without a stop in Chitengo...' (1989: 227). Portuguese President Américo Thomaz was one such visitor in 1964. A booklet published about his travels in the province included an image of two male lions on the Gorongosa tando, with the caption 'The President visited Gorongosa, a fine wildlife reserve and a famous tourist centre, where the rich fauna of Mozambique is assured protection.' Game viewing vehicles surround the lions, visually echoing the protectionist aims of the park. This image offers insight into the complicated messaging of conservationist planning in the 1960s and 1970s which asserted simultaneous wildlife 'protection' and tourist access to this national resource. Automobiles acted as both 'mobile viewing platforms' and 'mobile hides' from which visitors could enjoy the sensory pleasures of game viewing at a safe distance (Bunn 2003: 208). As evidenced in this photograph, publicity for Gorongosa National Park straddled a fine line between tourist comfort and the danger of proximity to wilderness.

National Geographic writer and photographer Volkmar Wentzel described his travels through Gorongosa with João Augusto Silva, a former administrator of the Gorongosa district and himself author of a monograph on the park in an article entitled, 'Mozambique: Land of Good People' published in 1964. He wrote

> Antelopes, buffaloes and zebras roamed the foggy plains, and herds of wildebeests stampeded through the morning mist, reminding me of the thunder of wild horses. We drove many miles through a vast wilderness, where some 4,000 elephants, 500 lions, 25,000 buffaloes, and thousands of other wild creatures roam at will (1964: 230).

Of all these animals, Wentzel was most impressed by the elephants:

> We photographed them grazing on the open plain and browsing calmly in the forest. One charged us. Quite unexpectedly he wheeled, at least four tons of him. Ears spread out and trunk raised, he screamed and came toward us in giant strides. Driving off swiftly, Senhor Silva remarked, 'That was just a mock charge.' Perhaps so, but I was glad that we fled (ibid.: 231).

This image and its accompanying text reflect the dual sentiments of danger and safety embedded in the marketing of Gorongosa National Park, where the thrill of the 'wild' is met with assurances of security. Here the author is charged, but not injured, and his movie camera is left behind as evidence of his proximity to the 'wild' and the intimate risk of entering the 'wilderness'.

In the same year, José Maria d'Eça de Queiroz published the monograph *Wild Sanctuary: The Astonishing Animals of Gorongosa and Safaris in Mozambique* and João Augusto Silva published his own pictorial treatise, *Gorongosa: Shooting Big Game with a Camera*, with translations in both English and Portuguese. Each book was introduced as a layman's contribution to natural history, with each author distinguishing himself from professional zoologists and experienced hunters and each propelled by the mission of preserving wildlife for the future. Silva wrote

> The myth that wild animals are ferocious is a very old one and it is not merely in one book that it can be destroyed. To bring this about it would require many years

*Figure 8.4
From João
Augusto Silva's*
Gorongosa:
Shooting Big
Game with
a Camera
*(Lourenço
Marques, 1964).*
Photo by João Augusto
Silva.

of revision. But in the meantime the fauna would continue to disappear from the bush and the savannahs of this magnificent Africa that is being pitilessly swept by the winds of greed. This extermination under the growing occupation and extensive exploitation of the land could be checked by the formation of Nature Reserves and National Parks. However, throughout this continent, ruled by the law of the jungle, the reserves are at the mercy of the exterminating hunting raids by a people hungry for meat and incapable of understanding that the wild fauna represents a treasure of inestimable value; one worthy of preservation (1964: 19-20).

Both of these books celebrate the unique attributes of Gorongosa National Park, described as 'the most beautiful animal sanctuary, accessible to the eyes of civilized man, in the whole of Africa' (ibid.: 51). Each features an extensive array of photographs, Silva's taken by the author; d'Eça de Queiroz's taken by his wife, Ludwig Wagner. The photographs in these books centre less on landscapes than on individual animals and wildlife groups at close range, simultaneously illustrating the risks taken by the photographers and Gorongosa's wildlife bounty. Others, such as the photograph below, demonstrate the close range at which each photographer was working, again emphasizing the risk involved in 'shooting big game with a camera', posited as an optimal alternative, of course, to shooting big game with a gun:

> As far as the variety and beauty of the landscape, comfort and accessibility and especially as far as the ease with which one comes across the lords of the jungle, are concerned, this Park has no equal. There must still be, deep in Africa, magnificent regions for game and beauty of scenery, but they are not easily reached and some of the most beautiful have to-day probably been reduced to mere hunting grounds by uncontrolled and lawless populations (ibid.).

One of Gorongosa National Park's most unique and renowned features was a camp built in 1940 that had been abandoned due to annual flooding and subsequently occupied by lion prides in the dry season (Rosinha 1989: 221). The 'Casa dos leões' became one of the most celebrated attractions of Gorongosa National Park (ibid.):

To-day these windowless and doorless huts, still with their roofs and verandahs, have become the dwelling place of a large and attractive pride of lions. It is a real little leonine city. On the verandahs the lionesses rest peacefully with their cubs. Looking out of the windows which once had shutters, may be seen lions taking their ease in what a few years ago were the bedrooms of visitors. As if wishing to contemplate the beauty of the horizon, some of the beasts climb the stairs or the former restaurant and stretch themselves upon the terrace which forms the roof of the building: some doze with half closed eyes, others scrutinize the veldt like watchful sentinels (d'Eça de Queiroz 1964: 85-6).

Figure 8.5
'Scenes at the Old Camp', from José Maria d'Eça de Queiroz's Wild Sanctuary (Lisbon, 1964).
Photo by Ludwig Wagner.

D'Eça de Queiroz's image of the 'Old Camp' shows these lounging lionesses atop the structure, basking in the sun at a strategic lookout point over the veldt. Again, this photograph integrates symbols of danger and security, which is perhaps what made the 'Casa dos leões' so popular. These animals, famed for their ferocity and inability to be tamed, appear settled and domesticated, yet only from a distance. Lions were Gorongosa's principle attraction, renowned throughout the world for comparatively high population numbers (Paisana & José 1972: 64). The lion still remains the emblem of Gorongosa National Park, described by d'Eça de Queiroz as a symbol of the Park as 'a constant mixture of the gentle with the harsh, the suave with the violent, the frail with the brutal', which 'would always be the great attraction of the intense and dramatic life of Gorongosa' (1964: 88, 93).

The photograph below (Figure 8.6) features both the emblem and the animal. It was published in Durban's *Daily News* in 1970 accompanied by the headline, 'Unheralded, Mozambique is creating a new reserve which in concept and planning puts the rest of Africa to shame...'[4] Although similar to the photograph published in conjunction with the Portuguese Presidential visit six years earlier, this image shows a marked shift in composition, foregrounding the lion instead of the game viewing vehicle and seeming to echo the changing publicity aims for the Park, moving from tourist solicitation to territorial expansion. The lion here, although a tourist spectacle, appears uncontained and free to rule the plains beyond.

The article centres around a proposed expansion of the Park following the recommendations of South African ecologist Ken Tinley, and it applauds Mozambique for 'foresight and planning' which would give the country 'a reserve probably unmatched in Africa – and a tremendous tourist attraction'. Conducting what has been called 'one of the most comprehensive analyses of an African ecosystem ever produced' and rife with illustrative drawings,

[4] 'The Birth of a Game Reserve' *The Daily News* (Durban) 11 November 1970.

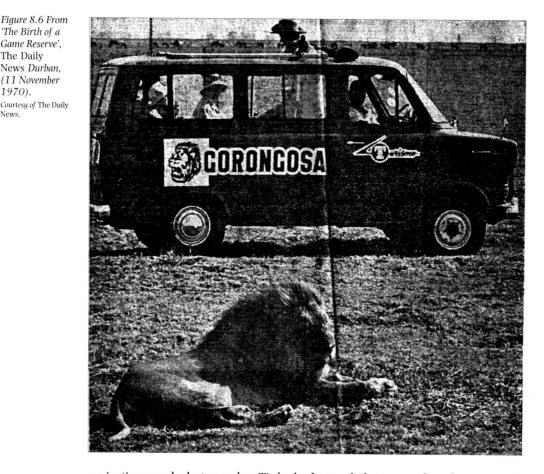

Figure 8.6 From 'The Birth of a Game Reserve', The Daily News *Durban, (11 November 1970). Courtesy of* The Daily News.

projections and photographs, Tinley's doctoral thesis was based upon work commissioned by the Portuguese government in 1968, the remit of which was to determine Gorongosa's ecological limits (Gourevitch 2009: 103). Tinley defined the boundaries of this ecosystem from the hydrological catchment area linking Mount Gorongosa, located outside the park, to Lake Urema, inside the park, projecting its eastern boundary all the way to the Indian Ocean. The forests on the mountains slopes funnelled rainfall into the valley, passing through various communities, and the mountain thus remained a critical component of Gorongosa's ecosystem processes. Believing hydrology and soil moisture balance to be crucial to the future preservation of this intricate landscape, Tinley suggested that the park be expanded to protect its primary water source (Tinley 1977: 6). Before Tinley arrived in Gorongosa, officials had been occupied with the mission of balancing the amenities necessary for a bustling tourism industry with the image of Gorongosa as a 'pristine wilderness', alongside concerns over African agriculturalists on Mount Gorongosa (French 2009: 236). Tinley's plan included a buffer zone that would mitigate the loss of resources while providing access to the Park's 'wilderness'.

Despite his interest in integrating local interests with park planning, Tinley remained critical of agricultural activity on Mount Gorongosa. The incorporation of the mountain into the park was meant to be the first step in a proposed expansion that would extend the National Park from 'mountain to

mangroves'. In 1972, Gorongosa elicited significant media attention around this issue and was designated 'another Eden in peril' (Fisher 1972: 176). This *National Geographic* article showcased plans to combat the ecological pressures of subsistence farming with an expansion of the Park's boundaries and the relocation of 16,000 people (ibid.). The proposal was lauded for its ecological aims. 'It would then be perhaps the only park in Africa that could be called an ecological entity, self-sufficient in water, forage, and space for its wild denizens' (ibid.). In the same article, the Governor General of Mozambique was quoted as saying, 'It is a dream – but sometimes dreams come true'.

RENAMO in Gorongosa: ruling over the bush

In the end, it was a brutal civil war rather than the impact of peasant cultivators that had the greatest impact on Gorongosa's ecosystem. Discussions around incorporating the mountain into the Park were irrelevant as Gorongosa became a critical theatre in protracted conflicts, first in the final years of Portuguese colonial rule and then more acutely during the violent conflict that followed independence. During this period, it seems that new visual associations with Gorongosa were created. Previously a site of 'wilderness', the area came to be associated with the 'bush'. Once 'pristine' and 'untamed', Gorongosa became linked to a different kind of wilderness, exemplified by secrecy and insurrection in one political camp and of a deep human relationship with the land in another.

The Gorongosa district first became a geographical focus for the operations of FRELIMO (Front for the Liberation of Mozambique) in the provinces of Manica and Sofala, with Mt Gorongosa providing adequate concealment from which to launch attacks (French 2009: 236). The Park remained open to tourists, with troops installed to defend the area, which many saw as 'a symbol of colonial sovereignty and prestige' in the face of liberation threats (ibid.: 240). Once Mozambique became independent from Portugal in 1975, the country soon descended into a second and more devastating war, and Gorongosa was further implicated in a violent struggle over conflicting claims to Mozambican statehood. RENAMO (Mozambican National Resistance) was supported externally by neighbouring Rhodesia and later South Africa, and gained internal momentum from the support of peasants opposed to FRELIMO's 'modernizing' mission which seemed to stand in opposition to 'traditional' customs and land tenure (ibid.: 250-2). To what degree RENAMO represented internal resistance or an externally created insurgency remains a contested issue.[5] Similarly, RENAMO's specific aims and ideology during the armed conflict were variably categorized in the international press. William Finnegan writes that the movement was often described as one composed of 'right-wing rebels', with editors of the London *Times* labelling RENAMO 'pro-Western' and the *Wall Street Journal* calling it 'anti-communist resistance' (Finnegan 1992: 77).

At various times during the conflict, the name 'Gorongosa' became analogous with RENAMO. The domestic press had already begun to make this association in 1979. The image below comes from the illustrated weekly news magazine, *Tempo*, published in the Mozambican capital of Maputo. The cover story describes the FRELIMO army neutralizing the 'internal enemy' in the

[5] For analyses of RENAMO origins and ideologies see Alex Vines (1991); William Finnegan (1992); William Minter (1994); Margaret Hall & Tom Young (1997); Colin Darch (1989).

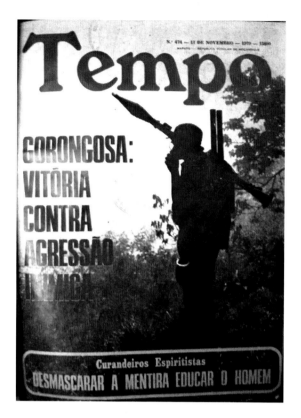

Gorongosa region.[6] The cover image is of a soldier silhouetted through the fog against forest foliage. It represents the return of a proposed legitimate, armed presence in the 'bush', and at the same time suggests the arcane nature of the Gorongosa territory.

In 1981, RENAMO launched its first attack on the Park, motivated by publicity aims. Soldiers kidnapped British ecologist John Burlison from Chitengo camp, asserting that his release depended upon his parents publishing a letter from RENAMO president Dhlakama in the British press (Fauvet & Gomes 1982: 9). In 1983 Gorongosa National Park was abandoned by Park administrators, and RENAMNO dubbed the Gorongosa district the 'Capital of Free Mozambique' (Vines 1991: 85). The area was now a strategic base for RENAMO operations, due in part to its location in the centre of the country. Casa Banana, located on the edge of Mount Gorongosa and peripheral to the Park, became RENAMO's principal headquarters.

Figure 8.7 From 'Gorongosa: Victory Against Enemy Aggression', Tempo, No. 474, (11 November 1979).

Many of the ideas associated with Gorongosa that circulated during the country's 16-year civil war emphasized primitive brutality rather than a pristine environment. The Mozambican government and its supporting press portrayed RENAMO 'as a violent apolitical movement whose only rationale must be that it operated on behalf of some malevolent outside interests' (Hall & Young 1997: 165). RENAMO was described as a group of 'armed bandits' terrorizing the Mozambican bush. As the site of 'bush' warfare, Gorongosa seemed to be reimagined as a space of violence, barbarism and clandestine activity. The name Gorongosa became most associated with a 'blow to banditry' when a 1985 raid at Casa Banana uncovered evidence that South Africa had been violating the N'Komati Accord with Mozambique, in which South Africa had agreed to cease support for RENAMO.[7] *Tempo* ran a three-month series on the 'Gorongosa Documents', which included reproductions of the documents themselves alongside photographs of the captured RENAMO base, showing stockpiles of arms amidst the dense forest. As part of this series, *Tempo* published a photo essay by Kok Nam entitled, 'Gorongosa: Make War to Have Peace', illustrating the takeover of 'Gorongosa' (or 'Casa Banana' more specifically) and the recuperation of RENAMO arms.[8]

RENAMO was not always portrayed negatively in the 'bush' images that typified coverage of the civil war. In many British and American publications, photographs and their accompanying stories served either to validate the

[6] 'Gorongosa: Neutralizada Agressão Inimiga' ['Gorongosa: Neutralized Enemy Aggression'] *Tempo*, 474, 11 November 1979, cover and pp. 13-19.
[7] 'Gorongosa: Golpe no Banditismo' *Tempo*, 779, 15 September 1985: cover and 2-3.
[8] 'Gorongosa: Fazer a Guerra para Ter Paz' *Tempo*, 780, 22 September 1985: 14-18.

faction's legitimacy as a structured opposition or to enforce ideas of RENAMO as a 'rural', indigenous movement. An article entitled, 'RENAMO's Hard Men Rule over the Bush' published in *The Sunday Times*, London, in 1987, quotes a Zimbabwean army sergeant in Zambezia province, just north of Gorongosa, asserting, 'These RENAMO are good. They control the countryside. The local people support them' (Radu 1990: 195). The 'bush' thus appeared as a site of RENAMO governance, enforcing a sense of effective and legitimate RENAMO rule. Another article published in Johannesburg's *Star* described the 'hidden headquarters of the RENAMO rebels' as 'a far cry from the brutal atrocities for which the rebels are blamed elsewhere in Mozambique':

> It's like a scene out of a 'Star Wars'-type fantasy. Rebel soldiers go screaming through narrow forest lanes on Honda scramblers. The action takes place deep in the forest in the Sofala province of central Mozambique at the Gorongoza headquarters of RENAMO leader Afonso Dhlakama. RENAMO's headquarters is [sic] a well laid-out camp, with the huts of the 400 or so workers and soldiers spaced out along the footpaths that wind through the trees. Dhlakama's complex at the centre consists of an office, his personal quarters, a row of comfortable huts for visitors and a kitchen compound. Deeper in the forest is a small parade ground, a church, a small clinic, a tailor's shop, an information centre with a hand-cranked copying machine and old type-writers – all well hidden under the forest canopy. (Wende 1992 :7)

Published alongside portraits of Dhlakama against a backdrop of Gorongosa's dense greenery, the 'bush' appears as a strategically selected, well-ordered site of political activity as opposed to a theatre of barbaric guerrilla warfare.

In 1988, RENAMO sought to redress some of the bad press it had garnered overseas and to overturn the findings of United Nations and US State Department

Figure 8.8 From Spencer Reiss's 'Heart of Darkness', Newsweek, 8 August 1988. Printed with caption, 'A 12-year history of bloodshed: Rebels on patrol in the bush'.

Photo by Mark Peters.

Figure 8.9 From Sibyl Cline's 'Forgotten Freedom Fighters', Soldier of Fortune, January 1990.

Photo by Eric Girard.

reports that 'branded RENAMO as one of the most brutal guerrilla armies in the world' (Battersby 1988: 16). US supporters organized and financed a trip for three journalists and one photographer to interview Dhlakama at his covert headquarters. Reporting from 'Gorongosa', Battersby of the *New York Times*, Reiss of *Newsweek* and Claiborne of the *Washington Post* offered Dhlakama the opportunity to position RENAMO as a valid force in Mozambique and for 'Mozambican Guerrillas to Launch an Attack on the PR Front'.[9] Whether or not this PR attack succeeded in overturning ideas of RENAMO as brutal and barbaric, it did provide evidence to suggest that RENAMO worked strategically, held support from the local population, and was spearheaded by a commander

[9] Battersby, 'Pariahs Abroad', 31 July 1988; Reiss, 'Heart of Darkness', 8 August 1988; Claiborne, 'Mozambican Guerrillas', 31 July 1988.

who had effectively managed to maintain power in the Gorongosa region. Each publication included Dhlakama's portrait, showing him to be calm and controlled. The *New York Times* and *Newsweek* also included images of RENAMO soldiers; one showing a group of uniformed men in the bush holding AK-47s, the other a group of mostly barefoot youths carrying supplies down a dirt path between two agricultural plots. The 'rebels' in the *Newsweek* piece appear particularly benign, perpetuating a sense of civilian, peasant support for RENAMO's cause.

An article published in *Soldier of Fortune* by one of the conspirators behind RENAMO's PR coup similarly supported RENAMO's cause. Entitled, 'Forgotten Freedom Fighters: Mozambique's RENAMO Lost in Maelstrom of Misinformation', this article attempted to insert RENAMO into international consciousness as a formidable, calculated, and unrelenting force against FRELIMO (Cline 1990: 30-9). As 'the West's best bet for a stable, democratic government in this crumbling communist country', the images illustrating these 'freedom fighters' show them also to be 'freely' aligned with RENAMO, in opposition to reports of forced conscription. Photographs embedding these soldiers in the countryside emphasized RENAMO support in vast swathes of territory. Whether intentional or not, the spread below visually situates Dhlakama at a place of strategic advantage, literally 'over'-seeing not only his soldiers, but also the Gorongosa landscape.

Photographs played an important role in demonstrating Dhlakama's local legitimacy even after a peace agreement was signed between RENAMO and the FRELIMO government in 1992. A *New York Times* article from the following year describes the checkpoint at the rebel zone in central Mozambique.

> The young sentry who first confronts visitors to this rebel zone in central Mozambique, up an overgrown dirt road that has just been cleared of land mines, wears camouflage fatigues over mud-caked bare feet. His companions loll in the shade of a wild fig tree, to which they have affixed tattered pictures of their ultimate leader, Afonso Dhlakama – a little snapshot of Mr. Dhlakama as guerrilla commander in a red beret, and a newer campaign poster of the leader as world-traveling politician, looking somber in a business suit. (Keller 1993)

The men described in the article and portrayed in an accompanying photograph are former RENAMO soldiers, presumably absorbed into the national army under the peace agreement. Yet they continue to demonstrate their allegiance to the RENAMO leader by displaying his portrait as if he were still the president of the Gorongosa region in which they sit, the former 'Capital of Free Mozambique'. 'Gorongosa' thus seemed to maintain some residual RENAMO nationalist sentiment, separate from the FRELIMO-led Mozambican state and legitimated through the politics of photographic display.

Paradise found: restoring an African Eden

The Mozambican government has made various attempts to restore Gorongosa National Park since 1994. However, none has received so much media attention as the investment of American entrepreneur Greg Carr, formalized in a Public Private Partnership with the Mozambican government in 2008. Edenic imagery of Gorongosa has been revived in the publicity surrounding this restoration project, and allusions to paradise are again being marshalled to attract tourists for the benefit of an independent Mozambican state.

For his restoration efforts Carr has been dubbed the 'Gardener of Eden', the saviour of Gorongosa, and the protagonist in 'one of the unlikeliest – and most hopeful – stories in Africa' (Shacochis 2009: 77). He recalls his first visit to Gorongosa in a *Smithsonian* article published in 2007. 'Tourists were a distant memory, as were the great animal herds; of a buffalo herd that once numbered 14,000, for example, about 50 animals remain. When I came along, nobody talked about it, nobody remembered it, and people said to me, "Don't bother, there's nothing there anymore"' (Hanes 2007). An article in South African *Getaway Magazine* describes how, with the onslaught of civil war, Gorongosa had been 'forgotten by the world' until Carr arrived to save it (Westwood 2010: 46). Another writer describes the dire situation of the park and the saviour working to revive it: 'Today, much of the game has been decimated – shot for the pot or traded during the desperate years of civil war. So Gorongosa isn't a pristine wilderness. It was badly battered during the war, poaching is still a problem but – and here's why it's now worth visiting – it's being brought back to life' (Van der Post: 2010: 52).

The temporal implications in contemporary discourse of Gorongosa as an Eden 'lost' and 'found' obscure the region's complicated history, while at the same time facilitating selective nostalgia and the reification of Gorongosa's past. In a travel feature for the *Financial Times'* luxury magazine, *How to Spend it*, Lucia van der Post recalls hearing stories about Gorongosa's old hunting days, 'when it was so stuffed with game that hunters were able to shut their eyes, shoot three times, and be sure of hitting at least two plains game' (ibid.: 52). She writes, 'It was an image so vivid, that conjured up such a Garden of Eden plenitude, that it has remained in my mind ever since' (ibid.). Many articles have referenced a myth of Gorongosa as the place where Noah left his ark.[10] These renderings perpetuate a timeless veneer over Gorongosa, eternally unpeopled and teeming with wild animals. They also foster a 'former glory' specifically linked to the period immediately preceding the war when the 'park was the most treasured in all of Africa' (Hanes 2007). An article published on the *Guardian's* website last year portrays this 'glorified' state as follows:

> In the 1960s and 70s, Gorongosa was one of the continent's most famous game parks, attracting a Who's Who of international icons. Foreign dignitaries were feted on its sun-drenched savannah; presidents pampered; celebrities welcomed from every corner of the globe. Hollywood luminaries like John Wayne and Gregory Peck checked into the stylish Chitengo Camp, gazing out to plains crowded with the highest concentration of game on the continent. (Vourlias 2009)

In some cases historical photographs from this period have been reprinted to foster a sense of this glorified past. For example, in 2008 the Portuguese newspaper *Diario de Noticias* used the photograph of automobiles surrounding two male lions that had first been circulated after President Thomaz visited the Park in 1964 (see Figure 8.2). The sub-headline tells the reader that the current Mozambican president sees Gorongosa as an essential instrument in attracting football fans who will be travelling to the region for the World Cup. Visual and literary images of Gorongosa's tourist heyday are used to present examples not only of what was, but of what could be. They represent

[10] See for example Van der Post 2010; Christopher Vourlias, 13 May 2009; Nicola Walker, 21 March 2009; Westwood 2008.

Figure 8.10
From 'Gorongosa,'
M de Moçambique,
No. 1, March-May
2010.
Photo by Jeff Barbee.
Reproduced by kind
permission of the
photographer.

possibilities for wildlife population expansion as well as the rebuilding of the country's tourism industry.[11]

Much of the recent media attention to Gorongosa has revived Tinley's work on the region, centring on the restoration and protection of the Gorongosa 'ecosystem'. In the aftermath of the conflict, old concerns about deforestation at Gorongosa Mountain have been resurrected and local communities have been pitted against conservationist agendas. A recent *New Yorker* article runs the following by-line under its title, 'Can Greg Carr save an African ecosystem?' This article brings to light the pressures faced by the restoration project in a context of diminishing resources. With the war over and restoration taking hold, agriculturalists are again condemned as threats to the landscape. In the revival of its glorified past, Gorongosa National Park is again posited in opposition to those elements once seen as a threat to its former glory. Perceived dangers to the park again revolve around the economic interests of local populations and on Tinley's conception of the Greater Gorongosa Ecosystem.

Tinley's proposed expansion of Gorongosa National Park was never realized during his tenure. However, in 2010 the highest area of Mount Gorongosa was officially incorporated into the National Park in an attempt to prevent further degradation, and the Park's buffer zone was expanded to include the area between the former boundary and the new territory. The image of Lake Urema (Fig. 8.10) was printed on a two-page spread in *M* magazine's cover story about Gorongosa with the words, 'Conservação Notavél'. The photograph was originally taken as part of a different story on the Park and has been reprinted in various articles and online media, emphasized as a critical part of the Gorongosa ecosystem.

[11] 'O novo Fôlego da Gorongosa,' *Diário de Notícias* (Lisbon), 29 June 2008, p.34.

While many photographs publicizing the Park feature tropes similar to those of the 1960s and 1970s, such as portraits of representative species (notably the lion) juxtaposed against each other with dissimilar backdrops, further evidencing the Park's diversity, humans play a more prominent role in contemporary imagery than they did in the past. The Gorongosa Restoration Project is portrayed as being equally committed to developing communities around the park as it is to restoring animal numbers and boasting tourism. Carr tells Chris Pelley in a *60 Minutes* special that he wants to 'attract the tourists who will spend the money to create the jobs, and lift everybody out of poverty'. He takes the camera crew to a village outside the park where he has erected the first of 25 planned local clinics. In Gourevitch's *New Yorker* article, Carr is quoted as saying, 'I'm a human-rights guy and a conservation guy trying to do both at the same time' (2009: 111). Thus, many articles juxtapose images of nature with images of the humans who will ostensibly benefit from their nation's natural heritage. The portrayal of the relationship between the Park and surrounding communities varies, of course, depending on the media source. In its article, *M* magazine describes this relationship as a healing one, bridging the region's violent past with a hopeful present:

> The presence of [the] Gorongosa Restoration Project here, along with the now steady flow of western tourists, is inspiring the local population to accept that peace and stability are here to stay in Mozambique. One cannot help but notice that self-esteem and optimism are on the rise in this part of the world, perhaps since the first time since the end of the bloody 16-year civil conflict. The project is not only restoring the ecosystem, but also slowly taking the residual neuroses of war away. (2010: 10)

The images of Gorongosa that circulated in the aftermath of civil war have revived the Park's glory days as a model for what the Park could be again. However, these images perpetuate a division between humans and the landscape, as different sides of the development coin. Neumann writes,

> Wild areas of national parks and reserves, as products of the creation of the modern nation state, are as much an expression of modernism as skyscrapers.... They are ... an integral part of the practice of modern statecraft and a result of numerous plans to divide and contain the central antimonies of modernity: nature and culture, consumption and production, wilderness and civilization'. (1995: 194)

Contemporary publicity of Gorongosa National Park perpetuates colonial tropes of divisions between African people and their environments, reinforcing former claims on 'wild' spaces in need of state protection, within a discourse of state and social development. Furthermore, photographs of Gorongosa in the present lend authority to ongoing processes of territory formation and regulated access to state spaces.

Conclusion

In July 2010, Gorongosa National Park celebrated its 50th Anniversary. The slogan for the commemoration was 'The Paradise Mozambique Offers the World' (*Notícias*, 27 July 2010). Ramutsindela contends that in postcolonial Southern Africa, 'the restructuring of the state resulted in national parks being incorporated into the construction of new identities' (2004: 63). In the case of Gorongosa National Park, these new identities seem to perpetuate old

ideas about nature, including wilderness myths, realigned with the state's economic objectives of reviving national heritage as a means to bolster tourism. Photographs of Gorongosa National Park offer analytical insight into the various ways that 'nature' is conscripted in the performance of state power and nation building, obscuring particular versions of the past in service of others. French describes Gorongosa as 'a lost wilderness that never was' (2009: 329). Whether enticing tourism in Mozambique's colonial past or postcolonial present, or representing the politics of the 'bush' during the country's armed conflict, photographs have legitimated a 'wilderness' narrative of the nation and its territories.

Bibliography

Adams, J. & T. McShane 1996. *The Myth of Wild Africa: Conservation Without Illusion*, Berkeley CA: University of California Press.

Alexander, J. 2006. *The Unsettled Land: State-Making and the Politics of Land in Zimbabwe 1893-2003*, Oxford: James Currey.

Anderson, D. & R. Grove (eds). 1987. *Conservation in Africa*, Cambridge: Cambridge University Press.

Battersby, J. 1988. 'Pariahs Abroad, Mozambique Rebels Fight On', *New York Times* (31 July).

Beinart, W. & J. MacGregor (eds). 2003. *Social History & African Environments*, Oxford: James Currey.

Brockington, D. 2002. *Fortress Conservation: The Preservation of the Mkomazi Game Reserve*, Oxford: James Currey.

Brooks, S. 2005. 'Images of "Wild Africa": Nature Tourism and the (Re)creation of Hluhluwe Game Reserve, 1930-1945', *Journal of Historical Geography* (31) 220-40.

Bunn, D. 2003. An Unnatural State: Tourism, Water & Wildlife Photography in the early Kruger Park, in *Social History & African Environments* (eds) W. Beinart & J. MacGregor. Oxford: James Currey.

Cline, S. 1990. 'Forgotten Freedom Fighters', *Soldier of Fortune*, January 30-9.

Cohane, O. 2007. 'Once and Future Eden', *Condé Nast Traveler* (December 2007).

Daily News (Durban) (1970) 'The Birth of a Game Reserve', 11 November.

Darch, C. 1989. 'Are there Warlords in Provincial Mozambique? Questions of the social base of MNR banditry', *Review of African Political Economy* 45/46: 34-9.

Doucette, K. 2009. 'Paradise Regained', *Men's Journal*, 5 May.

Duffy, R. 2000. *Killing for Conservation: Wildlife Policy in Zimbabwe*, Oxford: James Currey.

Dunn, K. 2009. 'Contested State Spaces: African National Parks and the State', *European Journal of International Relations* 15:423-46.

d'Eca de Queiroz, J. M. 1964. *Santuario Bravio: Os Animais Surpreendetes da Gorongosa e Safaris em Moçambique*, Lisbon: Empresa Naçional de Publicidade.

Fauvet, P. & A. Gomes. 1982. 'The "Mozambique National Resistance"', *Supplement to AIM Information Bulletin* 69.

Finnegan, W. 1992. *A Complicated War: The Harrowing of Mozambique*, Berkeley CA: University of California Press.

Fisher, Jr. & C. Allan. 1972. 'Save a Mountain to Save a Park'. *National Geographic* (February).

French, T. 2009. '"Like Leaves Fallen by Wind": Resilience, Remembrance, and the Restoration of Landscapes in Central Mozambique'. PhD dissertation., Boston University.

'Gorongosa', in *M de Moçambique* 1 (March-May 2010)

'Gorongosa: Neutralizada Agressão', *Tempo* 474 (11 November 1979) 13-9.

'Gorongosa: Golpe no Banditismo', *Tempo* 779 (15 September 1985) 2-3

'Gorongosa: Fazer a Guerra para Ter Paz', *Tempo* 780 (22 September 1985) 14-8.

Grove, R. 1995. *Green Imperialism*, Cambridge: Cambridge University Press.

Gourevitch, P. 2009. 'The Monkey and the Fish', *New Yorker* (December 21 & 28) 98-111.

Hall, M. & T. Young. 1997. *Confronting Leviathan: Mozambique Since Independence*, London: Christopher Hurst & Co.

Hanes, S. 2007. 'Greg Carr's Big Gamble', *Smithsonian Magazine* (May 2007).

Júnior, J. P. 2006. 'O Salvador da Gorongosa', *Visão* (9-15 November 2006).

Keller, B. 1993. 'Rebels with a Quandary: What's the Cause Now?' *New York Times* (26 February).

Lecanides, B. 1948. *Gorongoza, Grass and Game*, Pretoria: Wallachs.

MacKenzie, J. (ed.). 1990. *Imperialism and the Natural World*, Manchester: Manchester University Press.

Marjay, F. P. 1963. *Moçambique*, Lisbon: Livraria Bertrand.

Minter, W. 1994. *Apartheid's Contras: An Inquiry Into the Roots of War in Angola and Mozambique*, London: Zed Books.

Moore, D. S. 2005. *Suffering for Territory: Race, Place and Power in Zimbabwe*, Durham: Duke University Press.

Mosse, D. 2003. *The Rule of Water: Statecraft, Ecology and Collective Action in South India*, Oxford: Oxford University Press.

Neumann, R. 1995. 'Ways of Seeing Africa: Colonial Recasting of African Society', *Ecumene* (2): 149-69.

—— 2004. Nature-State-Territory: Toward a Critical Theorization of Conservation Enclosures, in *Liberation Ecologies* (eds) R. Peet & M. Watts. 2nd Edition. London: Routledge.

'O novo Fôlego da Gorongosa', *Diário de Notícias* (29 de Junho 2008).

Paisana, F. C, & A. José. 1972. Inventariação dos Problemas Relacionados com a Proteccao da Fauna e seu Aproveitamento Racional, in *Reunio para o Estudo dos Problemas da Fauna Selvagem e Protecção da Natureza no Ultramar Portugues*. Luanda and Sá da Bandeira, Angola (17 November – 2 December).

'PNG aos 50 anos: Servir e cada vez melhor a humanidade', *Notícias* (27 July 2010).

Radu, M. (ed.). 1990. *The New Insurgencies: Anti-communist Guerrillas in the Third World*, New Brunswick NJ: Transaction Publishers.

Rajan, R. 2006. *Modernizing Nature: Forestry and Imperial Eco-development 1800–1950*, Oxford: Oxford University Press.

Ramutsindela, M. 2004. *Parks and People in Postcolonial Societies*, Dordrecht: Kluwer Academic Publishers.

Rasool, C. & L. Witz. 1996. 'South Africa: A World in One Country: Moments in International Tourist Encounters with Wildlife, the Primitive and the Modern', *Cahiers d'Études Africaines* 36: 335-71.

Rosinha, A. 1989. 'Alguns dados históricos sobre o Parque Nacional de Gorongosa', *Arquivo* 6: 211-38.

Scott, J. C. 1998. *Seeing Like a State*, New Haven CT: Yale University Press.

Shacochis, B. 2009. 'The Gardener of Eden', *Outside*, July.

Silva, J. A. 1964. *Gorongosa: Shooting Big Game with a Camera*, Lourenço Marques.

Tinley, K. 1977. 'Framework of the Gorongosa Ecosystem'. PhD dissertation, University of Pretoria.

Varian, H. F. 1953. *Some African Milestones*, Wheatley, Oxford: George Ronald.

Vines, A. 1991. *RENAMO: Terrorism in Mozambique*, London: James Currey.

Vourlias, C. 2009. 'Life Returns to Gorongosa', *Guardian Online* (13 May).

Walker, N. 2009. 'Return of the Wild Things: Destination Mozambique', *Sydney Morning Herald* (21 March).

Wende, H. 1992. 'Deep in Renamo's Nerve-Centre', *The Star* (6 June).

Wentzel, V. 1964. 'Mozambique: Land of Good People', *National Geographic* (August) 191-230.

Westwood. 2008. 'Where Noah Left his Ark', *Getaway* magazine (November).

Political billboards as contact zones
Reflections on urban space, the visual & political affect in Kabila's Kinshasa
Katrien Pype

9

Kinshasa could well be characterized in terms of a city obsessed with the visual. People attach much value to their own physical appearance,[1] to the image of their city beyond the confines of their community, and photographs are ubiquitous in Kinshasa's public places. Cruising around the city, one will easily encounter a hearse adorned with a large photograph of the deceased attached to the front window. Streets are paved with billboards that show local musicians endorsing the actions of NGOs, top models advertising consumer goods, and religious leaders announcing mass events. Murals depict local celebrities, often in the style of passport photography. People wear T-shirts with portraits of local politicians which have been distributed during election campaigns, and during mass rallies and political manifestations, crowds often carry posters or paintings depicting their favourite leader.

In a more abstract way, the visual also plays a significant role. Pastors continuously stress the tensions between visible and invisible spiritual worlds (De Boeck 2005) and since 2007, when Kabila's political power was confirmed, 'visibility' (*la visibilité*) has become the watchword of the presidential propaganda machine. Both the religious and political imaginary thrive upon the tensions between what is/can be shown and seen, and its counterparts, the hidden and the secret. So too its transgressions: the revealed and the exposed. As West and Sanders (2003) suggest, these tensions are common for the political and economic imagination in postcolonial societies and they produce narratives about conspiracy and engender new practices of investigation and exposure.

This chapter, based on ethnographic material collected in 2009 and 2010,[2] will deal especially with the political significance of the visual. The primary goal is to deepen our understanding of the intersections of visual media and politics in postcolonial urban Africa. The main slogan of Kabila's propaganda, *La Visibilité des 5 Chantiers* ('the visibility of the 5 construction sites') justifies the strong media production in Kabila's political programme. A skilfully mastered programme renders Joseph Kabila virtually omnipresent in the city. Those who participate cover a wide range: the Ministry of Information, the Presidential Press, the state-owned radio and television channels RTNC1, RTNC2 and RTNC3 and pro-Kabila audio-visual and written private press (among others DigitalCongo, Télédu50enaire, RTG@) as well as the especially created Office charged with the 'Visibility of *5 Chantiers*'. On Fridays, Saturdays and Sundays, a truck with a huge TV screen is placed on a corner, or on open terrain somewhere in

[1] The *Sapeur* phenomenon, in which clothes and self-image are cultivated, is a good example.
[2] This article is part of a larger project on visual media and political mediation in Kabila's Kinshasa. Mid-2009, I embarked on a study of media, charisma and politics in contemporary Kinshasa. Fieldwork (7 months) mainly focussed on political journalism in local, pro-government television channels. I also worked with various bureaucratic institutions responsible for Kabila's propaganda, such as the Presidential Press and the Office of the visibility of the *5 Chantiers*. Fieldwork was funded by the Newton International Fellowship Programme (British Academy).

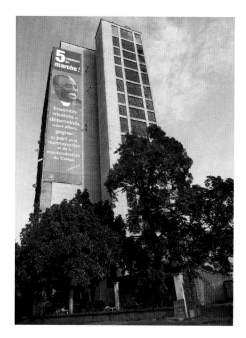

Figure 9.1 'Ensemble motivés et déterminés, nous allons gagner le pari de la reconstruction et de la modernisation du Congo. Joseph Kabila' (Billboard on the tower of the National Radio and Television Channel, on the Voix du Zaire premises).
Photo by Katrien Pype, 24 January 2010.

Kinshasa, displaying adverts for the *Cinq Chantiers* programme. All media publicize moving and still images of the president's visits to construction sites related to access to health services, education, energy, mobility and housing; snapshots of finished projects, of scale-models of future sites (or utopian visions? cf. De Boeck 2011); and of recorded citizens' testimonies of gratitude towards the president and the government at large.

Various new print magazines have also been published; examples are *La RDC en chantier* (*RDC in Progress* [lit. RDC under Construction]), *Construct. Magazine d'architecture, de bâtiment et de travaux publics* (*Construct. Magazine of Architecture, Buildings and Public Works*). First issues are spread freely at political events or gatherings of government related politicians, while subsequent issues are sold around town (ranging from US$1,5 to US$5). These magazines document state-of-the-art developments, often illustrated with pictures of Kabila visiting the building sites. Interviews are published about relevant ministers or heads of state services (e.g. the utilities for electricity, Régideso, and for water, Snel.[3]

In addition, since the take-off of the *Visibility* programme, Kinshasa's inhabitants, the Kinois, have observed a gradual increase in Kabila's propaganda portraits in the city space. Just like the media clips and advertisements in the written and audio-visual press, billboards focus on infrastructure: roads, bridges, the airport, and hospitals. Most of these hoardings clearly centre on the works themselves, and they usually show the smiling face of Joseph Kabila in the upper-left corner. Other billboards display Joseph Kabila more centred in the picture, addressing the spectators and stating: 'Together, motivated and determined, we are going to win the bet concerning the reconstruction and modernisation of DR Congo. [Signed] Joseph Kabila.'

This chapter will focus on the above-mentioned public photographs of Kabila and (to a lesser extent because less available), of other political leaders. Public photography produces the urban experience just as much as it is shaped by

[3] The magazine *RDC en chantier*, for example, edited by the Presidential Press, categorizes articles according to the 5 construction sites. Article headers, of the November 2009 issue for example, read '*Le Président Kabila redonne vie aux quartiers Kinsuka-Pompage et Mbudi à Kinshasa*' ('President Kabila restores life in the neighbourhoods of Kinsuka-Pompage and Mbudi in Kinshasa' – dealing with the rehabilitation of three main roads in that area), '*La Direction Générale de Migration à l'ère des cinq chantiers*' ('The General Office of Migration in the era of the 5 Chantiers'), '*La Régideso déterminée à réduire de moitié, d'ici à 2025, le nombre des personnes n'ayant pas accès à l'eau potable*' ('Between now and 2025, The Régideso [national water catering service] determined to diminish by half the number of people without access to drinking water'), '*Le gouvernement s'implique dans la création d'emplois en RDC*' ('The government now also creates jobs in RDC'), '*Le programme sino-congolais et la reconstruction de la RDC*' ('The Sino-Congolese programme and the reconstruction of RDC') etc. The issue counts 83 pages, and contains no less than 32 photos of Joseph Kabila.

the imagination of it. Billboards and the circulation of pictures influence the ways in which people move, interrupt their movements and incite reflection on their lives and the larger world. Often, these large panels are the subject of discussion during taxi rides. People also attend the installation of a new picture which further engenders much curiosity and reflection. Billboards are thus important objects to study if we want to understand how cities and human beings interact and how they think about their lives and their environment. An analysis of the installation and the circulation of billboards offers interesting material for a better comprehension of how political actors and others negotiate or renegotiate the boundaries between public and private spaces; between what can be said and shown and what is forbidden; between collective and individual desires and how political power flows through the city.

The main premise of this chapter is that political public photography facilitates that 'intimate touch of sight' (Benjamin 1969) through which political power penetrates daily life. I will try to combine the fields of the optical and the political. The analysis is inspired by insights of visual anthropology (Taussig 1993, Marks 2000, Pinney 2002), where the tactile aspects of contemplating are put forward and are understood as significant ways of transmitting knowledge, meaning and value. The concept of 'haptic' or 'tactile visuality' (Marks 2000) captures the sensuous reception of images, in contrast to 'optical visuality', where the reconstruction of narratives based on the images dominates. Optical and haptical modes of contemplating always go hand in hand. Certain genres seem to provoke the junction of both modes of watching: for example, Congolese popular paintings often display various scenes that at once propel the onlooker to produce stories out of the images, which are in themselves shocking and thus play with the emotions of the spectators (Fabian 1996, Jewsiewicki 1996).[4] Political billboards do the same: intellectual reflection is encouraged via the slogans, while at the same time sentiments are intended to be awakened and also transmitted.

My analysis is also situated within what we may call a sensitive turn in political anthropology where attention is paid to the sensuous experiences of politics and to the role of affect and emotions in the production of political identities and subjectivities. The work of authors such as Anne Stoler (2002) and Ulli Linke (2006) reminds us, in two different settings (the colonial empire in Indonesia and the Nazi regime), that political experience and the formation of political communities are strongly channelled through sensuous regimes. These authors and other political anthropologists who aim at unravelling the intimate connections between power and people (citizens/power holders/ all kinds of political actors) understand political identity first and foremost as embodied. Political power operates through the senses (Linke 2006: 218). On the one hand, the state appears as a site of emotional investment and fantasy; on the other, the modern political subject is the outcome of a stratification and specialization of the senses and of the manipulation of perceptual dispositions (Seremetakis 1994). These are the various regimes through which knowledge can be gathered and inspire people to act. Therefore, it is important to pay attention to the concrete spaces of power, 'where the machination of the state and the embodied subject collide' (Linke 2006: 206), where subjectivities, bodies and states are entangled.

[4] I thank Karin Barber for bringing this to my attention (personal communication, 1 December 2010).

Political billboards constitute one kind of such sensually concrete spaces of power – they are 'contact zones'[5] between political actors of various kinds. My use of the notion 'contact zone' is inspired by Linke (2006), who uses it to indicate the specific zones of contact where 'the violent spaces of state and subjectivity interlock through practices aUS$nd regimes of the body, and emotional sentiments are further elaborated by the machinations of national discourses' (Linke 2006: 206), or 'where the matrix of state power touches the subject's everyday lifeworld' (Linke 2006: 216). In this chapter I will enlarge this notion and also include political actors who are outside the state, since, as will become apparent, billboards are not the exclusive domain of the state even in a context of censorship.

Photographs themselves constitute a particular zone of contact. They set in motion a sensuous connection between the body of the perceiver and the image perceived (Taussig 1993: 21, Linke 2006: 212). Pictures establish relations of various kinds. As Marks argues in her discussion of intercultural cinema, viewers may lose themselves in the image, may lose their sense of proportion, and thus enter into a mutual relationship with it (2000, 184). In my own previous research with evangelizing TV production in Kinshasa, I learned how this haptical mode of watching was taken for granted both by evangelizing media producers and their audiences. Spiritual knowledge was said to be transmitted in the very first instance when the viewers engaged in a bodily way with the images. The range of emotions experienced during the act of contemplating is indicative of the spiritual origins of images (either diabolical or Christian), and they inspire evangelizers to develop a media pedagogy (Pype 2010).

In the case of politically charged photographs in Kinshasa, we can thus expect a similar emphasis on the haptical. We are all familiar with the fact that political passions can and often are evoked through visual stimuli. Via political photography, optical and haptical regimes of knowledge gathering and identity formation are set in motion. Therefore, I will pay attention to the social and physical spaces in which political billboards are planted, the discourses that surround them, the messages that these billboards convey and the range of political affects that are involved in producing and contemplating them.

The material is limited to the first years of Kabila's democratic regime.[6] With the organization of elections in 2006, DR Congo has entered a new political era. For the first time in the country's history the president has been appointed by suffrage.[7] This does not suggest a total rupture with characteristics of earlier postcolonial politics. What is does mean is that new 'languages of power' (Mbembe 2001, 103) – signs, vocabulary and narratives – are produced by the government. These borrow heavily from the Western ideal of political representation and legitimacy, rouse political passions while both revealing and evoking fantasies of the state.

The concept of 'contact zone' is extremely helpful when thinking about the interactions between citizens and the postcolonial state in Kinshasa, in

[5] The concept of 'contact zone' originates in sociolinguistics, in the context of pidgin and creole languages.

[6] More historical research on Mobutu's visual politics in the city's public spaces is needed in order to trace continuities and ruptures between the various postcolonial regimes. However, this falls beyond the scope of the chapter.

[7] The official results have been seriously contested by Kabila's opponents.

particular the way in which Marie Louise Pratt (1991: 4) has defined it. She argues that the concept in part 'contrast[s] with ideas of community'. In particular it indicates social spaces where cultures meet, often in the imperial and postcolonial context. Basically, the concept of 'contact zones' points to the 'spatial and temporal co[-]presence of subjects previously separated by geographical and historical disjunctures, and whose trajectories now intersect' (1992: 6-7). A 'contact' perspective emphasizes 'how subjects get constituted in and by their relations to each other' (ibid.: 8), and does not treat relations 'in terms of separateness, but in terms of co-presence, interaction, interlocking understandings and practices, and often within radically asymmetrical relations of power' (ibid.: 8).

The Kinois and Kabila literally share one spatial and temporal living space but maintain a sense of a strong alienation. Difference between the Kinois and Kabila is pervasive in Kinshasa today. Kinois are said to be anti-Kabila. The 2006 election results indicated that a majority of the Kinois voted for Jean-Pierre Bemba, Kabila's main opponent. Furthermore, Kinois voice time and again a strong distance between them and their president, who does not speak Lingala (Kinshasa's lingua franca), and whose origins lie in the eastern part of the country. Linguistic and territorial belonging are important vectors of political affiliation in DR Congo, just as in many other African societies (Geschiere, 2009). All this turns Kinshasa into an extremely complex political space, one in which the ruling president has to experiment in order to gain affect from the urbanites and to impose his leadership. As will become clear throughout the text, the *Visibility* campaign, which attempts to establish connections between the Kinois and the president, is a response to this anti-Kabila climate.

In the first part of this chapter, I will concentrate on the presence and absence of photographs of political leaders in Kinshasa's public space in order to understand how space and image are simultaneously embedded in the installation and contestation of Kabila's leadership and how public images impact on the circulation of political affects. The second part concentrates on the visual language of Kabila's representation. In particular, the visualization of Joseph Kabila and the accompanying discourses on emotions will be scrutinized in order to identify the signs and narratives that are deployed in this new phase of postcolonial commandment.

Visual presence in the city

To date there is little research on the production and reception of political images in urban public spaces in Africa. Still, cities are important places where 'citizens come to understand, and even negotiate the form and shape of their societies and their places within' (Freeman 2001: 37). According to Holston and Appadurai (1999), cities are salient sites for examining the current renegotiations of citizenship, democracy and national belonging. 'Place' remains fundamental to changes in the relations between nations and cities (Holston & Appadurai 1999: 3). Public places are spaces where negotiations of citizenship, political identity, desires and activities are occurring. The structuring of the everyday ocular public space, as the street, and (in)formal reactions to this are all part of the formation of political subjectivities (Linke, 2006).

Figure 9.2
Private photo
studio engaged
by the president
putting up a
new portrait of
Mobutu.
Photographer wishes
to remain anonymous,
date unclear (sometime
around 1975-1980).

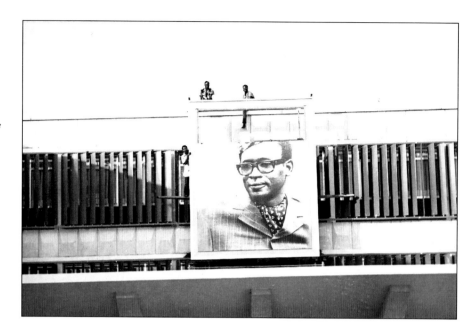

In Kinshasa, hardly any images of political leaders other than the president are allowed in the public space. While the audio-visual and written media seem to have been liberated (in so far that politicians are allowed their own radio or television channel or newspaper), the streets have not been 'set free'. It is unclear how much of the ban on public images of other political leaders in the city's public space is officially instigated. It is certainly familiar in terms of Congo's postcolonial history. Indeed, since the early postcolonial period images of other political leaders in the city's public space were forbidden.

According to Schatzberg (1991: 118) portraits of Mobutu appeared in schools, hospitals and other public buildings, replacing pictures of the pope, from late 1974 and early 1975.[8] Many informants told me that around town and in football stadiums, pictures of a stern-looking or sometimes smiling Mobutu were also hung out, thus rendering the president omnipresent in the city.[9] Time and again the portraits showed the president with the famous leopard skin, big glasses and sometimes also with a can, all paraphernalia of customary chiefs.[10] Mobutu's successor, Laurent D. Kabila, also followed this strategy: he removed all of Mobutu's posters and replaced them with his own portrait/image. This monopolization of the public space by the ruler occurs also in other African cities. Schatzberg (2001) provides an interesting discussion of the distribution of posters of former presidents Shagari and Kenyatta in Nigeria and Kenya respectively. When local politicians refused to put up presidential portraits they performed a symbolic act in which that person's authority was rejected, an act that was also 'an unstated recognition and understanding

[8] Presidential photographs thus played an important role in the competition between the Catholic Church and the early postcolonial state.
[9] And also as I saw on various pictures documenting Kinshasa during the Mobutu era.
[10] One of my informants who worked during the 1980s as a presidential photographer, and who prefers to remain anonymous, told me during an informal interview that Mobutu's public photographs had to be replaced every three months. Because of the low quality of the paper on which the pictures were printed, rain, sun and wind made that the posters did not last very long. Some of these billboards were more than three meters high.

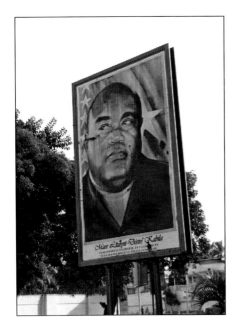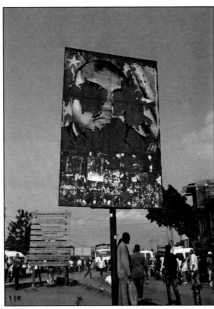

Figures 9.3 and 9.4 Two billboards depicting Laurent D. Kabila.

Photos by Katrien Pype, 24 February 2010 and 25 January 2010, respectively.

that power is eaten whole and cannot be divided easily' (ibid.: 60). So, what is at stake here is control over several symbolic dimensions of politics. Political opposition and conflict are partially channelled into a struggle for control of politically resonant cultural symbols that most leaders are unwilling to share (Schatzberg, 2001: 59-60).

The (in)visibility of political leaders past and present is an important issue in the construction of power and also of political subjectivity. As mentioned earlier, there are no pictures of Mobutu in the contemporary public space in Kinshasa. However, portraits of L. D. Kabila are still available. Today, in various locations, large pictures of the assassinated president remain visible: in February 2010, I counted eight such billboards. Of course, there were many more during L. D. Kabila's term (1997-2002). Some have been destroyed by weather; others have been attacked by Kinois expressing their disappointment after years of unfulfilled political promises. Some remaining billboards show gun holes; on others only the metal frame is visible, with only tatters of the poster.

Allowing billboards of the previous president is unique in Congolese political history. It is a significant symbolic gesture, in which Joseph Kabila literally shares power with his predecessor. This is first and foremost a political strategy. Joseph Kabila is at times mentioned in rumours concerning the assassination of the previous president, his father L. D. Kabila. Indeed some argue that Joseph Kabila is not the former's son. However, keeping L. D. Kabila's images around town confirms a strong tie between the assassinated president and the incumbent, and attempts to silence all suspicions of rivalry between the two.

Other political leaders, however, are rendered invisible in the city's public space. The particular politics of visualization reveal the state's ocular intrusion (Linke, 2006: 211). The Congolese optical apparatus transforms the public place of the street into a political space. With the impossibility of visualizing past leaders and also those of the opposition, creative political tactics are at play, most consciously on the permeability of the borders between public and private spaces.

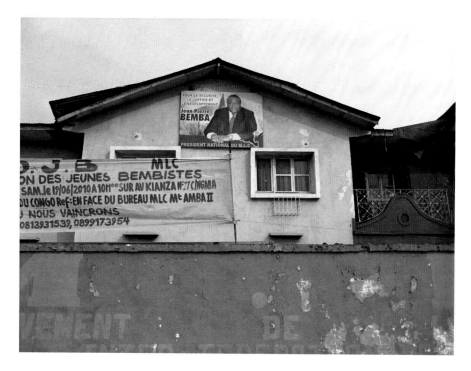

*Figure 9.5
Poster of Jean-
Pierre Bemba,
in the compound
of the MLC
headquarters.*
Photo by Katrien Pype,
16 June 2010.

Most political parties have huge billboards depicting the party's leader on the outer sides of their compound walls or high on the house walls inside the compound.[11] The panels are placed on private territory, since the walls belong to the plot's owners, but their message spills over into the public area of the street. A similar tactic is used by Mobutu's family. In a compound in Bandalungwa, one of Kinshasa's communalities, two large posters depicting Mobutu can be seen from the street. The portraits are directed towards those who have entered in the compound, but their huge size (approx. 3 x 1.5m) makes them visible well beyond the compound's walls.

A second tactic is used by the PALU,[12] one of the longstanding opposition parties during both Mobutu's era and the first Kabila period. Its history of opposition has inspired the PALU group to respond in a very inventive way to the silencing of oppositional voices and the absenting of its faces. For many years now, eight or ten PALU activists (ranging between thirty and seventy years old) gather every morning in the city centre, in the shadow of Hotel Memling, one of Kinshasa's most exclusive hotels. This place is not only an important space where PALU news is spread out, but it is also the only place where PALU photographs are publicly displayed.[13] About six pictures of the two main PALU leaders (Antoine Gizenga and Adolphe Muzito) display the men either shaking hands with other political leaders or shouting at an animated PALU crowd. These photographs, printed on Kodak paper (9 x 13 cm), are pasted onto a board approximately 1 m x 70 cm, which itself rests on a small

[11] As is usual in DR Congo politics, political parties are the playground of one person; these billboards show the group's founder and leader.
[12] PALU stands for *Parti Lumumbiste Unifié* (United Lumumbist Party), and, since the 2006 elections, the Prime Minister is one of their members.
[13] With the exception of the large billboard at the political party's headquarters along Boulevard Lumumba.

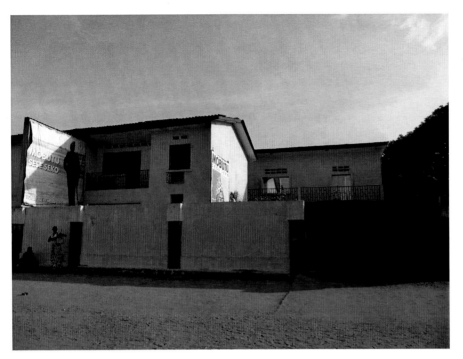

Figure 9.6
Private compound
of the Mobutu
family. It is said
to be the first
house Mobutu
ever bought in
Kinshasa.
Photo by Katrien Pype,
24 January 2010.

wooden table. This movable object is hidden during night time in the private compound of one of the PALU activists, who brings it to town and carries it back home again when the group disperses. The carton construction reads first and foremost as an archive of the major achievements of the political party. Furthermore, like any advertising board, it attracts pedestrians. As soon as someone approaches and starts looking at the photographs in a concentrated way, one of the eight engages him/her in conversation, with a quick rundown of the PALU movement's history. The placard is small and easy to carry and as PALU activists reminded me, it means they can run away fast if the police are on the lookout for political opposition.[14]

A final note here: MPCR,[15] a political party that does not participate in the government, has transformed its private compound into a public space where images of political leaders are on display. From the outside, it reads as a gallery dedicated to the Congolese sculptor André Lufwa Mawidi.[16] However, on entering one discovers not an artistic world but rather a political visual museum. Based on photographs of politicians and other local leaders, painters have visualized their subjects in the style of passport pictures, which line the walls. One sees first, on the left, the passports of the national leaders Mobutu, L.D. Kabila, Joseph Kabila, Jean-Pierre Bemba, Etienne Tschisekedi, and on the right side one notices, among others, Barack Obama, Simon Kimbangu,

[14] But, since the party had entered the ruling groups of the government, this hardly occurred anymore.

[15] *Mouvement du Peuple Congolais pour la République* (Mouvement of the Congolese People for the Republic).

[16] On the compound walls one reads *'Galérie André Lufwa Mawidi. Grand Sculpteur Congolais né en 1924'* ('Gallery André Lufwa Mawidi. Important Congolese sculptor born in 1924'). The inscription is added above a painted passport portrait and the words *'Parmi ses œuvres célèbres: le batteur de tam tam de la fikin; les léopards du mont ngaliema etc.'* ('among his well known work : the tam tam drummer on the Fikin premises; the leopards on Mont Ngaliema, and so on').

Figure 9.7
Murals inside
the MPCR
compound.
Photo by Katrien Pype,
19 June 2010.

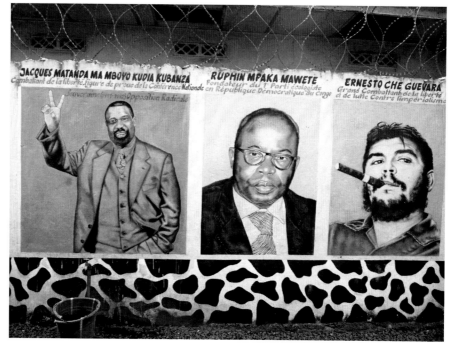

Leopold II, and King Baudoin. All the inside walls of the compound as well as the outer walls of the two houses built on the premises are adorned with similar murals. Depictions abound of former and current ministers (e.g. Jean de Dieu Nguz a Karl Ibond, Azarias Ruberwa, Didier Mumengi, Antoine Gizenga); military leaders (a.o. General Masiala Kinkela, Colonel Kokolo); political activists (ABAKO leaders, the Pentecost martyrs, Moise Tshombe, Kalonji Mulopowe); religious leaders (Mgr L. Mosengwo Pasinya, Soeur Annuarite Nengapeta, Isidore Bakandja, Cardinal Malula); local musicians (a.o. Wendo Kolosoy, Joseph Kabasele) and foreign political and cultural leaders (e.g. [former] African presidents Abdou Diouf, Thomas Sankara, Kadhafi, and Hassan II – King of Morocco). The ultimate goal of this space is to represent everyone who has had an impact on Congolese society.

MPCR politicians try to counter the one-sided visibility of political leaders in the public sphere. In the same manner as above, they attempt to re-actualize the political past by visualizing influential political actors in the private space of their own compound. The compound doors are open during daytime, thus allowing free access. During an interview, MPCR politicians referred to the lack of democracy and the experience of being rendered invisible in the physical public space. Thus, by not only visualizing their own leaders, but also those of the past, these activists attempt to raise political awareness among the Kinois. Visitors contemplate the main faces of the national political history, but also acquire additional information. Inside the main house of the compound one can consult a card box containing biographical information about the depicted individuals (places and dates of birth and death; political career; significance for DR Congo or on an international level).

All these initiatives to render visible certain political leaders in the urban space emphasize how the current political establishment manages control of the visual part of public space in Kinshasa. It also calls attention to the linkage between the optical and politics or to the fact that political power operates

through the senses including sight. According to Kinshasa's political leaders, political power is highly mediated by the visibility or lack thereof in the public space.

While the above-mentioned tactics demonstrate how political actors creatively circumvent the limitations of visibility in the public space, citizens also powerfully engage with visual political messages. During the months preceding the first democratically organized elections in July 2006, streets, pavements, markets, roundabouts and other public places were opened up to all political candidates, thus seriously disrupting the general structuring of everyday ocular space that Kinois were accustomed to. Very soon, the city was literally flooded with banners, posters and billboards all of a varying size and quality depending on the politician's budget for his campaign.

On 27 July 2006, a few days before the elections, thousands of young and old Kinois followed Jean-Pierre Bemba, his spouse, relatives and various MLC members, on foot, by car and on trucks, as they walked from the Ndjili airport towards the Tata Raphael football stadium. The promenade, under a beating sun, took more than eight hours. Everywhere along the track Bemba was cheered and people waved fronds of palm at him. The whole walk was broadcast live on various television channels so that many others followed it on screen. Since the cameras were zooming in on Bemba and his company while they walked along the Boulevard Lumumba, they did not record the moments when campaign posters for Joseph Kabila and other candidates for presidency were removed, stamped upon and burnt. Glossy, large-size pictures depicted a glowing Joseph Kabila were the main targets.[17] Rumour has it that they were designed by a New York marketing office. Gold lettering promised, in French, *'Je vote Joseph Kabila, pour un Congo uni, fort et prospère'* ('I vote Joseph Kabila for a united, strong and prospering Congo'). Kabila's picture and the slogan were set against a royal-blue background. People turned to me and shouted 'Lies!' (*Li* sg. *lokuta*) whenever we passed one of these items.

Later that evening, I noticed how the Boulevard had been totally transformed; only Bemba's posters remained. They had hardly been touched by the crowd that had passed a few hours before, while all other political posters and even advertising boards for travel agencies and local beer brands, telephone networks and cosmetics, not to mention those for religious gatherings had all been stripped off. Some of these boards were lying on the ground; others were half-burnt; and still others were torn to pieces. It was a strange experience to observe how, in the midst of this chaos, the posters with Jean-Pierre Bemba still reigned. A gently smiling Jean-Pierre Bemba, dressed in a wax-printed shirt evoking a modern African lifestyle, and with his head surrounded by the sketch of DR Congo's national territory, now dominated the Boulevard, promising the reconstruction of the country through sheer hard work.

When a week later Joseph Kabila attempted a similar entry in Kinshasa, a less modest but still significant crowd assembled on the Fikin terrains in the middle of the Lumumba Boulevard. While Kabila was also cheered and people were obviously enjoying the music of the hired dance groups, one could clearly observe less fanaticism than in the mood blown throughout the city the week before. When the Kabila rally ended, Bemba's posters were still untouched. This non-action conveyed a deep political message. Through

[17] In his media campaign for the 2006 elections, Kabila was dressed in a dark blue costume and thus appeared more like a business man than a president.

their decision to reject or accept photographs in the urban space, Kinshasa's population communicated to Kabila that their presence at the rally should not be misunderstood as a gesture of support.

Removing Kabila's posters during the Bemba walk was a symbolic act that first and foremost reveals the intense emotional responses images can provoke. By allowing Bemba's images to adorn one of Kinshasa's main streets and, importantly, by not damaging them, Kinois expressed political affection with Bemba, while the violent removal and destruction of Kabila's glossy campaign material signalled intense distrust and rejection of the incumbent president. The street as such was the only space where Kinois could engage in such an overt way with these politically charged pictures. Everywhere else, in the media and in official or state-related spaces, Kabila's entourage closely controlled Kabila's 'image' (here used in a double sense: literally, his portrait and also the way in which people talked about him). Offices of mayors, schools, public institutions and many private enterprises were all decorated with posters of Kabila.[18] In these official and formal spaces, no such violent engagement with imagery was possible.

Such civic violence is a powerful reaction to the zones of contact that images generate. The rage and anger that incited the removal of the billboards indicate the haptical visuality (Marks, 2000) with which these public photographs were perceived. The connection established between the politicians and the citizens via the political billboards allowed for a trade of political passions and emotions that escaped the government, the state apparatus, and the image-producers.

Leadership visualized

In the following part, I want to extend my discussion of the interaction of public photography and political affects by examining the feelings that the producers of the Visibility billboards intend to evoke among the citizens/spectators. Here, I move on to the aesthetics of these billboards.

On the level of representation, there is a strong departure from classic depictions of leaders in such imagery. Mobutu's pictures and those of L.D. Kabila merely show(ed) the individual leader. This style, which is also used in the huge billboards for the leaders of political parties (cf. Figure 9.5) relates to their patron-status. Political parties rarely survive the death of a leader or his withdrawal from the scene. By contrast, Joseph Kabila's propaganda does not focus that much on the person. In the Visibility billboards, Kabila's portrait is usually fairly small and confined to the upper left corner. Snapshots of construction sites, by contrast, dominate the design. This produces a totally different image of the nation's leader. Kabila does not appear as a 'father'[19] or as someone who monitors his citizens. Rather he controls a construction site, and at times, Kabila himself is represented as a a builder. Such images are repeated in media reports on television and in print magazines, where Kabila,

[18] At times the president was dressed in military uniform; at other times he was wearing a suit. Sometimes only the upper body was shown, at other times he was seated at an office desk, next to the Congolese flag. Since 2006, however, portraits depicting Kabila in army outfit have become extremely rare because the Commission controlling the 2006 elections (CEI) demanded that presidential candidates occupied no military function. Therefore, Joseph Kabila resigned from military office just a few months before the elections.

[19] The idea of the family father and the government as a family led to the production of 'family photographs', grouping the government members (see Schatzberg, 2001: 21-23).

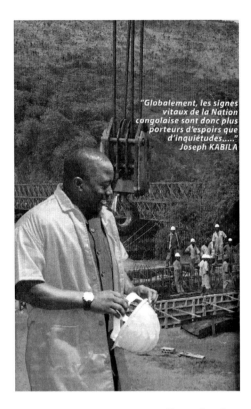

"Globalement, les signes
vitaux de la Nation
congolaise sont donc plus
porteurs d'espoirs que
d'inquiétudes....."
Joseph KABILA

Figure 9.8 Scanned image from the book
L'Etat de La Nation 2007-2008-2009'
(The State of the Nation 2007-2008-
2009' by Joseph Kabila, edited by The
Presidential Press, Kinshasa, January
2010. Picture on p. 72). I purchased the
booklet from a young street vendor for
FC3.000 (approx. US$3.5).

often carrying a safety helmet, is sometimes seen wearing overalls and either
sits in a fork-lift truck or inspects a construction site.

While the representation of Kabila in these billboards suggests the intro-
duction of a new paradigm of postcolonial leadership, the inscriptions accom-
panying such images are also indicative of new concepts in postcolonial rule.
'Participation' is primary. This is particularly voiced in the phrase *'Ensemble*
motivés et determinés, nous allons gagner le pari de la reconstruction et la modernisation
du Congo. Joseph Kabila' ('Together, motivated and determined, we are going to
win the bet on the reconstruction and modernization of DR Congo. [Signed]
Joseph Kabila'), which can be read on various billboards (see Figure 9.1).
These words distance the future from the classic image of the nation as a
family, held together by one father. Participation according to Kabila's
propaganda machine lies in the fact that Kinois/Congolese are joining Kabila
in the project. It emphasizes a common goal, which is visualised in images.
The population is included in the campaign ('Look what WE are doing'). In
this discourse, participation in local politics does not refer to mere voting or
political competition, but rather to the sharing of collective aspirations to
achieve a common goal. The nation is bonded together by the communality
of its political desires.

While this kind of participation moves beyond the classic interpretation of
democratic rule, a similar creative stretch of 'transparency' is also at play in the
Visibility campaign. While it could suggest at first a stand against corruption,
it also references a new proof of appropriate leadership. In an interview, Jean-
Marie Kassamba, the leading figure of Joseph Kabila's propaganda machine,
explained the following:

DR Congo has not remained the same, thanks to Joseph Kabila. Students, our future

*Figure 9.9
Billboard showing
three scale-
models: the new
monument of
Independence at
the beginning of
the Boulevard
30 Juin; the new
control tower
at the Ndjili
airport; and a
new hospital
(Hôpital du
Cinquantenaire).*
Photo by Katrien Pype,
19 June 2010.

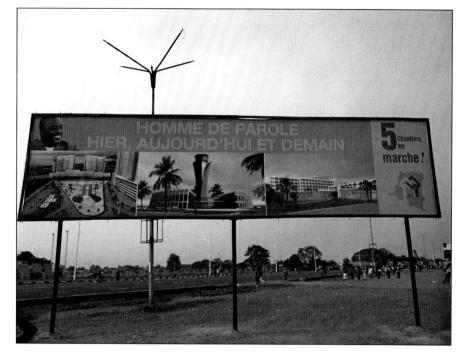

generation, should have confidence that our current leader is achieving results.
Joseph Kabila is really concerned about the people's living conditions. (...) But, people
hardly believe that he is achieving results. They only want to see changes in their
immediate environment: in their own street, in their own neighbourhood. But, DR
Congo is so vast, and also Kinshasa is big. Kabila cannot change the whole country
overnight. This takes time, it takes careful planning, and, in the meantime, in order
to show the Congolese the progress in the 5 *Chantiers* programme, I am producing
TV clips, posting photographs on the website, and placing billboards all around
town. (Interview, July 9 2009)

The coordinator of the billboards installation in effect identified the Kinois
with 'doubting Thomas'. This epithet recurs in TV news reports, when for
example PPRD[20] politicians or state officials visit construction sites. By evoking
this biblical figure, the political establishment skilfully uses the hegemonic
Christian discourse of the city in a powerful way. First and foremost, it suggests
a linkage between Jesus and Joseph Kabila and locates the Kinois in the camp
of Jesus' adversaries. Secondly, the trope also blames the Kinois for having a
selective gaze and thus 'not seeing what is apparent'. What is important here
is that the intended audience of the Visibility media campaign (those who
are not convinced about Joseph Kabila's good leadership) is not only defined
as a religious 'other', but first and foremost as '*an* other'. This is how they
explain the breach between the president and the Kinois. The major concern
of Visibility is thus to restore, in popular form, the relationship between the
president and the people.

The producers of the Visibility billboards target the 'zone of sensory
mutuality' (Pinney, 2002) that is established in the installation and circulation
of images. Contemplators as well as producers of these images share a common
space. Affects are being traded in the activities of showing and watching. The

[20] PPRD being the political party created by Joseph Kabila.

billboards and Visibility propaganda at large aim at establishing trust and confidence among the population. This is an immediate response to the general culture of suspicion that reigns among Kinois, which is embedded in various occult cosmologies that are at play in the local interpretation of contemporary African politics. As West and Sanders (2003: 6) argue, a fundamental characteristic of occult cosmologies is that they suggest that there is more to what happens in the world than meets the eye. Reality is perceived as not transparent at all (West & Sanders, 2003: 6). This plays on a spiritual level (in which an occult invisibly influences material reality)[21] and is also meaningful in a more secular dimension, where a distinction is perceived between 'what is shown' and 'that what is hidden' as in a theatre, a drama. During Mobutu's time, it was said that various shadowy cabinets in fact ruled over the nation instead of the publicly recognized government. Under Joseph Kabila it is also commonly argued that the real politics take place during the night, while the Parliament meetings and other gatherings in the day are merely shows. In this regard, Kinois often reduce Congolese postcolonial politics to mere 'performance', 'pretence' or 'lies'. According to De Boeck (1996: 92), in local statecraft 'the *faire croire* and the *faire semblant* have taken over from reality'. In the same vein, Jackson (2010: 51) mentions that there is a long history of a strong contradiction between what centralized power (colonial or postcolonial, national or international) *said* and what it *did*, Thus it engendered a yawning gulf in political culture.

This 'political culture of make believe' (Jackson, 2010: 51) and the play of occult cosmologies have led to feelings of distrust and suspicion towards political actors. Kinois express profound suspicions about the real intentions of the United Nations, the new deals between Kabila and the Chinese government, the president's own intentions, and so on. This problem of trust, a general one in African postcolonial societies (West & Sanders 2003), is something with which political leaders have to grapple. It is exactly in this context that we should understand Kabila's *visibility of the 5 Chantiers* programme.

There is another billboard planted all over town stating '*Joseph Kabila. Homme de Parole. Hier, aujourd'hui et demain*' ('Joseph Kabila. A Man of His Word. Yesterday, today and tomorrow'). It promises stability amidst the sense of turmoil and is intended to generate a feeling of hope. The billboard thus evokes the breach Kinois perceive between what politicians say and what they actually do. Kabila here is presented as someone who does away with this 'old' political culture, and guarantees an effective politics. He is presented as a trustworthy leader, whose ambitions are the same as those of the nation. While this phrase obviously relates to the general culture of distrust in local politics

[21] Especially since the early 1990s, Kinois commonly held that Mobutu derived much of his authority and powers from alliances with occult worlds. Still today, sensational stories travel around the city and via broadcast media in which it is recounted how Mobutu drunk human blood, participated in occult gatherings and sacrificed souls of citizens in order to secure both power and wealth. Here, it is important to mention Thierry Michel's film *Mobutu. Roi du Zaïre* (1999), which is continuously screened on local TV channels, and in which Dominique Sakombi Inongo, former Minister of Information under Mobutu's rule and known as the major propagandist of Mobutu, recounts how he has seen Mobutu drinking human blood. Sakombi related stories about the former president and other occult dealings of the president's staff, among which himself, around town in churches and on local media in the genre of 'public confessions', after he turned towards Pentecostal Christianity in the early 1990s. Similar occult cosmologies, although circulating less than tales about the Mobutu period, explain also Joseph Kabila's power. Accidents with many casualties (such as shipwrecks or train accidents) are interpreted as occult sacrifices commissioned by the Devil for Kabila to maintain power.

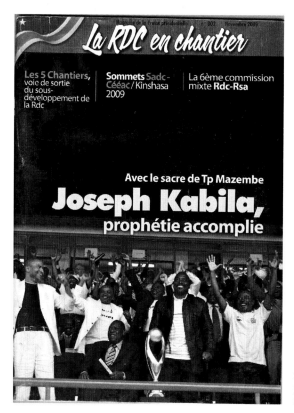

La RDC en chantier

Les 5 Chantiers, voie de sortie du sous-développement de la Rdc

Sommets Sadc-Cééac / Kinshasa 2009

La 6ème commission mixte **Rdc-Rsa**

Avec le sacre de Tp Mazembe

Joseph Kabila, prophétie accomplie

Figure 9.10 Cover of the journal
RDC en chantier.
Reproduced by kind permission of the Presidential Press.

among the population, the slogan takes on another meaning when situated within the overall propaganda discourse. In interviews and in their reports, Visibility journalists define Joseph Kabila as '*un visionaire*'. During interviews, most of his propaganda staff explained this qualification in secular terms: 'Joseph Kabila has an idea, a goal. He is an ambitious leader and aims at reaching a particular goal, being the development of the nation.' In Visibility publications, however, a more spiritual quality is attributed to the president. Kabila's promises are identified as 'prophecies' (Li. sg. *bolakeli*), through which they produce an image of Kabila as a man bestowed with supernatural gifts. At times, Joseph Kabila even acquires the epithet '*le prophète*' (Li. *mosakoli*).[22]

Elsewhere in Africa, religious themes are also infused with propaganda in order to lend further legitimacy to state decisions and leadership (a.o. Chitando 2005). The main goals are to project a government that upholds Christian values and principles and to generate the idea that Kabila has divine approval. By tapping into the hegemonic Christian culture in the city, Kabila's propaganda machine skilfully locates the president on the right side of the moral map, thus borrowing the trust and confidence that Christian charismatic leaders produce among the population.[23]

[22] Allusions to the interference of the spiritual in the political world are underscored by various Pentecostal leaders who identified Joseph Kabila already during the political campaign in 2006 in their sermons and public appearances as 'a man chosen by God' and 'a man whose mouth is sacred' (fieldnotes, Church of the Holy Mountain, Limete Kingabwa (Kinshasa), 18 June 2006).
[23] Examples of other practices: from time to time, the president appears in public with church leaders; and Kabila's spouse organizes collective, nation-wide prayer meetings for divine protection for the country.

Conclusion

My examination of the intersection of public photography and political leadership has revealed some continuities and discontinuities in contemporary politics in Kinshasa. Items of visual media and optical regimes were critical to the image of Mobutu as a leader, and they are still important today for Joseph Kabila. As has been shown, throughout the postcolonial history, the Congolese/Zairian State has attempted to monopolize the urban visual space.

What is new is that the Visibility images document a paradigmatic shift in the imagination of DR Congo's present and also of apt leadership. While most of the Kinois population is experiencing a crisis, the images displayed project a future characterized by material wellbeing and guaranteed by the state. The Visibility material centres on progress through infrastructural reparation and extension. A new nationalist narrative is emerging through these pictures, granting a new role to the leader.

Common desires, trust and confidence in the unifying leader are the main political passions intended to be awakened among the Kinois while contemplating the Visibility billboards. Yet deliberation and political agency come to the fore when scrutinizing these engagements. The ethnographic material suggests that the political affects intended to be transmitted via the images do not necessarily arrive at the other end. This calls for a more detailed analysis of the haptical visual mode. The violent reaction to Kabila's billboards during the election campaign (of which we can assume that the goals were very similar to those of the Visibility panels) shows that spectators are not passive recipients of these images, and the affects involved in the contemplating act are much more complex than what 'meets the eye'. Affects do not circulate freely, but their exchange is channelled by the political history of the community and the individual desires of the onlookers. Hostility, frustration and anger can block the transmission of the emotions intended by the image producers and thus seriously hamper the flow of power. Even if images construct 'contact zones' between political actors and citizens or 'zones of sensory mutuality' (Pinney, 2002) between producers and receivers, these zones can be rife with opposition and resistance.

Acknowledgements

I would like to express my gratitude to Richard Vokes for encouraging me to contribute to this volume. The text has been presented at the African Humanities Seminar at the Free University of Brussels (ULB) and during the monthly Research Seminar Series at the Centre of West African Studies at the University of Birmingham. I wish to thank all participants for the stimulating and inspiring discussions. In particular, Karin Barber, Lynne Brydon, M. Insa Nolte and Kate Skinner have given valuable comments, which are interwoven in this final version.

Bibliography

Benjamin, W. 1969. The Work of Art in the Age of Mechanical Reproduction, in *Illuminations* (ed.) H. Arendt (trans.) H. Zohn. New York: Schocken.

Chitando, E. 2005. '"In the Beginning was the Land": The Appropriation of Religious Themes in Political Discourses in Zimbabwe', *Africa* 75 (2) 220-39.

De Boeck, F. 1996. Postcolonialism, Power and Identity: Local and Global Perspectives from Zaire, in *Postcolonial Identities in Africa* (eds) R. Werbner & T. Ranger. London & New Jersey: Zed.

—— 2005. *Kinshasa: Tales of the Invisible City*, pictures by M-F. Plissart. Ghent: Royal Museum for Central Africa.

—— 2011. 'Inhabiting Ocular Ground: Kinshasa's Future in the Light of Congo's Spectral Urban

Politics', *Cultural Anthropology* 26 (2) 263-286.

Fabian, J. 1996. *Remembering the Present: Painting and Popular History in Zaire*, illustrations by T. K. Matulu. Berkeley: University of California Press.

Foucault, M. 1979. *Discipline and Punish* (trans.) A. Sheridan. New York: Vintage.

— 1980. The Eye of Power, in *Power/Knowledge* (ed.) C. Gordon. New York: Pantheon.

Freeman, R. 2001. 'The city as mise-en-scène. A visual exploration of the culture of politics in Buenos Aires', *Visual Anthropology Review* 17 (1) 36-59.

Geschiere, P. 2009. *The Perils of Belonging. Autochtony, Citizenship, and Exclusion in Africa and Europe.* Chicago: University of Chicago Press.

Holston, J. & A. Appadurai. 1996. Introduction: Cities and Citizenship, in *Cities and Citizenship* (ed.) J. Holston. Chicago: Chicago University Press.

Jackson, S. 2010. "It Seems to Be Going:" The Genius of Survival in Wartime DR Congo, in *Hard Work, Hard Times. Global Volatility and African Subjectivities* (eds) A-M. Makhulu, B. A. Buggenhagen & S. Jackson. Berkeley & Los Angeles: University of California Press.

Jewsiewicki, B. 1996. *Cheri Samba: The Hybridity of Art.* Quebec: Galeria Amrad.

Linke, U. 2006. 'Contact Zones: Rethinking the sensual life of the state', *Anthropological Theory* 6 (2) 205-25.

Marks, L. 2000. *The Skin of the Film. Intercultural Cinema, Embodiment, and the Senses.* Durham & London: Duke University Press.

Mbembe, A. 2001. *On the Postcolony.* Berkeley: University of California Press.

Pinney, C. 2002. The Indian Work of Art in the Age of Mechanical Reproduction: Or, What Happens when Peasants 'Get Hold' of Images, in *Media Worlds. Anthropology on new terrain* (eds) F. D. Ginsburg, L. Abu-Lughod & B. Larkin. Berkeley: University of California Press.

Pratt, M-L. 1991. 'Arts of the Contact Zone', *Profession* 91 33-40.

——1992. *Imperial Eyes.* London: Routledge.

Pype, K. 2010. 'Charismatic Spectatorship and Media Pedagogy in Post-Mobutu Kinshasa'. Unpublished paper presented at the ASAUK conference. Oxford (September).

Schatzberg, M. 1991. *The Dialectics of Oppression in Zaire.* Bloomington: Indiana University Press.

—— 2001. *Political Legitimacy in Middle Africa: Father, Family, Food.* Bloomington: Indiana University Press.

Seremetakis, N. C. 1994. *The Senses Still: Perception and Memory as Material Culture in Modernity.* Boulder: Westview Press.

Stoler, A. 2002. *Carnal Knowledge and Imperial Power: Race and the Intimate in Colonial Rule.* Berkeley: University of California Press.

Taussig, M. 1993. *Mimesis and Alterity: A Particular History of the Senses.* New York: Routledge.

West, H. G. & T. Sanders. 2003. Introduction: Power Revealed and Concealed in the New World Order, in *Transparency and Conspiracy: Ethnographies of Suspicion in the New World Order* (eds) T. Sanders & H. G. West. Durham: Duke University Press.

The Social Life of Photographs

PART

III

On 'the ultimate patronage machine'
Photography & substantial relations in rural South-western Uganda
Richard Vokes

10

I recall an incident that occurred shortly after I first arrived in the field, in September 2000.[1] I was asleep in bed at the time, when I was woken up by a persistent tapping on the wooden shutters and by my name being spoken in hushed tones. A member of my drinking circle had come to summon me to Caesar's bar – the largest and most popular saloon in the locality – for a clandestine meeting. It transpired that two other friends of ours had been accused of a serious crime and, facing possible imprisonment, had decided to make a run for it towards Rwanda where one of them had a relative. However, they had no money for the trip and so wanted me to donate UgSh 50,000 towards their costs. We spoke for some time – not least in order that I could try to gauge the ethical implications of what I was being asked to do – following which I did hand over a small amount of cash. Our business complete, one of the men produced a camera with which he and I had a picture taken together. And it was then that a curious thing happened: rather than bidding their farewells, both men insisted that we should all stay where we were until the photograph had been developed. This struck me a little strange at the time, given that it was the middle of the night and given that both men surely had more pressing concerns. Nevertheless, stay put we did as a runner was dispatched to the home of a local photographer (some 3 miles away), as the film was developed on that person's darkroom equipment, and as the prints were brought back – two identical copies, one for each of us. The resulting picture was not very good, of course. Given the manner in which it had been produced, its image was grainy and blurred and it was badly lit. In addition, as I now held the photograph in my hand, I realized that I was smiling in it, something which even at the time struck me as peculiarly inappropriate. Nevertheless, my friend seemed happy with the photo and continued with his preparations for leaving. It was nearly dawn by the time we finally parted.

In the days that followed I frequently reflected on this incident and often wondered why my friend had insisted on us exchanging photographs in this way. At the time, however, the event seemed destined to remain an example of one of those many imponderable moments that so frequently occur during the early phases of one's fieldwork career. However, in the years since – and especially since I have begun to conduct more systematic research on the history and sociology of photography in Uganda, from around 2005 onwards – I have instead come to regard this incident not only as explicable but even as exemplary of broader photographic practice in the rural Southwest, as this

[1] Earlier versions of this chapter were presented in 'The Image Relation: Towards an Anthropology of Photography' workshop (Wolfson College, University of Oxford, November 2009), to the Anthropology Departmental Seminar (University of Canterbury, New Zealand, October 2010), and to the World Art Research Seminar (University of East Anglia, January 2011). I would like to thank the audiences at all of those venues for their useful comments and suggestions. I would also like to thank Corinne Kratz, Christopher Morton, and one anonymous reviewer for James Currey for their advice on previous drafts. Of course, any mistakes or omissions remain mine alone. Additional visual materials related to this chapter can be viewed at: www.richardvokes.net.

has developed over half a century or more. In particular, I now take the event to be indicative of what I have elsewhere called 'village photography' (Vokes 2008)[2] a vernacular mode of photography that became increasingly important in rural districts like Bugamba Sub-county, Mbarara District – where my own action is set – from the late-1950s onwards.

As such, a discussion of the above incident also serves as a good starting point for this chapter, which is an attempt to develop a detailed history of this vernacular mode and to theorize its emergence in relation to recent historical and anthropological writings on the development of African photographies in general. The chapter draws on almost a decade of ethnographic observation but is primarily based on a period of fieldwork undertaken in early 2009, during which I spent more than a month interviewing several key protagonists in the recent (post-colonial) history of urban studio photography in South-western Uganda and working alongside a number of independent photographers as they moved throughout the countryside carrying out their work.[3] In addition, I took advantage of the latest developments in digital camera technology and in particular the recent emergence of affordable high capacity memory cards that can take digital reproductions of several thousand photographs held in people's personal albums or household collections. In this way, I was also able to return from the field with a sizeable archive of images with which I could conduct a subsequent analysis.

The central argument I want to develop from this research concerns how we conceptualize the relationship between more 'official' forms of photography in Africa, and the kind of vernacular mode with which I am concerned here. As described by Liam Buckley, by roughly the late 1990s a general consensus had been reached in much of the scholarship on African photographies that there are at least 'two genres of photography in Africa during the colonial period' (2010: 147). The one is constituted of 'administrative photography [as] was commissioned by the colonial governments and consists of official state events, civic life, examples of "progress" and portraits for helping categorize individuals', the other of 'vernacular photography [which] includes images captured by independent, professional photographers who specialised in studio and street portraiture. These photographs are understood to exist outside colonial governance, subverting its power in self-representation and aesthetic acts of resistance' (ibid.: note that I have reversed the order of the two modes as discussed by Buckley).

However, from here, a more recent body of scholarship – to which Buckley's own work contributes – has suggested that the relationship between these two modes may have been more complicated than was previously understood. Specifically, further archival research has revealed that the contexts of these two photographic modes were often 'closer in practice than is usually supposed' (ibid.). On the one hand, we now realize that it was relatively common across many colonial contexts for images that were taken for official purposes to later become reprinted, or in other ways reproduced in a range of 'popular' – i.e. commercial – formats, including postcards (Geary 2003),[4] stereoscopes

[2] Without wishing to suggest that urban and rural areas exist as discrete geographical or social domains, I nevertheless find it useful to retain the descriptor 'village' here as an heuristic device, to distinguish the practices and orientations of this mode of photography from those associated with commercial studios (which throughout South-western Uganda, are invariably located in towns).
[3] For a definition of an 'independent photographer', see Footnote 20.

(Sobania 2007), and other formats besides (Kratz & Gordon 2002; Landau & Kaspin 2002). On the other hand, it is also clear now that in many parts of colonial Africa, individual photographers would often be engaged in producing both official and vernacular imagery at the same time. In just one example, Bajorek (this volume) documents the case of a photographer in late-colonial Senegal – Doudou Diop – who was employed by the state yet who also worked as a private, commercial photographer 'on the side'. Meanwhile, Buckley documents how the colonial authorities in the Gambia frequently hired local photographers as a means for gaining a 'vernacular window' into government policies (2010: 147). Similar examples are identified by Haney (2010).

However, the main purpose of this chapter is to complicate our understanding of the relationship between official and vernacular modes of photography in other ways besides. Specifically, I do not want to challenge here the idea that an administrative mode of photography *can* be identified as a distinct genre in South-western Uganda during the late colonial period, and into the post-colonial period. On the contrary, an association between state power and certain types of photographic practice appears to have been as clearly marked in this context as perhaps it ever was anywhere on the African continent. Rather, my primary intention is to suggest that what makes the vernacular mode distinct from this cannot be captured only through reference to an alternative set of aesthetic and political orientations (although some differences can certainly be identified: see also Vokes 2008).

I want instead to argue that any attempt to trace the unique characteristics of this vernacular mode must also, and perhaps more importantly, move beyond only such questions of representation *per se*, to look at the social relations within which the photographs themselves were (and are) embedded.[5] In this way, my general argument is that, in this Ugandan context at least, the difference between official and vernacular forms of photography has less to do with their respective fields of representation than with the alternative relations within which their photographs are located (and within which the photographs may exert a degree of agency of their own). In the case of the vernacular mode, these social contexts of production, exchange and consumption appear to have generated an entirely different set of orientations towards the photographic image-object (i.e. from those engendered by the state-sponsored mode). This has in its turn produced important effects.

Photography and statecraft

As elsewhere in East Africa, photography was first introduced to (what became) Uganda by the European 'explorers' who began passing through this region from the 1870s.[6] However, these early experiments aside, it was really the arrival of the famous 'Uganda Railway' – a line that was begun in the

[4] Cf. my own work on the reformatting of official photographs as picture postcards in early colonial Uganda, 2010)

[5] In this way, I am following a more 'relational' approach to photographic analysis (Edwards 2005: 29), which emphasizes that photographs aren't 'just stage settings for human actions and meanings, but [are also] integral to them' (Edwards & Hart 2004: 4).

[6] In 1875, Henry Morten Stanley, who was carrying dry-plate apparatus as part of his first transcontinental expedition, took what is probably the first photograph in Uganda, when he shot a portrait of King Mutesa and his senior chiefs, which was later used to prepare an illustration for Stanley's subsequent account of the expedition, *Through the Dark Continent* (1878, I: 189). Unfortunately, this image appears to have exhausted Stanley's stock of dry plates and as a result

1890s with the aim of connecting Mombasa, on the coast, to Kisumu, on the shores of Lake Victoria – that established photography throughout the interior of the Eastern continent. Thus it was the railway's official survey party who first photographed the territory in anything like a systematic way[7] and it was railway employees who first brought significant numbers of personal cameras into Uganda (from the late 1890s).[8] However, most important of all, it was also former railwaymen who on completion of their colonial service went on to establish the first photographic studios in Uganda.[9] The significance is that from the very beginning and throughout the colonial era, these studios – and the dozens of others they spawned in the decades following – remained the primary sites of photographic production. For example, the first studio to be established in South-western Uganda was begun by a Muslim Indian trader called Mahmoud in Mbarara Town, in the mid-1940s. The enterprise enjoyed a near monopoly of photographic production throughout the closing years of the colonial period. (Uganda achieved independence in 1962.)[10] Indeed, it was not until two smaller African-owned studios were also established in Mbarara, in the late-1950s – although both of these also took several years to 'get going' – that Mahmoud faced any commercial competition at all.[11]

More importantly, studios such as Lobo's, and later, such as Mahmoud's, also played a central role in establishing a colonial 'regime of seeing', one that was intimately bound up with the establishment of new colonial institutions (and therefore, ultimately, with the spread of state power itself). Key here was the studios' focus on the new, 'modern' institutions of state – especially schools, but also courts, hospitals, and prisons (and also the new state-sponsored Christian churches). Throughout much of the colonial period, and into the post-colonial period too, much of the studios' practice revolved around these institutions, and studio output was dominated by such institutional subjects. For example, within just weeks of Mahmoud's opening, a typical *modus operandi* had been already established whereby its employees would travel out to a given

[6] cont. he took no more photographs during his subsequent journey through Buddu and the western regions. Four years later, however, the Austrian explorer Richard Buchta produced a more extensive collection, when as part of his own travels to the west of the Upper Nile, he took portraits of many of the region's ethnic groups including portraits of Northern Uganda's Acholi, Lango, and Banyoro peoples. These images were later used to illustrate not only Buchta's own writings but also those of various other European explorers who visited Northern Uganda in the decades following (Killingray & Roberts 1989: 200).

[7] The original survey party was sent out in 1892 under J. W. Pringle. The party's work was continued from the mid-1890s onwards by the Railway's 'official photographer', William Young (Miller 1971).

[8] Although it should be noted that from 1895 at least missionaries were also regularly carrying cameras as part of their work. The most notable missionary-photographer of this period was the Church Missionary Society's (CMS) Charles Hattersley who between 1898 and 1906 produced a quite stunning set of images of Buganda and its surrounds. Some of these images were later published in Hattersley 1906 & 1908.

[9] Although a number of studios had existed on the coast, particularly in Zanzibar and Mombasa since 1868, it was not until more than three decades later that the first studios were established in the interior of the Eastern continent (Behrend 1998: 162; Monti 1987: 172). For example, the first studio to be established in Uganda was set up by a former railwayman called Alfred Lobo, who in 1904 began an operation in Entebbe. The studio later moved to Kampala, where it remained until its closure *c.* 1939 (Macmillan 1930; see also the RCS Photographers Index, University of Cambridge).

[10] Mahmoud's studio also served several of the Southwest's other urban centres including those of Bushenyi and Ntungamo.

[11] Of the two new studios, one had no title, while the other was named after its proprietor, one Tibategyeze.

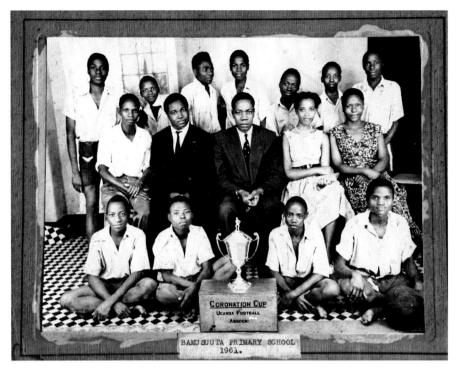

*Figure 10.1
During a school
visit, studio
photographers
would usually
take pictures
of each of the
institution's clubs
and associations,
as in this example,
from 1961.*

Reproduced by kind
permission of the
family of the late Mzee
Koyekyenga.

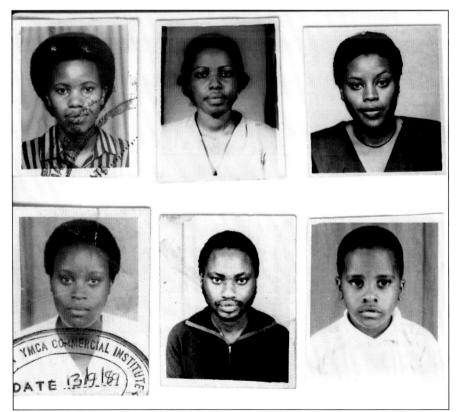

*Figure 10.2
Examples of
ID or passport
portraits produced
by the studios en
masse throughout
the twentieth
century. (The
photographs were
taken on various
dates, but are
stored together
in a photograph
album).*

Reproduced by kind
permission of the family
of 'Felicity' and 'Tracey'
(pseudonyms).

institution with the studio's mobile equipment for a period of several days or more, to have time to create a series of official portraits. The pictures taken would then be developed and returned to the institution several weeks later. This remained the normal practice for more than two decades; as a result, in the period between 1947 and (roughly) the late-1960s, as much as 80 per cent of Mahmoud's output was made up of institutional portraits of this sort.[12]

However, just as important here were the *type* of portraits produced in this manner. Thus, during a visit to a school, for example, Mahmoud's photographers would typically begin by taking 'classroom' photographs of each of its constituent form-groups, each of its sports clubs and academic associations, and so on (Figure 10.1). However, more importantly, much of the photographers' stay would then be taken up with the production of individual 'ID' or 'passport' photographs of the students who were joining the school that year (Figure 10.2). These images were later incorporated into the subjects' school membership documents which would be rendered incomplete without these images. Indeed, I know of at least two cases in which students who were absent on the day of the Mahmoud photographers' visit – as a result of which they did not have their ID pictures taken – were effectively excluded from their schools as a result. In fact both absentees were only readmitted the following year. Thus, the production of these passport pictures, for incorporation into official documentation, became the crucial or necessary prerequisite for full participation in institutions such as schools. The student's 'presence' as a photograph became a key marker of acceptance, and ultimately, of valid identity in the colonial state itself (cf. Werner's work on photography in colonial Côte d'Ivoire, 2001: 252).

Equally significantly, the key visual trope of the ID picture, its focus on a single body, set against a white (or in another way plain) background also contributed to the establishment of the colonial gaze as a dominant scopic regime in Uganda. Because by casting people outside their webs of social relations, without any reference whatsoever to their lived contexts, this trope – itself a reproduction of the Victorian and Edwardian vignette – served to visualize a relatively novel form of personhood in East Africa, one based on a modernist notion of *in*dividual personhood (again, cf. Werner, ibid.: 262-3). Moreover, apart from institutional portraits, the only other type of image that was mass produced by studios throughout the colonial era was the family portrait shot, which also produced a similar effect. In particular, the Ugandan family portrait – which from the very beginning bore a remarkable resemblance to the traditional European family photograph – typically conveyed an image of familial relations in which an (imagined) nuclear family was central. Alternate generations were both distinct and hierarchically organized, thus reproducing the European (colonial) ideal.[13] In these ways, the family portrait further cast the newly contrived *in*dividual in another peculiarly modernist way: as the

[12] This figure is based on the sample of Mahmoud images contained in the larger collection of digital copies made during my 2009 field trip.

[13] The former effect was achieved through the selection of people to be included in the portrait and by the symmetrical placement of adjacent generations within it. In most instances, this placement followed the European convention of locating the grandparental generation at the top (standing), the parental generation in the middle (seated), and the younger generation at the bottom (on the floor). In others, it located the grandparent or parental generations in the middle with the junior generations arranged in a rough circle around them (cf. Bouquet's discussion of the symmetry of family photographic portraiture in contemporary Holland, 2000).

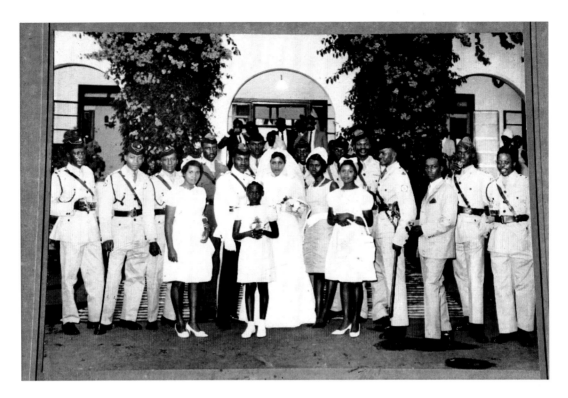

outcome of a specified nuclear family (itself the product of a broader and entirely linear family history).

Thus, if European colonial expansion into East Africa first introduced photography to the region, so over time colonial state institutions increasingly drew on photography as a means for visually classifying (and therefore in a sense 'fixing') their citizenry. Moreover, this relationship between state power and studio photography only deepened over time, reaching its zenith in the 1970s during the Idi Amin regime (1971–1979). Following the expulsion of Ugandan Asians in 1972, all Asian photographic studios – like all other Asian businesses – were handed over to new African owners. The majority went to army officers or to senior members of the predominantly Catholic Democratic Party (DP) who were rivals to the former president Milton Obote's largely Protestant Uganda People's Congress (UPC). In this way, the army itself quickly became the majority owner of photographic studios throughout the country. Yet even when the army did not own the studio, they often became its primary – and in some cases only – client.

In the case of the main Mbarara studio, following Mahmoud's expulsion in 1972, his operation was taken over by a senior member of the regional DP, one John Kaganzi, who renamed the enterprise 'Electronic Studio'. He quickly realized how important army patronage would be to the continued success of the operation, not least because it was required in order to legally export used coloured films to Kenya for processing.[14] Thus, within weeks of taking over

Figure 10.3 The wedding of Lt. Col. Ruhinda. A picture to which 'so many stories' attach (anon.).
Reproduced by kind permission of Alex Ruhinda.

[14] By the early 1970s, no commercial colour developing machines had been established in Uganda. As a result, studios wishing to produce colour photographs had to export their used films to Kenya for processing. Throughout the Amin years, the only person who was officially licensed to export films in this way was a senior army officer who acted as the country's Kodak agent (although extensive photographic smuggling networks were also in operation during this period).

the studio, Kaganzi adorned all of its walls with portraits and other images of senior army officers. As a result, and as Kaganzi himself now reflects, anyone coming into the studio at that time would have 'thought that it was a studio for Amin'.[15] Included in the display was a photograph from the wedding ceremony of one Lt. Col. John Ruhinda, who was at the time one of the most senior army officers from the Southwest (Figure 10.3).[16] More significantly, throughout the 1970s, in addition to continuing the kinds of school and church assignments already described, much of Electronic Studio's photography came to revolve around its military clientele. As both Kaganzi and others recall, by the middle of the decade, much of the studio's individual portraiture work was of soldiers (in particular, of personnel based at the nearby Makenke barracks), while much of their family photographs were of army officers' families. The majority of the outside functions the photographers attended were for military men. Certainly, this recollection is borne out by the fact that the only people in Bugamba today who have Electronic Studio photographs from this period in their collections are those who had some former connection to the military (at least, based on my sample of reproductions from those collections, described above).

In these ways, over the course of the 1970s, a particularly close bond was formed between the army and Electronic Studio. Indeed, so marked did the association become, in the popular imaginary at least, that after the overthrow of the Amin regime in 1979 – by a combination of the Tanzanian army and various groups of Ugandan dissidents – the *only* business, indeed the only building in Mbarara, to become the target of popular resentment was Electronic Studio. By all accounts, following the liberation of the town a mob promptly gathered at the place and proceeded to destroy all of its photographs and equipment.[17] Kaganzi himself was lucky to escape with his life, eventually fled the town, and subsequently spent several years in internal exile in Kampala.

The emergence of a vernacular mode

The above narrative offers an outline history of 'official' uses of photography in South-western Uganda. However, the main focus of this chapter is a 'second history' of the camera in this region. It began outside of the urban studios – in the villages themselves – sometime in the mid-1930s, although it became particularly important from the late-1950s onwards. Based on my recent research in South-western Uganda, it is clear that the sources of this second vernacular mode were various. In its earliest phase, it was made up primarily of images taken by studio employees on their days off. From quite early on it seems to have become the norm for studio workers sent out by their employers on an institutional visit to add a couple of extra days to the trip, during which they would travel around the villages with the studio's portable equipment, taking photographs of their own. Sometimes they had the studio owner's permission, but more often did not (in which case it was also a means for the employees to make a little extra money 'on the side').[18]

[15] Pers. comm., 25 January 2009.

[16] The picture was actually taken in 1963 but only became part of the studio's display during the 1970s.

[17] The picture of Lt Col Ruhinda's wedding (Figure 10.3) was among the photographs destroyed in this mob violence. The image that I have reproduced in this chapter is taken from another copy of the photograph held in the Ruhinda family collection.

[18] The photographs taken in this manner would later be developed in the studio's darkroom, again, 'out of hours'.

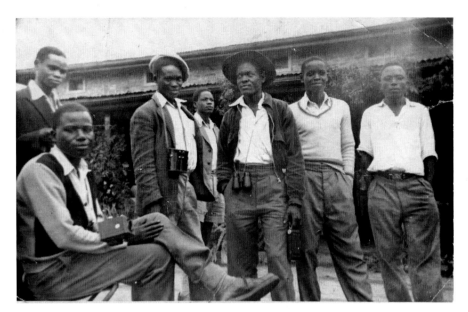

*Figure 10.4
Students at a
teacher training
college pose with
their personal
cameras and
binoculars, late-
1950s.*

Reproduced by kind
permission of the family
of the late Onasmus
Bwire.

However, my recent findings also reveal that by the late-1950s a second and probably more important source of vernacular photography had emerged in the form of privately-owned portable cameras. Some of these cameras were purchased by wealthy Ugandans, either in Kampala or on trips abroad which were becoming more common for a section of the elite at that time. However, a greater source of these personal cameras came from Euro-American expatriate school teachers, missionaries and government advisors, who during their visits home would frequently purchase highly-prized manufactured items, including cameras, on behalf of their most promising students, their best catechumens, and so on (Figure 10.4). In some instances, the expatriate purchased the items themselves, as gifts. More commonly, they were given the money to do so by the protégés themselves). For example, I have documented at least 12 cases of this type from the late-1950s and early-1960s. In one instance, a seminarian at Kitabi Seminary in Bushenyi District was given a camera by an Italian priest who had purchased it for him during a visit to France. However, unable to devote much time to photography himself – given the rigours of his training for religious orders – the seminarian promptly passed the camera on to his brother-in-law (ZH), Byaruhanga.[19] Operating from his home near Nyeihanga, on the main road from Mbarara to Kabale, Byaruhanga went on to become one of the most prolific independent photographers in the Southwest.[20]

[19] A pseudonym. Throughout this chapter I use pseudonyms for all of my respondents, with the exception of Mzee Kaganzi. In addition, the family of the late Lt Col Ruhinda gave me permission to use his real name. My acknowledgements in the captions for the figures also refer to real family names (with the exception of the acknowledgement for Figure 10.2, which preserves the pseudonyms used in Vokes 2008).

[20] Throughout this chapter I use the phrase 'independent photographer' to refer to those individuals who sold their photographic services and prints for money and who were therefore commercial photographers, yet (in almost all cases) had no 'fixed' location from which they worked. In other words, the vast majority of their images were taken in places to which they had travelled to work. In this sense, the phrase 'independent photographer' is also synonymous with that of 'itinerant photographer'. In addition, very few of these people had either the knowledge or the equipment to develop their own prints and therefore relied on the studios to do this for them. However, the term 'independent' does not imply that these individuals worked in isolation (see below).

The point is that from the very beginning, these sources made photography far more accessible to a much wider range of people than the studios themselves ever had. It must be borne in mind here that although studio portraiture was a necessary prerequisite for participation in certain institutions of the colonial state, such participation was only ever open to a relatively privileged few. Thus, the vast majority of people simply never went to a school, never received a catechist's training, and so on. In addition, the cost of a private visit to a studio was prohibitive to all but the wealthiest few. In addition to the costs of the photographer's time, and the photographs themselves, such visits – given the studios' urban location – also involved the costs of transport, the cost of board and lodging in the town, and so on. Against this, studio employees moving about the countryside, operating on an unofficial 'every penny profit' basis, were always more accessible and more affordable. The later independent photographers who used portable compact cameras were even more mobile and even cheaper still. For these individuals, the only overhead was the cost of developing their used films, something that most of them did through the studios. By operating in this way, they were able to sell their images for just 20 per cent of the cost of a studio photograph.[21] As a result, already by the late-1950s, vernacular photography had become a major source of photographic production throughout Southwestern Uganda, and no doubt beyond. By the early 1970s, it had become the primary mode, with at least 24 more or less full-time independent photographers operating throughout the region, each of them shooting up to 20 films per month – about the same number that Electronic Studio produced in a month, at that time.[22]

More importantly, from quite early on vernacular photography also started to develop a set of critical orientations that were quite distinct from those of the state-sponsored scopic regime. At first, the sorts of images taken by studio employees as they moved about the countryside tended simply to reproduce the visual tropes and structures of studio portraits proper, which is understandable, given the photographers' studio training. Thus, although the rural location was different, the basic structuring of the images – in terms of their minimalist background, the positioning of their subjects, the formal poses, and so on – remained more or less unchanged.[23] However, quite quickly, and especially following the introduction of privately owned portable cameras, vernacular photography began to take shape as an entity in its own right, as a distinctive genre with its own set of forms and styles. The elements of this emergent mode were various but key among them was a particular fascination with the *double* portrait image, in which subjects were photographed in pairs, usually in some or other domestic setting (Figures 10.5 and 10.6). Indeed, at least 60 per cent of my sample of village photography from the 1960s is made up of this type of image. In some cases, these double portraits are of two siblings, or other close relatives. More commonly, they picture a pair of exchange partners, such as two male *bakago* (reciprocal bond-partners – an especially important category of non-kin who are cast as having fictive blood-relations, cf. Edel 1957: 109).

[21] This figure – as others referred to in this chapter – is derived from various interviews I conducted during my 2009 field trip.

[22] One consequence of which was that throughout the 1970s, Electronic Studio made almost as much money from developing independent photographers' films as it did from its own photographic production.

[23] I would like to thank Steven Hooper for drawing my attention to the continuity of posture and pose across studio and vernacular photography (pers. comm., 26 January 2011).

Figures 10.5 and 10.6 From early on, the vernacular mode demonstrated a particular fascination with the double portrait image (both pictures here are c.1965).

Reproduced by kind permission of the family of Mrs Topista Mbaine, and of the family of the late Mzee Koyekyenga.

Sometimes the images are of two female work associates, or two cooking partners, or two fellow co-operative members (*bagombe*).

Over time, vernacular photography began to move away from studio photography in other ways besides. In addition to its innovation with the double portrait, the vernacular mode began to also locate its subjects within various meaningful social milieus, such as within a group exchange, or a 'feast' (*obugyenyi*), a wedding delegation, a communal beer-drink, a savings society (*ekigombe*), or something similar (Figure 10.7).

From quite early on, vernacular photography also developed a particular focus on images of the dead (Vokes 2008). Indeed, the first ever image taken

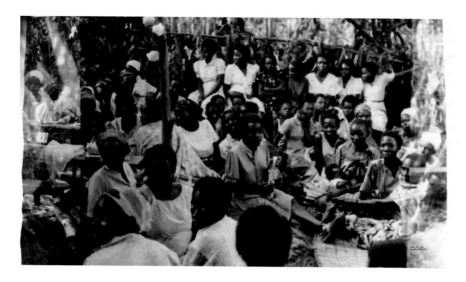

Figure 10.7 Over time, vernacular photography increasingly located its subjects within meaningful social milieus, c. 1960s.
Reproduced by kind permission of the family of the late Onasmus Bwire.

Figure 10.8 An image from a burial.
Reproduced by kind permission of a family who wish to remain anonymous, c. 1970.

by a village photographer in Bugamba shows an old man standing next to his family's 'ancestor hut' (*ekidaara*, a temporary structure that was put up shortly after a kinsperson's death, in order to provide a shelter for their ghost, *omuzimu*, before it began its 'onward journey'). Later photographs also picture ancestor huts as well as other sorts of physical memorials, in particular permanent gravestones, which began to be constructed in some of the wealthier households from the 1960s onwards. In addition, vernacular photography commonly also includes shots of coffins, of various burial practices including mourning rites, valedictory speeches and rites of internment, and even, in some instances, of dead bodies themselves. Moreover, whilst almost all other Ugandan photography I have seen from the 1960s and 1970s (both studio and vernacular photography) is in black and white, practically every contemporary image of death is printed in *colour*. This further emphasizes just how important

the association between photography and death was within the vernacular mode, given the fact that throughout this period, colour prints were four times more expensive than their black and white equivalents.

Photography, aesthetics and exchange

The key question is how best to explain the emergence of this alternative set of photographic orientations? Certainly, it is possible to read the vernacular mode as an outcome of alternative aesthetic considerations, especially given its emphasis on the double portrait. As C. Angelo Micheli has argued, whilst the double portrait has been a key motif in many forms of vernacular photography more or less since the invention of the technology, the motif appears to gain a particular resonance in those African contexts in which there is a marked 'collective imagery inspired by myths and practices related to *twinness*' (2008: 66, emphasis mine). In his own wide-ranging survey of contemporary West African photography, Angelo Micheli finds not only that the double portrait is also a popular form there but that its prevalence may be best explained with reference to the fact that so many West African double portraits incorporate certain signs and symbols of twinness. Thus, in many of the portraits he examines, 'an attempt is made to create a twin-like resemblance between two different people by using identical clothing, attitudes and poses' (ibid.). Following Angelo Micheli, it is interesting to note that whilst there is no evidence of any direct link between West African photography and the Ugandan mode with which I am concerned here, the type of argument he develops in relation to Togo, Benin, Burkina Faso and Mali may also hold for this East African context.

As the missionary-ethnographer John Roscoe first observed in the 1920s, and as anthropologist John Beattie later elaborated upon in his work in nearby Bunyoro – work which dates, incidentally, from around the same time that village photography was beginning to take shape as an entity in its own right – 'collective imagery ... related to twinness' has for long been *particularly* marked in the societies of Western Uganda (see especially Roscoe 1923: 161-165 and Beattie 1965: passim). According to Beattie, twin births were thought to have special cosmological significance, and as a result, any woman who experienced one entered a special state called *mahasa*, which conferred both 'ritual potency and danger' (ibid.: 1). The condition conferred some advantages upon the woman, yet so too it 'impose[d] a complex series of ritual obligations on [both] parents, and on the maternal grandparents of the twins' (ibid.). Some of these obligations continued over the lifetime of the twins, and even over the lives of their two following siblings. Moreover, although Beattie's observations are based on work carried out in Bunyoro in the early 1960s, his descriptions would largely hold as an account of attitudes towards twin births and the ritual practices involved in Mbarara District to the present day. It is interesting to note that several of the double portraits with which I am concerned here do indeed also include some of the same signs and symbols of twinness that Angelo Micheli identifies, especially in their use of 'identical clothing, attitudes and poses' (above).

Thus, a focus on aesthetic considerations offers a degree of insight into the subject. Nevertheless, as Gell has cautioned, a truly *anthropological* approach to the study of 'art objects' (a category in which we may include a wide

range of visual artefacts, including photographs) must also try to move beyond the analysis of only 'culturally specific aesthetic intentions', to consider 'the social context of art production, circulation, and reception' (1998: 2-3).[24] Gell further argues that we must take seriously the idea that the art objects themselves may also have a degree of social agency within these wider contexts.[25] Art objects may be not only reflective of social contexts, but also *generative of them.* Significantly, in relation to this particular case study, an examination of the social contexts of 'production, circulation and reception' reveals that from quite early on, the image-objects of vernacular photography became part of the exchange relations to which they referred. In addition, it also highlights that the image-objects themselves also had a degree of agency within these exchanges. These findings may also offer an entirely different set of perspectives through which to understand certain features of this vernacular mode including, for example, the prevalence of the double portrait shot.

In one sense, a connection between the camera and locally meaningful exchange practices was already implied by the 1950s, given the way in which expatriate schoolteachers and missionaries used cameras to cement their ties with their favourite students, seminarians, and others. In so doing, these expatriates' actions mirrored a longstanding set of practices, common throughout the Great Lakes, in which social elites use prestige items to patronize various types of clientage relationships. Moreover, through the following decades, an exchange of cameras has become even more explicitly associated with the forging of patron-client ties. Thus, as the aforementioned Byaruhanga's son described to me at length, it has for long been common practice for village photographers to invest the lion's share of their profits in the purchase of additional portable cameras, and to use these to patronize further 'apprentice' cameramen. Another photographer, Baturine, claimed that he has created a network of over 15 such dependants (all men), whom he refers to as his 'paparazzi'. The first young man to whom Baturine gave a camera was his nephew, and the second, his cousin's son. However, he patronized a range of non-kin as well. In all instances, the bond which is created between a master and his apprentice is more than just an economic one. In one sense it is that, given that a paparazzi is expected to pay to his patron a percentage on the approximately 3 or 4 films' worth of images (between 72 and 96 exposures) he shoots in an average week. One outcome of this is that the position of master photographer is today widely associated with great wealth. In addition, though, the master is expected also to train his dependants in the photographic craft, to come to their aid in times of difficulty

[24] Gell continues, 'aesthetic judgements are only interior mental acts; art objects, on the other hand, are produced and circulated in the external physical and social world. This production and circulation has to be sustained by certain social processes of an objective kind, which are connected to other social processes (exchange, politics, religion, kinship, etc)' (ibid.: 3). In other words, when attempting to define the meanings which attach to art objects, anthropologists should focus not only on their interior aesthetics, but also, more importantly, on the social relationships and processes within which they are embedded.

[25] According to Gell, this agency may take one of several forms. On the one hand it may involve a process of 'abduction', whereby a human actor comes to perceive the art object as 'standing in for' (i.e. reflecting the intentionality, even the presence) of another person with whom s/he has a relationship. On the other, art works may also be both the object of, and the subject of, social relations in their own right. In this way 'the immediate "other" in a social relationship does not have to be another "human being" ... Social agency can also be exercised relative to "things" and social agency can be exercised by "things" (and also animals). The concept of social agency has to be formulated in this very permissive manner for empirical as well as theoretical reasons' (1998: 17-8).

(see below), and even to give them board and lodgings if necessary. (At the time I interviewed Baturine, he had two paparazzi living in his home.) In these ways, networks of village photographers may even be described as having something of a caste-like quality. Indeed, it was in an attempt to emphasize just how strong is the bond between a master and his apprentices that Baturine described the portable camera, in his pidgin English, as 'the machine that makes the best bonds', which I have paraphrased in the title of this chapter as 'the ultimate patronage machine'.

Cameras were not the only objects to have become embedded within locally meaningful exchange practices: photographs are similarly implicated. This again seems to date from the earliest days of vernacular photography. Based on the testimonies of a large number of my respondents, it had become quite typical by the 1950s for people to include photographs amongst other exchange items within a wide range of contexts. For example, Stephen Kato described to me how his father would invite an independent photographer to any meeting of his *ekigombe* group hosted in his home, and would later distribute the photographs to his guests. Francis Kayinga recalled how paparazzi often moved around communal feasts and beer drinking sessions, which from the 1950s increasingly took place in the new public spaces of bars.[26] The photographs taken on these occasions would later be distributed to members of the same social networks who had gathered at the events. Another respondent, Mbabazi David, described how his future father-in-law insisted that a photographer be present during the visit of Mbabazi's bride-wealth delegation to his home. The photographs were later distributed during one of the wedding functions: the bride's 'giving-away' ceremony (*okuhingira*). Perhaps most significantly, much independent photographic work in the late 1960s, but more so into the 1970s, also revolved around the funerary practices of 'burial societies'.[27] As described at length elsewhere, the photographs taken in these contexts would sometimes be exchanged on the dead person's behalf, in a manner which, in a sense, allowed the dead person to remain an active participant in these exchange relations (Vokes 2008). In all these ways, vernacular photography appears to have placed its subjects within meaningful social milieus precisely because these were the very same contexts within which its artefacts (i.e. the photographs themselves) would later be circulated.[28]

However, the fact that the image-objects of this vernacular mode became part of the exchange relations to which they referred does not in itself explain the prevalence of the *double* portrait image. If much of the village photographers' work revolved around the types of exchange contexts outlined above, then it is noteworthy that all these contexts were (and continue to be) group events, involving multiple actors. Why, then, should so much of the village photographers' output have been taken up with these dual portraits? It may be that – questions of aesthetics notwithstanding – this outcome was at least partly shaped by the technology itself. Thus, it is important to note that from the 1960s onwards, independent photographers who took their exposed

[26] Bars were introduced, in this location at least, by soldiers returning from WWII, who also brought back with them knowledge of the techniques of distilling alcoholic drinks.

[27] Burial societies became particularly important during the period of Idi Amin's rule.

[28] Thus, during my field trip in 2009 I was permitted to make reproductions of family photographs belonging to only those households with whom I already had substantial exchange relations. In other words, the archive of several thousand reproductions with which I returned from the field was made up entirely of pictures taken from families with whom I have longstanding ties, built up over a decade or so working in this village.

*Figures 10.9
and 10.10*
*Two copies of a
double portrait
image contained
in each of the
subjects' personal
collections, mid-
1970s.*
*Reproduced by kind
permission of the
families of Mzee
Kaseta, and the late
Onasmus Bwire.*

films into a studio for developing always received their photographs back *in duplicate*. In other words, all studios produced two copies of every print they developed as a matter of course. These would be either inversions of each other, as in the 'magic lantern' style, or else straight doubles. In addition, all films that were sent off to Kenya or Kampala for processing, as was the situation for all colour films before 1992,[29] also came back in duplicate. So well established did this practice of double printing become that it remains widespread today. Moreover, in this context it is revealing that the Runyankore/Rukiga term for 'a photograph', *ekishushani* (literally 'a thing that resembles') has in fact two meanings. Because, given the common practice of double printing, every photograph bears a direct resemblance not only to its subject/s, but also to its own second copy.

Therefore, if every print came back in duplicate, then it may simply have made the most sense for people to have their photographs taken alongside just one other exchange partner, so that each actor could keep one of the two resulting prints. Such an act would presumably become marked as a meaningful exchange in its own right. It may be this which explains why the image of exchange relations that village photographers constructed was more often than not only dyadic in nature – even though they commonly worked in quite large milieus. It also reveals why all double portraits are imbued with an inherently relational quality, in that each one of these photographs, when placed in a personal photograph collection, continues to reference its double, located in someone else's collection. Indeed, during my recent fieldwork, it was often possible to trace both copies of a given double portrait image, across both of its subjects' personal collections.

[29] The year in which the first colour printing machine was set up in Mbarara.

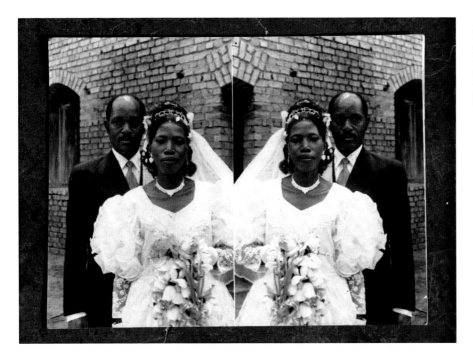

Figure 10.11
The wedding
of Mr Manueli
Koyekyenga,
2001.

Reproduced by kind
permission of Mr
Koyekyenga.

In addition, this practice has also had the effect of marking any instance in which *both* copies of a given portrait were placed in *one* location as an instance of completion or closure of social relations – and therefore as especially symbolically significant. For example, the incorporation of both copies of a double portrait of a bride and groom at the end of a wedding album is often used as a means of symbolizing the conclusion of the union (Figure 10.11). For another example of this symbolism of 'completion', see Vokes (2008).

Photographs, bodies, persons

If the image-objects of vernacular photography *did* become part of the exchange relations to which they referred, further evidence suggests that they also became an especially privileged category of exchange items within these contexts, and may even have been elevated as one of the very 'substances of life'. Throughout South-western Uganda and beyond, personhood is conceived in very different terms from that of the 'modern' autonomous individual. Constructs of the person generally conform more to what Marilyn Strathern (following Marriott and others) has famously called '*dividual* personhood' (my italics). Others have used the terms 'fractal', 'partible', or 'extended' personhood (Strathern 1988; Wagner 1991; Busby 1997). Thus all bodies are understood to be made up of different types of substance, all of which trace ultimately to a single cosmological source (*imaani*). At conception various of these substances – the male 'water' (*amaizi*) and the female 'blood' (*eshagama*) – are combined to form the unborn child, cast as a composite of different substances. Later, through an unfolding sequence of exchanges of certain vital substances, such as water and blood, but also food, beer, livestock, this original self can, in a sense, become 'extended' to include those substances that have also been consumed by other bodies (Neema n.d.: 59; cf. Taylor's discussions of concepts

of personhood in nearby North-western Rwanda, especially 1988 and 1990). These exchanges are usually referred to by the verb 'to flow' (*kujwa*). Thus, the Runyankore/Rukiga category of 'the person' (*omuntu*) refers less to the operations of any single body than to a series of exchange objects that pass within and between multiple bodies.

Significantly, all of the social milieus to which I have referred involve the exchange of precisely such vital substances (in addition to the circulation of various other sorts of exchange objects). Thus, by becoming embedded within these same milieus, photographs were inevitably brought into association with these other substances. From this juncture a further shift appears to have occurred, whereby photographs themselves became marked as one of the constituent objects of personhood. This was first revealed to me during an incident that occurred early on in my 2009 field trip. A young woman asked me to take her picture and then requested to see what I had taken. As I was using a digital camera, I was able to bring the image up on the camera's LED screen and show it to her. On taking hold of the camera, the woman quite obviously looked entirely past the image and instead tried to open the back of the camera to get at the photographic object (*ekishushani*) that she assumed was contained inside. So marked was her response to the *image* at this moment that it brought to mind anthropologist Melville Herskovitz's famous encounter where a female respondent allegedly failed to recognize, at first, that a photographic image of her son was a representation of someone with whom she was familiar (see the discussion in Seppaenen 2006: 112). The key aspect of my example is the language the woman used to describe her actions in trying to open the camera. As she tried to pry open the cover, she said that she was doing so in order to see '*the part of [her] body/person*' (*eki'kyweka kya'muntu*) that I was going to take back to England with me.[30]

My subsequent research has revealed additional evidence of the ways in which photographs have become marked as vital substance in their own right. For example, an exchange of photographs is today commonly used to establish 'relations of substance' where none had previously existed. Young men now frequently introduce new partners to their informal drinking groups through an exchange of photographs, while young couples will often exchange photographs as a necessary precursor to engaging in sexual relations. More generally, today it is a very common occurrence for village photographers to take young women's photographs and to then give them free copies of the resulting prints, in exchange for sexual favours. So frequent has this practice become that the profession of photographer is today synonymous with an image of the 'sexual predator'. The headmistress of one nearby girls' secondary school confirmed that between 2001 and 2009, several dozen incidents of this sort had been brought to her attention. In at least three cases, the girls involved had become pregnant and as a result had been excluded from the school. The headmistress described how, in the light of these events, she now invests a great deal of time and energy in vetting and policing the itinerant photographers who continue to visit her institution. Finally, in an even more direct example relating to the AIDS epidemic, photographs have come to replace even bodily substances in the formation of certain types of relationships: an

[30] Significantly, her words here do not imply any sort of abstract or metaphysical meaning. Thus, they suggest that she understands the photograph to be, literally, an extension of her physical body.

exchange of photographs is now one key element in the establishment of relations of *bakago*, where previously a mixing of actual blood would have been required (see Vokes 2009).

Yet if photographic image-objects have indeed become marked as one of the vital substances of life, this has profound implications for changing notions of personhood in this context. In particular, the fact that, whatever the costs, photographs can be much more easily produced and circulated than any of the other 'vital substances' means that, today, personhood can potentially be cast over a much larger number of exchange partners and across vastly greater distances than would have been possible before. Thus, even for a wealthy person, crops must still be grown, beer must be prepared, animals reared, and all such items can only ever be exchanged across a relatively limited distance. In contrast, a photograph can be produced in a matter of hours (as the incident with which I opened this chapter attests) and can of course be circulated over limitless distance. In addition, photographs also 'fix' substantial relations in ways in which other vital substances cannot. Thus, unlike food, beer and animals, which are all either consumed, or rot, sour, or die, photographs may fade but nevertheless endure (not least given the widely held belief that as vital substances they cannot/should not ever be destroyed).

By way of illustration of all of these points, I am reminded of the photographic practice of one particular 'big man' who hails from Bugamba, and who owns a large house there, yet who lives for most of the year in Kampala where he holds a senior post in a major government institution. Whenever this man, whom I shall call Gerald, returns to Bugamba for a visit – usually of no more than a few days' duration – his arrival invariably arouses the interest of local photographers, several of whom may stay in and around his home for the length of his visit. Thus it is quite normal for Gerald's every move to be photographed and for all of his interactions to be documented, whether at wedding functions, visits to his *bakago*, or drinks in local bars. Subsequently Gerald will usually buy all of the photographs taken (a visit may generate 4 or 5 rolls of film, i.e. between 96 and 120 images). He will then distribute most of the prints to the people with whom he has engaged, whilst retaining a few for posting to his extensive network of contacts in the UK, the USA, Australia, Dubai, Iraq, and elsewhere. In this way, Gerald uses photographs taken in his natal village to maintain a vast number of substantial ties within that locale, as well as a wider, indeed, global network of contacts. Moreover, it is interesting to note just how enduring the photographs which remain in Bugamba become: practically every adult in the locale (as far as I can tell) has at one time or other had their photograph taken with Gerald, and on the basis of the resulting prints, claim to have an ongoing and substantial relationship with him. Indeed, it is not at all uncommon for someone to produce a photograph of him/herself with Gerald during perhaps a night's drinking ten years ago, and to claim the photograph as proof of an enduring connection to the 'big man'. One result of this is to give Gerald a kind of presence in Bugamba even when he is not physically there. In fact, it was not until four months into my initial fieldwork in the village, in 2000, that I finally met Gerald in person. However, by then I had been shown so many pictures of him that I already felt as though I knew the man. And photographs may also give the dead a kind of ongoing 'presence' in the social life of the village as well (Vokes 2008).

Photography and secrecy

If photographic image-objects have become marked as vital substance, this has also had a number of additional social effects. Although much more could be said about these further consequences than space allows, I will conclude this chapter by noting one of the more profound ways in which photographs have impacted upon social life: by altering commonly held understandings of secrecy and its effects. Because, if photographic image-objects have become implicated within fundamental flows, then it is noteworthy that at least some of the exchanges which make up these flows on a day-to-day basis are concealed in nature. In short, these covert exchanges may even be said to constitute a 'secret part of the self'. Moreover, as in other contexts of everyday secrecy that are well known in the ethnographic record, wider knowledge that such exchanges are taking place, yet sometimes with limited knowledge of their specific details, generates a particular fascination with the dynamics of revelation and concealment. Indeed, 'language games' associated with the processes of accusation, denial, revelation, gossip and rumour have become central components of everyday speech in many South-western Ugandan contexts and beyond (Vokes 2009: 17; 47-48). Thus public knowledge of any given person's 'secret life' is, in most cases, constantly open to contestation, and remains permanently unstable, even ephemeral in nature (a dynamic which is also well documented in the wider ethnographic and sociological literature on secrecy). However, when *photographs* become included in these secret exchanges, as is common today, the dynamics of such language games may be radically altered. Precisely because photographs are objective, enduring, and thus create what is to all intents and purposes a permanent record of these concealed exchanges, they significantly constrain these processes of revelation and concealment. In consequence, photographs may even result in the secret aspect of personhood becoming itself more objectified, and more 'fixed' than ever before.

By way of illustration, I recall several incidents in which photographs were included in secret exchanges. The first involves a teenage boy who had had a brief relationship with a young woman from a neighbouring household in the previous year. During their short liaison, the girl had sent him a 'love letter' – an increasingly popular mode of communication among young people throughout Uganda (see Parikh 2004) – in which she had included an informal portrait photograph of herself taken at her school. Fearing that the discovery of the letter would anger his parents, the young man promptly burned it. However, feeling that he could not destroy the *photograph*, he placed it in his personal album, yet hid it behind another of the images displayed. This is a practice which I discovered during my recent fieldwork to be remarkably common. Nevertheless, some months later the photograph was discovered by an older brother who as a relatively well-paid civil servant was the family member who paid the teenager's school fees. Interestingly, the older brother immediately interpreted the existence of the photograph as proof that his sibling was engaged in substantial (i.e. carnal) relations with the young woman, despite the young man's protestations to the contrary. As a result, the older brother withdrew his financial support on the grounds that someone who was engaging in such an affair could not possibly be 'taking his studies seriously'. The boy dropped out of school. (However, at the time I recorded this incident in early 2009 it seemed likely that another relative would come to the aid of the teenager, so that he might return to school for the next academic year).

The second incident involves a young woman, 'Stephanie', who became pregnant out of wedlock and gave birth to a baby girl. When her paternal aunt 'Felicity', head of the household in which she lived, heard the news, she became extremely angry. In the ensuing argument, Felicity threw the young woman out of her home. Stephanie moved in with the father of her child who lived in a neighbouring house. From that time on, Felicity (who had in fact brought up Stephanie from birth) refused to have anything to do with the young woman, not even acknowledging the existence of the child. On one occasion, I overheard a conversation with a third party in which Felicity openly denied that her niece had even given birth. Later, however, another young woman in Felicity's household who was a cousin of Stephanie's (FBD),[31] 'Charlotte', came to regard her aunt Felicity's position as pig-headed, and set about trying to effect a shift in her attitude. Interestingly, Charlotte's strategy revolved entirely around the use of photographs. Specifically, Charlotte, who had been visiting Stephanie regularly from the time she had left her aunt's household, began surreptitiously to place photographs of Stephanie's infant baby all over aunt Felicity's house. At first, this involved Charlotte leaving the odd shot of the baby somewhere in the household's living-room or in the kitchen area. However, over time, her efforts became more systematic, and she even began to insert shots inside Felicity's own photograph albums. Eventually, the strategy began to have the desired effect. Thus, although on the first occasion that the aunt discovered one of these photographs she flew into a rage (in fact she beat Charlotte with a stick), the ongoing presence of the images made it increasingly difficult for her to deny the substantial relationship she had with Stephanie's child. In the end, an occasion took place in which a protracted family conversation over Stephanie's situation (involving at least a dozen members of the extended family) took place. This conversation was itself prompted by one of the family members having spotted the baby photographs in an album. The aunt, Felicity, finally relented, and allowed Stephanie and her child to visit her home.

My third example is the incident with which I opened this chapter: the events surrounding my own clandestine meeting in a bar one night in late 2000. At the beginning of this chapter I argued that I have now come to regard this incident as indicative of vernacular photography in general, and I hope that this has now been established. Because on the one hand, the very details of this particular photographic encounter – from the village setting, to the milieu of drinking partners, to the dual portrait image, to the developing in a local (master) photographer's darkroom, to the fact that we both took away one copy of the print – are all quite typical of the vernacular mode that I have been seeking to define. Yet on the other, the very fact that this picture was taken at all may be explicable in terms of the connection between photography, personhood and secrecy that I have also pursued. Because by insisting that we each take away a photographic image-object, my drinking partner made me, in effect, both substantially and permanently complicit in the secret (criminal) project in which he was engaged. For this reason, it is probably a good thing, at least, that the local authorities never learned of its existence.

[31] Father's Brother's Daughter.

Bibliography

Angelo Micheli, C. 2008. 'Doubles and Twins: A New Approach to Contemporary Studio Photography in West Africa', *African Arts* 41 (1): 66-85.

Beattie, J. H. M. 1965. 'Twin Ceremonies in Bunyoro', *Journal of the Royal Anthropological Institute* 92 (1): 1–12.

Behrend, H. 1998. A Short History of Photography in Kenya, in *Anthology of African and Indian Ocean Photography*, (eds) Saint-Léon, P.M., N'Gone Fall, Jean Loup Pivin, Paris: Revue Noire (English edn).

Bouquet, M. 2000. 'The Family Photographic Condition', *Visual Anthropology Review* 16 (1): 2-19.

Buckley, L. M. 2010. 'Cine-film, Film-strips and the Devolution of Colonial Photography in The Gambia', *History of Photography* 34 (2): 147-57.

Busby, C. 1997. 'Permeable and Partible Persons: A Comparative Analysis of Gender and Body in South India and Melanesia', *Journal of the Royal Anthropological Institute* 3 (2): 261–78.

Edel, M. 1957. *The Chiga of Western Uganda*, London: Oxford University Press.

Edwards, E. 2005. 'Photographs and the Sound of History', *Visual Anthropology Review* 21 (1-2): 27–46.

Edwards, E. & J. Hart. 2004. Introduction: Photographs as Objects, in *Photographs, Objects, Histories: On the Materiality of Images* (eds) E. Edwards & J. Hart. Routledge: New York.

Geary, C. 2003. *In and Out of Focus: Images from Central Africa, 1885-1960*, Washington DC: Smithsonian Museum of African Art.

Gell, A. 1998. *Art and Agency: An Anthropological Theory*, Oxford: Clarendon Press.

Haney, E. 2010. *Photography and Africa*, London: Reaktion.

Killingray, D. & A. Roberts. 1989. 'An Outline History of Photography in Africa to c. 1940', *History in Africa* 16: 197-208.

Kratz, C. & R. J. Gordon. 2002. 'Persistent Popular Images of Pastoralists', *Visual Anthropology* 15 (3-4): 247-65.

Landau, P. S. & D. D. Kaspin (eds). 2002. *Images and Empires: Visuality in Colonial and Postcolonial Africa*, Berkeley CA: University of California Press.

Miller, C. 1971. *The Lunatic Express*, London: Penguin.

Monti, N. 1987. *Africa Then: Photographs, 1840-1918*, New York: Random House.

Neema, S. (n.d.). 'Mothers and Midwives: Maternity Care Options in Ankole, South-western Uganda'. Unpublished PhD Thesis, University of Copenhagen, 1991.

Parikh, S. 2004. 'Sex, Lies and Love Letters: Condoms, Female Agency, and Paradoxes of Romance in Uganda', *Agenda: African Feminisms* 62 (1-2): 2-20.

Roscoe, J. 1923. *The Bakitara or Banyoro: The First Part of the Report of the Mackie Ethnological Expedition to Central Africa (1919-1920)*, Cambridge: Cambridge University Press.

Seppaenen, J. 2006. *The Power of the Gaze: An Introduction to Visual Literacy*, New York: Peter Lang Publishing.

Sobania, N. W. 2007. 'The Truth Be Told: Stereoscopic Photographs, Interviews and Oral Tradition from Mt. Kenya', *Journal of Eastern African Studies* 1 (1): 1-15.

Stanley, H. M. 1878. *Through the Dark Continent*, London: Sampson Low, Marston, Searle & Rivington.

Strathern, M. 1988. *The Gender of the Gift: Problems with Women and Society in Melanesia*, Berkeley CA: University of California Press.

Taylor, C. 1998. 'The Concept of Flow in Rwandan Popular Medicine', *Social Science and Medicine* 27 (12): 1343-8.

—— 1990. 'Condoms and Cosmology: The "Fractal" Person and Sexual Risk in Rwanda', *Social Science and Medicine* 31 (9): 1023-8.

Vokes, R. 2008. On Ancestral Self-fashioning: Photography in the Time of AIDS, in *Haunting Images: The Affective Power of Photography* (eds) B. Smith & R. Vokes, in *A Special Edition of Visual Anthropology* 21 (4): 345-63.

—— 2009. *Ghosts of Kanungu: Fertility, Secrecy and Exchange in the Great Lakes of East Africa*, Rochester NY and Woodbridge: James Currey.

Wagner, R. 1991. The Fractal Person, in *Big Men and Great Men: Personifications of Power in Melanesia* (eds) M. Godelier & M. Strathern, Cambridge: Cambridge University Press.

Werner, J-F. 2001. 'Photography and Individualization in Contemporary Africa: An Ivoirian Case-Study', *Visual Anthropology* 14 (3): 251-68.

'The terror of the feast'
Photography, textiles & memory in weddings along the East African Coast
Heike Behrend

11

This chapter attempts to explore not only the making, circulation, and consumption of photographs on the Kenyan coast, but also the other side, their rejection and obliteration: essential aspects of a medium's history that should not be neglected. While the adaption and creative use of travelling visual media technologies by local actors in the context of globalization processes have been extensively explored, the following focuses on the opposite processes of disentanglement, rejection and withdrawal from global media, as well as the creation of new opacities and secrecies that have been largely ignored by scholars. This contribution is an attempt to complement the existing theories of mediation by concentrating on the discontinuous and disruptive role of media technologies in the processes of globalization.

On the East African Coast in Mombasa since the 1950s, perhaps even earlier, photographers and photographs have played an important role in lavish feasts, mostly weddings, which at the same time constituted battles of status. But since the 1980s, pious Muslims have increasingly reinforced and invoked Islam's preference for aniconism and notions of (female) purity to control the production, distribution, and consumption of photographs, especially those of women. The tensions arising between the global medium of photography that always gives something 'more' to see, its insertion into local spectacular wedding ceremonies, and the various attempts to withdraw women from visibility are the subject of this contribution.[1]

I will also explore the complicated relationship between photographs and textiles at weddings. Textiles were not only a medium that preceded photography, but also intensively shaped techniques of codifying, recording, and processing the visibility, social status, and meaning in photographs. Like photography, textiles served as a material support for memory.

Thus, this chapter traces a local media history that begins with textiles and explores how the materiality and functions of textiles were translated into the medium of photography. Second the way in which, conversely, when photography was adopted into existing modes of mediation, it also transformed the production and uses of textiles.

Coastal potlatches

Feasts mark and interrupt the flow of time. As liminal space and time (Turner 1969), they offer the opportunity to break the rules of everyday life, turn the world upside down, to distribute or waste large amounts of food and prestige goods, and to indulge in drunkenness, ecstasy, or orgies. On the one hand, they serve to reinforce the solidarity of the participants; but on the other hand,

[1] This contribution is part of a larger publication entitled *Contesting Visibility: Photographic Practices and the 'Aesthetics of Withdrawal' along the East African Coast* (forthcoming 2013, Bielefeld: Transcript). The tensions between the medium of photography and the aniconic tendencies of reformed Islam on the East African Coast in Lamu are also explored in Behrend 2009.

they can also become the site of fervent competition, conflict, terror and even open fighting.

Along the East African Coast, festive occasions constituted what Marcel Mauss (1968) has termed 'total social phenomena' in which social relationships, kinship, economics, politics and rituals became deeply entangled. *Rites de passage*, in particular weddings, and religious festivities, offered a stage for ambitious men to claim or reconfirm positions of rank and prestige. Chiefs, *majumbe*, and other Muslim men of rank could raise their status by residing over rituals or other festivities. High rank was – and to a certain extent still is – intimately linked with generosity and waste, qualities that a man's relatives, clients, and followers demanded he display if he wanted to retain their respect and allegiance (Glassman 1995:147). Ostentation in textiles, dress and adornment, competitive dance and the recital of verses by rival poets, as well as the lavish distribution of food and other gifts, formed part of a feast that often led to debt, or sometimes even to the host's financial ruin. Gifts of imported luxury commodities were manipulated to challenge a rival who, when humiliated, had to organize another feast and display an even more aggressive generosity to outdo his opponent. On certain festive occasions, as Glassman (ibid.:147) has shown, social restraints were relaxed and members of youth groups took the chance to engage in public mockery of authority. Such carnival licence for derision could turn into actual fighting and rebellion. Competitive feasting in which hosts and guests were provoked and humiliated to outdo one another was a widespread feature on the East African Coast in the late nineteenth and early twentieth centuries (ibid.: 164, 167). The temptation to affirm or enhance one's rank coincided with the temporary possession of relatively huge amounts of money or trade goods earned in the then highly profitable caravan trade. Extravagant feasting and rivalry went so far that, for example, *ngoma* or dance associations in 1937 started to drop *kangas* (highly valued pieces of fabric) by plane, a practice known as 'kanga bombing' – aimed at enhancing their own prestige and inciting the envy of a rival (Loimeier, 2006: 113f).

Not only extravagant feasting but at times even the ostentatious destruction of wealth (comparable to the North American *potlatch*) took place, as money and other valuables were thrown into the Pagani River. This would lead to a spiral of conspicuous consumption and destruction[2] (Glassman 1995: 173, 167). Expenditure, defined as unproductive, non-utilitarian, clearly accented loss, had to be as great as possible in order to take on its true meaning (Bataille, cit. Taussig 1995: 387).

As Hyder Kindy has mentioned in his biography (1972), in Mombasa in the 1920s, the actual marriage ceremony was preceded by various *ngoma*, celebrations that included dancing, lasted about a month and resulted in exorbitant expenses. The poor especially suffered because they always wanted to show that they could do better than the well-to-do; to finance the festivities they would often be obliged to mortgage their land. Many were unable to pay their debts and eventually lost everything to Indian and Arab moneylenders and thus ruined their lives and their families (ibid.: 63).

[2] This aspect has been neglected when characterizing Swahili society as 'mercantile'. It would be important to find out if this tradition of feasting accompanied by the destruction of wealth was widespread in the nineteenth century and if it functioned in an anti-capitalistic spirit endangering primary accumulation. If this was the case, the mercantile character of Swahili society in the nineteenth century has to be discussed in a more complicated way.

However, the values of 'exaggerated' generosity, expenditure and redistribution clashed with the imperatives of the international market, and the site of the clash was the feast, 'where those seeking to gain prestige through the dispensation of largess [sic] found the demands of creditors, clients and competitors increasingly difficult to satisfy' (Glassman 1995: 168). Not only the colonial government but also some Muslim scholars tried to curb these conspicuous acts of feasting and uneconomical expenditure (Loimeier 2006: 114ff). Although competitive feasting among men declined during colonial and post-colonial times, it never disappeared completely and traces of excessive expenditure are still to be found in today's wedding celebrations. For instance, in about 1995 in Zanzibar at a wedding of high-ranking people, male relatives of the bride burned banknotes to demonstrate conspicuous consumption, loss and destruction. Although conspicuous feasting has been strongly restricted since the 1980s due to the general economic decline,[3] today some families still ruin themselves with lavish expenditure at weddings.

'A wife is clothes'[4]

Along the East African Coast, a wide range of different male–female unions is recognized. Besides 'official' marriage, there exist various forms of concubinage and so-called 'secret marriages'. Within the background of high divorce rates, it is, above all, the first 'official' marriage (which is also an initiation ceremony marking the passage from girlhood to married woman) that is celebrated in a costly and elaborated feast. Later marriages do not take place in such a splendid way (Middleton 1992: 120f). Thus, wedding celebrations form a key ritual for a woman around which the drama of transformation unfolds.

Today most marriages are no longer arranged. Although endogamous marriages (between cousins) are preferred, women rather often insist on their own choice. Frequently the future husband and wife know each other already, consent to marry and then the negotiations between the two families start.

While weddings[5] used to offer men a stage to reconfirm or claim positions of rank and prestige, since the 1970s or perhaps even earlier, women primarily have taken over this task in gender-segregated Mombasa and Lamu (Strobel, 1975: 36). Whereas men meet in the public domain of the neighbourhood mosque and in political associations or social clubs from which women are excluded, weddings offer women a chance for gossip, discussion, entertainment, and competition. While the legal and religious aspects of a wedding have been the purview of men, women were and still are primarily responsible for the wedding festivities (ibid.). Whereas men no longer indulge in lavish expenditure and thus have appropriated the capitalist spirit of economic accumulation, it is women who follow 'tradition'. Women very often decide to hold a festive event; they are occupied with cooking great quantities of delicious food, assisted by female relatives and neighbours. They invite relatives and friends, thereby renewing or confirming alliances while at the same time discarding others. They arrange the decoration of the house, organize music, and, above all, each woman chooses her own clothing, hairstyle, and jewellery. Women attending

[3] Anne Storch, personal communication.
[4] Compare Swartz 1991:242ff.
[5] For detailed descriptions of weddings on the East African Coast, see Middleton 1992; Guennec-Coppens 1980; Strobel n.d., 1975.

a wedding will be closely examined by others after they have removed their veils, and what they wear will be discussed in detail by friends as well as rivals over the following weeks (Swartz 1991: 244f). A wedding was and still is mainly a fashion show, with women showing off their connection to the modern world, their class, beauty and their style to other women. Thus, women are under great pressure to conform to certain standards of prestige and status. They have precise ideas about what is fashionable and what is not.[6]

There are two important rules guiding individual display during a wedding: a woman should never wear *mitumbe*, second-hand clothing that is locally associated with cast-offs from the deceased; and she should never be dressed in a garment she has worn on a previous occasion. Likewise, her shoes and jewellery should also be new. The continued wearing of these outfits is considered a disgrace and is associated with the mourning period for a relative, during which no change of dress is permitted (Middleton 1992: 158). Thus, these constraints can only partially be related to modern, quick-changing fashion and capitalist consumption. In fact, the singularity and uniqueness of women's appearances is most important, and women who cannot afford to buy new jewelry for each wedding take their bangles and necklaces to the gold- or silversmith to be melted down and reworked into a fashionable new design.

If a woman participates at a wedding dressed in clothes and jewellery she has worn on a previous occasion, the other women guests will say 'Repeat!'; this statement marks not only her social death but also seriously lowers her husband's prestige. His wife's poor outfit is seen to express either that he does not love her or that he is too poor to dress her properly. Indeed, a man's love for his wife is made publicly visible by her expensive outfit. A woman not loved by her husband is taken to be a pitiful, disgraced creature and will often be despised (Swartz 1991: 246). Thus, a woman's body, with jewellery, expensive clothes, perfume and henna designs also becomes a statement of her husband's standing, thereby reproducing the structural dependency of (married) women. Reciprocally, of course, the dependence of women on men allows them to demand the supply of expensive material and jewellery for public display. Since his status is tied to hers, it is difficult for him to refuse. For a wedding, a husband is supposed to buy at least two to four new dresses for his wife.[7] Although most men do not share women's enthusiasm for spending money on clothing and jewellery, they nevertheless provide the necessary funding, because 'a wife is clothes' (ibid.: 242ff).

In the 1990s, however, women made attempts to reduce the 'terror' of weddings as fashion shows. Because of the economic crisis and an increasing unwillingness to spend large amounts of money on clothes when they could not even afford the school fees for their children, women in Lamu and Mombasa started to build up groups to reduce the pressure on them individually. As a wedding group, they decided to buy a certain material and together

[6] I can confirm this from my own experience. Although I tried hard to fulfil local standards, I committed a terrible *faux pas* at the first wedding I attended in Mombasa in August 2007 and succeeded in being a simple failure at the second. At the subsequent wedding, while I was far from hitting the local standard, at least my efforts were appreciated and I received more than a reluctant smile.

[7] August being the month of weddings, some women in Mombasa and Lamu attended a wedding nearly every evening for a whole month!

chose one style so that during the wedding they were dressed uniformly, thereby minimizing any rivalry. Dressing alike and sharing the same textile expressed their desire to identify with each other and to celebrate the unity and commonality of women. Whereas previously women had attempted to outdo each other, they now openly demonstrated their solidarity by sharing the same material.

However, competition did not disappear completely, but was shifted to another, more collective level between wedding groups. Through the creation of wedding groups, the women not only expressed their solidarity and unity, but also furthered a certain detachment and independence from their husbands, because their clothing no longer reflected the latters' status but was now the result of the group's decision.

However, in Mombasa in 2007, women told me that during weddings individual rivalry had reappeared and they took great pains to be as stylish as possible and to outdo each other. There were also exceptions. As I observed during the weddings I attended in August of the same year, a few women consciously chose to dress in a simple, more puritanical way in order to express their religious objection to the profane splendour of others. They did not form a group but acted individually, and as far as I could establish, their religious asceticism was largely accepted.

Photography's insertion into spectacular weddings

As a cosmopolitan society, women and men of the stone towns have for centuries enriched their material culture and rituals through foreign influences, which they turned into their own to differentiate themselves from other people. They took over, adapted and transformed elements from those who colonized them and with whom they traded. In fact, the weddings rituals up to today are characterized by the assimilation of foreign elements. While the Arab hegemony of the nineteenth century was (and still is) given expression in the clothing of bridegroom and bride, also the Western impact has left its traces, the bride at one occasion during the wedding process wearing a Western style white wedding dress. Whereas during colonial times, Western clothing was seen as the utmost of elegance, since the 1980s the latest fashion comes from Oman, Dubai and India, thus de-hegemonizing the West. In fact, India's 'Bollywood' films as well as Egyptian and Mexican soap operas provide the ideals that are followed and reworked by local women in their wedding outfits.

Like other imported luxury commodities turned into prestige goods to be displayed, manipulated, and circulated as gifts to challenge a rival, photography also entered the wedding rituals. Though strongly contested by some Muslims, photography – as act and object – became part of expenditure and the conspicuous display of wealth, prestige, and battles of status. People readily understood the camera as a medium that created not only images to record and remember an event but also a theatrical space of performance that could be connected to the theatricality and spectacularity inherent in wedding rituals.

Even before the introduction of the camera, people displayed themselves and their wealth during weddings and other festivities in spectacular theatrical scenes. The architecture of the famous stone houses provided, on the one hand, the possibility of keeping certain spaces hidden and inaccessible while on the other offering a stage where people could present themselves as a 'picture' to

be seen and admired. Contrary to the claims that only capitalist societies have produced the spectacle (Debord 1967), 'spectacularity' was already constitutive of local subjectivities long before the introduction of photography to other parts of the world (cf. Silverman 1996: 91). Thus, photography's insertion into weddings followed first of all the logic of the already existing spectacular choreographies that decided when, where, and what was displayed, and what was not.

In fact, photographic acts as performance themselves soon gained the repetitive fixity of rites and were inserted as 'photo sessions' into weddings. Since the 1950s, the presence of the camera has essentially restructured the ritual process.

The photographic act as a cut in time and space, as a sudden freezing of a now and 'here' (Dubois 1990: 157) isolates certain moments of the flow of time and the continuity of ritual space. Photographers through both their actions and image-making strongly heighten and intensify certain spectacular moments of the wedding ritual. The moment of singularity that is captured through this cut in time and space by the camera is thereby transferred into another temporality that lasts and endures. It enters the pictorial space as frozen time, endlessly present and immobile (ibid.: 164).

Today, at (non-reformist) Muslim weddings, there are two moments of great beauty and visibility of the bride that must be recorded on photographs (and video). The first takes place when she is presented to her husband before the marriage ceremony. At one of the weddings I was invited to in August 2007, the bride had been prepared in the 'Saloon of Brides', a beauty parlour and hairdresser in Old Town. Covered by a *buibui*, a loose black garment that protects the entire body, the bride was brought to the house of the groom, where she was unveiled and displayed in all her splendour. Her outfit consisted of a light green dress (green being the colour of Islam) with a veil, a mass of gold jewellery, heavy mask-like make-up and with her hair in a big shining knot, in two colours, at the back. It was at this moment of revelation that she was photographed in various positions, sometimes with, sometimes without, the veil, sometimes with the groom or without him.

The second moment of utmost visibility that 'is crowned by photography (and video)' took place after the marriage had been completed. On the last evening of the wedding ritual, female relatives, friends, neighbours, and workmates gathered in a big hall to eat, drink and dance. A stage had been built at the end of the large hall, decorated with strands of glitter, sparkling lights, paper flowers, and a festive sofa and chairs, clearly inspired by the glamorous wedding scenes of Bollywood films. When the music[8] started, the women began to dance and to enjoy the festive occasion. After a few hours, the bride arrived in a shiny white dress, holding a bouquet of white flowers; she entered the hall and then, as if in slow motion, walked towards the stage. She climbed the steps, and, visible to all, stood still for a while and then sat down to be seen and admired by the other women, her face unveiled. While her walk through the hall was captured on video, photographers took her picture in various poses on the stage, first alone and then in different arrangements

[8] Before the 1980s, male musicians played *taraab* music, but nowadays their presence has been condemned by religious reformists. Their criticism is also focused on the waste of money that could be better spent on education and development. In all the weddings I attended, only cassette recordings were played (cf. Fuglesang 1994: 111).

with relatives and friends. Whereas in Taiwan, as Bonnie Adrian (2003) has suggested, bridal photography depicts the bride alone or the couple without other family members, thereby intentionally obliterating intergenerational ties in their representations of marriage, this is not the case in Mombasa or Lamu. Although romantic poses may sometimes be staged in opposition to the older generation, weddings are seen as a ritual that connects two families, and is also represented in the photographs of the bride and groom embedded in a complex network of social relations.

However, as in Taiwan, weddings have become, above all, a celebration of femininity and a ritual of transformation of the bride from girl to woman and wife. In particular, heavy cosmetics turn a bride's face into a mask that transforms her individual characteristics into a generic, stylized beauty. The difference between bridal beauty and everyday looks is extreme; it is as if a new person is created for the new life of a married woman (cf. Adrian 2003: 155f). The glittering decoration, the radiance of the bride's face, her silky dress, the festive illumination, and the flashbulbs of the cameras create a fascinating tapestry of light, displaying her as the 'star' of the show and surrounding her with an aura of the divine. At the same time, the reflections of light all but blind the onlookers, protecting the bride from vulnerable exposure to the evil eye (cf. Fuglesang 1994: 135).

These two moments of heightened visibility were captured, intensified, and frozen by the cameras for the duration. They formed part of a complex ritual regime of concealing, veiling, and revealing and the camera preserved, expanded, and celebrated these moments of heightened visibility as part of the bride's transformation. As 'before' and 'after' images, they also gave evidence of the radical change the bride underwent during the wedding. Like the clothes, so also the photographs not only symbolized the new status acquired, but formed in themselves an essential component of the woman's transformation. In fact, at weddings, the presence of the camera has become one of the principal devices for experiencing an event, for giving an appearance of participation. The omnipresence of cameras persuasively suggests the importance of the event and the people present (Sontag 1977: 10f). The acts of photography 'crown the celebration' as a photographer in Mombasa put it.

Photographs as gifts

During weddings, photographs also served as gifts to be distributed among relatives and guests. Besides other gifts, the quantity of photographers present as well as the quantity of pictures taken determined the status of the host and his family. The photographs entered a process of communication and circulation safeguarding against the individual's propensity to 'keep to oneself' (Mauss 1968). As at a potlatch, during weddings photographs formed part of the exchange of gifts and counter-gifts, and the quantity and quality of photographs distributed affirmed and added to the host's social standing. As various people told me, hired photographers would take pictures of 'everything and everybody'. 'People are crazy', one Indian photographer remarked, 'they want 400 to 600 pictures for one wedding'. Besides the two moments already mentioned, photographers were invited to take pictures of each and every action, he said. Sometimes the host spent so much money that he could not pay for the developing and printing.

With photographs, a form of gift was established that functioned in a double way: as an object that was given as part of the host; and as a picture that represented the participants. In these 'wars of wealth' (Mauss 1968), of excess, laughter and dance, photographs function as highly ambivalent gifts because they record either the victory or the defeat of the host and his guests, storing memories of happy and/or disastrous moments of life.

Photographs were not only distributed as gifts to guests but also sent to relatives and friends living abroad in the Diaspora who had not been able to attend. Thanks to the new technology, people separated in space were able to maintain relations, share the experience of festivities and rituals, and form one community (Clifford 1997: 246f). In fact, photographs constituted new spaces of connection and interaction. They animated, replicated and extended the experience and sensations beyond the home to the Diaspora, so that while viewing photographs and their inscriptions, the information is transported across time and space; the experiences captured are immutable, though displaced (Latour, 1986: 8). At home or in the Diaspora, family members and friends would meet together with neighbours in front of a television to view the videos and photographic images of a wedding, sometimes actually repeating the feast and participating in the status struggles that the technical media not only record but have become a part.

Textiles, photography and memory

Both men and women told me that women have very sharp eyes and a good memory. They notice not only the material of a dress, its design and where it comes from, the way it is sewn, a woman's make-up, hairstyle, and so forth, but also use clothes to remember events.

Along the coast, there is a long tradition of so-called commemorative *kangas*, rectangular pieces of cloth matched in pairs that have been worn by women for the past 140 years. *Kangas* have been integral to realms of signification that extend beyond mere clothing. In the nineteenth century, these pieces served as a kind of currency; they entered into spirit possession cults, and because of the proverbs and sayings printed on the fabric, they became the site of indirect communication, particularly among women. In addition, the design of certain *kangas* not only referred to specific events, but sometimes even a concrete place and date would be given in the 'name' or text printed on the material. To commemorate the Mombasa Exhibition Show in 1939, a special *kanga* printed with that title was produced (Beck 2001: 185). Some *kangas* were expressly made to mark the founding of institutions or political parties, elections, or harvest celebrations held every August.

Sayings and proverbs as well as specific motifs on the *kangas* would not be repeated in successive years. A woman would not normally wear a *kanga* with a slogan or name that was regarded as outdated. A sense of datedness through the design as well as the text strongly characterized this clothing (Parkin 2005: 52).

The same applies to dresses tailored and worn only once for a wedding. Obviously, the interdiction against repeat wearing turned kangas and dresses into mnemotechnical devices to recall specific events in the irreversible flow of time. Textiles served as the material support of memory; like photographs, they functioned as a sensitive medium that recorded and preserved traces of

people and events. Besides transmitting purity or pollution, a piece of cloth is, like a photograph, an object of remembrance. As a technique of codifying, recording, and processing visibility, social status and meaning, the technology of textiles preceded photography and provided essential rules for the display and the transformation of textile into social texture in photographs (Pinther 2007: 122).

With the introduction of photography into weddings, women's outfits were duplicated and 'stored' in photographs along with the events of the day. Even when the very cloth had rotted away, women possessed durable photographic documentation of their own appearance and those of other women, which they often commented on, praised or criticized without mercy. Indeed, for some women their albums served as a type of visual diary in which the photographs gave durable evidence of a rival's victory or defeat, thereby continuously feeding the social memory that, without the photographs, might more easily efface some women's catastrophic defeats. Although photographs are 'cuts' in time and space (Dubois 1998: 155ff), they have the power to prolong an event of the past, to extend and renew it in the present. And they can prolong the shame of having been defeated as well as the joy and pleasure of success.

Photography, *purdah* and the withdrawal of women from visibility

Since the 1980s, within the context of a new Islamic revival, pious Muslim men and women have increasingly attempted to control and reduce the visibility of women. With the discovery of oil in the 1970s and the recent surplus of wealth, reformed Islam, locally called Wahhabism, has spread to the East African coast. While criticizing various local (Sunni) practices as un-Islamic, Wahhabism must also be seen as a response to the West and the increasing growth of secularism. In addition to cautions against heresies such as celebrating the prophet's birthday, erecting shrines on graves, seeking assistance from the dead, mourning for longer than three days, spirit possession rituals, and using music as part of worship, Wahhabism has also strongly reinforced Islam's preference for aniconism and notions of female purity. Since 1988 in Nairobi and since the 1990s also in Mombasa, new Islamic schools called *mahad* have been established especially for women to teach what is *haram* (forbidden) and what is *halal* (allowed). In these schools, the visibility of women in photographs (and other media) is problematized and discussed. What used to be a theological debate among scholars has become increasingly popularized nowadays. Thus, interactions and oppositions between different Islamic traditions as well as interactions with the (Christian) West have created a more intense awareness of the ways images (of women) intrude into everyday life and have opened up various debates on Islamic aniconism in relation to visual media.

These debates form part of a more general discourse criticizing the West as materialistic, amoral, and degenerate, giving warnings against Westernization while at the same time invoking Islam as a source of identity and authenticity. In strong opposition to the West, a moral and visual order has been actualized that seeks its basis in 'traditional' Swahili culture and more importantly in (reformed) Islam. It favours an Islamic ideal of (gendered) modesty, purity, and seclusion – *purdah* – that does not allow women to expose themselves in public and has been redefined to include photographs of women as well as videos,

tape recordings, and paintings. Pious Muslims have drawn attention to the complementary effects of unveiling and women's exposure in photographs and videos, both of which violate purdah. While veils and other textiles cover and protect the (female) body, the camera unveils and reveals what should not be seen in the public domain. This is why photographs of Muslim women have disappeared completely from the public sphere. In addition, in many houses photographs of (male and female) relatives or friends have been removed from the sitting room and either put up in the more private domain of the bedroom or stored in albums. However, I heard of only one case in which a pious woman destroyed all her photographs in order to comply with Islam's aniconism. The other women I talked to kept their photographs more or less hidden in albums or boxes to control access to them.

It is not only that photographs may reveal women's faces and bodies to unrelated men, it is also the quality of photography as a mass medium that poses special problems. When a photographer takes a picture of women dancing, for example, he or she can produce many copies and publish them so that they may appear at a distance in time, space and context from the original event. Photographs can be displayed in contexts beyond the control of the photographed women, and this poses complex and worrying problems.

Whereas in the 1980s, photographs were 'a must' and 'everything and everybody was photographed' nowadays at a wedding many women prefer regulations that allow them to control picture taking. In such a context, *not* photographing becomes as much of a statement as photographing (cf. Michaels 1991: 270). At one of the weddings I attended in August 2007, a special space – a decorated stage – was reserved for taking pictures. Only women who climbed onto the stage were photographed. At another wedding, women used their veils even inside the room to protect their faces from being photographed. No videos were taken. I was informed that some pious families preferred not to record weddings anymore. Video cassettes and DVDs showing women dancing an elaborate *chacacha* dance full of sexual allusions, had been sent to relatives living in the Diaspora and had been seen by unrelated men creating domestic tensions to the extent that a few marriages even split up. This, I was told, was one reason why the video camera was banned from (some) weddings.

Whereas some families continued to send 'modest' photographs to relatives, others stopped doing so. While in the 1970s and 1980s hundreds of photographs were produced as part of the ostentatious display of wealth and status and given as gifts to the guests and sent to relatives living abroad, nowadays, at least in pious families, only photographs of the two main moments of heightened visibility are printed for the wedding album of the bride. Thus, the exchange and circulation of photographs (of women) as a gift and counter-gift and as a kind of 'family currency' has been greatly restricted, sometimes even abandoned. Pious families have dispensed with one of the most important qualities of photography: its capacity to celebrate the extended family as a unit, and, at the same time, as an instrument and tool to effect that unity (Bourdieu 1981). Such families have also dispensed with the specific qualities of photographs as gifts, as a possibility to give oneself to another by offering oneself in a picture. To assure *purdah*, they have renounced the 'binding quality' of photographs and videos and the chance to 'repeat' the feast and enjoy once more the 'special moments' of heightened social density that a wedding provides when reviewing the wedding video or the wedding photographs.

However, there were also Muslim women who did not mind being photo-graphed at all as long as they were 'modestly dressed'. In addition, some Muslim families seemed to be indifferent to reformed Islamic tendencies and continued to celebrate their weddings in the manner of the 1970s. I attended one such wedding in 2007, where a range of female and male photographers and also affluent women guests took hundreds of pictures, some with their own digital cameras or mobile phones. A woman also recorded the audience and the dancing on video. But some guests were not happy about the way women had been photographed by male photographers. They also objected to the fact that the bridegroom was accompanied by other men when he entered the hall to take the bride home.

Because of this reinforced separation of women and men and because many women prefer to be photographed by other women, a new professional field has opened up for women. In the private domain of the home and during external festivities, female photographers have started to take pictures of women for women and their close relatives and friends. While photographers everywhere in Africa are predominantly male,[8] on the East African coast female photographers as well as female video producers have emerged and occupied a professional space that formerly belonged to men. I talked to some women in Mombasa and Lamu who had become professional photographers and video producers and specialized in taking pictures and videos of women at weddings and other celebrations. They are requested to take great pains to develop and print photographs of women in such a way that no unrelated man will see them. Even with such limitations, they are doing well and make a living. In the restricted female domain, women have made use of the segregation of the sexes to control and author the production of their own images. Here, relatively independent of the male gaze, they invent their own representations. These women are, however, reproducing a femininity that, as always, derives from elsewhere. I remember the complaints of a few husbands who realized that the money they gave to their wives, as well as the enormous amount of energy the women spent to look beautiful and fashionable was not so much directed at pleasing them, but to please and impress other women. In a way, the gaze with which the women are fixing themselves in photographs could be understood as a partial expropriation, as a theft of the former closed relay between the camera, the male photographer, and the male viewer.

Against the background of the actualization of *purdah* and its extension to visual media such as photography (and video) in recent times, it has become obvious that the role of new media is not only to expand transnational Muslim networks and to increase visibilities, as has been assumed in a rather general way by scholars such as Eickelman and Anderson (2003: xiv). Instead, there are also counter-attempts to withdraw from visibility and to interrupt the flow of images, in particular the images of women, and to create new opacities.

In postcolonial Kenya, as a marginalized, discriminated, and repressed minority – especially after the Embassy bombings in 1998 and 9/11 – a number of Muslims have given up a public presence in the mass media and instead

[9] According to the research of Erika Nimis (2006), in southwestern Nigeria women photographers have multiplied since the 1990s, rising to the highest number of women photographers in West Africa (Nimis 2006: 427). But the reason for success seems to be above all that the training of female photographers has become a substantial source of profit for some (male) photographers in this region (ibid.: 431). Unfortunately, Nimis's article celebrates the feminization of the photographic profession without further exploration of the conditions for this specific local development.

have opted for invisibility, secrecy, and opacity, contrary to the Western ideal of transparency. At the same time, others are seeking new forms of visibility and presence. Although contradicting the logic of mass media, the withdrawal from visibility may not only be understood as a loss, but also as an act of empowerment. As Michel Foucault (1977) has suggested, visibility is a trap, and it seems that at least some Muslims on the East African coast are attempting to avoid it.

Bibliography

Adrian, B. 2003. *Framing the Bride. Globalizing Beauty and Romance in Taiwan's Bridal Industry*, Berkeley CA: University of California Press.

Beck, R. 2001. *Texte auf Textilien in Ostafrika*. Cologne: Köppe Publisher.

Behrend, H. 2009. 'To Make Strange Things Possible': The Photomontages of the Bakor Photo Studio in Lamu, Kenya', in *Media in Africa*, (eds) J. Middleton & K. Njogu. International African Institute, Edinburgh: Edinburgh University Press.

—— 2013 (forthcoming). *Contesting Visibility: Photographic Practices and the 'Aesthetics of Withdrawal' along the East African Coast*, Bielefeld: Transcript.

Bourdieu, P. *et.al.* 1981. *Eine Illegitime Kunst. Die sozialen Gebrauchsweisen der Photographie*, Frankfurt: Europäische Verlagsanstalt.

Clifford, J. 1997. *Routes. Travel and Translation in the Late Twentieth Century*, Harvard MA: Harvard University Press.

Debord, G. 1967. *La Société du Spectacle*, Paris: Editions Buchet Chastel.

Dubois, P. 1998. *Der fotografische Akt. Versuch über ein theoretisches Dispositiv*, Amsterdam & Dresden: Verlag der Kunst.

Eickelman, D. F. & J. W. Anderson (eds). 2003. *New Media in the Muslim World*, Bloomington ID: Indiana University Press.

Foucault, M. 1977. *Überwachen und Strafen. Die Geburt des Gefängnisses*, Frankfurt: Suhrkamp Verlag.

Fuglesang, M. 1994. *Veils and Videos. Female Youth Culture on the Kenyan Coast*, Stockholm: Almqvist & Wiksell for Stockholm University.

Glassman, J. 1995. *Feasts and Riots. Revelry, Rebellion and Popular Consciousness on the Swahili Coast 1856-1888*, London & Nairobi: Heinemann and James Currey.

Kindy, H. 1972. *Life and Politics in Mombasa*, Nairobi: East African Publishing House.

Latour, B. 1986. 'Visualisation and Cognition: Drawing Things Together', *Knowledge and Society* 6: 1-40.

Loimeier, R. 2006. Coming to Terms with 'Popular Culture': The 'ulama' and the State in Zanzibar, in *The Global Worlds of the Swahili. Interfaces of Islam, Identity and Space in 19th and 20th Century East Africa*, (eds) R. Loimeier & Rüdiger Seesemann. Berlin: Lit.

Mauss, M. 1968. Essai sur le don, in *Sociologie et anthropologie*, Paris: Presses universitaires de France.

Michaels, E. 1991. 'A Primer of Restrictions on Picture-Taking in Traditional Areas of Aboriginal Australia', *Visual Anthropology* 4 (3-4): 259-75.

Middleton, J. 1992. *The World of the Swahili. An African Mercantile Civilization*, New Haven CT & London: Yale University Press.

Nimis, E. 2006. 'The Rise of Nigerian Women in the Visual Media', *Visual Anthropology* 19 (5): 423-41.

Parkin, D. 2005. Textile as Commodity, Dress as Text: Swahili Kanga and Women's Statements, in *Textiles in Indian Ocean Societies* (ed.) R. Barnes, London & New York: Routledge Curzon.

Pinther, K. 2007. 'On the Parallel History of Cloth and Photography in Africa', *Critical Interventions: Journal of African Art History and Visual Culture* 1: 113-23.

Silverman, K. 1996. *The Threshold of the Visible World*, New York & London: Routledge.

Sontag, S. 1977. *On Photography*, London: Penguin Books.

Strobel, M. n.d. 'Muslim Women in Mombasa, Kenya, 1890-1973'. PhD Thesis, University of California, Los Angeles, 1975.

—— 1975. 'Women's Wedding Celebrations in Mombasa, Kenya', *African Studies Review* 28 (3): 35-45.

Swartz, M. J. E. 1998. 'Justified Dissatisfaction and Jealousy in Mombasa Swahili Culture', *Afrikanistische Arbeitspapiere* 53 Cologne.

Taussig, M. 1995. 'The Sun Gives Without Receiving: An Old Story', *Comparative Studies in Society and History* 37 (2): 368-98.

Turner, V. 1969. *The Ritual Process: Structure and Anti-Structure*, New York: Aldine de Gruyter.

Ceremonies, sitting rooms & albums
How Okiek displayed photographs in the 1990s[1]
Corinne A. Kratz

12

His living room is a box in the theater of the world.
Walter Benjamin (1999: 9)

The photo evolves its own life through the context of display.
Divya Tolia-Kelly (2004: 682)

The changing ways that people display and use personal photographs constitute a telling intersection of visual and political economies, showing how visual resources and aesthetics are caught up in and help forge differences of power, status and value in particular settings. This path through the 'social life of photographs' weaves together notions of personhood and identity, memory, narrative, the differentiated meanings of domestic space, and social relations dealing with family, friendship, gender and generation (Appadurai 1986; Kopytoff 1986; Pinney 1997). At the same time, display histories draw attention to how photographic objects become part of material practices of decor, ritual, storytelling and exchange (cf. Myers 2005: 89), helping to shape the texture and affective potential of various contexts, events and experiences. Theoretically, the topic bridges and combines optics and insights from several literatures on photography in Africa and material culture. This synthesis can be further enriched with work on landscape and place as well as exhibition and display.

To examine these issues and processes, I will turn to Kenya in the 1980s and 1990s, where Kipchornwonek and Kaplelach Okiek[2] were in the midst of far-reaching social and economic transformations. Shifts in daily life and practice at the time included greater interest in having and displaying photographs, increases in the number of photographs individuals held, a new house type with a sitting room where photographs were displayed, and creation of photo albums. The extent to which individuals embraced these shifts, and when they did so, varied. The ways Okiek related to photographs in the 1990s, then, trace one of 'photography's other histories' (Pinney & Peterson 2003) and offer interesting perspectives on shifts in visual culture and the social work that people do with photographs as they endow them with meanings and values through acquisition, exchange and display. As Elizabeth Edwards argues, photographs are 'relational objects', and 'it is only by engaging with the mundane and taken-for-granted that we can see what photographs

[1.] Discussions with kind colleagues helped me develop and improve this paper: Johnnetta Cole, Joanna Davidson, Carla Freeman, Christraud Geary, Erin Haney, Patricia Hayes, Heather Horst, Ivan Karp, Christine Kreamer, Erika Nimis, Doran Ross, Michael Rowlands, Jay Straker, Amy Staples and Richard Vokes. My title pays homage to Sprague's pioneering articles on photography in Yoruba life (1978a, 1978b).
[2] My field research with Okiek covers 1974-1994. Since 1994, we have been in touch by letter and email. In the late 1990s, several Okiek founded non-governmental organizations to bring recognition to land issues. These organizations use the spelling 'Ogiek' in their names, and that has become preferred spelling for everyday use. 'Okiek' is the phonemically accurate rendering and I use it to be consistent with the phonemic spellings in my publications for all Okiek words and texts.

actually do in social terms' (2005: 27). When the mundane includes domestic display practice, we also see how the material forms and configurations in which photographs appear can shape and define that social work.

In recent decades a substantial literature has addressed photography in Africa as representation and self-fashioning, considering both photographic histories and contemporary studio, itinerant and art photographers (Wendl & du Plessis 1988; Kaplan 1991; Behrend 2000; Buckley 2000, 2006; Geary 2003; Vokes 2008; Peffer 2009; Haney 2010; Wu 2010).[3] While valuable, an emphasis on representation and photographic production may overlook the many uses, meanings and contexts involved in the circulation, consumption and interpretation of images. Other fruitful work foregrounds photographs' evocative and mnemonic roles and their effectiveness as a medium for negotiating social relations. These studies of how photographs relate to memory, narrative, identities, social relations and histories intersect with burgeoning work on material culture, adding the 'materiality of pictures' to analyses of representation, imagery and composition (Poignant 1996; Parkin 1999; Edwards 2005: 27; Miller 2005; Edwards, Gosden & Phillips 2006; Meyer 2010: 103-6).

These themes also resonate with the anthropology of place and landscape, building on classic studies of symbolism in domestic space and offering analytical tools for studying how placement and use of material objects such as photographs help constitute and communicate personhood, social relations and the life course and create affectively textured settings (Bender 1993; Hirsch & O'Hanlon 1995; Keane 1995; Stewart 1996; Feld & Basso 1997; Weiner 2002; Beidelman 2003; Low 2003). Inventories of domestic material culture (including photographs) contribute to analyses of consumption, identity and class, but patterns of collection, arrangement and domestic display have received less attention and may be particularly relevant for photographs. Scholarship on exhibition and display in other settings is thus helpful (Ruffins 1985; Karp & Lavine 1991; Bal 1996; Greenberg, Ferguson & Nairne 1996; Kirshenblatt-Gimblett 1998; Kratz 2002, 2011; Karp, Kratz et al. 2006).

If personal photographs capture particular moments and serve as evocative mnemonics, documentation and testimony to situations and events, they do so in specific contexts and interactions. They provide resources through which people might create, foster and advertise social relations; imagine, shape and show identities, values and personhood; and bridge past, present and future. In the process, photographs may be embedded in various narratives and endowed with meanings and emotions. But where and how does this happen? Does it matter if photos are stored away, put on display or circulated in various ways? Who sees them and how are they shared? When contexts of use and display include domestic space, as they often do, the very locations may also become meaningful through narration and emotionalization, contributing to photographic associations and significance (Cieraad 1999: 6-7; cf. Parkin 1999: 313).

In parlours in postcolonial Cameroon, for instance, 'photos of family members receiving awards or attending prestigious occasions will usually be accompanied by religious symbols and Christmas style decorations'

[3] See Morris (2009) for comparable work on Asia.

(Rowlands 1996: 206), while large family portraits, including photographs, hung high in the halls of wealthy Gold Coast homes in the 1840s (Haney 2010: 121). Decor in a West Indian front room in 1950s-1970s London might have enlarged coloured passport photos, crocheted lace doilies and varnished wooden clocks (McMillan 2003: 408-10; Miller 2008: 400), while 1980s homes around New York city showed clusters of photographs that 'reflect a shift from formality to informality' (Halle 1993: 108, 96). Sitting rooms and photo albums go together in some places (Kaplan 1990, 1991; Mustafa 2002; Buckley 2006; Vokes 2008), but the particular histories and social transformations that brought them together, and how that conjunction is configured and understood, varies.

I turn now to one such history to consider how Okiek were reconfiguring photographic display in a context of wider social transformations in the 1980s-1990s. Different modes of display emerged in Okiek life in association with different conjunctions of economic activity, architecture, land tenure and related changes. They first displayed framed photographs temporarily, during initiation ceremonies, a practice with clear conventions and aesthetics by the 1980s-1990s. Later they were hung in sitting rooms and arranged in albums, practices still uneven and emerging at that time. By exploring these entwined shifts in visual and political economies of photographs, I hope to add consideration of display practice to the rich testimony offered by ethnographic and historical studies of photography in Africa and elsewhere, and to continue expanding discussions of photographic practice and history to include rural areas (*cf.* Werner 2001; Vokes, this volume).

Entwined transformations: economy, architecture, photography[4]

Kaplelach and Kipchornwonek Okiek histories with photography entwine with significant social and economic shifts in their lives since the 1940s-1950s. Okiek began diversifying their forest-based hunting and honey gathering economy by planting small gardens during the colonial period. Kipchornwonek started in the late 1930s-1940s, while Kaplelach began ten to fifteen years later. Initially they continued moving among forest zones with different honey seasons, but eventually this simple addition would ramify through many domains of life, resulting in different residential, subsistence and consumption patterns that included larger gardens and herds, more permanent houses and settlements in mid-altitude forest and gendered labor changes. The addition of small gardens followed a period of far-reaching colonial policies that altered land distribution and use for Okiek neighbors, creating native reserves for both Maasai and Kipsigis and appropriating fertile highlands from Kipsigis for European settlement. It took several decades for effects of these policies to reverberate throughout the region and affect Okiek more directly, but eventually Kipsigis extended their grazing and settlement into western Kipchornwonek areas.[5] Several of these changes coincided during the 1950s. By the 1970s-1980s, these economic and demographic transformations produced what seemed a relatively stable mix of farming maize and millet, keeping small herds of cattle,

[4] This section draws on Kratz (2002: 141-8) and Kratz (in press).
[5] Other Okiek groups were directly affected by colonial land policies, when they were moved or displaced from their forest tracts. See Huntingford (1929), Dale, Marshall and Pilgram (2004) and Kimaiyo (2004). Kratz (2010: 70-92) provides detailed description of Kipchornwonek and Kaplelach economic diversification and related changes.

Figure 12.1
A kaat aap
Okiek *(Okiek
house) could
be constructed
relatively quickly
and was the kind
of house Okiek
lived in when they
moved seasonally
to different parts
of the forest.*
Tirap, 1975.
Photograph by Corinne
A. Kratz

sheep and goats, gradually decreasing hunting and honey collecting by Okiek men and some aspirations to larger gardens and cash crops.

An architectural shift related to these transformations changed possibilities for photographic display, as Okiek began to acquire photographs. When moving seasonally as hunters and honey-gatherers, Okiek built small homes with an elongated framework of flexible branches, roofed with cedar bark and insulated with bark and leafy branches (Figure 12.1). A *kaat aap Okiek* (Okiek house) could be constructed relatively quickly, and people might have several to use as honey ripened in different ecological zones. As the name suggests, Okiek regard these as 'traditional' and distinctively Okiek dwellings, part of their history as hunters and honey-gatherers (Kratz 1993). In a 1984 interview about ceremonial history, a senior woman noted that they still lived in these houses when she was initiated into adulthood during *il ny'angusi* age-set (1940s-1950s), so they could not decorate them for ceremonies as Okiek do now.[6] Men of this age-set were the first Kaplelach to encounter personal photographs, though photos remained unfamiliar for most.

As Okiek made larger gardens, they also began establishing more permanent settlements in mid-altitude forest from which they continued to make hunting and honey gathering trips. The *kaat aap suusweek* (grass-roofed house) became the standard dwelling – a larger, sturdier building with peaked thatch roof and mudded walls (Figure 12.2). These were the homes where Okiek started hanging framed photographs to decorate for male and female initiation ceremonies, a practice begun during *eseuri* age-set (1960s-1970s). The mud walls and higher ceiling allowed photographs to be hung for these occasions,

[6] Okiek men belong to named initiation age-sets. Age-sets cover a number of years and provide a useful chronology for Okiek history and comparing age cohort experiences. Kratz (2010: 61) lists Okiek age-sets and corresponding dates.

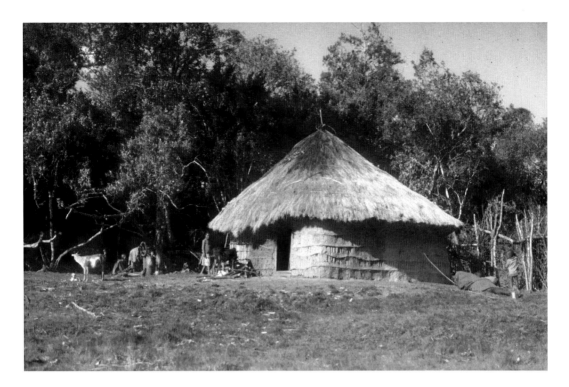

but the fire maintained inside for cooking and heating precluded longer-term display because smoke and soot would accumulate on them. Again, Kaplelach followed Kipchornwonek in these shifts. Kaplelach experience with personal photographs remained slight during *eseuri*, but age-sets from the 1980s onwards had more experience with them and increasing interest in obtaining photographs in studios or, later, from itinerant photographers who began appearing in the 1990s.

By the mid/late-1980s, other broad transformations had been taking shape in Okiek life in conjunction with state-initiated land tenure changes. If the effects of colonial land laws on Kaplelach and Kipchornwonek were mediated through neighboring communities, these postcolonial reallocations and redefinitions engaged Okiek directly, amplifying earlier shifts and combining with other factors to reshape Okiek communities and social relations in barely a decade. The postcolonial government legislated general land demarcation in 1969, but before that a policy creating group-owned ranches was developed for Maasai-dominated districts (Galaty 1980:161). Okiek land in Narok District was included, though their fertile highland forests differed sharply from semi-arid Maasai savannah. Group-ranch demarcation began in the 1970s, crossing lineage land boundaries, incorporating non-Okiek into groups situated in Okiek lineage territories, and registering some Okiek land to individuals who never lived there. Highest altitude forests became forest reserve.

In the 1980s Okiek learned of new policies for subdividing group-ranches into individual holdings and began working out individual claims and boundaries in anticipation of the division. Settlement patterns shifted again as people dispersed to land they would claim. Subdivision would enable individuals to sell or lease their land. Long before demarcations were official, most Okiek began to do so, paving the way for a large influx of settlers from western

*Figure 12.2
As Okiek made larger gardens and more permanent settlements, a thatched, mud-walled house (kaat aap suusweek) became the standard dwelling. Beginning in the late 1960s and 1970s, the outer room of these homes was decorated for initiation ceremonies. Ng'apng'eenta, 1983. Photograph by Corinne A. Kratz.*

Figure 12.3
A later architec-
tural addition
for Okiek was
the kaat aap
mabaatiinik,
with metal
roofing. The
sitting room
in such houses
became a place
for photographic
display. Nkaroni,
1983.

Photograph by Corinne
A. Kratz.

Kenya areas with land shortages. A trickle of new Kipsigis or Kisii neighbors in the late-1980s became a host of immigrants in the 1990s, significantly changing the region's demography and environment. By the late 1990s major forest areas had been cleared and Okiek were effectively a minority in an area once populated by kin and friends. Daily interaction patterns changed too as immigrants became their Okiek vendors' nearest neighbours.[7] As individual Okiek made different decisions about managing land sales and the money they brought, wealth disparities increased. And while Okiek did not regard land sale proceeds as 'bitter money' (Shipton 1989), bad choices and poor judgement entangled some in difficult situations and fraud. My fieldnotes in January 1989, after eight months away, noted one example:

> Money is much more available now than I have ever heard of, and in large sums. M. has bought a maize grinding mill and wanted to build a *mabati* shed near N.'s for it. At the moment the shed is not done, though *mabati* has been brought. He also has a vehicle, an old, old Land Rover that he bought through a long story that L. [his wife] told me about a Kipsigis man who made friendship with him and then over time cheated him out of about Ksh. 50,000/ (!!) [then about US $2175].

[7] Other factors combined with these broad transformations. These included greater participation in education as schools, roads and shops were built. For Kipchornwonek, the late 1970s saw a school opened at Sogoo, construction of a road, the government post of assistant chief established for the area and rapid growth of a market centre. These developments also had implications for Kaplelach further east. Schools and shops in their immediate area began opening in the mid-1980s, with additional commercial centres and schools established in both areas during the 1980s–1990s. In the late 1990s, two young Kipchornwonek men created NGOs, joining a Nakuru-based Okiek NGO registered a few years earlier, to bring recognition to Okiek issues and representation at regional, national and international levels. Cf. Hodgson (2001, 2002, 2007) on Maasai NGOs in Tanzania.

All these developments were part of growing Okiek integration into regional and national concerns in the last twenty years.

These recent transformations were associated with another architectural change, as Okiek started building multi-roomed, tin-roofed, mud-walled frame houses (kaat aap mabaatiinik; house of mabati [Kiswahili for tin roofing]), the construction of which entailed the considerable expense of carpenters and materials (Figure 12.3).[8] By early 1983 some Kipchornwonek in my research area had begun to build them. Most consisted of a central sitting-room with a small room off each side, used as bedrooms or sometimes for storage. By 1988, when Kaplelach started building mabati houses, virtually all Kipchornwonek families had them and some were constructing more elaborate, L-shaped structures with additional rooms and talking about building stone houses. Income from land sales enabled most Okiek to build the new houses.

Two features of the new houses were pertinent for photographic display. First, mabati houses had no hearths or open fires. Families continued using their kaat aap suusweek for cooking and some still slept there. If the mabati house was cold, a small charcoal stove might provide heat, but without generating smoke and soot to blacken roofing or things hung inside. Second, the houses had sitting-rooms where people began to hang framed photographs that were previously archived in trunks or bags, pulled out occasionally for ceremonies or to show visitors.

Okiek experience with and attitudes toward photographs have been age-stratified, as this history suggests. Older Okiek encountered personal photographs later in life and came to appreciate them as reminders of events and people, signs of friendship, and indicators associated with development and modernity; some have visited photographic studios or sought photographs to display. Younger Okiek became familiar with them at an earlier age and typically were more interested in acquiring photos, as well as saving, trading, loaning and framing them. They were the ones who began making photo albums in the 1990s. Architectural changes connected to broad transformations in Okiek life have also been a factor in the political economy of photography in the area. When people began displaying photos in mabati houses, what was shown had often been photographed somewhat by happenstance. Relatives or friends might have visited a studio together when already in town on errands,[9] or gotten photographs from friends or agemates. Reviewing photograph collections, often quite small, on display in sitting-rooms was a spur for some to identify photos they wanted to include and which might inspire them to acquire more. Few Kaplelach in the early 1990s had enough photographs to both frame for display and have in an album.

Like the 1970s oil booms in Trinidad and Nigeria, though on a smaller scale, land sales brought Okiek a short-lived influx of money in the late-1980s and 1990s (Barber 1982; Miller 1990). This had material manifestations in people's homes and clothes, as well as splurges on food and drink and various investments to develop their properties and projects. Proceeds from land sales allowed Okiek to build mabati houses and provided disposable income,

[8] In 1983, constructing a basic three-room mabati house cost roughly Ksh 15,000/. Basic furniture (four chairs, table, bed frame) might add 1,500/ to 2,000/. The exchange rate was Ksh 14.3 = US$1.

[9] Cf. Vokes (2008: 352 and this volume) on expenses for visiting a photo studio. Some Kaplelach might walk to Narok, but the day-long trip was an investment of time and effort and required money for food.

temporarily at least, with which younger Okiek could indulge photographic desires. With this background on the interconnected transformations in Okiek life and the political economy of photography in the past sixty years, I look more closely at Okiek photographic display.

Initiation homes: photographs as innovation and decorative element

During this same period, Okiek introduced and expanded their modes of photographic display. They first displayed framed photos to help decorate grass-roofed houses for initiation ceremonies; some twenty years later sitting-rooms and albums, the other contexts for photo display, became part of the mix. Display practices are tied to time and space in ways that shape associated activities, expectations, the experiences they offer, and even their social and affective potentials. They are situated in and help create the material texture of settings and occasions. Okiek photographic display ranged from ephemeral, occasion-specific ceremonial decor, to long-term exhibition as part of domestic space, to more focused, portable and intimate album viewing. Each lent itself to different modes of visual and discursive attention, different ways of looking and narrating, different aesthetic variations. Each incorporated and indexed social relations of kinship and friendship, as well as particular identities and values.

Okiek began decorating the outer room where guests sit during initiation ceremonies in the late 1960s and early 1970s, part of concurrent changes that constituted a kind of neo-traditional ceremonial practice (Kratz 1993: 54). During my research in the mid-1970s, one typical ceremonial house decoration[10] consisted of a canopy ceiling created with cotton cloths and a paper border near the top of the walls created by pinning up a row of Kepler Cod Liver Oil advertising posters, sheets of newspaper, and colourful brochures from tourist game lodges. A few framed photographs, borrowed from a relative working as a policeman in town, were hung on the border (Figure 12.4). Young men went from house to house to decorate the day before the ceremony; each host family brewed them a small pot of beer. Posters, brochures and photographs were lent around, with the same Kepler posters and brochures appearing at different ceremonies that year.

This basic decoration style remained remarkably consistent. Ceremonies I attended from the mid-1980s until the mid-1990s followed the same conventions, though border materials changed. In 1983, for instance, several homes were decorated with a roll of printed milk cartons with bright green, white and red patterns (Figure 12.5).

One of the most elaborately decorated homes that year belonged to the family of a young man who worked in Nairobi in the army. He too borrowed a milk carton roll to decorate for his brother's initiation, but his parents' house also had an upper border row made from pages of a 1981 calendar and newspaper sheets. The milk carton border covered the calendar months so the large colour calendar photos showed prominently. Five unframed photographs and three framed ones were hung on the upper border (Figure 12.6).

The *mabati* house of the assistant chief at the time was decorated in the same way for his daughter's ceremony, with ten framed photos (some borrowed) hung on a high border of newspapers. Travel brochures from Nairobi were included in some homes as well, after Kaplelach friends asked me to acquire

[10] Decoration is called *maalet aap kaa*, using the verb for smearing mud on walls (-*maal)*.

Figure 12.4
Men drinking
at an initiation
ceremony at
Nentolo in April
1975. Kepler
Cod Liver Oil
advertisements
and newspaper
form a high
border around
the walls as
decoration for the
occasion. Framed
photographs are
hung on top of
this paper border.
Photograph by Corinne
A. Kratz.

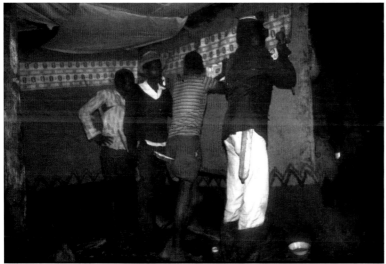

Figure 12.5
Young men
pinning up a
printed roll of
milk cartons as
they decorate
for an initiation
ceremony. Note
the cloth canopy
ceiling and
painted border
around the
bottom of the
walls. Sinentoiik,
1985.
Photograph by Corinne
A. Kratz.

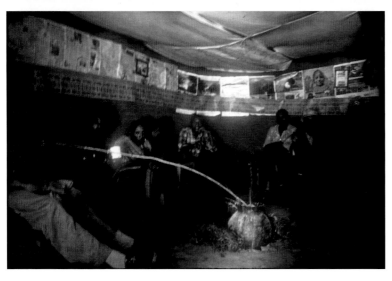

Figure 12.6 Men
drinking a pot of
maize beer in a
house decorated
for initiation.
This house had
an elaborate
border with a
row of printed
milk cartons
layered over or
below a row of
calendar pages
and newspaper.
Two framed
photographs are
hung on top of
the paper border.
Nkaroni, 1983.
Photograph by Corinne
A. Kratz.

Figure 12.7 This studio portrait of Simon Inkutukai Leboo is framed with a bright floral mat and shows props typical of Narok photographic studios in the 1980s. Narok, 1988

some for their daughter's initiation. Like other decorative border materials, they were regularly borrowed and circulated among families holding initiations. Photographs too were borrowed, and when girls went to invite friends and relatives from elsewhere, they might return with framed photos.

This sketch suggests both the broad circulation of photographs and decorative materials and the relatively narrow range of decorative style in homes hosting initiations. Only a few photographs were hung in any home; two or three per wall constituted an abundance. They were incorporated into an overall display aesthetic that emphasized layering, borders and an interplay of patterned textures and colours. Some framed photos were bordered with bright floral mats, adding to the interplay (Figure 12.7).

In some homes, painted wall designs or two-tone walls added a final touch. While most houses had basic brown mud walls, some had a light wash on the upper walls, creating a low brown border. In Figure 12.5 this is enhanced and emphasized by a painted border of triangles above the brown band.[11] Usually painted by young women (sometimes initiates themselves), designs might decorate outside walls as well. As discussed below, painted wall designs may contribute to photo displays in sitting rooms too.

Some photographs in South African artist Zwelethu Mthethwa's *Interiors* and *Empty Beds* series show a similar approach to home wall embellishment in informal settlements in the Western Cape and men's hostels in Durban. Residents create a collage of 'visual exuberance' (Enwezor 2010: 108; Aperture 2010) by plastering walls with newspaper, advertising posters and circulars, and repeated images from magazines. Framed images appear in a few photographs. Taken before Mthethwa's, Chris Ledochowski's sensitive and intimate *Cape Flats Details* photographs also include several such interiors. He

[11] The triangular row is similar to some Okiek beadwork patterns. The borders and light/dark division also resonate with the beadwork aesthetic (Klumpp & Kratz 1993; Kratz & Pido 2000).

underlines that the primary purpose of plastering walls with 'the Cape printing industry's excess waste' of posters or 'sheet rolls of uncut printed labels' is pragmatic; it improves insulation, reinforces flimsy building materials and provides a clean interior surface (2003: 179, 187). Yet the arrangement of materials also shows an aesthetic sense.

Like Okiek initiation decoration, printed patterns and textures are juxtaposed and layered, but here papers and posters are treated more like wallpaper, without the concern for horizontal borders that break wall space into distinct sections. Mthethwa used these striking domestic spaces as a kind of studio backdrop for portraits, highlighting their 'drama of colour' and pattern (Godby 1999; Wu 2010). In doing so, he blurs the association of individual and home and 'the home's interior can no longer be read as a direct reflection of the sitter's identity' (ibid.: 76).[12] Like other settings where choices may be limited (cf. Makovicky 2007: 290), this South African comparison shows that the notion that home decor is a primary form of individual expression operates within material constraints, but it also operates in relation to guidelines defined by tradition, custom, fashion and community values.[13]

Okiek home decoration for initiation raises similar questions about photographs. Many studies explore how personal photography in Africa expresses identities, personhood and fantasies, considering them from the perspective of those represented (e.g. Ouedraogo 1996; Behrend 2000; Buckley 2000, 2006; Werner 2001; Mustafa 2002; Vokes 2008). How does this change as photographs are displayed, circulated, and used by others? What domestic space is used for display, how do photographs figure as part of a display, and how are they reframed by grouping, juxtaposition and particular display settings? What kinds of looking and seeing do displays encourage or instigate (Keane 2005: 194)? Why hang borrowed photographs during initiation or in sitting rooms?

Thinking about this, I could recall no one in all the initiations I attended looking directly and specifically at the photographs on the walls, as in a gallery. Nor did I note conversations about them during ceremonies when houses were full of relatives and guests. Those present typically focused on ongoing ceremonial events and celebratory drinking, often engaged in lively interaction with others (Kratz 2010). If people notice photographs hung on the decorative borders, it may be in a general way or they may be seen in glancing, indirect ways.[14] On the day when houses are decorated, however, photographs may be passed around before hanging; young men might look at them closely, identify those shown and make joking comments.

As part of initiation decoration, framed photographs became associated with particular groups and values – youth (particularly young men), ceremonial

[12] There are contradictions between Mthethwa's claims of collaboration with sitters and his exhibition of large format portraits without identification. Similar questions concern his relations with his brother's farm workers, shown in the *Sugar Cane* series (Peffer 2009: 267-8).
[13] For instance, Miller comments on the remarkable homogeneity in Trinidadian sitting rooms in furnishings, colour and decorative items and relates this to Trinidadian attitudes and values (2008: 399).
[14] Different ways of looking and viewing may be appropriate to different settings and objects, as art historian Susan Vogel shows through subtle exploration of Baule art in Côte d'Ivoire (1997). Thompson (2011) discusses performative redefinition of visibility and invisibility in Bahamian youth culture. Similarly, Empson (2007) analyses Mongolian household chests as a means for constructing social relations through an interplay between things to be seen and shown (including photographic displays) and things to be contained and hidden.

innovation and modernity. Borrowed through networks of kinship, agemate relations and friendship, photographs were also incorporated into extended social relations invoked when families host an initiation. These too were implicitly on display in the festive homes. Within visual economies of circulation and display, photographs may take on additional meanings and roles beyond representation and be incorporated as elements within other aesthetics. Different constituencies may also see and value photographic displays in varied ways.

Decorating is one way through which people transform domestic space to mark and make special occasions. Just as people in the United States might decorate for parties, Halloween or Christmas, Abaluyia women paint murals on home exteriors in western Kenya around Christmas, a practice encouraged by Quaker missionaries early in the twentieth century (Burt 1983). Similarly, Gambians update their parlours after Ramadan during the Koriteh festival (Buckley 2006: 72) and in Trinidad 'the living-room is closely related to the celebration of Christmas, which consists in large measure of buying things for the living-room, emptying it, tidying it, and ending Christmas Eve with the ceremonial re-hanging of the curtains' (Miller 2008: 399-400). Apart from such temporary changes and refurbishments of home decor, the configurations, textures and meanings of domestic space itself transform over time, with different rooms and objects taking on new meanings and associations. For Okiek, personal photographs have been part of decorating grass-roofed houses for the special occasion of initiation for over forty years now; photographs were also incorporated into architectural changes in the 1980s-1990s as Okiek created sitting rooms in their new *mabati*-roofed homes.

Sitting rooms: moral economies of photographic display and circulation

Parlour, sitting room, front room, living room, family room, den – what's in a name? In this case, different names point to fascinating histories in which region, class, gender, fashion and function intersect in domestic space. Most scholarly writing about living rooms, sitting rooms, and parlours has focused on cities or towns, with rooms that are far more elaborately furnished and decorated than those of Okiek.[15] Nonetheless, the rooms' changing associations are instructive.

'Although the parlour, copied from England, was well established as the "best room" in America by the colonial and early national period, it had been a recent development in England, at least for those outside the aristocratic dwelling' (Halle 1993: 231 n.4). In nineteenth-century England, the parlour, or front room, was reserved for special occasions and seen as women's domain; a less formal living room by the kitchen was common. During the twentieth century, house plans separating servants and employers and defining strongly gendered spaces became less appropriate as norms of sociality and formality changed. Thus, when England rebuilt public housing after World War II, open-plan houses were adopted, associated with modernity and greater social equality (Attfield 1999: 73-77; Logan 2001). Similar shifts occurred in the US, where front and back parlours were standard in nineteenth century urban upper class homes, but deemed too formal late in the century. In rural areas

[15] McMurry (1985) is a notable exception.

parlours were common but came to be seen in moral terms, as wasted space, not suited to rural social relations. From 1850 to 1900 house plans offered rearrangements that promoted a sitting room more integrated with the rest of the house (McMurry 1985: 268-79).

Class and race also factored into home design. In the US, some considered parlours inappropriate for 'working men's' homes, although many kept them through the 1920s (Halle 1993: 36). By then, 'parlors were the exception rather than the rule in most new middle-class homes' (McMurry 1985: 280); a more informal 'living room' replaced the formal room later that century. After World War II, the living room itself gave way to the den (more male associated), the rec room (for the kids), and particularly the family room, which was joined with the kitchen in the 1970s and grew larger as living rooms grew smaller (Halle 1993; Iovine 1999).

In 1950s Britain, 'racism meant postwar black settlers could only find one-room rented accommodation' and home loans for Caribbean migrants were elusive (McMillan 2003: 405-6). When they did move into properties with front rooms, the space was imbued with that struggle to achieve middle class respectability in their new country. Women defined decor, which 'signifie[d] on one level black women's aspirant mobility' and had a 'shrine-like quality... [O]ften no-one used it except on Sundays' (ibid.; Miller 2008: 400). This contrasted with understandings of the front room and regular, familial use in places such as Trinidad, so that even though decor was similar, the room indexed different kinds of respectability in the two places (Miller 1990: 52-5; 2008: 398-401).

In Africa, the sitting room/parlour/living room has more commonly been considered male space, when gendered (Kamau 1978-79: 108; Jewsiewicki 1996: 339; Platte 2004: 175). Historical information on the rooms is limited, although contemporary arrangements and decor are sometimes described (Kaplan 1990: 322-3, 1991: 222-6; Rowlands 1995: 21-3, 1996: 197, 205-7; Behrend 2000: 73; Gore 2001: 332-4; Buckley 2006). For instance, homes in South-western Uganda have had sitting rooms since the 1960s (Vokes 2008: 350), while entry to Kanuri men's rooms through a 'room furnished in the style of a "Western living room"' was a 'very recent development' in late 1990s Nigeria (Platte 2004: 175). In the Democratic Republic of Congo, the living room emerged twice in urban homes, first in the 1950s Belgian Congo 'houses of the *évolués*, who hoped to receive the status of "assimilated" (certified by a card of civic merit)' and again in 1970s Zaïre 'as a sign of local economic and social success' (Jewsiewicki 1996: 339). Gambian parlour decor was elaborated over time, beginning in the 1980s: 'We had [parlours], but not like today, not all the furnishings that there is today – just wooden chairs, a table ... but no lace, no television sets obviously' (Buckley p.c., 2006: 62).

This aptly describes Okiek sitting rooms in the 1980s-90s too. Since Okiek kept their grass-roofed homes when they built *mabati*-roofed ones, the new houses were used in several ways. The man of the house usually slept there, often joined by his wife, but it sometimes became a sleeping house for the youth or a guest house. The central sitting room was for visitors, special occasions or meetings. Often sparsely furnished, calves or chickens might also sleep there. Yet even homes with basic furnishings often had a few photographs on the wall (Figure 12.8).

This brief review shows how the parlour/sitting room is layered with

Figure 12.8
A Kaplelach
sitting room in
1993 with two
photographs hung
high on the walls.
Photo by Corinne A.
Kratz.

meanings, associations and values and how configuration and use of domestic space has interlaced in different ways with changing notions of formality, privacy, gender, class, social relations and modernity. Yet in all these settings – suburbs, cities, housing estates, towns, rural farms – sitting rooms were a place for display, underlining the material sense of associations and experiences connected with the rooms. When British planners promoted open-plan houses, some 'proposed reserving a corner as a "token parlour substitute"' where photographs and souvenirs could be shown (Attfield 1999: 79), and a 1999 US home buyer observed, 'Even if it's a room that will never be used, it's nice to have for display' (Iovine 1999: 2). Similarly, in a 1970s urban Kenyan housing estate, an attractive living room was 'as full of furniture as can be accommodated and ... lavishly decorated with pictures, photographs, embroidered cloths, and a great variety of knickknacks [sic]' (Kamau 1978-9: 110).

Rowlands talks about 'parlour culture' in Bamenda, Cameroon as a way to 'project a life style' through a creolized 'material culture of success' that conveyed a modern identity and in the 1980s drew on film, magazines, hotel lobbies and US television shows like *Dynasty* as fashion sources. Photographs were integral to Bamenda parlour decor, showing family members receiving awards, at prestigious occasions or wearing traditional dress (1994: 157-60, 1995: 21-3, 1996). Connections between photographs, sitting rooms, identity and status are widespread, recognized and represented in studio photographs that show subjects in settings that resemble parlours or sitting rooms, sometimes in their own home. 'Studios look like parlors and parlors look like studios' (Buckley 2006: 61; cf. Behrend 2000; Wendl 2001; Platte 2004: 174, 187 n.9; Peffer 2009: 266-9; Wu 2010).

Most photographs in Okiek sitting rooms in the 1980s-90s were studio portraits done in Narok town after 1986. In the early 1990s itinerant photographers began visiting Kaplelach areas, adding pictures done outside (cf. Werner 2001: 260). Photographs I had taken were also in some sitting

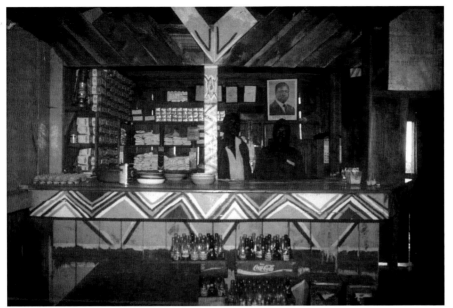

Figure 12.9 This tea shop displays a large framed photograph of President Moi with its permits and another framed photograph. Geometrical designs painted on the counter are similar to those painted on houses. The top of the pillar includes the shield from the Kenyan flag, a motif also found in initiation headdresses. Nentolo, 1984.

Photo by Corinne A. Kratz.

rooms.[16] Narok studio settings were not elaborate: background curtains, a patterned floor, and simple props such as a stool, wooden chairs and a pot of plastic flowers (Figure 12.7). This relatively austere setting echoed the basic furnishings in many Okiek sitting rooms then. Commercial venues in nearby trading centers also displayed photographs, with a prominent portrait of President Moi hung highest; some shops also plastered their walls with news-paper, magazines or had painted motifs like those on houses (Figure 12.9).

Most Kaplelach sitting rooms had two or three photos hung high on plain brown walls, though some had a larger array of images and decorative materials (e.g. posters, calendars, and occasionally religious images). Such mixtures were closer to the aesthetic of homes decorated for initiation, but less elaborate. Sitting rooms did not have paper borders around the walls (as during initiation) but painted murals offered similar counterpoint with photos in one home, the most elaborately decorated at the time.[17] A border of red, black and white designs was painted around the outside, as well as inside, high around the sitting room walls (Figure 12.10).

The inside border consisted of solid bands of colour surmounted by black chevrons filled with red and white dots. Chevrons also surrounded windows and doors and a wide reddish band formed a second, low border around the room. Large floral patterns appeared between the borders, with religious sayings in English added by the owner's brother. Over twenty photographs were hung high around the room, positioned between chevrons and sometimes on top of posters. Nails holding them handily hung artifacts of daily life as well, overlapping pictures – a leather strap, say, a comb or mirror. While Kaplelach in the early 1990s used the same kind of materials to decorate sitting room walls for daily use as for initiation, there was more range of interest and elaboration in approaches to daily decor. Generational

[16] My own history with Okiek is also entwined with Okiek photographic history. Until the 1990s, I had the only camera in the area; I always brought people copies of my photos.
[17] Burt (1983) describes western Kenya house murals with similar patterns and motifs.

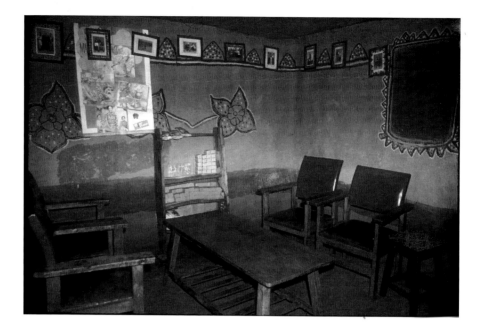

differences were one factor in this, as with initiation decoration. The home in Figure 12.10 belonged to a young couple, while Figure 12.8 shows the sitting room of older adults.

Notably, photographs were hung high, above eye-level ('skyed'), in all homes. How this convention developed is unclear, but it has been described elsewhere in Africa, from 1840s Accra, to western Kenya in the 1970s, or to 1980s Benin (Haney 2010: 121; Burt 1983: 62; Kaplan 1990: 322-3; Gore 2001: 332).[18] Given the widespread occurrence, one might wonder about distant colonial influences from Victorian parlour decor, mediated and taken up in various ways and places. Some images of Victorian parlours show pictures high on the wall, like Okiek sitting rooms.[19] In the Late Victorian period, walls were divided into three sections – dado (bottom), filling or field (middle) and frieze (top), a treatment associated with a change from skying pictures to hanging them at eye level (Logan 2001: 69; Grazhina 2007). Perhaps some colonial homes continued to use skyed hanging and it became an example in some settings.

In addition to looking at what photographs Okiek displayed, it is worth asking how they came to be there. In the mid-1990s, most people owned a limited number of photographs. Studio visits were often unplanned, happening when in town for other reasons.[20] When itinerant photographers visited, pictures included those people present, leaving others out. Though the range of people shown in displayed photographs at any time was somewhat fortuitous, images were also exchanged and passed along social networks (cf. Vokes, this volume). Each had a story of how it came to be in the sitting room, who brought or

[18] Burt's (1983) description of photographs and decoration in a 1970s Abaluyia house resembles the Okiek sitting room in Figure 12.10.

[19] See images 25 and 37 at http://picasaweb.google.com/grazhe/VICTORIANPARLORSDRAWING ROOMS#. Accessed September 6, 2010.

[20] For instance, Figure 12.10 includes an Imani Studio image showing four brothers and one brother's daughter. They went to Narok to take the child to the hospital and buy school clothes for the younger brothers. The oldest decided to have a photograph taken while there.

borrowed it from whom.[21] Together, photographs and stories sketch a moral economy of photographic display – who is shown, who is evoked, what social relations and notions of personhood and identity are indexed and created through photographic aesthetics and narratives. Given the emergent nature of photographic display at the time, this should be understood as partial, in formation.

For instance, neither photo in Figure 12.8 belonged to the homeowners; both were borrowed through affinal relations. One belonged to their firstborn daughter's husband, borrowed by his wife's sister to hang in their parents' house. This black and white Narok Studio portrait from 1987 shows their son-in-law with his brother and mother's brother's son (Kratz 2002: 149). The other was borrowed from another daughter's husband by his wife's younger brother. Taken near his home, the 1992 colour portrait shows the son-in-law by a maize field with his brother and a Kipsigis friend. The young man who borrowed the photograph told me he brought it so he could 'see' (-*suee*, to see) his male affine (*saantet*). 'Seeing' here includes a sense of 'seeing to'. For Okiek, 'seeing' can refer to fostering relations by paying attention to someone (see below). Seeing the photo would make him think of his *saantet*. He also showed me two other borrowed photos which had no frames. One showed his *saantet* with his brother near a *mabati* house; the other portrayed his sister's wedding procession.

Multi-generational family portraits and individual identity photos were prominent in 1990s Uganda (Vokes 2008: 347-9), while in 1980s Benin photographs of important persons and high status groups were shown in sitting rooms, with some placed on end tables. Benin family portraits were more often placed in interior sitting rooms or albums. Halle found photographs in clusters in 1980s US homes – on tables, shelves, and walls; a single image of a living adult alone was rarely displayed (1993: 108-11). Okiek in the 1990s only displayed photographs on walls, not on tables. There were few multi-generational family portraits, occasional large framed identity photo portraits, and the only VIP picture I saw was of President Moi.

Displayed photographs emphasized kin, usually in pairs or small groups, but also included peer groups and friends. Relatives shown most often were siblings, cousins, affines and age-mates, along with portraits of young children with one or both parents. Most notably, they represented youthful social networks, rarely including older relatives. This may not be surprising since younger Okiek were the most interested in photos: perhaps now, over fifteen years later, sitting rooms include more photographs across age groups. As seen earlier, youth networks were also prominent in photographic borrowing and exchange. Photographic occasions were not obvious in images themselves, given the circumstances in which most were taken, but were remembered and narrated. Photographs often marked visits to relatives, trips to town or market with friends or relations, or special occasions. As William Nagorum Sirma explained in 1993, you take such photographs 'so you show [your] child and tell them "That's when I went to Nairobi, I went to Narok, wherever."'

[21] Writing about genre paintings in Zaïrian living rooms, Fabian found 'a painting was valued for its capacity to remind the viewer of past events and present predicaments, specifically for its becoming the subject of [an] occasion to tell a story' (2007: 74). Similarly, Makovicky examines narratives about domestic interiors and 'epiphany objects' (2007: 289) and Money considers stories about gifts and objects displayed in Manchester living rooms (2007: 360-6).

Vokes found that personal albums in 1990s Uganda presented 'a narrative structure in which its creator was the main protagonist', creating a life story with 'key personal and familial events' and a changing array of influential personal relations (2008: 350-51). To produce such albums, cameras and photographs would have to be a more regular part of life than they were for most Okiek. Nonetheless, it is worth asking whether particular characters and relations emerge as central in sitting room displays. This may be hard to discern from small displays, although considering images together with related narratives in the example above foregrounded affinal relations as important in bringing photographs to the house in Figure 12.8.

The twenty-one photographs in the home of Simon Inkutukai Leboo and his wife Grace Chepopoo presented a different emphasis (Figure 12.10). Many showed Inkutukai with various configurations of brothers, cousins, friends, wife and young children and a co-initiate. Two showed him alone: an enlarged passport picture from his Tanzanian business exploration and a studio portrait 'so that my wife and children can see me alone'. One portrayed his mother's brother's son in Nairobi. Two were photographs I took, during his wife's initiation and her co-initiate's wedding. Finally, a photo of President Moi remained from Inkutukai's time as a shopkeeper. He could certainly be seen as the collection's protagonist, but associated narratives bring out a different sense.

Inkutukai himself initiated about ten images. Four actually belonged to his younger, unmarried brother, Daudi, taken when Inkutukai visited the family with which Daudi stayed while in school. An older brother, Sanare, initiated and paid for another four, including one done in Narok while bringing Sanare's second wife home. The Nairobi kinsman gave Inkutukai his picture. When photographic stories are included, Inkutukai still figures centrally, to be sure, but the sitting room also seems more like a collective display by the three brothers. Only Inkutukai had a completed *mabati* house then, and he gathered and displayed the photos, but the array joined the brothers as co-protagonists at the centre of a range of relations and occasions. Indeed, Inkutukai told me he had other pictures that Sanare had stored away until his own *mabati* house was built, when it seems they would be part of another collective display.

As photographs are exchanged and circulated, Okiek sitting rooms provide a place where images and associated memories and narratives come together in displays that foreground and constitute particular social relations. During initiation ceremonies, these configurations are fleeting; framed photographs are one of several decorative elements in the overall festive decor. Nonetheless, temporary photo loans are obtained through social networks that trace a range of relations and obligations. After the ceremony, borrowed photos are returned, although perhaps not immediately. Sitting rooms may also include borrowed or exchanged photographs, but the display is more lasting. In some cases, they may even offer a way of 'reconstructing the self in other people's homes and memory' by combining family photos to emphasize certain relations and identities (Marcoux 2001: 231).[22]

Vokes found that the exchange of photographs helps define personhood, and

[22] Marcoux studied how elderly Montreal homeowners distributed possessions in the *casser maison* ritual when leaving their homes, recreating their identities, relations and memories in the homes of family and friends.

that it is 'regarded with the utmost seriousness, and is used both to maintain and to extend the very networks of substantial relations' in Uganda (2008: 357). Photographic exchanges were also important among siblings, husband and wife, and close friends in Benin. 'They validate existing relationships and can be used to establish a relationship as well. Taking someone's photograph, "is like being honest with them"' (Kaplan 1990: 327). Yet photograph exchange can also signal and create a reorientation of social networks, as Simon Inkutukai Leboo illustrated in explaining one problem of circulating photographs:

> When people ask for them, to take them, they go and get lost like that. When I used to drink, I would give them to people. But now that I am part of a church and don't drink, it is [only] church people that can take them if they want to borrow them, and they won't get lost.

His comment pertains more to friends than close relations, however. Siblings and affines continued to borrow and exchange photographs and in the process to shape sitting room space and displays. Photographs inflected the rooms with sociality, affect and memories, indicating some of the owners' values through decor and associated material experiences.

Seeing my people: emergent practice in Okiek photographic display

In addition to using photographs for initiation decoration and sitting room display, Okiek also began creating photo albums in the 1990s. Fully examining this third mode of display is beyond this chapter's scope, but it too began with younger Okiek, including those attending school. Elsewhere in Africa, photo albums were a more established practice by 1990, often associated with sitting rooms and the protocol of visits (Houlberg 1988: 3; Kaplan 1990: 323; Mustafa 2002: 183; Buckley 2006: 78; Vokes 2008: 350). Kaplan, for instance, reviewed roughly forty albums belonging to royal court members in Benin. Each wife in a polygynous household had her own album, which focused on family but excluded other wives (1990: 335). Vokes viewed several hundred Ugandan albums during his research. Developed in the 1970s, they were 'a common feature of social life, especially among better-off households'. One album included twenty-one individual portraits in the final section alone (2008: 350-51).

Compared to these settings, Kaplelach Okiek were just getting started. As one album-keeper said, 'There aren't many who have albums. They don't yet see the point.' Indeed, in the mid-1990s, I found fewer than ten Okiek in my research area with photo albums, each with twelve to seventeen images total (including some I had taken). Some Kipsigis immigrants moving to the area after buying land also brought their albums. Notably, young Kaplelach women were about as likely to have albums as young men. Women with albums had attended (or were attending) school; their albums usually included class pictures and photos with school friends.[23] As in Uganda, albums were spoken of as belonging to individuals and seen as something to show visitors (ibid.). Just as for sitting rooms, they included portraits with cousins, siblings, affines and friends.

[23] Mustafa describes photographs in 1990s Dakar as a form of women's property, including elaborate wedding albums with hundreds of images (2002: 180, 185). Cf. Pinney (1997: 118-34).

Though relatively small and still taking hold as practice at the time, photo albums offered unmarried young people another way to form, show and remember important relationships and events. They presented their own social networks and established their own sense of place within their parents' household. For young married Kaplelach, albums offered a display mode for unframed photographs before the couple had a *mabati* house or for surplus photos not in the sitting room. When one young woman left her husband in 1993, she returned to her parents' home with her album of fifteen photos and a framed image of herself with her young son to hang in her parent's sitting room. Her album photos showed sisters, brother, mother's sister's son, father's brother's daughter, other cousins, school friends as well as myself and one of my sisters, but bore no trace of her married life and relations. Here, too, the album may have been a way not only to remember home and loved ones, but to maintain a sense of her own autonomous connections early in the marriage.[24] She was clearly the protagonist of her album, situated within social networks centred on her own family.

In the 1990s, Okiek displayed photographs as part of initiation decoration, on sitting room walls and in albums. Photographs became part of different forms of material practice and different aesthetic textures in each, showing the adaptability of photographs as material objects. Photographic circulation was central to creating these display practices and to the meanings and social relations that Okiek constitute through display, showing exchange and display as linked facets of photographs as relational objects. Tracing shifts in how Okiek display photographs led through the tangled intersections of visual and political economies, showing how photographic display has been interwoven with socioeconomic and architectural changes and with the transformations in social relations related to land sales, immigration and growing participation in schools.

Initiation decoration, the longest-standing of the three, began after Okiek were building thatched, mud-walled homes and it became common neo-traditional ceremonial practice by the 1970s (Kratz 1993: 54). Photographs were one element of a decorative border that featured a layered interplay of textures and colours. An ephemeral embellishment created for the occasion, the components of initiation decoration were largely borrowed, brought by young men and combined as they decorated the house before the ceremony began. Young men showed more interest in photographs in general and placed greater value on acquiring them than more senior age-sets.

With *mabati* houses in the 1980s came sitting rooms without wood fires and the possibility of more enduring photo displays. The sitting room remained a somewhat inchoate space at the time, its emotional and social valence only partially defined. Associated more with men than women, it was generally seen as a place for guests. Beyond that, the sitting room could be a multi-purpose space. Depending on household and occasion, it might be where men took meals, young people gathered, visitors slept, things were stored, or also where calves or chickens slept if furniture was minimal. In the 1990s, sitting room displays covered a similar range, from blank walls to a handful of framed images or an ample set of photos, hung high and interspersed with

[24] I had no sense that she removed or left behind photographs of her husband or affines. She said her husband sent an itinerant photographer to take the framed photo and two others – individual portraits of her son and herself, since her husband was absent when the photographer came.

painted wall designs, posters and calendars. Photos displayed might have been acquired and framed by the homeowners, represent a joint collection drawn from close relatives, or simply be borrowed from various friends and relations. A moral economy of display emerged when the photographs were considered together with the narratives they evoked. Again, younger Okiek were more enthusiastic in creating sitting room photo displays.

Photo albums, the most recent of the three display modes, were still catching on among Kaplelach Okiek in the 1990s. Once more, young people were the vanguard. The photographic range was similar to sitting rooms, but some albums featured school friends more prominently as more Okiek attended school.[25] While young women had relatively slight roles in initiation decoration and sitting room display, they were among early album-keepers. Albums were personal photographic collections that allowed them to construct their own narratives of connection and kinship, emphasizing some relations and experiences over others. Although collections shown in albums and sitting rooms were somewhat fortuitous, they nonetheless encapsulated notions of personhood and family, along with values related to youth, town settings and modernity.

If exploring how Okiek displayed photos in the 1990s has illuminated shifts in visual culture and intersections of visual and political economies in their particular history, it has also shown the importance of photographic circulation and display in tracing how memories are shaped and sustained through photographs, and how people form, portray and nurture identities and social relations with them. In late 1970s Chicago in the US, older people placed greater value on photographs (Csikszentmihalyi & Rochberg-Halton 1981: 66-9), but age-stratified Okiek experience with photographs led to the opposite: younger Okiek were consistently more involved in photographic display. Nonetheless, when Okiek talked about why they hung photographs in sitting rooms, they echoed comments from the Chicago study and many other situations (Chalfen 1987, 1991; Halle 1993: 115; Parkin 1999; Gore 2001; Edwards 2005: 27-33; Vokes 2008). They stressed the mnemonic capacity of photographs to remind them of family and friends, of significant or memorable occasions, and to inspire stories – personal narratives that bound them to the people and places depicted through 'narratives of remembrance, evocative imitations, and identifications bridging time and place' (Kratz 2002: 54).[26]

'Seeing' was a recurrent idiom for talking about why photographs matter, found in quotations cited earlier about getting photographs to hang in order to 'see a brother-in-law', or so 'my wife and children can see me alone'. Simon Inkutukai Leboo elaborated further, saying that he likes photographs so he can 'see his people':

> You see your mother, you see your father, you see your children when they are still young. So when you are old you see them, you say at such and such a time the picture was taken. They were healthy then, they were thin then, they were rich then, they were doing such and such a work at that time.

[25] School-related photographs included other poses and gestures. I have not been able to consider here how these relate to changing identities, values and relations or the narratives and kinds of attention associated with albums. Compared to initiation decoration, albums invite more intense looking and scrutiny of photos, foregrounding the images rather than a broad decorative aesthetic.
[26] For discussion of Okiek commentaries about photographs in a travelling exhibition, see Kratz (2002: 148-57).

The literal sense of visual perception was certainly one aspect of these comments. But for Okiek, 'seeing' is an idiom also used in talking about visits, ceremonies and marriage negotiations. In the first two, it is a way of reporting whether one was cared for, fed well, given attention and treated with respect. As a marriage negotiation meeting ends, the bride's family may tell the groom's family 'We've seen you' as a way of concluding and summarizing the situation. This means their interest and intent has been recognized and the negotiation process will continue (Kratz 2000). For both sides, it also means developing and nurturing the potential alliance. These notions of 'seeing' add another dimension to Okiek comments on photographs, pointing to photographic display as a way of fostering and sustaining social relations and giving care and attention to relatives and friends. Inkutukai's comment anticipates long-term relations and shared memories, ongoing and future conversations about a long life, interwoven with relatives and friends shown in his sitting room gallery of photographs and the changing narratives which the photographs will continue to evoke.

Bibliography

Aperture Foundation. 2010. *Zwelethu Mthethwa in Conversation with Okwui Enwezor*. http://vimeo.com/11046928, accessed 4 November 2010

Appadurai, A. (ed.) 1986. *The Social Life of Things: Commodities in Cultural Perspective*, Cambridge: Cambridge University Press.

Attfield, J. 1999. Bringing Modernity Home: Open Plan in the British Domestic Interior, in *At Home: An Anthropology of Domestic Space* (ed.) I. Cieraad. Syracuse NY: Syracuse University Press.

Bal, M. 1996. *Double Exposures*, New York: Routledge.

Barber, K. 1982. 'Popular Reactions to the Petro-Naira', *Journal of Modern African Studies* 20 (3): 431-50.

Behrend, H. 2000. '"Feeling global": The Likoni Ferry Photographers', *African Arts* 33 (3): 70-6.

Beidelman, T. O. 2003. *The Moral Imagination in Kaguru Modes of Thought*, Washington DC: Smithsonian Institution Press.

Bender, B. 1993. *Landscape: Politics and Perspectives*, Oxford: Berg.

Benjamin, W. 1999. *The Arcades Project*, (trans.) H. Eiland & K. McLaughlin. Cambridge MA: Belknap Press of Harvard University Press.

Buckley, L. 2000. 'Self and Accessory in Gambian Studio Photography', *Visual Anthropology Review* 16 (2): 71-91.

—— 2006. Studio Photography and the Aesthetics of Citizenship in The Gambia, West Africa, in *Sensible Objects: Colonialism, Museums and Material Culture* (eds) E. Edwards, C. Gosden & R. Phillips, Oxford: Berg.

—— 2010. Personal communication, email to author (20 September).

Burt, E. 1983. 'Mural Painting in Western Kenya', *African Arts* 16 (3): 60-3; 80.

Chalfen, R. 1987. *Snapshot Versions of Life*, Bowling Green KY: Bowling Green State University Popular Press.

—— 1991. *Turning Leaves: The Photograph Collections of Two Japanese American Families*, Albuquerque NM: University of New Mexico Press.

Cieraad, I. (ed.). 1999. *At Home: An Anthropology of Domestic Space*, Syracuse NY: Syracuse University Press.

Csikszentmihalyi, M. & E. Rochberg-Halton. 1981. *The Meaning of Things: Domestic Symbols and the Self*, Cambridge: Cambridge University Press.

Dale, D., F. Marshall & T. Pilgram. 2004. Delayed-Return Hunter-Gatherers in Africa? Historic Perspectives from the Okiek and Archaeological Perspectives from the Kansyore, in *Hunters and Gatherers in Theory and Archaeology* (ed.) G. Crothers. Center for Archaeological Investigations Occasional Paper 31. Carbondale IL: Center for Archaeological Investigations, Southern Illinois University Carbondale.

Edwards, E. 2005. 'Photographs and the Sound of History', *Visual Anthropology Review* 21 (1-2); 27-46.

Edwards, E., C. Gosden & R. B. Phillips (eds). 2006. *Sensible Objects: Colonialism, Museums and Material Culture*, Oxford: Berg.

Empson, R. 2007. Separating and Containing People and Things in Mongolia, in *Thinking Through Things: Theorising Artefacts Ethnographically*, (eds) A. Henare, M. Holbraad & S. Wastell. London:

Routledge.

Enwezor, O. 2010. Photography After the End of Documentary Realism: Zwelethu Mthethwa's Color Photographs, in *Zwelethu Mthethwa*, New York NY: Aperture.

Fabian, J. 2007. *Memory Against Culture: Arguments and Reminders*, Durham NC: Duke University Press.

Feld, S. & K. Basso (eds). 1997. *Senses of Place*, Santa Fe NM: School of American Research Press.

Galaty, J. 1980. The Maasai Group-Ranch: Politics and Development in an African Pastoral Society, in *When Nomads Settle: Processes of Sedentarization as Adaptation and Response* (ed.) P. Salzman. New York NY: Praeger.

Geary, C. 2003. *In and Out of Focus: Images from Central Africa, 1885-1960*, Washington DC: Smithsonian Museum of African Art with Philip Wilson Publishers.

Godby, M. 1999. The Drama of Colour: Zwelethu Mthethwa's Portrait Photographs, in *Zwelethu Mthethwa*, Torino: Marco Noire.

Gore, C. 2001. 'Commemoration, Memory and Ownership: Some Social Contexts of Contemporary Photography in Benin City, Nigeria', *Visual Anthropology* 14 (3): 321-42.

Grazhina. 2007. *Victorian Interiors and More: Victorian Life Wasn't Quite What You May Have Thought It Was.* http://victoriandecorating.blogspot.com/2007/02/victorian-decorating-1870-1890.html, accessed 6 September 2010

Greenberg, R., B. Ferguson & S. Nairne (eds). 1996. *Thinking about Exhibitions*, New York: Routledge.

Halle, D. 1993. *Inside Culture: Art and Class in the American Home*, Chicago IL: University of Chicago Press.

Haney, E. 2010. 'Film, Charcoal, Time: Contemporaneities in Gold Coast Photographs', *History of Photography* 34 (2): 119-33.

Hirsch, E. & M. O'Hanlon (eds). 1995. *The Anthropology of Landscape: Perspectives on Place and Space*, Oxford: Oxford University Press.

Hodgson, D. 2001. *Once Intrepid Warriors: Gender, Ethnicity and the Cultural Politics of Maasai Development*, Bloomington IN: Indiana University Press.

—— 2002. 'Precarious Alliances: The Cultural Politics and Structural Predicaments of the Indigenous Rights Movement in Tanzania', *American Anthropologist* 104 (4): 1086-97.

—— 2007. 'Positionings: Transnational Advocacy, Civil Society and the State'. Paper presented at Department of Anthropology, Emory University, Atlanta GA

Houlberg, M. 1988. 'Feed Your Eyes: Nigerian and Haitian Studio Photography', *Photographic Insight* 1 (2-3): 3-8.

Huntingford, G. W. B. 1929. 'Modern Hunters: Some Account of the Kamelilo-Kapchepkendi Dorobo (Okiek) of Kenya Colony', *Journal of the Royal Anthropological Institute* 59: 333-76.

Iovine, J. 1999. 'The Last Gasp for the American Living Room', *The New York Times* (28 January). Available at www.nytimes.com/1999/01/28/garden/design-notebook-the-last-gasp-for-the-american-living-room.html?pagewanted=all, accessed 17 September 2010.

Jewsiewicki, B. 1996. Zaïrian Popular Painting as Commodity and as Communication, in *African Material Culture* (eds) M. J. Arnoldi, C. Geary & K. Hardin. Bloomington IN: Indiana University Press.

Kamau, L. J. 1978-79. 'Semipublic, Private and Hidden Rooms: Symbolic Aspects of Domestic Space in Urban Kenya', *African Urban Studies* 3: 105-15.

Kaplan, F. 1990. 'Some Uses of Photographs in Recovering Cultural History at the Royal Court of Benin, Nigeria', *Visual Anthropology* 3 (2-3): 317-41.

—— 1991. 'Fragile Legacy: Photographs as Documents in Recovering Political and Cultural History at the Royal Court of Benin', *History in Africa* 18: 205-37.

Karp, I. & S. D. Lavine (eds). 1991. *Exhibiting Cultures: The Poetics and Politics of Museum Display*, Washington DC: Smithsonian Institution Press.

Karp, I., C. A. Kratz, L. Szwaja, T. Ybarra-Frausto et al. (eds). 2006. *Museum Frictions: Public Cultures/Global Transformations*. Durham NC: Duke University Press.

Keane, W. 1995. 'The Spoken House: Text, Act, and Object in Eastern Indonesia', *American Ethnologist* 22: 102-24.

—— 2005. Signs Are Not the Garb of Meaning: On the Social Analysis of Material Things, in *Materiality* (ed.) D. Miller. Durham NC: Duke University Press.

Kimaiyo, T. J. 2004. *Ogiek Land Cases and Historical Injustices 1902-2004*. Ogiek Welfare Council. Available at http://freeafrica.tripod.com/ogiekland/index.htm, accessed 25 August 2010.

Kirshenblatt-Gimblett, B. 1998. *Destination Culture: Tourism, Museums, and Heritage*, Berkeley CA: University of California Press.

Klumpp, D. & C. A. Kratz. 1993. Aesthetics, Expertise, and Ethnicity: Okiek and Maasai Perspectives on Personal Ornament, in *Being Maasai: Ethnicity and Identity in East Africa* (eds) T. Spear & R. Waller. London: James Currey.

Kopytoff, I. 1986. The Cultural Biography of Things: Commoditization as Process, in *The Social Life of Things: Commodities in Cultural Perspective* (ed.) A. Appadurai, Cambridge: Cambridge University Press.

Kratz, C. A. 1993. '"We've Always Done It Like This... Except for a Few Details": "Tradition" and "Innovation" in Okiek Ceremonies', *Comparative Studies in Society and History* 35 (1): 28-63.

—— 2000. Forging Unions and Negotiating Ambivalence: Personhood and Complex Agency in Okiek Marriage Arrangement, in *African Philosophy as Cultural Inquiry* (eds) I. Karp & D. A. Masolo, Bloomington IN: Indiana University Press.

—— 2002. *The Ones That Are Wanted: Communication and the Politics of Representation in a Photographic Exhibition*, Berkeley CA: University of California Press.

—— 2010. *Affecting Performance: Meaning, Movement, and Experience in Okiek Women's Initiation*, Wheatmark AZ: originally published 1994 by Washington DC: Smithsonian Institution Press.

—— 2011. 'Rhetorics of Value: Constituting Value and Worth through Cultural Display', *Visual Anthropology Review* 27 (1): 21-48.

—— In press. Uncertainties and Transformations in Okiek Marriage Arrangement, in *Place versus Path: Reconfiguring Nomads to Fit the State*, special issue of *Social Analysis*.

Kratz, C. A. & D. Pido. 2000. Gender, Ethnicity, and Social Aesthetics in Maasai and Okiek Beadwork, in *Rethinking Pastoralism in Africa: Gender, Culture, and the Myth of the Patriarchal Pastoralist* (ed.) D. Hodgson. Oxford: James Currey.

Ledochowski, C. 2003. *Cape Flats Details*, Pretoria: South African History Online & Unisa Press.

Logan, T. 2001. *The Victorian Parlour: A Cultural Study*, Cambridge: Cambridge University Press.

Low, S. & D. Lawrence-Zunigais (eds). 2003. *The Anthropology of Space and Place: Locating Culture*, Oxford: Wiley-Blackwell.

Makovicky, N. 2007. 'Closet and Cabinet: Clutter as Cosmology', *Home Cultures* 4 (3): 287-310.

Marcoux, J-S. 2001. 'The "Casser Maison" Ritual: Constructing the Self by Emptying the Home', *Journal of Material Culture* 6 (2): 213-35.

McMillan, M. 2003. 'The "West Indian" Front Room in the African Diaspora', *Fashion Theory* 7 (3/4): 397-414.

McMurry, S. 1985. 'City Parlor, Country Sitting Room', *Winterthur Portfolio* 20: 261-80.

Meyer, B. 2010. '"There Is a Spirit in that Image": Mass-Produced Jesus Pictures and Protestant-Pentecostal Animation in Ghana', *Comparative Studies in Society and History* 52 (1): 100-30.

Miller, D. 1990. 'Fashion and Ontology in Trinidad', *Culture and History* 7: 49-77.

—— 2008. 'Migration, Material Culture and Tragedy: Four Moments in Caribbean Migration', *Mobilities* 3 (3): 397-413.

—— (ed.). 2005. *Materiality*, Durham NC: Duke University Press.

Money, A. 2007. 'Material Culture and the Living Room: The Appropriation and Use of Goods in Everyday Life', *Journal of Consumer Culture* 7 (3): 355-77.

Morris, R. 2009. *Photographies East: The Camera and Its Histories in East and Southeast Asia*, Durham NC: Duke University Press.

Mustafa, H. 2002. Portraits of Modernity: Fashioning Selves in Dakarois Popular Photography, in *Images and Empires in Africa* (eds) D. Kaspin & P. Landau. Berkeley CA: University of California Press.

Myers, F. 2005. Some Properties of Art and Culture: Ontologies of the Image and Economies of Exchange, in *Materiality* (ed.) D. Miller. Durham NC: Duke University Press.

Ouedraogo, J-B. 1996. 'La figuration photographique des identités sociales: valeurs et apparences au Burkina Faso', *Cahiers d'Études Africaines* 36 (1-2): 25-50; 141-42.

Parkin, D. 1999. 'Mementoes as Transitional Objects in Human Displacement', *Journal of Material Culture* 4 (3): 303-20.

Peffer, J. 2009. *Art and the End of Apartheid*, Minneapolis MN: University of Minnesota Press.

Pinney, C. 1997. *Camera Indica: The Social Life of Indian Photographs*, Chicago IL: University of Chicago Press.

Pinney, C. & N. Peterson (eds). 2003. *Photography's Other Histories*, Durham NC: Duke University Press.

Platte, E. 2004. 'Towards an African Modernity: Plastic Pots and Enamel Ware in Kanuri Women's Rooms (northern Nigeria)', *Paideuma* 50: 173-92.

Poignant, R. & A. Poignant. 1996. *Encounter at Nagalarramba*, Canberra: National Library of Australia.

Rowlands, M. 1994. The Material Culture of Success: Ideals and Life Cycles in Cameroon, in *Consumption and Identity* (ed.) J. Friedman. Chur, Switzerland: Harwood Academic Publishers.

—— 1995. The Creolisation of West African Material Culture, in *Where to Start, Where to Stop?* (eds) L. Hill & S. Giles. Museum Ethnographers Group Occasional Papers, No. 4 19-23.

—— 1996. The Consumption of an African Modernity, in *African Material Culture* (eds) M. J. Arnoldi, C. Geary & K. Hardin. Bloomington IN: Indiana University Press.

Ruffins, F. D. 1985. 'An Elegant Metaphor: The Exhibition as Form', *Museum News* 64 (1): 54-60.

Shipton, P. 1989. *Bitter Money: Cultural Economy and Some African Meanings of Forbidden Commodities*, American Ethnological Society Monograph Series, No. 1. Washington DC: American Anthropological Association.

Sprague, S. 1978a. 'Yoruba Photography: How the Yoruba See Themselves', *African Arts* 12 (1): 52-9.

—— 1978b. 'How I See the Yoruba See Themselves', *Studies in the Anthropology of Visual Communication* 5 (1): 9-28.

Stewart, K. 1996. *A Space by the Side of the Road*, Princeton NJ: Princeton University Press.

Thompson, K. A. 2011. 'Youth Culture, Diasporic Aesthetics, and the Art of Being Seen in the Bahamas', *African Arts* 44 (1): 26-39.

Tolia-Kelly, D. 2004. 'Materializing Post-colonial Geographies: Examining the Textural Landscapes of Migration in the South Asian Home', *Geoforum* 35: 675-88.

Vogel, S. 1997. *Baule: African Art, Western Eyes*, New Haven CT: Yale University Press.

Vokes, R. 2008. 'On Ancestral Self-Fashioning: Photography in the Time of AIDS', *Visual Anthropology* 21 (4): 345-63.

Weiner, J. 2002. 'Between a Rock and a Non-Place: Towards a Contemporary Anthropology of Place', *Reviews in Anthropology* 31 (1): 21-8.

Wendl, T. 2001. 'Visions of Modernity in Ghana: Mami Wata Shrines, Photo Studios and Horror Films', *Visual Anthropology* 14 (3): 269-92.

Wendl, T. & N. du Plessis. 1998. *Future Remembrance: Photography and Image Arts in Ghana*. Watertown MA: Documentary Educational Resources.

Werner, J-F. 2001. 'Photography and Individualization in Contemporary Africa: An Ivoirian Case-study', *Visual Anthropology* 14 (3): 251-68.

Wu, C. 2010. 'What Is This Place? Transformations of the Home in Zwelethu Mthethwa's Portrait Photographs', *African Arts* 43 (2): 68-77.

Index